DANGEROUS
CREATURES
OF AFRICA

DANGEROUS
CREATURES
OF AFRICA

Chris & Mathilde Stuart

Published by Struik Nature
(an imprint of Random House Struik (Pty) Ltd)
Reg. No. 1966/003153/07
80 McKenzie Street, Cape Town 8001
PO Box 1144, Cape Town 8000, South Africa
www.randomstruik.co.za

Log on to our photographic website
www.imagesofafrica.co.za
for an African experience.

First published in 2009

1 2 3 4 5 6 7 8 9 10

Publisher: Pippa Parker
Managing editor: Helen de Villiers
Project manager: Colette Alves
Editor: Roxanne Reid
Proofreader: Tessa Kennedy
Indexer: Mary Lennox
Designers: Janice Evans, Martin Endemann
Illustrator: Sally MacLarty

Reproduction by Hirt & Carter Cape (Pty) Ltd
Printed and bound by Times Offset (M) Sdn Bhd

ISBN 978 1 77007 355 5

DISCLAIMER: The information in this book is not
intended to be a substitute for professional medical
advice. While every effort has been made to ensure
that the information provided here is correct, the
authors and publisher do not accept responsibility
for loss, injury, sickness or death suffered as a result
of using information provided in this publication.

PHOTOGRAPHS:
Front cover: Nile Crocodile (Martin Harvey/Images of Africa)
Back cover: Sahara sand viper; author photograph (Henni Allesch);
African elephant (Lanz von Hörsten/Images of Africa); *Harpactira* sp.;
Page 1: Olive baboon (Daryl Balfour/Images of Africa);
Pages 2–3: Hippopotamus (Nigel Dennis/Images of Africa);
Page 4: Ostrich; **Page 5:** Assassin bug (Alan Weaving)

CONTENTS

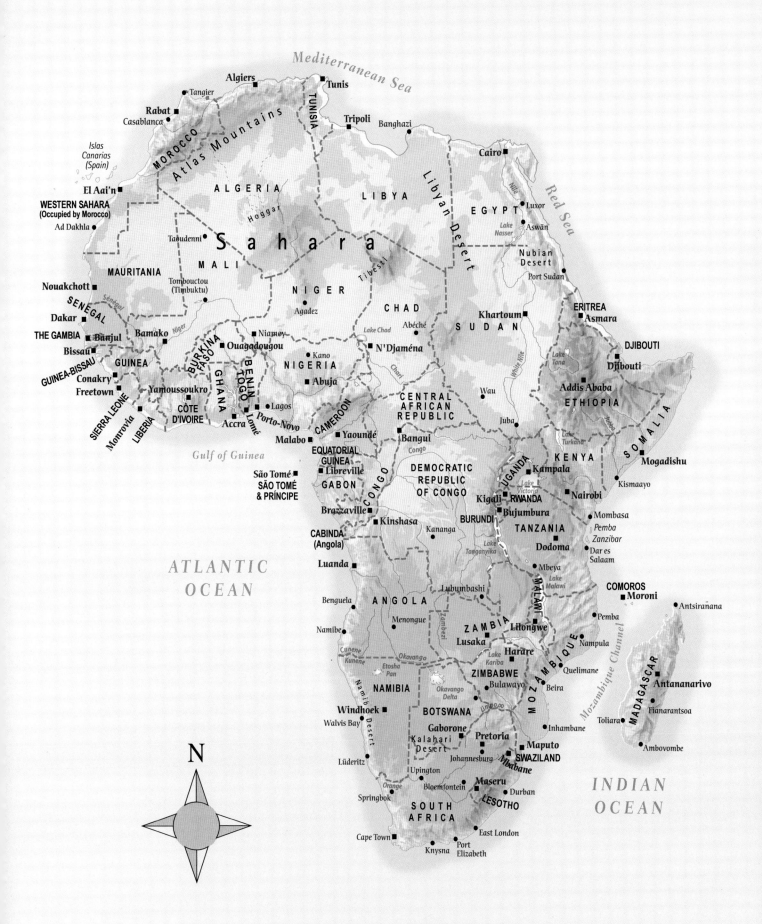

Mediterranean Sea

Tangier • Algiers • Tunis
Rabat •
Casablanca • TUNISIA Tripoli • Banghazi
MOROCCO
Islas
Canarias
(Spain)
Atlas Mountains
Cairo
El Aai'n • ALGERIA LIBYA Luxor
WESTERN SAHARA Libyan Desert EGYPT Red Sea
(Occupied by Morocco) Hoggar Lake
Nasser Aswān
Ad Dakhla •
Taoudenni • Sahara Nubian ERITREA
MAURITANIA MALI Desert Asmara
Nouakchott ■ Tombouctou Tibesti Port Sudan
(Timbuktu) NIGER CHAD Khartoum DJIBOUTI
SENEGAL Sénégal Agadez SUDAN Lake Djibouti ■
Dakar ■ Niger Niamey • Abéché Tana
Bamako N'Djaména White Nile
THE GAMBIA ■ Banjul BURKINA Lake Chad Addis Ababa
Bissau ■ FASO Ouagadougou NIGERIA Chari Wau ETHIOPIA
GUINEA Kano
GUINEA-BISSAU Abuja CENTRAL SOMALIA
Conakry ■ GHANA BENIN AFRICAN Juba
Freetown Yamoussoukro TOGO REPUBLIC Congo KENYA
SIERRA LEONE CÔTE Lagos Bangui Mogadishu ■
Monrovia D'IVOIRE Accra Porto-Novo CAMEROON UGANDA Kampala
LIBERIA Lomé Malabo Yaoundé Kismaayo
Gulf of Guinea EQUATORIAL DEMOCRATIC Kigali Nairobi
São Tomé ■ GUINEA Libreville REPUBLIC RWANDA Mombasa
SÃO TOMÉ GABON CONGO OF CONGO BURUNDI Bujumbura Pemba
& PRÍNCIPE Brazzaville Kananga TANZANIA Zanzibar
Kinshasa Dar es
CABINDA Lake Dodoma Salaam
(Angola) Tanganyika
ATLANTIC Luanda Mbeya COMOROS
OCEAN Lake Moroni ■
Benguela Lubumbashi Malawi Antsirañana
ANGOLA Pemba
Menongue Zambezi MALAWI MADAGASCAR
Namibe ZAMBIA Lilongwe Nampula Antananarivo
Cunene Lusaka Lake
Kunene Okavango Harare Kariba MOZAMBIQUE Quelimane Fianarantsoa
Etosha Zambezi ZIMBABWE Beira
Pan Okavango Bulawayo Mozambique Channel Toliara
NAMIBIA Delta Inhambane
Namib Desert BOTSWANA Limpopo Ambovombe
Windhoek ■ Gaborone Maputo
Walvis Bay Kalahari Pretoria SWAZILAND INDIAN
Desert Johannesburg Mbabane OCEAN
Lüderitz Upington Maseru
Orange SOUTH Bloemfontein LESOTHO Durban
Springbok AFRICA
Cape Town Knysna Port East London
Elizabeth

N

ATLANTIC OCEAN

INDIAN OCEAN

Introduction

*'... no country in the world abounds
in a greater degree with dangerous
beasts than southern Africa'*

Charles Darwin, *The Descent of Man*

Humans have evolved with a great fear of creatures that can wound or
kill us by biting, goring or kicking. Some can inject us with potent venom,
others can deliver fluids that cause agonising pain if we stand on them
or they push against us. Even worse are blood-suckers and deliverers of
parasites and viruses, which can cripple, debilitate or even kill.
However, more people are killed by lightning strike than by sharks in
Africa, and the number of deaths caused by 'dangerous creatures' is
minuscule when compared to man's impact on fellow humans.

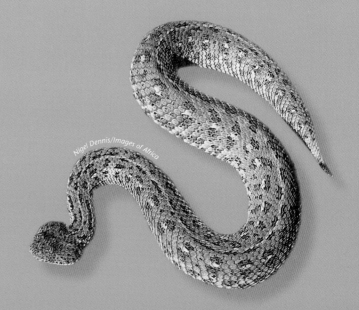

Man – the greatest threat

Africa is riven by civil wars, cross-border conflicts, starvation and death by disease. The southern region of Sudan was in a state of civil war for 21 years, when some 1.5 million people died, while at least 200 000 have been killed in the region of Darfur in the past four years. In the Democratic Republic of Congo possibly as many as three million humans have died from violence, hunger and disease since 1997. It is believed that despite the 'peace' in that country, 1 000 people continue to die every day. A tenth of the population of Somalia has died since 1991. Diseases and parasites thrive and prosper in situations of chaos, climatic extremes and warfare, situations all too well known in Africa.

In South Africa alone about 15 000 people die on the roads every year, and more than 10 000 are killed by bullet, knife or other assault. By contrast, dangerous creatures kill fewer than 50 with their venoms and poisons; and stompers, horners, tuskers and biters perhaps account for 100 human fatalities each year in southern Africa. The number of humans killed or debilitated in Africa by the insect-borne diseases, such as malaria, still tops the list. The death toll and misery resulting from disease could

be greatly reduced with the application of simple and often basic measures. Sadly, due to poverty and the lack of political will, death tolls remain high in many countries and regions.

In most cases, whether wittingly or not, we humans create the scenario for injury and death as a result of an encounter with one or other of our dangerous creatures.

This book is not intended to frighten but to enlighten, to show how to avoid conflict situations and prevent discomfort. Most situations can be avoided and knowing how to do this allows us to enjoy our environment and the many creatures with whom we share it. Whatever our conceptions about our fellow creatures, most prefer to avoid conflict with us. It is possible to avoid contact with disease-carrying parasites, but they remain the most dangerous creatures of all. Avoidance is possible in some cases but the risk of infection, or having parasites sharing your body, is still quite high.

Together we share an increasingly threatened planet, but the most dangerous creatures of all, the ones damaging the planet directly or indirectly, are human beings – well over six billion of us.

NOTE: Where accurate figures for the whole of Africa are not available, statistics for southern Africa alone are quoted.

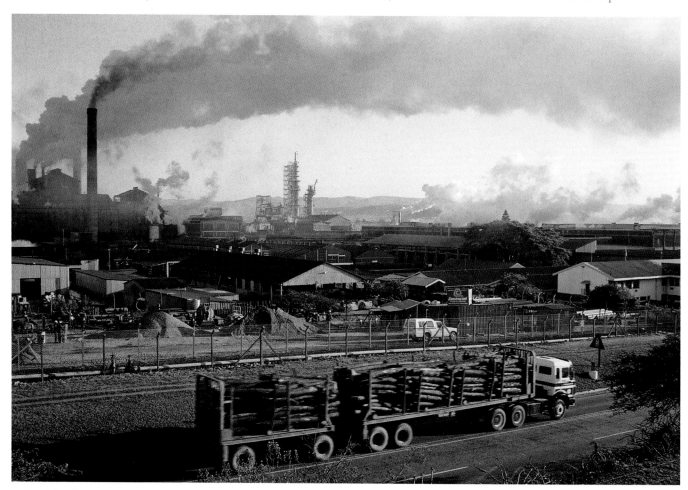

Industrial pollution is an ever-growing problem in parts of Africa.

POPULATION FIGURES AND DEATH RATES FOR SOUTH AFRICA
(2006)

ESTIMATED TOTAL POPULATION (2005)	47 432 000	
TOTAL NUMBER OF REPORTED DEATHS	**607 184**	
Deaths of natural causes	554 570 (= 91.3 %)	
Deaths of unnatural causes (all ages)	52 614 (= 8.7 %)	
Deaths of unnatural causes for 15–19 year olds	43 %	
LEADING NATURAL CAUSES OF DEATH	**Number**	**Percentage**
1. Tuberculosis	77 009	12.7 %
2. Influenza and pneumonia	52 791	8.7 %
3. Intestinal infectious diseases	39 239	6.5 %
4. Heart diseases (excluding ischaemic heart disease)	26 628	4.4 %
5. Cerebrovascular diseases	25 246	4.2 %
6. Diabetes mellitus	19 549	3.2 %
7. Chronic lower respiratory diseases	15 823	2.6 %
8. Certain disorders involving the immune system	15 736	2.7 %
9. Human immunodeficiency virus (HIV) disease	14 783	2.4 %
10. Ischaemic heart disease	13 025	2.1 %
OTHER NATURAL CAUSES OF DEATH	**Number**	**Percentage**
Deaths caused by cancer (all organs)	34 002	5.6 %
Protozoal diseases (e.g. malaria, sleeping sickness)	5 225	0.9 %
Helminthiases (e.g. schistosomiasis, filariasis, intestinal worms)	76	
Arthropod-borne viral fevers (e.g. dengue fever, yellow fever)	23	
UNNATURAL CAUSES* OF DEATH	**Number**	
Vehicle accidents: total; of which:	15 393	
• drivers	4 466	
• passengers	5 151	
• pedestrians	5 776	
Accidental discharge of firearm	5 479	
Assault	5 375	
Accidental drowning	1 376	
Contact with venomous animals and plants (latest available – 2002)	37	
Accidents in sport (latest available – 2002)	15	

* NOTE: many unnatural deaths are due to 'Unspecified event of undetermined intent' (35 133), or 'Other external causes of accidental injury' (3 947).

Laura Glover

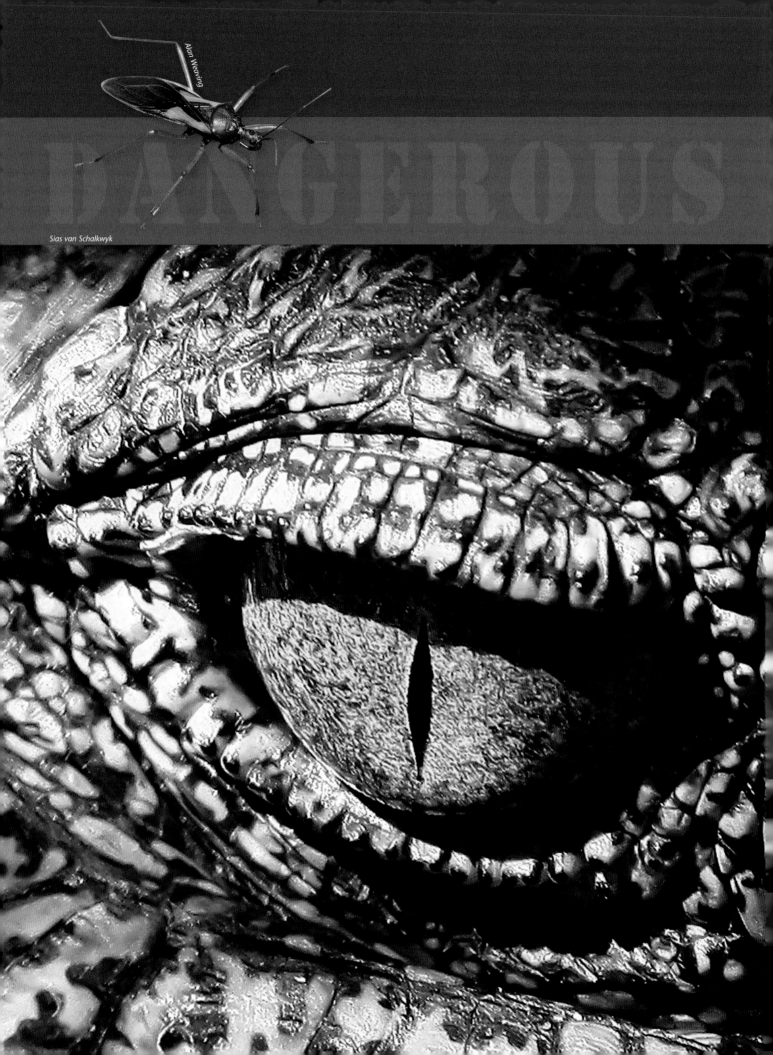

DANGEROUS

PART ONE
Animals that can wound

Many of the creatures that share the planet with us, both domesticated and wild, can bite, scratch, tear, cut, crush and sometimes kill. Most would rather avoid conflict with man, and it is usually human behaviour that starts the trouble. The rare cases of attack that do occur usually involve animals that have been wounded, feel threatened and cornered, or are suffering from a disease or injury that changes their normal behaviour, such as in the case of rabies. Extreme conditions such as drought or flooding may drive animals closer to man than usual, resulting in conflict. This is not to say, however, that unprovoked attacks are unknown, whether it is a predator seeing man as legitimate prey or a pet turning on its owner.

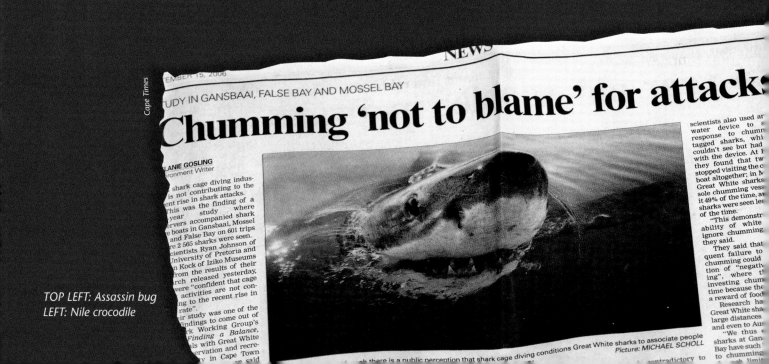

TOP LEFT: Assassin bug
LEFT: Nile crocodile

Cape Times

NEWS

SEPTEMBER 15, 2006

STUDY IN GANSBAAI, FALSE BAY AND MOSSEL BAY

Chumming 'not to blame' for attacks

MELANIE GOSLING
Environment Writer

shark cage diving indus-
is not contributing to the
ent rise in shark attacks.
This was the finding of a
year study where
rvers accompanied shark
boats in Gansbaai, Mossel
and False Bay on 601 trips
re 2 565 sharks were seen.
cientists Ryan Johnson of
University of Pretoria and
Kock of Iziko Museums
from the results of their
rch released yesterday,
were "confident that cage
activities are not con-
ng to the recent rise in
rate".
ir study was one of the
ndings to come out of
rk Working Group's
Finding a Balance,
ls with Great White
ervation and recre-
y in Cape Town
said

scientists also used an
water device to
response to chumm
tagged sharks, whi
couldn't see but had
with the device. At
they found that tw
stopped visiting the c
boat altogether; in M
Great White sharks
sole chumming vess
it 49% of the time, a
sharks were seen les
of the time.
"This demonstr
ability of white
ignore chumming
they said.
They said that
quent failure to
chumming could
tion of "negati
ing", where t
investing t
time because the
a reward of food
Research ha
Great White ha
large distances
and even to Au
"We thus
sharks at Gan
Bay have such
to chumming

t there is a public perception that shark cage diving conditions Great White sharks to associate people
Picture: MICHAEL SCHOLL

MAMMALS

Africa is blessed with a great diversity of mammals. They range from the largest land mammal, the African elephant weighing from 2.8 to 6.3 tons (bulls are larger than cows), to one of its smallest, the dwarf shrew at just 3.5 grams. Virtually all, given the circumstances, can injure or, on rare occasions, cause death.

Throughout prehistory and recorded historical times man has come into conflict with wildlife, whether it be for space, food or sport hunting. In as many as 85 % of cases where an animal has attacked a human it has been found to have been wounded, trapped, pursued or otherwise pushed to defend itself.

Some attacks are unprovoked and cannot be adequately explained – such as the time an elephant cow initiated a full charge over an open floodplain when she was more than a kilometre from our vehicle. At first we believed she would break off the charge, but she kept after us for at least two kilometres. This was uncharacteristic given the distance involved, but poaching was rampant in the area at that time and she might have had a bad experience with a vehicle, or been wounded.

There are cases where a person encounters an animal that has been wounded or injured, follows the 'rules of the bush', but is still attacked. It is possible to enter a threatening situation without being aware of the danger – the animal cannot be blamed if it retaliates in what it sees as defence.

The heavyweights
African elephant

The African elephant (*Loxodonta africana*) is a great, grey, gentle giant, and is usually happy to be left alone, but sometimes its awesome strength can be put to frightening use.

A full charge usually starts with the elephant raising its massive head and holding its tusks high while searching for the source of the disturbance. The great ears fan out and the tail is held erect. To intimidate, it may resort to high-pitched trumpeting and slapping its ears against its head and neck. Once the adversary is located, the elephant begins to run, holding its ears tightly against its body and curling its trunk under its jaw. As the elephant approaches its target it will try to knock the person down and crush them with the base of its trunk. It may drop to its knees, usually screaming and trumpeting (though eerily silent according to some reports), and stab at the victim with its tusks.

That is the classic charge, but there are variations. The elephant may simply trample the person into the ground with its massive front feet or throw them around like a rag-doll with its trunk. Once satisfied that the adversary has been dealt with, the animal may just wander away, or it may bury the victim under branches and other plant debris.

Surprisingly, some people have walked away from such a terrifying incident. Michael Fay, well known for his exceptional conservation work in Central Africa, was one of the lucky ones. Michael and a group he was leading were charged by a cow elephant on a beach in Gabon. He stepped into the elephant's path to distract her from the other members of the party. He described the incident: 'We fell to the ground, her tusks in my hands. Her eye was six inches from mine. For a moment we looked at one another. She started to roll over on me. My ribs cracked; my lungs collapsed. She stood up to regain her balance, or maybe because my death was not her objective. Then she ambled off. She'd stabbed me 13 times, but only punctured skin and muscle.' He felt that surviving this incident had brought him even closer to elephants than previously; he was the intruder after all.

TRAMPLED BY TSHOKWANE

Well-known wildlife photographer Daryl Balfour was getting the last photographs for his book on the big tuskers of Kruger National Park. Last on his list was Tshokwane, the second largest tusker in the park and probably in Africa.

He set off with his photographic equipment, staying downwind of the elephant. 'Then [the elephant] started moving deeper into the thorn scrub, out of view, and I decided to attract his attention,' Daryl recalled. 'Softly I clicked my gold wedding band on the aluminium leg of my tripod.' It certainly got his attention: he mock charged, coming to a stop just six or seven metres from Daryl. After a tense standoff, with Daryl throwing his arms in the air and shouting, both retreated. After Daryl had covered about 100 metres, he turned and saw Tshokwane feeding. As a dedicated photographer in a competitive field he could not resist turning again towards the elephant to take more photographs. This was to be his date with near death. Again there was a mock charge, or at least that is what Daryl thought. Tshokwane stopped 15 metres away in a cloud of dust.

'Then, with chilling fury, he trumpeted in rage, lowered his head, and came on. I had a few more shots before realisation struck. I scrambled to my feet, scooped up the tripod and turned to run, knowing it was too late … I thought, momentarily, "That's all he's going to do!" The second blow knocked me flying, and I tumbled through the sharp thorns. Before I had a chance to gather my wits or attempt to roll clear, the elephant was upon me, kicking, stomping and flailing with massive feet and legs. It was a moment of sheer terror.'

Tshokwane curled his trunk around Daryl's leg and threw him in a swinging arc through the air. Now the elephant was getting ready to deliver the *coup-de-grâce*. Daryl was knocked senseless when a tusk struck a glancing blow on his head. Rangers examining the site later believed Tshokwane had knelt and tried to kill him with the base of his trunk, but the huge tusks had prevented this.

When Daryl regained consciousness he was badly injured but managed to fire off shots in a pre-arranged signal to tell his wife Sharna something had gone wrong. Despite his grave condition he still insisted she pick up what was left of the cameras as the film might be salvaged. After a difficult and worrying journey he was stabilised at the park's headquarters at Skukuza. The camp doctor believed he would not live. A helicopter flew him to the hospital in Nelspruit and he started his long road to recovery. Tshokwane's 'gift' to Daryl was a dislocated right hip, numerous fractured ribs, a slight fracture of the skull, sprained ankle, badly bruised calf and a checkerboard of bruises and abrasions all over his body.

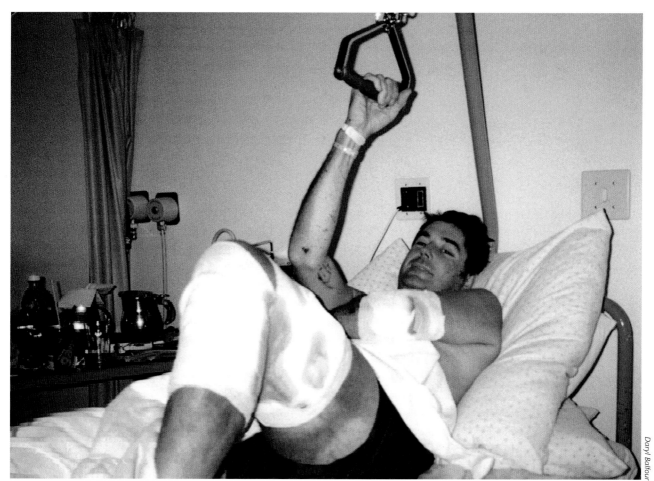

Wildlife photographer Daryl Balfour after being trampled by Tshokwane, the second largest elephant in the Kruger National Park.

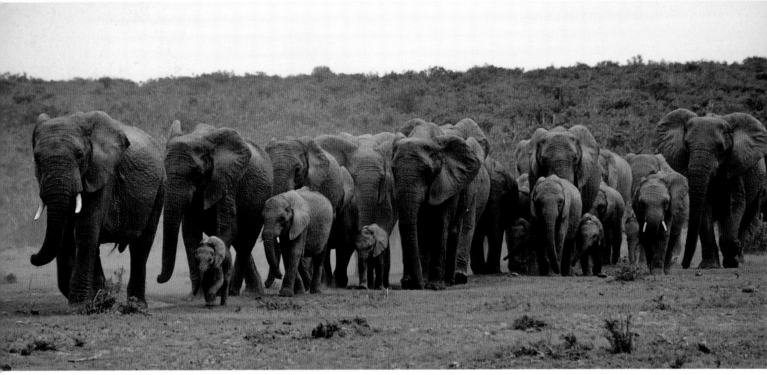

Elephant herds with small calves should be treated with considerable caution.

Counting elephants

There is no certainty as to how many elephants roamed the African continent when the first European explorers and settlers were setting down their deep footprints. Certainly there were few places in sub-Saharan Africa where they did not roam and it is estimated that perhaps as many as 10 million wandered the savannas and forests. By 1979 this number had dwindled to slightly more than one million and today half of that number survive. In some areas they are in serious decline but in parts of southern Africa where protection levels are high, elephants have proliferated to the point where they pose a threat to the survival of their habitats.

Ancient Egyptians, Greeks, Romans and now our more modern civilisations have always coveted the ivory of elephant tusks; even today the Chinese and Japanese see it as a valuable commodity. The first determined slaughter of the African elephant was spear-headed by 'great white' elephant hunters such as Jacobus Coetse, Petrus Jacobs, William Cotton Oswell, Frederick Selous, William Finaughty, Henry Hartley and Karamojo Bell. By the early 1900s southern Africa had lost virtually all of its elephants to the guns of the ivory hunters. But in the 1970s and 1980s an even more bloody slaughter ensued across Africa when corrupt military officers, politicians and even some conservation officials gave the elephants no quarter. With the slaughter of adult cows, herd cohesion suffered. As the social structure of family groups and herds was disrupted, leaderless groups of sub-adults and weaned juveniles wandered aimlessly. Lack of leadership often led these 'mobs' to turn to cultivated crops and, inevitably, conflict between man and elephant escalated. Under these circumstances the number and severity of the clashes increased, along with human fatalities.

TRAGEDY AND DRAMA

The importance of retaining the social structure of elephants has been graphically illustrated on a number of translocation exercises. One of the first of these took place in 1979, when five young elephants were captured in South Africa's Addo Elephant National Park and transported north to the newly proclaimed Pilanesberg in North West Province. They were placed in temporary holding pens, but one young bull broke out of the boma and the park and set off to the south. During his four-day journey covering 100 km, people and dogs continuously harassed the elephant and one elderly farmer was trampled and killed. There is no doubt that the animal was traumatised and terrified and retaliated in the only way it knew how.

In 1981, 18 young elephants, survivors of culling operations, were transferred to Pilanesberg from Kruger National Park. Inevitably, problems resulted from moving leaderless young animals: some tourist vehicles were attacked, as were other animals (in particular square-lipped rhinoceros), and even people. Later, adult elephants were introduced from Kruger to stabilise the situation.

Despite these experiences, lessons have not always been learned and a number of conservation authorities and private game reserves have repeated the mistake of introducing young animals only – and more attacks have taken place. Certainly the elephants cannot be blamed for these attacks where humans have placed them in strange and frightening situations.

Conflict with man

Through the ages people have killed elephants and elephants have killed people – in the latter case not because of malice, but usually because female elephants protected their calves, elephants retaliated when farmers tried to drive them from their crops (which the giants see as a legitimate source of food) or simply when surprised or frightened. Most reported attacks on humans were by elephants that were being hunted, populations that were being continuously harassed, or wounded individuals. In many areas where elephants survive they are coming into ever more frequent conflict with man. When villages and farmland block ancestral migration routes and fences are erected to control their movement, elephants are increasingly isolated in small enclaves from which they cannot escape. If they do they are generally doomed.

In recent years the elephant population in the Shimba Hills of southeastern Kenya had grown to three times its carrying capacity. Surrounded by settlements and small farms, the animals had nowhere to go. Culling was an option but under pressure from animal-rights groups it was decided to capture up to 400 animals and transfer them to Tsavo East National Park, which is unfenced and surrounded by areas that are sparsely settled by humans.

In the 1970s, in the Sihangwane sand thicket country of Maputoland/Tongaland along the Mozambique–South Africa border, bull elephants used to move seasonally from the Maputo Elephant Reserve to the Sihangwane thickets.

Although human habitation in the area was low, several peasant farmers were attacked and killed. The then controlling authority, the Natal Parks Board, employed problem animal control officers to hunt down and shoot bull elephants that were causing problems. Of the eight shot in three years all already had wounds of some kind inflicted by man – multiple bullet wounds, scrap iron from muzzleloaders embedded in their flesh, or trunk tips amputated by steel snares. With increased protection in the form of the proclamation of the Tembe Elephant Reserve, lying between Ndumo Game Reserve and the coast, matriarchal elephant herds are now present and elephant/human conflicts are, at least for now, limited.

In Zimbabwe, the latest elephant population estimate is around 100 000, mainly concentrated in and close to conservation areas. Because of the high levels of hunting and poaching across Zimbabwe, elephants crowd into the protected areas and have negative impacts on the vegetation. During periods of drought they are forced to move into the rural farming areas to obtain enough food and water. Expanding human populations in rural areas will increase conflicts between elephant and man. Ten people were reportedly killed in Zimbabwe by elephants in 2004 and 12 in 2005. The wildlife management authority says most of the people killed went into elephant habitats in search of food, but the peasant farmers say that the elephants are entering their fields. Some of these fields are on the fringes of the conservation areas.

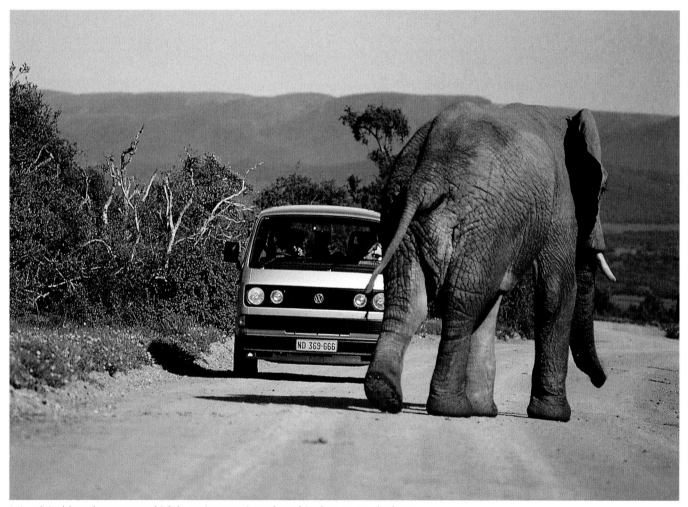

It is advisable to keep your vehicle's engine running when this close to an elephant.

Zimbabwe's *Herald* newspaper reported the death of a game scout in the Gonarezhou National Park in May 2007. The bull elephant had been seriously injured in a fight with another elephant. The incident would probably have had a better outcome if the shooting skills of the scout and his two companions had been more accomplished. The report states: 'They came across the elephant which was hiding in the bush and started shooting at it, prompting it to flee. They tracked it and caught up with the animal and continued firing shots at it in an attempt to kill it. However, the elephant got incensed and charged at the three game scouts forcing them to flee. It gave chase and caught up with Admire Kayungwa and trampled him. The two surviving scouts continued to pump bullets into the animal until it dropped dead.'

The same newspaper also recorded the death of a man in the vicinity of Chirundu Sugar Estates in May 2007. He had gone on a fishing expedition but his badly crushed and mutilated body was found two days later. His right leg was found several metres away from the rest of his body and his abdomen had ruptured. In this case the reason for the attack is unknown.

Another incident in which the cause is unknown happened near Phalaborwa in South Africa in April 2007. An elderly woman was trampled to death and it was reported that 'all her bones had been broken'.

Elephants were said to be responsible for the deaths of three people in Livingstone, Zambia, in March 2006. At least one of the two elephants thought to have been involved had a broken tusk and was suspected of having been wounded. Apparently the victims were killed at night but at least one had no marks or injuries, indicating that an elephant was not responsible. A number of cases we have investigated indicate that wild animals have been falsely implicated to cover up a crime.

ATTACKS ON TOURISTS

Apart from conflict between elephants and local people, there have been a growing number of cases where tourists have been killed. In October 2006 a British honeymoon couple were on a guided walk at Richard's Camp in the Masai Mara National Reserve in Kenya. The man was trampled and killed when an elephant attacked them just 300 metres from the camp.

In March 2007 a British mother and daughter were trampled to death by an elephant in the Hwange National Park in Zimbabwe while walking with a tour guide, who was injured in the attack. They were crouching behind a termite mound when the elephant charged and the guide tried to distract the animal with a warning shot. The authorities said they believed the elephant had been wounded by poachers, but this has not been confirmed.

Many thousands of tourists go on guided trails in elephant-inhabited areas in Africa and most never see any elephant aggression. Most game guards are sensible and well trained to deal with emergencies, but there are always some that are 'cowboys'. Some years ago in Botswana's Tuli Block we saw a guide sneak up on foot to several dozing elephants to impress his vehicle-load of tourists. In Greater Addo Elephant National Park we saw a father encourage his wife, holding a small child, to walk within 20 metres of a herd that included small calves – so he could get a photograph for the family album. It is this sort of behaviour that often results in tragedy, and the elephant gets the blame.

It is not only when a person is on foot that conflict can arise; elephant have also attacked vehicles. Usually the driver has provoked the elephant by approaching too closely, switching off the engine, or simply lacking any understanding of elephant behaviour. An incident occurred in Etosha National Park in the 1970s when an elephant attacked a Volkswagen Beetle. It placed its tusks through the door and bounced the vehicle until it got bored and backed off, leaving two very frightened people behind. The driver had got too close to the animal and switched off the engine – suffering the consequences.

Two Britons trampled to death in safari stampede

By Cahal Milmo

A mother and her daughter were killed when an elephant trampled them during a safari in a game reserve in western Zimbabwe.

The woman's husband was injured in the accident, which occurred after the group of holidaymakers had left their vehicles to look closer at a male bull elephant while on a two-night visit to Hwange national park.

which is renowned for its diversity of big game, said: "It happened extremely quickly.

"They were with an experienced, professional guide who fired a warning shot, but there was no time to fire a second as the elephant charged. The two who died were trampled under the animal as the rest of the group tried to get away."

Police in Hwange, in the far west of Zimbabwe close to the Botswanan border, said they were investigating if there had been any negligence on the part of the guide.

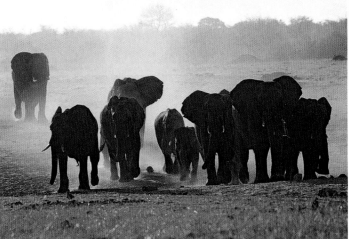

Elephants at Hwange. Twelve people were killed by charging elephants in Zimbabwe in 2005

band of the Italian fashion designer Anna Molinari, was killed

phant, they left the vehicle to reach close quarters on foot.

can get out of the vehicle and walk towards the animal of interest,

The Independent, 27 March 2007

Elephant kills two in Caprivi

The *New Era* newspaper of Namibia reported the deaths of two officials in the Mahango Game Reserve in the western Caprivi Strip in Namibia in May 2007. Six officials, in two groups of three, were on patrol in the reserve when a bull elephant charged one of the groups and trampled Tekla Haseb to death. When her colleague, Kapinga Kasanga, ran to try to help her, he was also killed. It appears that they had only seen the elephant when they were almost upon it because the bush was dense. The bull was tracked down and shot.

Both human and elephant populations in Caprivi have increased in recent years, and the potential for conflict is thus also increasing. The area is also a 'hotspot' for fatal attacks by Nile crocodile and hippopotamus.

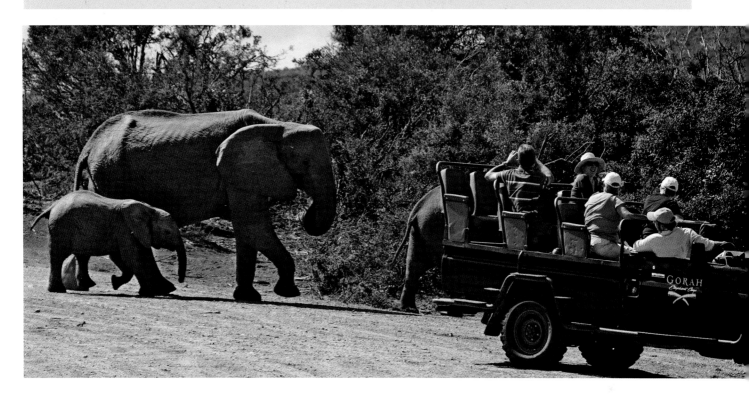

Avoiding trouble

Of the many thousands of interactions between elephants and humans, very few end in conflict. If you follow a few simple rules you will not become an elephant statistic. These rules apply to contact with most other potentially dangerous species too.

- Never walk in areas frequented by elephants unless you have an excellent knowledge of their behaviour or you are accompanied by someone who does.
- Avoid walking in areas where there has been poaching activity because elephants may be frightened and aggressive, and there is a risk of encountering a wounded animal.
- Whether on foot or in a vehicle, keep your distance. Never try to approach close to any herd that contains small calves. If another driver tries to do so, move further away if possible. Under these circumstances elephants may feel threatened and retaliate. If you are on a guided tour and your driver/ guide behaves in a fashion that obviously disturbs animals, report him to his employer. Not only does this type of behaviour upset the animals but it puts people in the vehicle at risk.
- When elephants are close to your vehicle keep the engine running.
- If elephants are blocking the road both in front and behind you, wait quietly until the herd has moved away from the road. Never attempt to rush through.
- If you are waiting in a vehicle at a waterhole make sure you are not blocking any trails between the water and the surrounding bush. This ensures you do not anger approaching or departing elephants and avoids inhibiting more timid game from coming to drink.

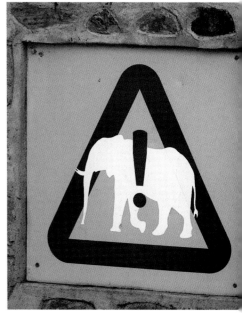

TOP: *Ensure that you are not blocking game trails, especially near sources of water.*
ABOVE: *Always heed warning signs; they are there for your safety.*

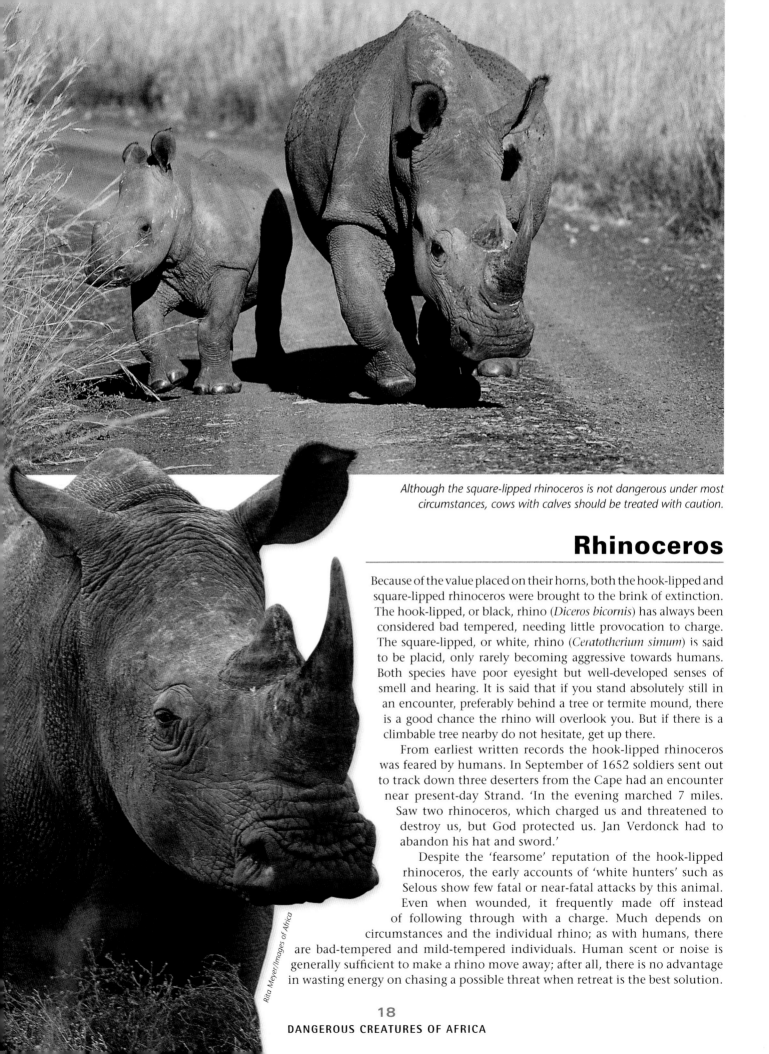

Although the square-lipped rhinoceros is not dangerous under most circumstances, cows with calves should be treated with caution.

Rita Meyer/Images of Africa

Rhinoceros

Because of the value placed on their horns, both the hook-lipped and square-lipped rhinoceros were brought to the brink of extinction. The hook-lipped, or black, rhino (*Diceros bicornis*) has always been considered bad tempered, needing little provocation to charge. The square-lipped, or white, rhino (*Ceratotherium simum*) is said to be placid, only rarely becoming aggressive towards humans. Both species have poor eyesight but well-developed senses of smell and hearing. It is said that if you stand absolutely still in an encounter, preferably behind a tree or termite mound, there is a good chance the rhino will overlook you. But if there is a climbable tree nearby do not hesitate, get up there.

From earliest written records the hook-lipped rhinoceros was feared by humans. In September of 1652 soldiers sent out to track down three deserters from the Cape had an encounter near present-day Strand. 'In the evening marched 7 miles. Saw two rhinoceros, which charged us and threatened to destroy us, but God protected us. Jan Verdonck had to abandon his hat and sword.'

Despite the 'fearsome' reputation of the hook-lipped rhinoceros, the early accounts of 'white hunters' such as Selous show few fatal or near-fatal attacks by this animal. Even when wounded, it frequently made off instead of following through with a charge. Much depends on circumstances and the individual rhino; as with humans, there are bad-tempered and mild-tempered individuals. Human scent or noise is generally sufficient to make a rhino move away; after all, there is no advantage in wasting energy on chasing a possible threat when retreat is the best solution.

Even when charging, a rhino may be warned off by a rifle shot or a loud shout. Once a charge is deflected it is very rare that a rhino will return for a second attempt.

Even up to the 1960s, hook-lipped rhinoceros were abundant, with an estimated 8 000 in Kenya's Tsavo National Park alone. By the end of the 1970s some 65 000 survived across sub-Saharan Africa. Today around 4 200 survive in a few selected conservation areas, with the largest number in South Africa. Brought to the brink of extinction, the southern square-lipped rhinoceros has benefited from strict conservation, with numbers now reaching 17 500. It is this species you are most likely to encounter in southern Africa's national parks, reserves and privately owned game ranches. These days rhinoceros are relatively abundant in South Africa and northern Namibia, and can also be found in a very limited number of locations in Botswana, Zimbabwe, Swaziland, Zambia, Kenya and Tanzania.

Separated by habitat needs

Both species of rhinoceros are formidable. The square-lipped rhino is the second largest land mammal (after the elephant), with body mass in bulls exceeding two tons and a shoulder height of almost two metres. Hook-lipped rhinos weigh in at between 800 kilograms and just over a ton and measure up to 1.6 metres at the shoulder. Despite their bulk and cumbersome appearance they can reach a speed of 40 kilometres per hour and are amazingly agile when disturbed.

The two species can be separated by their habitat requirements, which are related to their diet. Hook-lipped rhinos feed on woody plants and are associated with a variety of wooded habitats, but in a few areas, such as Damaraland in northern Namibia, they have adapted to arid open country bisected by numerous dry river courses. The square-lipped rhino is a grazer and although it will lie up in woodland fringes it rarely enters densely bushed areas.

The rhino's revenge

In recent years more attacks by the square-lipped rhinoceros have been reported than those by its hook-lipped cousin. This is not because they have become more aggressive, but simply because they are more abundant and widespread, so the chance of encountering them has increased.

Charging rhino shot

In November 2006 four British soldiers at a training ground in Laikipia Conservancy in Kenya became lost in the bush at night and were charged by a square-lipped rhino bull. They opened fire, killing the bull, whose horns were retrieved by the authorities the following day. There are fewer than 300 of this rhino species in Kenya, all originating from stock introduced from South Africa's healthy population.

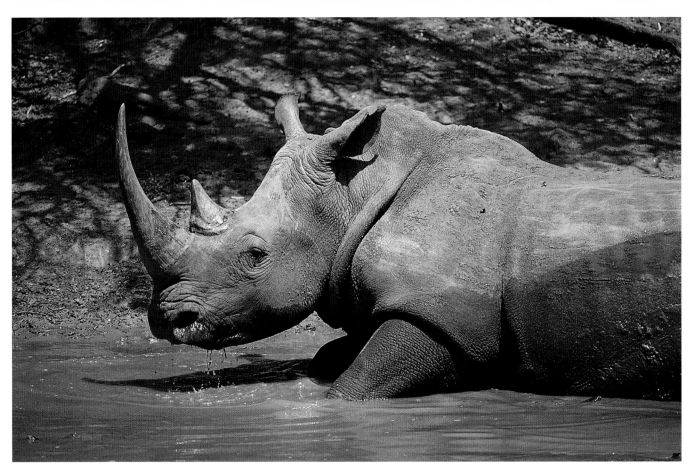

Despite its heavy and clumsy appearance, the square-lipped rhinoceros can move with great speed and agility.

Mkuzi Game Reserve in KwaZulu-Natal has seen tragedy and serious injury visited on researchers. In one incident, one of the conservation authority's rhino researchers was attacked and seriously horned by a hook-lipped rhino; in another, a British researcher was killed by a square-lipped rhino. Part of the problem in these rare attacks is that the person is only aware of a rhino when he is almost upon it. The rhino gets a fright and may beat a hasty retreat or immediately attack; until it happens you do not know which will be the case.

Interestingly, there are few records of square-lipped rhinoceros charging vehicles, whereas there are plenty of accounts of the hook-lipped rhino doing so. This may in part be a product of their favoured habitat, the former frequenting mainly open country and the latter more densely bushed areas. It is far easier to come up suddenly on a rhino in dense bush than it is in open grassy woodland. It is also more difficult to evade a charge when it is impossible to turn a vehicle rapidly. A hook-lipped rhinoceros once charged out of dense bush straight for our vehicle at Greater Addo Elephant National Park. Fortunately, we were moving and could outdistance the animal, and the charge was sustained for only 50 metres. The park was particularly busy that day, so it is possible that the rhino was irritated by the constant traffic movement, or by some cause of which we were not aware.

Tragic rhino attack

A young student from St Andrews University in Scotland arrived at Mkuzi Game Reserve in KwaZulu-Natal, South Africa, in 1986 to undertake a study on savanna baboons. A ranger took her on an orientation walkabout, stopping for a rest in a clearing in the bush. Without warning, a square-lipped rhino calf entered the clearing a few metres away, then fled into the bush. Before they could move away, knowing that the mother would be close behind, the cow appeared in the clearing and immediately charged, thrusting its front horn into the student's ribcage just below the armpit. She died instantly. The ranger was unharmed.

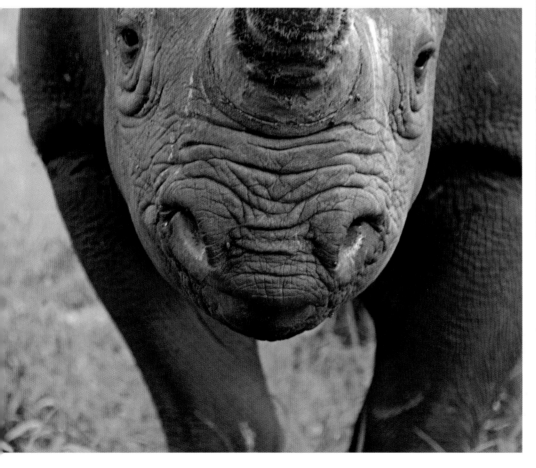

LEFT: As with all large game species, it is a good idea to maintain a safe distance from rhinoceros, whether you are in a vehicle or on foot.
ABOVE: Female rhinos with small calves are always on the alert for real or perceived threats.

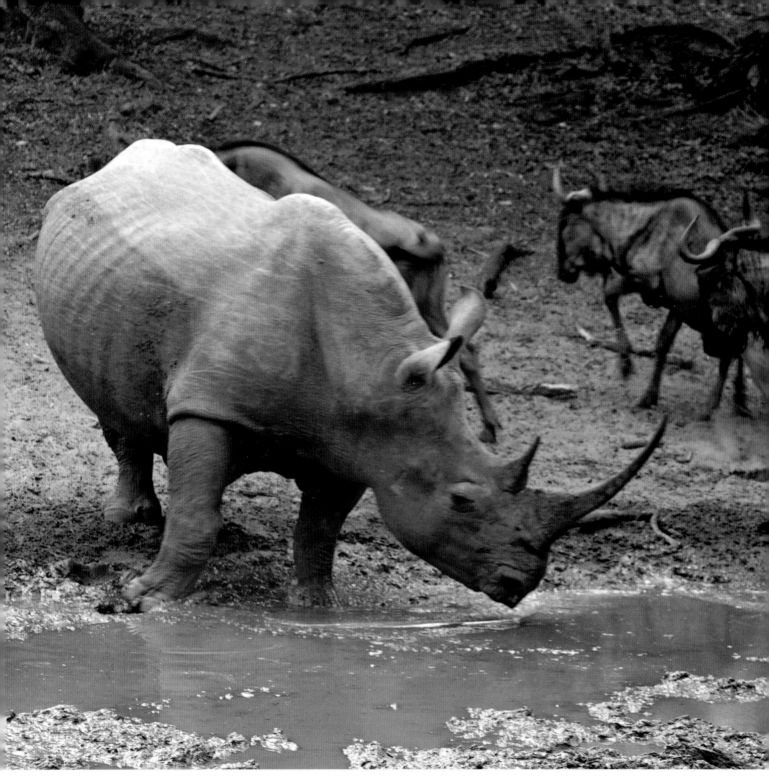

⚠ Avoiding trouble

- Do not walk in areas where rhinoceros occur unless you are familiar with rhino behaviour, or you are accompanied by somebody who is knowledgeable. Despite their large size, it is easy to come within a few metres of a rhino without being aware of its presence.

- If you encounter a rhino at close quarters, keep still and look for a climbable tree nearby. If you are close to a hill or ascending slope, move upwards because rhinos rarely charge uphill. Move into rocky terrain if it is available because this may deter a rhino charge.

- Remember, out-running a rhino is nigh impossible, as it is with most wild mammals. If you have no escape options you can try one of two things (we are told that it sometimes works): stand absolutely still and hope the rhino cannot locate you; or shout, wave your arms above your head and look as big as you possibly can in the hope of frightening off the rhino. We know of one case where the person being charged threw down his rucksack, which the rhino attacked, giving him a chance to get into a tree.

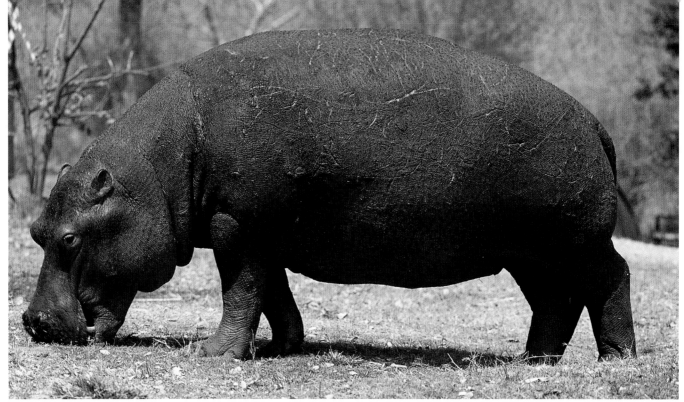

Do not be fooled by its portly appearance, the hippopotamus is a fast runner and deadly adversary.

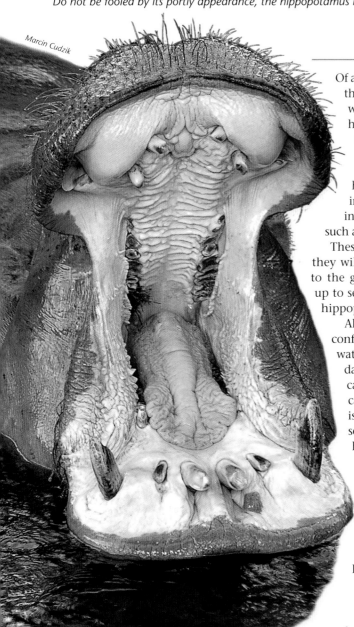

Marcin Cudzik

Hippopotamus

Of all the large herbivores it is the hippopotamus (*Hippopotamus amphibius*) that you should be most wary of, especially at night or if you are on the water in a small boat. It is considered to be Africa's most dangerous large herbivore and is responsible for more human fatalities than elephant, rhinoceros and buffalo combined.

Hippopotami range in size from one to two tons, males being larger than females, and reach an average shoulder height of 1.5 metres. The head is massive, with a broad muzzle and impressive array of tusk-like incisors and canines that are capable of cutting a human in half. The inner edges of the large canines are razor-sharp and injuries received from such a bite are often fatal.

These creatures spend most of the daylight hours in the water, although they will emerge to bask in the sun, but it is at night that they move out to the grazing grounds. These may be close to the river or lake bank, or up to several kilometres away. Although you may encounter solitary bulls, hippopotami normally live in herds, or schools, of 10 to 30 or more.

Although they are known to attack boats or people swimming, most conflict situations occur on land when an animal feels cut off from its watery retreat. Lone bulls and cows with small calves are particularly dangerous. Do not be fooled by their bulk – they are extremely agile and can put on an impressive turn of speed on land or in the water. A hippo can reach a speed of 30 kilometres per hour in a short run. Anyone who is unfortunate enough to be confronted by an angry hippo on land will see the animal running rapidly, somewhat hunch-backed, scything the head from side to side and opening and closing the mouth.

In virtually all parts of Africa where people live in close association with hippopotami there are tales of injury and death. These conflicts have increased as human populations have expanded, habitats have been modified and hippopotami have slowly been squeezed out of their ancestral feeding grounds. In some areas they have become particularly aggressive where they have come under massive hunting pressure, such as in the Virunga region of the eastern Democratic Republic of Congo.

In South Africa attacks are restricted to the north and east of Limpopo Province and northern KwaZulu-Natal, the last areas where hippos occur. In February 2007 a woman near Giyani, Limpopo, was fishing in a local river when she was attacked and seriously injured by a hippo. She died shortly afterwards. In March 2007 a man was injured by a hippo as he walked past the Westfalia Dam at night, and died later in hospital.

A hotspot of hippopotamus attacks in southern Africa is in the Caprivi Strip of northeastern Namibia, where the human population has grown several fold in recent years. This has resulted in increased conflict not only with hippopotamus, but elephant, buffalo, lion and crocodile. During December 2006 hippo bulls killed two people along the Zambezi River, and were shot by the conservation authorities. In many parts of Africa where hippopotami occur such attacks often go unreported simply because communications and infrastructure are lacking, and the authorities are unable to control 'problem' animals.

Fatal hippo attack

Some years ago, when the missile-testing base was still operational in the Greater St Lucia Wetland in northern KwaZulu-Natal, South Africa, a young military serviceman was returning to duty close to Fanies Island one evening. The fan belt of his vehicle came off, the car overheated and he decided to cover the remaining distance on foot. The following morning his severely battered and mutilated body was discovered surrounded by numerous hippo footprints. He had obviously stumbled on the animal in the dark, when his chances of survival were very slim indeed.

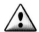 Avoiding trouble

- Never walk around at night where hippopotami are known to forage. This includes open campsites and lodges, where hippopotami come to feed on lawns. Tourists have been killed by doing so. These animals are very unpredictable, so do not believe the tales that they regularly graze nearby and ignore people. A sudden noise or movement may be all that is needed to trigger an attack.
- Avoid walking along regularly used hippo tracks, even during the day, especially in cool weather when the animals may be out feeding. If a hippo perceives a threat and you are between it and the water it will not hesitate to attack you. Do not turn and run; your best chance is to jump off the track and stand dead still.
- If you are in a canoe or small boat do not approach hippopotamus closer than 50 to 100 metres, and be alert for any bubble-trail that may indicate a hippo approaching underwater. In water, relying purely on muscle power, you will not be able to out-distance a hippopotamus.
- Avoid fishing at night in areas where hippopotami are known to occur.

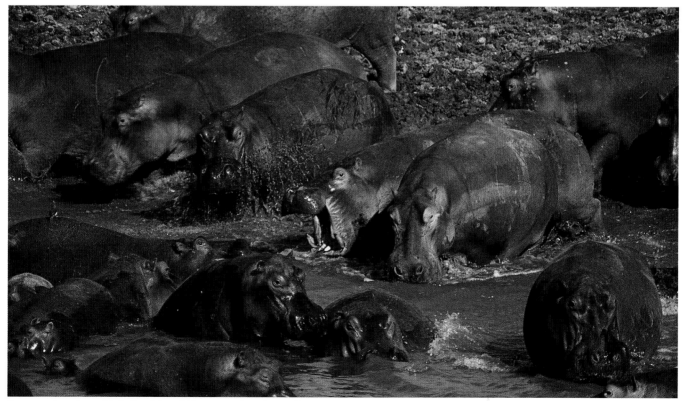

Some regions have high densities of hippos, such as here along the Luangwa River in Zambia.

Hoof and horn

Buffalo

Left alone and undisturbed, buffalo rarely attack humans, but it is very different if they are hunted or if an animal is wounded. Hunters must take their chances and a number have paid with their lives, or have suffered serious injury, but a wounded buffalo will attack any human who crosses its path, not just a hunter. A recent trend to hand-raise buffalo because of their high economic value has resulted in a new occurrence of human death and injury.

Buffalo are inquisitive. Individuals and herds may move towards something new, human or animal, but usually present no threat under these circumstances. Bulls weigh in at more than 700 kilograms and females often exceed 500 kilograms. Both sexes possess impressive horns but it is those of the bulls, with their massive bosses (the point at the top of the head where the horns meet), which attract the trophy hunter.

Certainly their reputation as cunning and dangerous if wounded is valid. There are many tales of a wounded animal circling and stalking the hunter, when hunter becomes the hunted. The wounded animal may lie in wait under dense cover, giving the approaching hunter little chance to raise his rifle before the buffalo attacks. A charging buffalo is a frightening sight, neck outstretched, presenting little more than the mighty horn boss as target while the outstretched horns protect its shoulders. Even heavy-calibre bullets fired from high-powered rifles are easily deflected and only a lucky shot may halt the charge. Many a hunter has been forced into a tree, with an angry, wounded, buffalo circling the perch and waiting for a chance to destroy his persecutor. But, as with other large herbivores, buffalo attacks are largely restricted to those by wounded animals, individuals that have been continuously harassed, or animals raised in captivity.

Early in May 2007 three people were killed by what was called a 'rogue' buffalo in the Mushumbi Pools area of the

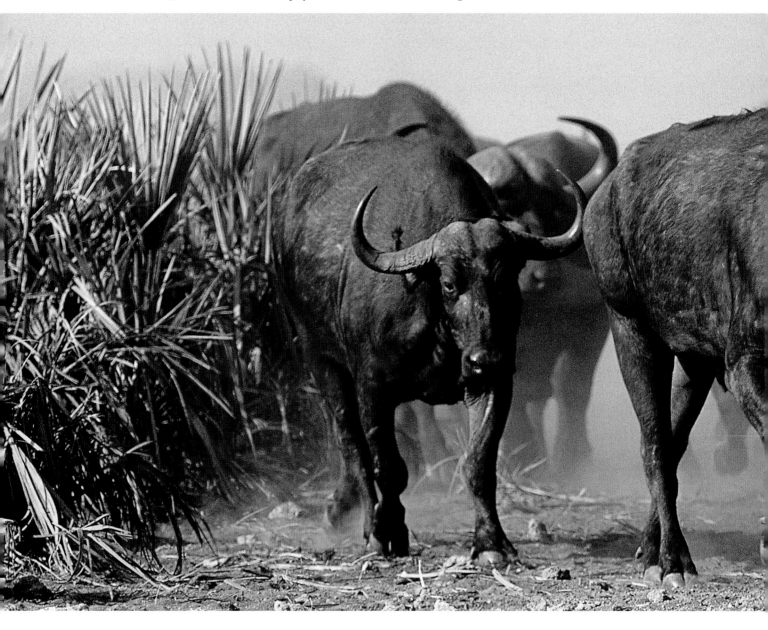

Zambezi Valley. A couple was working in their cotton field when a buffalo bull killed them, the attack apparently unprovoked. Later on the same day a lone buffalo – believed to be the same animal – killed a young man collecting firewood in the vicinity of the first attack. The cause of the attacks is unknown, though it is thought that the animal was injured.

Almost without exception, historical records of buffalo attacks on humans involve wounded animals, or animals being hunted. One of the earliest references is of a fatal attack on a farmer near Swellendam, South Africa, in 1720.

In recent years nearly all attacks by buffalo in South Africa have involved wounded animals or hand-raised individuals for the lucrative game farming industry. In 2003 we visited a game farm Spitskop in the Mara District just south of the Soutpansberg in Limpopo Province. Owner Koos Kemp gave us a tour of his 'tame' buffalo herd, all hand-raised and approachable on foot. One could even be stroked. We felt decidedly uncomfortable because we do not fully trust hand-raised wild animals. In October 2005 Koos went into the buffalo enclosure to move irrigation sprinklers and a bull attacked him, horning him in the groin and rupturing a major blood vessel. He died at the site.

On a farm near Bethlehem in the Free State a labourer was killed in 2007 by an adult buffalo bull. He was walking from a latrine to a fenced house when the habituated buffalo tossed him into the air, the horn piercing both legs and slicing up one thigh to the groin. The bull kept people who came to retrieve the body at bay for several hours. There are several buffalo on the farm and other attacks have apparently occurred but have not been documented. These largely artificial situations in no way reflect circumstances in the wild.

In fact nearly all buffalo attacks in South Africa in recent years have involved hand-raised animals. Elsewhere in Africa in the past 10 years we have located no incident of unprovoked buffalo attacks on humans. This is not to say there were no attacks, but most involved wounded animals – some that had broken free from snares and had festering wounds, others with bullet injuries. In Rwanda and Uganda there are stories of villagers being attacked when they tried to chase buffalo from their fields – just as farmers across the world have been killed by their own domestic cattle, bulls and cows.

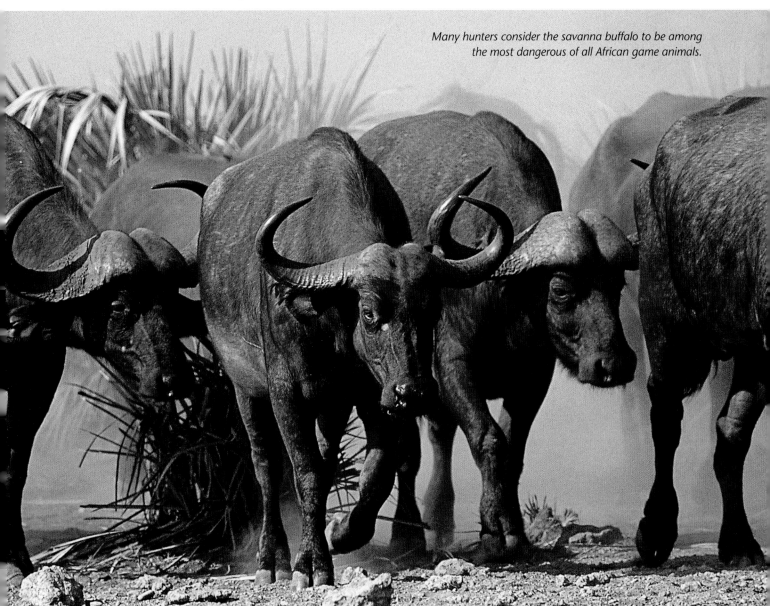

Many hunters consider the savanna buffalo to be among the most dangerous of all African game animals.

Antelope

Almost without exception, antelope pose no threat to humans if they are left unmolested and untamed. No wild animal can become truly tamed; it simply loses its fear of humans, which actually makes it much more dangerous.

A bottle-raised male common duiker killed its human 'parent' by thrusting its horns into the femoral artery in one of her legs. A seriously wounded bushbuck attacked and killed a beater sent in to despatch the antelope with a knife. A bottle-raised greater kudu bull, three years old, turned on its keeper, picked him up between its horns and tossed him into a thorn bush. Luckily the keeper suffered only scratches, bruises and a dented ego. An oryx (gemsbok) drove its lance-like horns into the radiator of a lorry sent to transport these antelope from a drought-ravaged area. A black wildebeest in a holding pen attacked a game-capture specialist, who was saved by firmly grasping the antelope's horns until others could come to his rescue. A steenbok caught in a capture net slashed out with its hoofs and almost caused its captor to lose an eye. Note that these are all direct human/antelope conflicts instigated and created by man. In the wild, there are almost no cases where antelope have attacked humans – unless they were hunted or pressured by man.

A bushbuck ram, when wounded or cornered, is probably the most dangerous of all antelope, despite its moderate size. The much larger sable antelope, with its sweeping sabre-like horns, has caused serious injuries and deaths in humans when wounded. There are several cases of adult lion being killed on the horns of sable bulls, testimony to their power.

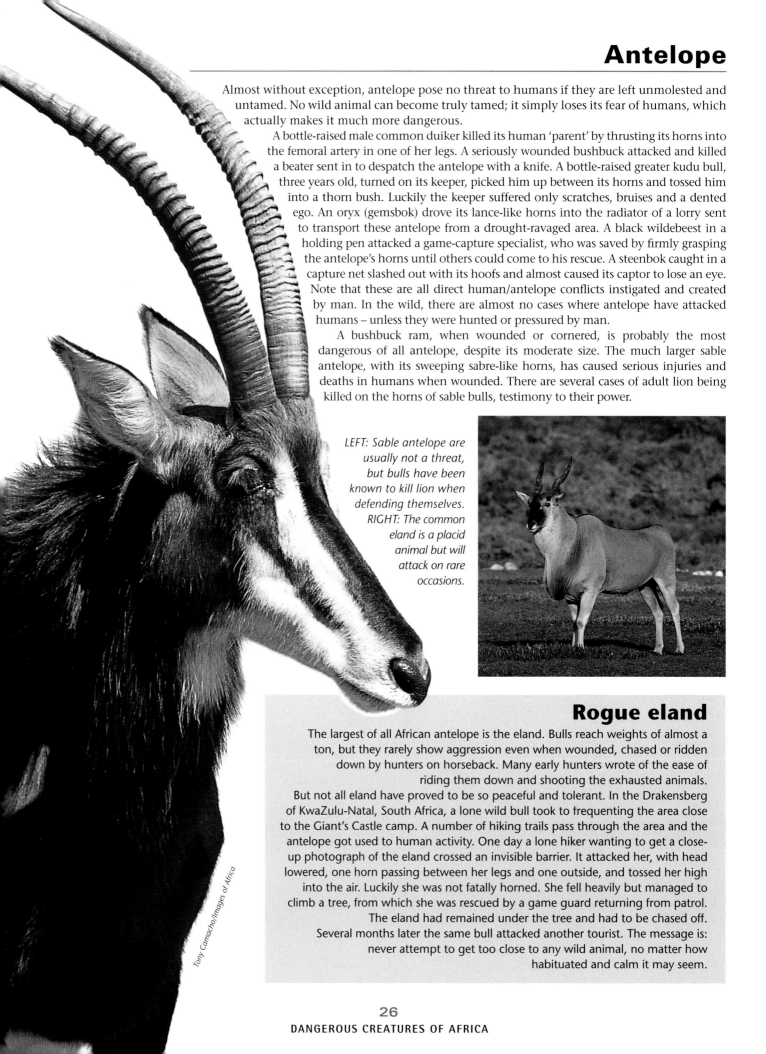

LEFT: Sable antelope are usually not a threat, but bulls have been known to kill lion when defending themselves. RIGHT: The common eland is a placid animal but will attack on rare occasions.

Tony Camacho/Images of Africa

Rogue eland

The largest of all African antelope is the eland. Bulls reach weights of almost a ton, but they rarely show aggression even when wounded, chased or ridden down by hunters on horseback. Many early hunters wrote of the ease of riding them down and shooting the exhausted animals.

But not all eland have proved to be so peaceful and tolerant. In the Drakensberg of KwaZulu-Natal, South Africa, a lone wild bull took to frequenting the area close to the Giant's Castle camp. A number of hiking trails pass through the area and the antelope got used to human activity. One day a lone hiker wanting to get a close-up photograph of the eland crossed an invisible barrier. It attacked her, with head lowered, one horn passing between her legs and one outside, and tossed her high into the air. Luckily she was not fatally horned. She fell heavily but managed to climb a tree, from which she was rescued by a game guard returning from patrol. The eland had remained under the tree and had to be chased off.

Several months later the same bull attacked another tourist. The message is: never attempt to get too close to any wild animal, no matter how habituated and calm it may seem.

ROAD CASUALTIES

Anybody travelling the thousands of kilometres of roads on the African continent cannot fail to notice the large numbers of wild animals killed in collisions with vehicles. Most are small creatures, and the highest numbers are usually made up of hare, striped polecat, bat-eared fox and spotted eagle-owl. This is unfortunate for the victims, but in most cases there is no serious harm to the vehicle or passengers.

However, certain larger mammal species are responsible for many accidents every year in which people are injured or killed. Although accurate statistics are hard to come by, in Namibia and South Africa's Eastern Cape Province the greater kudu is probably responsible for more vehicle accidents than any other wild mammal. Most accidents take place between dusk and dawn. Despite road signs warning of such dangers, drivers rarely reduce speed and if a kudu appears on the road there is little chance of avoiding it. An adult kudu weighs from 180 to 250 kilograms; if you hit one at speed it will result in a very nasty accident. Kudu generally land on the bonnet of the vehicle and are hurled back through the windscreen. Even the 11-kilogram steenbok can cause accidents, especially in collisions with small cars.

ABOVE: The bat-eared fox is often killed on roads. LEFT: In South Africa and Namibia you will encounter signs warning of the presence of greater kudu. To avoid a serious collision, it is important to heed these signs and slow down.

One of South Africa's wild animal-vehicle collision hotspots is on the R618 between Hlabisa and Matubatuba in KwaZulu-Natal. According to police reports and investigations by Ezemvelo KwaZulu-Natal Wildlife it appears that most accidents occur at night and are a result of excessive speed and intoxicated drivers. In April 2004 a speeding lorry killed seven buffalo. In late 2005 a car struck a buffalo and the driver was killed. According to Jeff Gaisford, spokesperson for the conservation authority, there is currently an average of three accidents each week involving wild animals. Species so far involved in accidents include buffalo, rhinoceros (species not specified), cheetah, wild dog and several species of small antelope.

In Tanzania, on the public road that passes through Mkumi Game Reserve, there are records of lorries colliding with elephant at night. We saw the results of one such incident – a written-off lorry and a young elephant cow dead at the roadside.

There are also many collisions with domestic cattle, donkeys, sheep and pigs that cause serious injury and death to drivers and passengers each year.

Most human injuries caused by antelope result from the capturing and handling of game.

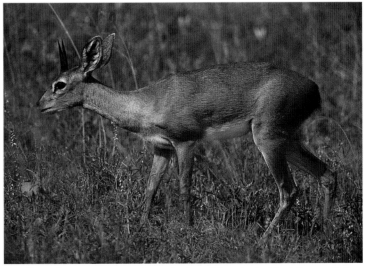

Small antelope are never a threat in the wild state, but 'pets', especially males, can deliver serious injuries.

Pigs and hogs

Warthog and bushpig have wide distribution ranges in Africa, with feral pigs found in some locations too. They are not normally a threat, but hunters can be at risk. The presence of small piglets and your unawareness of them could lead to attack, especially by bushpig.

Under most circumstances neither the common warthog (*Phacochoerus africanus*) nor the bushpig (*Potamochoerus larvatus*) is a threat to humans, but they may attack if wounded or cornered. The warthog occurs in open grass and woodland savanna, whereas the bushpig favours areas of dense bush and forest cover, but will forage into more open country at night. Both are weighty animals. Warthog range from 45 to 105 kilograms and bushpig tip the scales at 46 to 115 kilograms. Adult boars are noticeably larger than sows in both species.

The bushpig is mainly active at night but the warthog spends the hours of darkness in underground burrows, only emerging to forage during the day. They differ in their dietary preferences, with the warthog being mainly a plant-eater whereas the bushpig is a true omnivore, taking both plant and animal food. Bushpig have an amazing sense of smell and will hone in on a rotting carcass from two or more kilometres away. We have seen a cow carcass – dead for several days and decidedly high and maggoty – draw in bushpig from two kilometres. In this case they would have left dense riverine bush cover at night to traverse an open grassed hillslope.

Ariadne van Zandbergen/Images of Africa

TOP: Bushpig are not dangerous unless wounded or cornered, or when a sow with piglets feels that her offspring are under threat.
ABOVE: Red river hogs at rest. No attacks are known by this tropical forest species but injured animals could be dangerous.

Both species reach pest proportions in some areas and, despite control efforts, are adept at surviving the worst man can throw at them. In sheep- and goat-farming areas where bushpig occur, attacks on these farm animals are not unusual, especially during times of drought.

Most attacks, especially by bushpig, are provoked by hunters who wound or corner an animal. In addition to their weight and stocky build, both carry formidable teeth or tusks and these are especially well developed in the case of the boars. A bushpig's lower canines are rubbed against the uppers and honed to razor-sharpness, making them a weapon like a twin-edged dagger. An attacking animal bulldozes in at speed, gnashing the canines and rapidly moving the head from side to side, in much the same way as a hippopotamus. Although the lower canines, or more correctly tushes, usually average from 45 to 55 millimetres, the record length is 300 millimetres.

Wounded or cornered animals can be extremely dangerous, slashing with the lower canines and frequently holding their ground, or charging. Many a dog, even trained pig hounds, has been killed or seriously injured in this way. Beaters and hunters sometimes are slashed as a pig runs past and the cuts can be deep and long, causing considerable blood loss and pain. A cornered bushpig raises the mane along the back, making it appear larger than it is. The head is held low to the ground and it emits an intimidating series of squeals and roars. Although there are anecdotal stories of humans dying from wounds received from bushpig, we have been unable to verify any particular case.

An encounter with a sow protecting her piglets, especially if they are still in the grass nest, can also be dangerous. Tsetse fly control officer Viv Wilson recorded an incident in which a sow with piglets treed a game guard and circled the tree for several hours. If he had climbed down while it was still there he could have been severely mauled or even killed.

The warthog is seldom as aggressive as its porcine cousin, but when wounded or cornered it can give a very good account of itself. The tusks, or tushes, of the warthog are longer than those of the bushpig (record length almost 61 centimetres). The lower canines are razor-sharp daggers and the upper canines curved, solid and heavy. As with the bushpig, the lower canines are kept honed by their constant rubbing on the upper canines. A charging warthog (though this is rare) butts with its robust head, slashes with the lower canines and hooks and pulls/pushes with the upper canines. On occasion wild dogs, spotted hyaenas and even leopards have taken flight when the risk of serious injury is just too high. Adult warthog enter the burrow backwards, always alert and ready to put their teeth into action. By contrast, piglets rush down head first before their dental weaponry develops.

Adult domestic pigs (*Sus scrofa*) can also be extremely dangerous and there are records of pigs in pens attacking, killing and partly eating farmers or farm workers. Another potentially dangerous hog is the feral pig. These may be pure domestic pigs that have escaped and taken to a life in the wild, although some may be cross-bred with bushpig. In the Western Cape, South Africa, during the 1930s and 1940s domestic pigs were released into selected pine plantations in an attempt to control the

ABOVE: A wounded or cornered warthog can launch a dangerous attack, hooking with the long upper canines and slashing with the razor-sharp lower canines.
BELOW: More people are injured or killed by domestic pigs than by all the wild pig species put together.

depredations of the pine tree emperor moth. The pigs dig up the pupae that settle in the soil at the base of the trees.

Populations of feral pigs are found in several areas of South Africa. After several generations these pigs begin to resemble their ancestor the Eurasian wild boar, especially in build and head form. Feral pigs, especially adult boars, develop sharp and curved lower canine teeth that are formidable weapons. In areas where they occur, feral pigs are generally timid and seldom seen, but when wounded or cornered they are potentially as dangerous as their truly wild cousins.

Chris Windros

Tooth and claw

Lion

The lion (*Panthera leo*) is by far Africa's largest cat, and may be forgiven for seeing man as legitimate prey, especially in areas where its natural prey has been depleted.

Lions once roamed virtually the whole of Africa, avoiding only the dense equatorial forests and harshest desert lands. The 'king of beasts' now occurs only to the south of the Sahara Desert and populations are becoming increasingly fragmented and isolated. Although in some countries, such as Tanzania, Kenya and Botswana, there are still free-ranging lion prides, over much of Africa these big cats are confined mainly to national parks and game reserves. Conflict between lions and man (and his livestock) is being forced by circumstances. Growing human populations, increases in the number of their livestock, destruction of the natural prey animals and habitat changes will ensure that lion numbers continue to dwindle. It is estimated that there were possibly as many as 400 000 lions in Africa in the 1950s, today perhaps as few as 30 000.

Given the opportunity, these large, powerful cats are extremely dangerous to man and his flocks and herds. Lionesses reach weights of 110 to 152 kilograms and males as much as 225 kilograms, although most seldom exceed 200 kilograms. They are the most social of the African cats, living in prides of three to 30 individuals (mostly females and cubs), sometimes more, from which coalitions of two or three males periodically move away in order to start new prides of their own. This social aspect of their nature is further emphasised with their high level of synchronism in births and the fact that any lactating pride female will suckle cubs, even those of other females.

Under natural conditions they take a wide range of prey, dominated by medium to large mammals, particularly antelope. In some areas prides become specialist hunters, taking such species as hippopotamus, young elephant and even porcupine. In many larger parks and reserves the balance between predator and prey remains, but outside these conservation areas lion are often forced to seek out alternative sources of food. Unfortunately for the lion, this usually means killing cattle, camels, goats and sheep – and even humans.

Lions in some regions of Africa have acquired a taste for human flesh. This is often associated with a decrease in their natural prey species.

Gerald Hinde

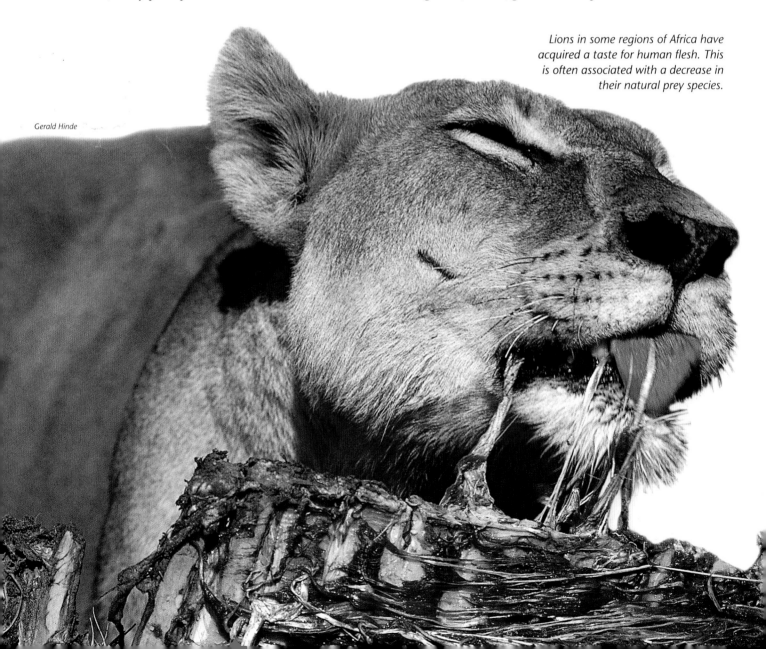

In many conservation areas lions have lost their fear of man, which can have dangerous consequences.

Man-eaters

It is generally held that only old, sick or injured lions take to eating humans, but there are cases where perfectly healthy animals have included people in their diet. Even in some areas where there is a healthy natural prey balance lion will occasionally kill and eat man. Cases have been recorded in Kruger, Etosha and Chobe national parks, all premier tourist destinations. In many instances man is at fault for entering into known lion areas unarmed and on foot, or sleeping in the open at night in areas where lions move freely and are known to have no fear of people. One horrific incident occurred in Moremi, Botswana, where a family was sleeping under the stars, the parents on either side of the child. Unheard, a lion took the child and carried it into a nearby reed bed to feed on it. The parents, helpless to rescue the child, had to listen as it was eaten. This feeding opportunity could have been avoided if they had slept in a closed tent or vehicle.

Man-eating by lion may involve a one-off incident of opportunity, or become a regular occurrence that drives fear into local inhabitants. Lieutenant-Colonel J.H. Patterson recorded one such story in his book *The Man-Eaters of Tsavo*. During the building of the Kenya–Uganda railway man-eating lions terrorised the labour-force for almost nine months. Before the lions were shot they had accounted for the deaths of 28 Indian labourers and an unrecorded number of local Africans. Although not accurately known, it is believed that at least 100 locals were killed and eaten. Later, in 1900, a male lion started killing labourers, local Africans and eventually a local police superintendent at a station known as Kimaa on the same railway line. In both Tsavo and Kimaa the man-eating lions were all male and no mention is made of injury; all were reportedly fine specimens.

In South Africa there are numerous accounts of lion attacking humans, ranging from direct man-eating to indirect deaths and injuries resulting from attacks on horses and cattle. The first documented attack took place at the Cape in December 1658 when a lion attacked Chief Oedasoa of the Cochoqua tribe, but his people went to his rescue and killed it with spears.

The classic tale of a lion attack took place in 1903, in the early days of what was to become the Kruger National Park. Ranger Harry Wolhuter was riding on horseback north of the Sabi River, close to Lindanda Flats, when he surprised two male lions. The horse bolted and he was thrown, caught by the shoulder by one of the lions and dragged for 50 metres

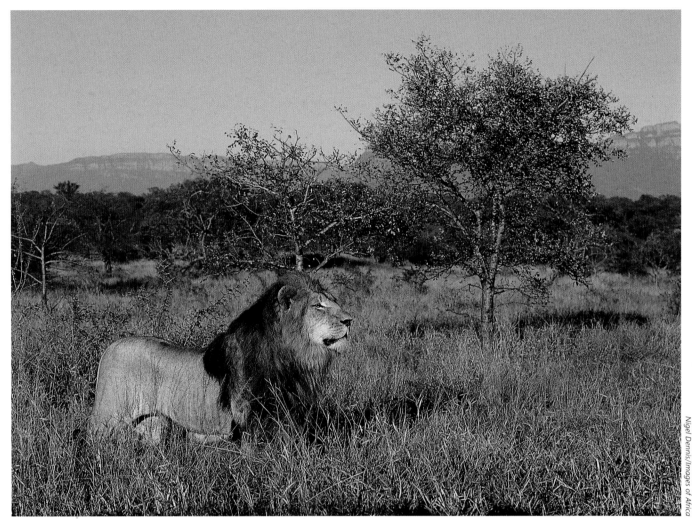
The lion is a powerful and potentially dangerous animal that should be treated with respect at all times.

into the bush. He had lost his rifle when the horse reared, but managed to draw his knife and stab the lion twice in the chest. It did not release him, so he stabbed it in the neck, severing the carotid artery. Severely wounded, Wolhuter managed to drag himself into a tree where he fastened himself with his belt to the branch. The second lion reared up against the trunk of the tree but the barking of one of his dogs distracted it. Game guards found him later that night and carried him to camp. He spent several months in hospital but made a full recovery.

One of Zambia's most notorious cases of man-eating by lions took place in Chief Kafinda's territory, to the north of the town of Serenje, close to the present-day Kasanka National Park. In April 1961 the headmaster of Mpemelembe School reported that lions were roaming in the school compound during the day and at night. A number of people from surrounding villages had been killed and a young man was killed 'a few yards from where the school children were working in the day time around 11 am, within the school premises'. By September the following year the authorities had wiped out all lions in the area by lacing meat bait with strychnine. The Serenje lion or lions (there is no clarity as to whether one or more lions were involved) were said to have killed 26 people and injured six in villages on both sides of the Northern Rhodesian (Zambian)/Congo border. Because of the isolated nature of the area and poor infrastructure, however, the death toll is believed to have been much higher.

Many cases of man-eating probably go unrecorded, especially in isolated rural areas where locals often hunt and kill the responsible lion or lions. The most carefully documented summary of lion attacks on humans appeared in the journal

Eaten on eve of wedding

In April 2007 the *East African Standard* ran the headline, 'Lions maul deaf bridegroom'. Salat Abdi Gesoth was driving a flock of goats that were to serve as bride price for his second wife, whom he was to marry the next day. People who did not know that he was deaf shouted to warn him of the presence of a lion pride but of course this went unheeded. It is probable that the lions were more interested in the goats, but when Salat tried to fight off the pride of nine with a stick and sword he was easily overpowered, killed and dragged into the thicket to be eaten. The newspaper reported that lions had killed and eaten two children the previous month. Following Salat's death villagers fled the area.

LION ATTACKS AT KRUGER

During the civil war in Mozambique many refugees fled to South Africa, crossing the Kruger National Park on foot. Economic refugees still make this chancy crossing. Given the park's vast size and many isolated areas, no accurate figures are known for people killed by lions or other wild animals. Guesses range from the tens to the hundreds, but nobody knows for certain.

In one recorded case in Kruger some years ago a 12-year-old girl, whose father worked in the park, was dragged by a lioness into the bush. Adults burned the grass to frighten off the lioness but they found the child dead. The next day the father was repairing the access track for the funeral vehicles when a lioness savaged him. He managed to stab it twice before it dragged itself away. Rangers hunting for the cat found the remains of another child who had been missing for three days. They put out bait and were able to shoot the lioness the same night. A post mortem revealed human remains in her stomach, and that she was old and heavily infested with parasites.

In 1997 rangers in Kruger shot a pride of five lions after a series of attacks on illegal immigrants; 11 were known to have been killed in the months to August. Human remains were found in the lions' stomachs.

In 2005 a man slipped into Kruger at the Phalaborwa gate at closing time. He eluded security guards and ran into the bush. Rangers were called in to search for the man, but because of the dense nature of the bush and closing darkness the search was called off until morning, when rangers shot a lion found with the remains of the body. Only the lower half of the body was recovered.

The danger lies in the large numbers of tourists who overnight in Kruger's camps. Although authorities maintain the camps are secure from large predators, at various times and in different camps we have observed lion, leopard and spotted hyaena within the fences. In Satara camp we saw a lioness easily scale the high fence at night, prowl through the campground and disappear among the huts.

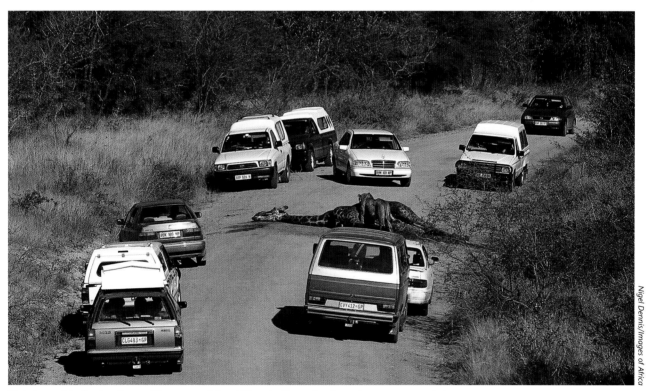

This type of jockeying for position around lion kills puts the animals under pressure and stress.

Nigel Dennis/Images of Africa

Nature (August 2005), which documents 815 lion attacks in Tanzania between January 1990 and September 2004. Just over 560 of these attacks resulted in death, and most incidents took place in the south of the country, particularly towards the Mozambique border. The researchers ascribed the high level of attacks to a greatly increased human population and depletion of natural prey species.

In the Kilosa district lion attacks were so frequent that villagers were relocated by the government in 1992. A single lion in the Rufiji River district, finally shot in April 2004, was responsible for the deaths of at least 35 people over a period of

20 months. All its victims came from just eight villages about 150 kilometres south of Dar es Salaam. A post mortem revealed that the lion had a large abscess under a badly cracked molar.

The most notorious and prolific man-eaters on record are the lions of the Njombe district of southwestern Tanzania, along the Kipengere Range. A single pride of lions is estimated to have killed and eaten more than 1 000 humans over some 15 years in the 1930s and early 1940s. Today few lions occur in this part of Tanzania, largely due to the destruction of natural vegetation and clearing for mainly subsistence agriculture, as well as the almost total absence of natural lion prey.

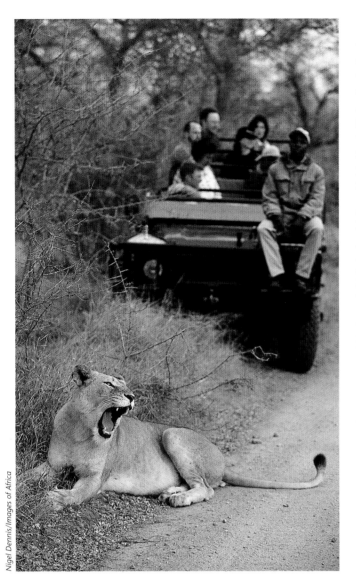

Another recent man-eating hotspot is southern Ethiopia where destruction of woodland and natural prey species has caused lions to turn to the abundant human population. It was reported in September 2005 that lions had killed and eaten at least 20 villagers and some 750 head of livestock. As a result of the attacks, more than 1 000 people fled from the Soro district, 370 kilometres south of Addis Ababa. Most of the attacks took place during the day. Attacks are regularly reported in western and southern Ethiopia, southern Somalia, parts of Sudan and northern Kenya. It is certain, though, that many other incidents go unreported.

There are also reports of Zimbabwean refugees in recent years being taken by lion, spotted hyaenas and crocodiles as they try to cross the Limpopo River into South Africa, while attempting to escape the Mugabe regime. In January 2007 the remains of a border jumper were found on a farm near Musina. He had been killed and partly eaten by lions; when he was found several spotted hyaenas were cleaning up.

Attacks also take place in conservation areas, but authorities are often reluctant to release information in case it affects tourist numbers. Probably the highest death rates have occurred in Kruger National Park, the most visited savanna conservation area in Africa.

In the Etosha National Park in Namibia, an old lioness frequented the Okaukuejo waterhole for some time, catching prey coming down to water. One night a tourist decided to sleep on one of the observation benches. The lioness scaled the fence that separated the camp from the waterhole and killed him. She was shot shortly afterwards. During the 1960s and 1970s there were a number of reports of Ovambo tribesmen being killed and eaten by lions when they crossed Etosha to look for work in the mines to the south and east of the park. No accurate casualty figure has ever been compiled as far as the authors are aware.

A tale from Masai Mara National Reserve in Kenya involved the so-called Mara Marsh lions and a young couple

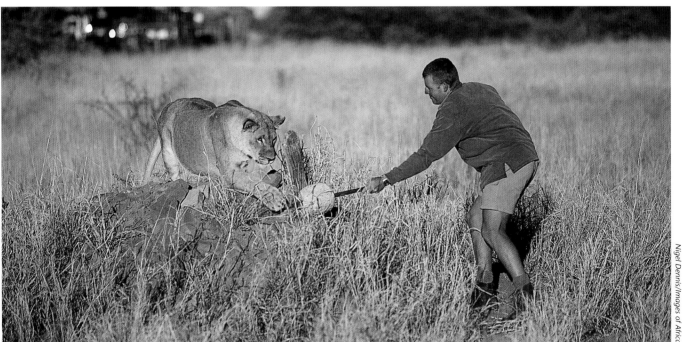

TOP: *Closely approaching a lion in an open vehicle is potentially dangerous.*
ABOVE: *This kind of behaviour should be condemned, especially when tourists are present.*

who had come for a break from the rigours of aid work in Ethiopia. There were just two widely separated tents, one occupied by the couple and the other by another camper. In the middle of the night the single camper heard the couple screaming, so he leaped into his Jeep and turned on his headlights to see a pride of lions tearing their tent apart. He was able to drive the lions away for long enough to allow the couple to get into the safety of their vehicle. This was unusual behaviour as lions seldom attempt to get into a closed tent. They may have been young, inexperienced lions but this is not certain.

Some privately owned game parks and 'lion parks' in South Africa and Zimbabwe have a record of attacks on people because of inadequate security measures and/or the stupidity of visitors. In October 2004 a lion grabbed five-year-old Lee Ann Baird at the Boskoppie Game Reserve in the Free State when it was able to get a paw between a gate and the gate-post. Her face and scalp were badly torn in the attack. Near a game farm in the vicinity of Henneman in the Free State, escaped lions killed two security guards, apparently by crawling under an unsecured fence.

A Japanese embassy worker was attacked by a pride of lions in the Lion & Cheetah Park outside Harare, Zimbabwe. in 2005 when she and a guide entered their enclosure. She was severely injured and died in hospital. At the same park in March 2007 an Australian embassy worker was badly mauled by lions, but recovered.

The message is clear: lions are potentially dangerous in their natural environment but are doubly so in captivity where they have lost all fear of man.

Canned lion casualty

In recent years lion hunting in South Africa has given sport hunting a bad name. These are usually lion that have been bred in captivity, often hand-raised and then released onto game farms where they roam until sought out by a hunter. They may be shot within a few hours to several months of their release. New legislation soon to come into force stipulates that captive-raised lions have to roam freely for two years before they can be shot. Although the exact number of captive-bred lions in South Africa is unknown it is certainly in the thousands.

According to a report in *Die Burger* in April 2007, American hunter Luis Titus was to shoot a lion on a game farm outside Cradock in the Eastern Cape. But the lion found him before he could get his shot, biting him on the right thigh. Other hunters looking on were so terrified they did nothing to help, but the hunter took out a handgun and shot the lion in the head. The man survived after hospitalisation, but the lion did not. Under natural conditions such a situation would probably not have arisen.

⚠ Avoiding trouble

- It helps to know the signs of an imminent attack by a lion. The lion usually drops into a crouch, flattens its ears against its head and gives vent to growls and grunts, meanwhile flicking its tail-tip rapidly from side to side. Just before the charge the tail is usually jerked up and down.
- Never try to run away: you will not be able to outdistance a charging lion. If you are unarmed the best you can do is to shout, put your hands above your head and move towards the lion. It has worked, we believe, but not very often.
- Never walk in an area where lions are known to occur unless you are accompanied by a knowledgeable, armed guard. In most instances they know how to prevent conflict situations from developing – or at least you hope they do.
- When camping in lion country, never sleep under the stars, but always in a closed tent or vehicle.
- If you have to move around at night in your camp always check the surroundings with a torch first and stay as close to the vehicle or tent as possible.
- In designated picnic sites within conservation areas that have lions, always scan the area for potentially dangerous game before alighting from your vehicle. On several occasions we have watched visitors get out of their cars at the Kgalagadi or Kruger parks and allow their children to run around beyond the designated boundaries when we could clearly see lions watching them intently from less than 100 or even 50 metres away.

John Philip

Leopard

Unlike in parts of Asia, in Africa there are comparatively few documented cases of man-eating for leopard, and they appear to be more opportunistic than habitual. Recorded cases of attacks on humans are usually by a wounded, trapped or cornered animal.

The leopard (*Panthera pardus*) is the most successful of the big cats in Africa and although numbers have decreased there are still many thousands. Their success lies partly in their secretive ways and their ability to survive on a wider range of prey species than either the lion or the cheetah. Leopards are now absent from most of North Africa, although a few may still survive in the Atlas Mountains of Morocco. Elsewhere they range from tropical forest to high mountains, semi-desert to savanna bushland.

These elegant, powerful cats vary greatly in size, with weights ranging from 20 to 90 kilograms in males, and 17 to 60 kilograms in females. An attack can have serious consequences because leopards are powerful, have long canine teeth and bring the claws on all four paws into play. A large male may exceed two metres from nose to tail tip, with the tail approximately half of the total length. Being mainly nocturnal and secretive, they generally do not trouble people unless they start including pets and other domestic animals in their diet. Just how easy it is to be unaware of their presence is illustrated by an effort to capture what was thought to be a single leopard that included one of Nairobi's public parks in its territory. No fewer than five leopards were caught in cage traps and translocated.

Attacks on man

By far the majority of records of leopards attacking humans can be linked to cases of injured, trapped or cornered animals. One of the earliest records of an attack was in 1669, when a soldier coming from Hout Bay in Cape Town was 'grievously

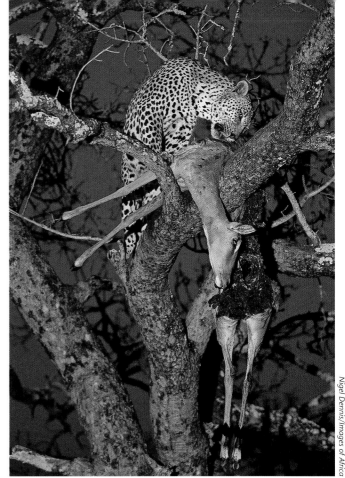

ABOVE: In areas where other large predators are present, leopard carry their prey into trees.
BELOW: Incidences of man-eating by leopard are few, with most attacks made by wounded or trapped animals.

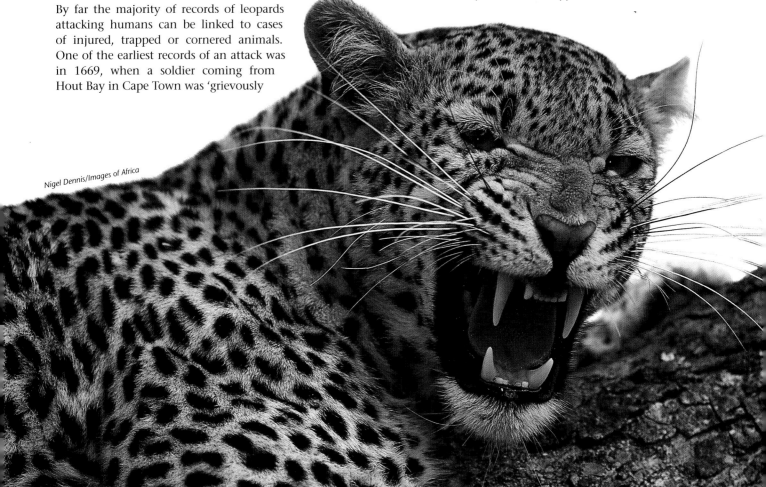

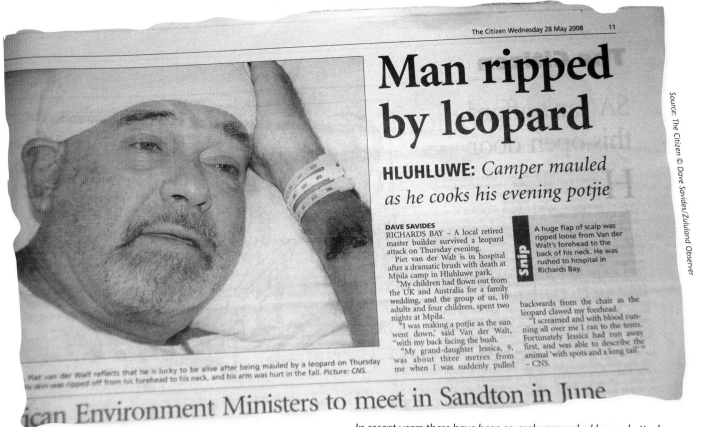

Source: The Citizen © Dave Savides/Zululand Observer

Man ripped by leopard

HLUHLUWE: *Camper mauled as he cooks his evening potjie*

DAVE SAVIDES

RICHARDS BAY – A local retired master builder survived a leopard attack on Thursday evening.

Piet van der Walt is in hospital after a dramatic brush with death at Mpila camp in Hluhluwe park.

"My children had flown out from the UK and Australia for a family wedding, and the group of us, 10 adults and four children, spent two nights at Mpila.

"I was making a potjie as the sun went down," said Van der Walt, "with my back facing the bush.

"My grand-daughter Jessica, 9, was about three metres from me when I was suddenly pulled

Snip A huge flap of scalp was ripped loose from Van der Walt's forehead to the back of his neck. He was rushed to hospital in Richards Bay.

backwards from the chair as the leopard clawed my forehead.

"I screamed and with blood running all over me I ran to the tents. Fortunately Jessica had run away first, and was able to describe the animal 'with spots and a long tail'." – CNS.

Piet van der Walt reflects that he is lucky to be alive after being mauled by a leopard on Thursday. His skin was ripped off from his forehead to his neck, and his arm was hurt in the fall. Picture: CNS.

ican Environment Ministers to meet in Sandton in June

In recent years there have been several unprovoked leopard attacks on humans in the Hluhluwe-Imfolozi region in KwaZulu-Natal, South Africa.

bitten'. In 1889 a leopard near Umtata in the Eastern Cape scalped a man, ripped open his chest and left him dying of his wounds, apparently with no intention of eating him.

Turnbull-Kemp in his book *The Leopard*, published in 1967, listed just 28 documented cases of these big cats killing and eating humans in sub-Saharan Africa. In those cases where the man-eating leopards were killed most were in good condition, not suffering from injuries or disease.

In recent years there have been reports of leopard attacking humans in Kruger National Park, including a night watchman killed in his hut and a woman who survived an attack in Skukuza camp. The most recent attacks in South Africa were recorded near the Hluhluwe Game Reserve in KwaZulu-Natal in July 2006. Three leopards (almost certainly a female with large cubs) attacked and killed a woman fetching water at a river at KwaMsane. A few days later a man was attacked in the same area, but he managed to kill the leopard by stabbing it in the neck with his spear. It is possible that in the first attack the female was protecting her cubs, or teaching them how to hunt, though it may well have been a deliberate attack.

It must be pointed out that many thousands of people work, hike and generally move around in areas occupied by leopards without conflict situations arising. Unfortunately, in some areas leopards take to killing livestock, ranging from dogs to cattle and horses, but primarily sheep and goats. This brings them into direct conflict with man, when efforts are made to poison, trap or shoot them.

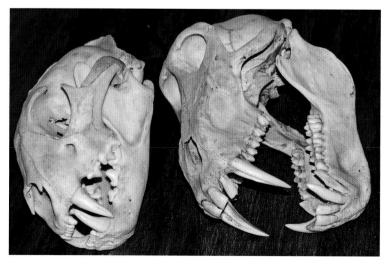

The canine teeth of the leopard (left) are formidable, but less so than those of the male savanna baboon (right).

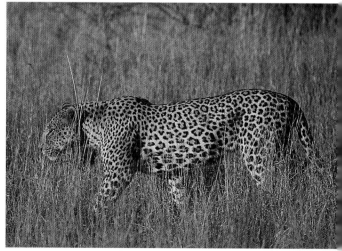

The coloration and patterning of the leopard provide it with excellent camouflage in its natural habitat.

Spotted hyaena

There are four species of hyaena in Africa, the striped hyaena (*Hyaena hyaena*), brown hyaena (*Parahyaena brunnea*), spotted hyaena (*Crocuta crocuta*) and the small aardwolf (*Proteles cristatus*), but only the spotted hyaena has been implicated as a man-eater. Incidences of striped hyaena in North Africa digging human corpses from graves are on record, but no direct attacks on man.

The spotted hyaena is the most social of the hyaenas, living in clans usually numbering up to 15 individuals, though clans of 40 and more are known. The largest clans on record, up to 80 animals, roam the great Serengeti and Ngorongoro plains of Tanzania. Contrary to popular opinion, they are not skulking scavengers but skilled and aggressive hunters, although they are not above driving other predators such as lions from their kills, nor raiding rubbish dumps at lodges and around villages. Clans occupy defended territories, which are marked and patrolled to ensure neighbouring clans do not impinge on their space.

With their massively structured teeth and jaw muscles they are able to crush up and break even large bones. Their diet is varied and ranges in size from buffalo, antelope and plains zebra, to springhare and even mice, but usually diet is determined by what is available and most abundant.

Nigel Dennis/Images of Africa

The spotted hyaena is one of four hyaena species in Africa, but it is the only one that is a potential threat to man.

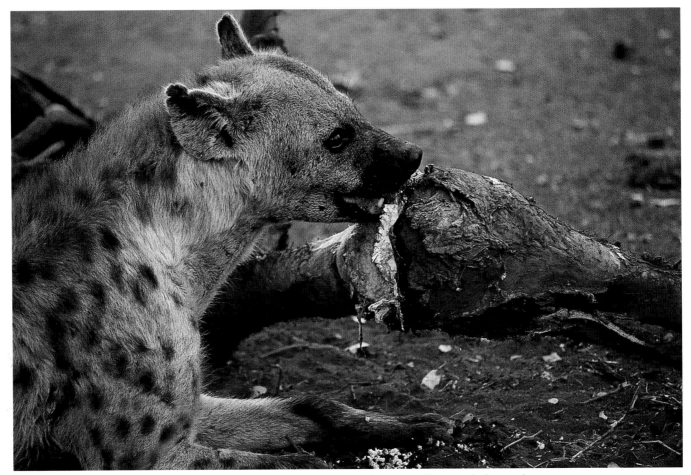

Spotted hyaena have powerful jaw muscles and massive teeth, enabling them to tackle even the largest bones.

Does rabies play a role?

In 1984 two children were killed by spotted hyaena in separate incidents in the Binga district of western Zimbabwe. The national news agency reported that a lone hyaena knocked down a mother with a baby on her back and carried the baby away. In the second case a five-year-old child was killed and partly eaten. The hyaena was said later to have run amok in the nearby village. Both attacks took place during the day.

In similar attacks in East Africa it has been suggested that solitary animals were suffering from rabies. This seems more likely in a number of cases when the victims were bitten and killed, but nothing was eaten. In December 2006 *The Nation* newspaper in Kenya reported that two lone spotted hyaenas made a series of attacks around the town of Naivasha. A worker at the Sopa Lodge tried to chase off a hyaena that was tearing up chair cushioning but it attacked, inflicting severe injuries before other staff members killed it.

In another incident a man was attacked by a hyaena that entered his house. He suffered serious injuries but was saved by the intervention of a neighbour. This kind of unusual behaviour may well indicate that the animals were rabid, or suffering from some other disease or injury.

Certainly, many recorded attacks that take place at night are of hyaena seeking legitimate prey, and not a few rural people in central and East Africa have damaged limbs or torn faces resulting from such attacks. Tourists are not immune either. A young American on a camping holiday in Kenya was dragged out of her tent by a lone spotted hyaena and badly mauled on the arm and face. Other people in the tent were unharmed. The guide repeatedly stabbed the hyaena with a spear and it ran off into the night. It was said that the animal was rabid. Unfortunately, in cases where rabies is suspected there are few follow-ups or confirmation.

Attacks on man

In some areas hyaenas show little or no aggression to humans and this is noticeably the case in parts of Ethiopia where spotted hyaenas are encouraged to scour streets and outskirts of settlements for human waste and scraps. In other words, they serve as rural Africa's refuse collectors and health workers, like their avian counterparts the vultures. Harar has received considerable publicity in the Western media because of the many spotted hyaenas that enter the town at night. They are fed meat by a 'hyaena keeper' to encourage them. Surprisingly, there are no known attacks on humans here despite the fact that the hyaenas show little fear.

Yet, in other regions of Africa, predation on humans by spotted hyaenas is not uncommon, and there are many reports of such attacks since European explorers and settlers started ranging across the continent. Hyaenas that take to man-eating often operate as individuals or in small numbers. Malawi has regularly recorded man-eating hyaenas, and they killed at least 27 people in the Malanje District in the early 1960s. Most attacks took place at night when people were sleeping, and most of the victims were children.

Three reports in the *Tanzania Standard* newspaper between December 1966 and January 1968 recorded attacks by spotted hyaenas on people, mainly in the north of the country. Two of the incidents involved single attacks – a patient leaving a hospital at night was killed and a schoolmaster cycling to work was attacked and badly mauled.

However, by far the worst series of incidents took place around Loliondo, northwest of Arusha, where more than 60 people were attacked, most of them women and children. At the same time hyaenas were making similar attacks on the Kenyan side of the border. Unfortunately, the records do not indicate how many people were killed and eaten, and how many were injured.

During the flooding in Somalia, towards the end of 2006, spotted hyaenas scavenged on human carcasses, but in at least some cases people were actively hunted and eaten. A report from Hiran Province in the centre of the country indicated that two women were killed and eaten by hyaenas when they were walking between two villages.

⚠ Avoiding trouble

- If you are camping in areas frequented by spotted hyaenas, especially where they are used to having people around, sleep in a closed tent or vehicle. Avoid sleeping under the stars.
- Never feed hyaenas, or any other animal; although we have seen it done regularly in a number of conservation areas, it is a dangerous practice.

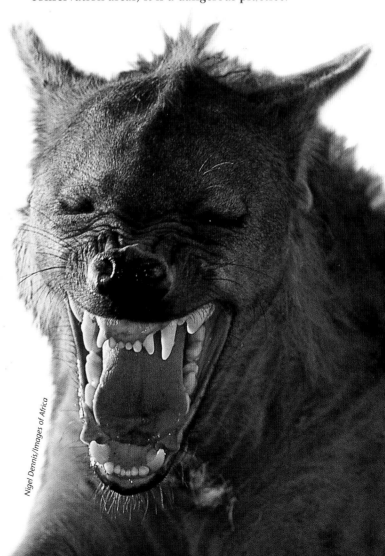

Nigel Dennis/Images of Africa

Other mammals that can wound

Potentially all of Africa's 78 or so mammalian carnivores have the ability to bite, scratch and cause substantial wounds, which often become infected. Although only the lion, leopard and spotted hyaenas have been implicated in the deliberate hunting of humans as a source of food, other species will attack for a variety of reasons. These may include animals suffering from rabies, wounded or injured carnivores, or animals that feel threatened and believe they have no means of escape. We have come across several cases of indirect attack when genets have been cornered in a henhouse or pigeon loft, inflicting severe bites and scratches.

The honey badger (*Mellivora capensis*) has a reputation for aggression but, left alone, will happily keep its distance from humans. There are, however, always exceptions. When we were doing a study of the home range of caracal (*Caracal caracal*) a friend volunteered to check the cage traps for us. He found a trapped honey badger and removed the trapdoor. He recounted: 'The badger slowly left the trap, looked around, saw me and started walking towards me. Knowing of their reputation I climbed some nearby rocks, which it began to circle. It then approached my motorbike and set about demolishing it in what seemed to be a systematic manner. Once it had satisfied its anger it moved away.'

In a second incident he removed the cage door and ran along the crest of a sand dune, but the honey badger followed him at a trot. Thinking it was coincidence that it followed the same route, he ran to another dune crest, but the badger followed. It was only when the badger approached a thicket that it veered off. Obviously, these were unnatural situations that angered the badger, and attacks on man under natural conditions are unheard of. But stories abound of these plucky carnivores driving away buffalo and even elephant, so they are not to be underestimated.

In nearly all cases we know of where smaller carnivores have attacked humans, they have been wounded, caught in traps, felt cornered or were rabid. In southern Africa rabid attacks usually involve black-backed jackal, bat-eared fox and the yellow mongoose. Any healthy, free-ranging small carnivore is interested in keeping as much distance as possible from humans.

FALSELY ACCUSED

The cheetah and the wild dog are innocent of any attacks on man, or at least there is no proven, fully documented case of an unprovoked attack by either species. Cheetah will generally move away from the presence of man, but the wild dog is curious by nature and a pack may draw closer to investigate, but will make no attempt to close in and bite. This curiosity is sometimes mistaken for aggression. Both species are increasingly rare across their African range, and the wild dog is considered to be endangered.

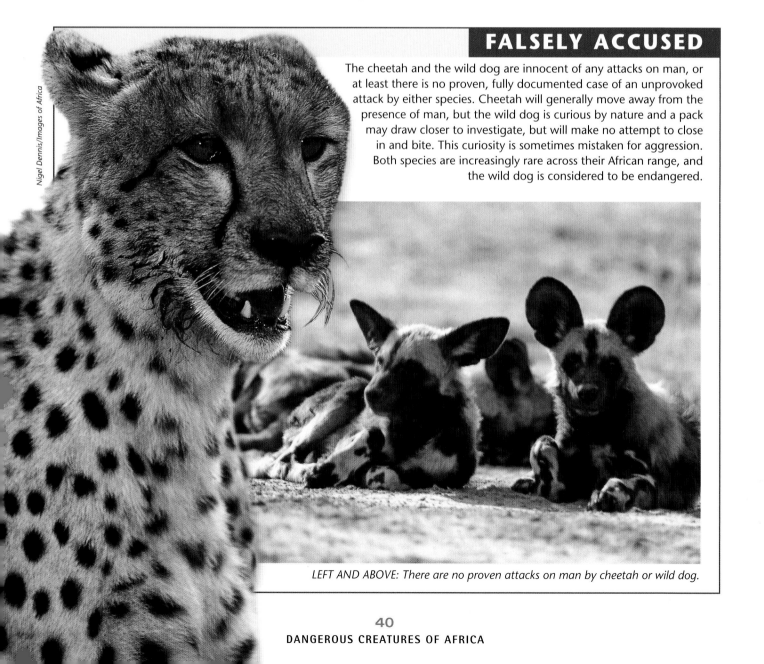

Nigel Dennis/Images of Africa

LEFT AND ABOVE: There are no proven attacks on man by cheetah or wild dog.

Feral dogs

Runaway and wild-bred dogs are a relatively new addition to the southern African dangerous creatures list. They are known sometimes to form into packs and wreak havoc among livestock and there have even been reports of their killing people.

There have always been problems with domestic dogs, whether pets or guard dogs, attacking domestic livestock and sometimes maiming or even killing people. In recent years the number of packs of wild running dogs has increased and in some areas their depredations on livestock have become so regular and wasteful that farmers have been forced to shift to other farming practices. Unfortunately, these feral dogs rarely kill just for their needs, but often descend into a hunting frenzy. We have seen dozens of sheep bloodied and torn, ewes with udders ripped away, lambs with broken legs, cattle with ears and tails bitten off – all the work of domestic or feral dogs. The unseen factor is the number of wild animals killed by these ranging packs. We know of steenbok, common duiker, southern reedbuck, bushbuck and hares, and no doubt there are many more.

All in the breeding

Not all dogs that turn to the feral life are suited to it and it is really a case of survival of the fittest. In southern Africa feral dogs are not known to have interbred with any of the wild canids, such as the black-backed jackal, but in other areas this has taken place. Feral dogs in Australia regularly interbreed with the dingo, resulting in the superior hunting ability of the dingo combined with the greater fertility of the dog.

In Ethiopia the Ethiopian wolf (*Canis simensis*) cross-breeds with the domestic dog, a case of breeding itself into extinction. As we have no wolves in southern Africa, and domestic dogs are said to be descended from wolves, this could explain why our feral dogs remain 'pure to the breed'.

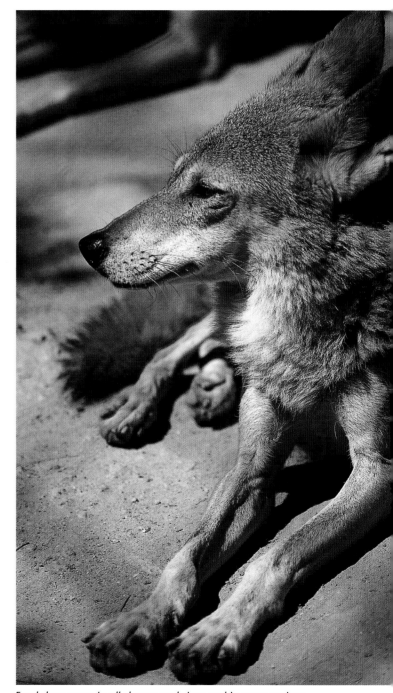

Feral dogs can be extremely dangerous and fatal attacks on people in southern Africa are on the increase. A marked increase in the incidence of rabies in dogs has also been partly ascribed to rising numbers of feral dogs. A report in the *South African Medical Journal* of May 2007 notes that six people, mostly children, were fatally savaged by packs of feral dogs hunting around homesteads and villages in KwaZulu-Natal for poultry, goats and cattle. Feral dogs also killed domestic dogs that tried to drive them away. The rise in numbers of feral dog packs has been in part correlated to the rise in the human death rate from HIV/AIDS, when more and more dogs are left to their own devices, forced to hunt to survive.

Breeding takes place in the feral state and the pups are essentially wild animals. According to Kevin le Roux, the province's rabies project manager, the rise in the number of feral dogs and the reduction in vaccination of domestic dogs, among other factors, has caused the incidence of rabies to rise from 141 cases in dogs in 2005 to 308 in 2006. At least four people are known to have died of rabies in 2006 in KwaZulu-Natal. So, apart from direct attacks on man and his livestock, feral dog packs are unwittingly aiding in the proliferation of rabies. A more recent resurgence in feral dogs has taken place in Limpopo Province.

The number of feral dog packs in the region is going to increase and it is quite likely that more people will lose their lives as a result; as has happened in other parts of the world, these dogs may well start to regard human beings as legitimate prey.

Feral dogs come in all shapes and sizes and in some regions have become significant predators of domestic livestock and, on occasion, even humans.

Hyrax

These unique, tail-less mammals occur over much of the African continent. The exact number of species is not known, but at present four species of rock-dwellers and three of tree-dwellers are recognised.

Hyrax, or dassies as they are known in South Africa, are a common sight in many areas of Africa, including popular sites visited by tourists. They are plant-eaters that spend much of the day basking in the sun. When it gets too hot they retreat into rock crevices, scree or, in the case of the tree-living species, holes. In some places frequented by visitors they show little fear of humans and will graze and rest as people move within a metre or two of them. But be warned, never try to feed them by hand or pick them up; despite their cuddly appearance, they can inflict severe bites. Both sexes have continuously growing upper canines and those of the males are particularly sharp. When they bite they tend to hold on and chew, creating substantial and very painful wounds. Always keep small children under supervision when near hyrax and never let them proffer food held in the hand.

These stoutly built mammals weigh between two and five kilograms. Most populations encountered by tourists over much of southern Africa are of the dark brown rock hyrax (*Procavia capensis*). This is a highly adaptable species that can be found under near desert conditions (for example, at Augrabies Falls National Park) to high rainfall areas, even on sea cliffs at such places as the Point at Mossel Bay, Garden Route National Park (Storm's River mouth), and Cape Point in the Table Mountain National Park. They are also habituated in a number of locations in eastern Africa. The yellow-spotted rock hyrax (*Heterohyrax brucei*) is common in Hell's Gate in Kenya and tourist camps in Tanzania's Serengeti National Park.

They are colonial animals and densities may be very high in favourable habitats. Each colony has a strict pecking order, with a dominant male and female. After an unusually long gestation period for such a relatively small mammal, some 210 days, one to three well-developed young are born. Shortly after birth they are able to move around and they are perfect miniatures of the adults.

Not so cuddly

Some years ago one of the authors was involved in a research programme on rock hyrax and a population was kept in captivity for observation. Part of the work required that certain animals be caught at regular intervals for measuring and weighing. For their size they are amazingly strong and they had to be handled with great care. On one occasion researcher Bob Millar slackened his grip on a hyrax and it bit into a knuckle and would not let go. We had to force open its mouth and by the time it let go Bob's finger was a mess. Unfortunately, we did not take photographs. Pictures of this would surely put off anyone tempted to feed wild but habituated hyrax by hand!

Tamas Roth

Primates

Man's closest relatives can deliver serious injuries and, on rare occasions, kill. The common chimpanzee (*Pan troglodytes*) in Uganda and Tanzania has been recorded killing and eating several human infants. Similar man-eating activity has been recorded from parts of West Africa, though they are harder to verify.

All species of non-human primate have sharp canines and if you try to handle them they can deliver painful, often serious wounds. In southern Africa only five primate species occur, ranging in size from the 150-gram southern lesser galago, or bushbaby (*Galago moholi*), to the 45-kilogram male savanna baboon (*Papio cynocephalus*), but many more occur across the African tropics. Many species are secretive and keep well away from man, but in areas frequented by tourists a number of species have become habituated. Even then most maintain a respectable distance, especially those that have specialised diets.

Although all will bite if handled, only two species can be considered to pose a real threat in most parts of Africa – the savanna baboon and the vervet monkey (*Cercopithecus pygerythrus*). All baboons, including the olive and yellow, should always be treated with caution across their African range. Throughout much of the range of these two primates they keep their distance from man but because they are intelligent they have learned that in some situations humans

A male patas monkey shows his formidable, sharp canines.

can be a source of food. Baboons will attack and seriously injure or kill sheep and goats, especially during drought. Hunting is usually undertaken by the adult males, which drive the animals against fences. Ewes may have udders bitten off, lambs' bellies may be ripped open and sometimes flesh may be torn from living animals. Both baboons and vervet monkeys will raid orchards, gardens and field crops.

But the real danger sometimes arises in campgrounds, picnic areas, lodges and other places where people gather with food. Many of these situations develop when people feed the primates, which then come to expect regular handouts. When food is not forthcoming they may try to help themselves; if you try to prevent this, the primate may retaliate with slashing bites.

Baboon attacks child

Four-year-old Luciano Adams of Eerste River, South Africa, was picnicking with his family at Kogel Bay in early 2006 when he was attacked by a male baboon, resulting in serious abdominal bite injuries and other lacerations. The report in *The Sunday Independent* said he had been virtually disembowelled. The attack took place when a large troop of baboons descended on the recreation area in search of food. A witness stated that the baboon troop had been raiding dustbins, stripping tents and open cars of food and frightening visitors for several months. The boy, who was flown by emergency rescue helicopter to the Red Cross Children's Hospital in Cape Town, survived the ordeal.

Shaen Adey/Images of Africa

ABOVE AND RIGHT: Savanna baboons are bold, very intelligent and potentially dangerous.

Baboons are intelligent animals. Once they find a reliable food source they are likely to keep returning. In some parts of Cape Town, such as Noordhoek, urban development has not kept them at bay – in fact, just the opposite, because they learn that an open door is a 'food possibility'. We know of one case where a baboon saw its chance while a woman was hanging washing on the line. It entered the house, opened the refrigerator, feasted on the contents and was out before she returned. If she had gone back into the house earlier she may well have suffered serious bites.

Baboons are also adept at observing people in campgrounds, nearly always selecting the moment when backs are turned to clear the table of a loaf of bread, fruit, even the meat for the barbeque. Never try to retrieve food taken by a baboon as you could be seriously bitten.

Although vervet monkeys are considerably smaller, weighing only four to eight kilograms, they have long canines, especially the males, which can inflict deep and painful wounds. In those areas where their ranges coincide with settlements, campgrounds and lodges where food is present, they often become a nuisance and bites will occur. As with baboons, children are always most vulnerable because they will hold on and protest if anything tries to snatch food from their hand.

AUTHORS ROBBED BY BABOONS

On a photographic trip to Moremi Game Reserve in Botswana's Okavango Delta we established our camp and left in different directions, on foot, to photograph bushbuck. After about an hour we both heard noises back in camp, but assumed the other had returned to prepare lunch. Then there was an almighty crash and a cacophony of baboon screams. We both arrived back in camp at the same time and found our food trunk in turmoil because we had forgotten to close the padlocks. Anything that could be torn open was, including packet soups, flour and sugar. But what caused the baboons to scream and run? We suspected the trunk lid had fallen on the head or hand of one troop member because it was closed. From that day on our mantra has been 'stow it and lock it'.

⚠ Avoiding trouble

- Never attempt to feed baboons or vervet monkeys because in the long term you are signing their death warrant and creating problems for people who come after you. Do not proffer or tease them with food. Obey signs forbidding the feeding of baboons and monkeys.
- Do not leave food unattended if you are at a picnic site or campground where these primates are known to be a problem. When you are not present make sure that all edible items are in secure containers, such as metal trunks, or locked in a closed vehicle or trailer. We have seen a baboon opening car doors and climbing in, so lock your car.
- Once a baboon or vervet monkey has snatched food do not attempt to take it back as you risk being severely bitten.
- Monitor children carefully when baboons and monkeys are around. No child is a contest for these two species.

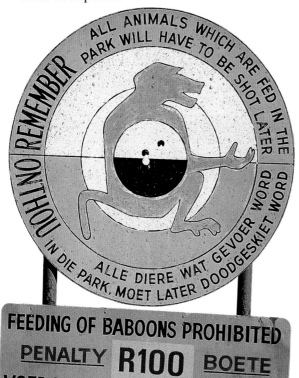

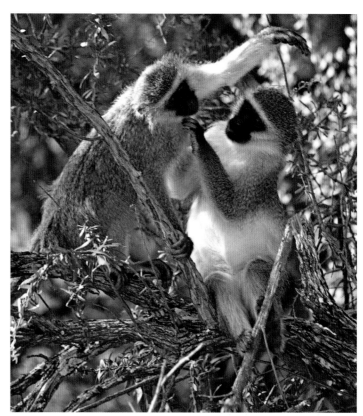

ABOVE: The vervet monkey is one of the most widespread African primates and normally poses no threat. However, these monkeys learn to frequent areas where humans assemble as they know that food may be in the offing. Under these circumstances they can become dangerous. LEFT: Obey signs that forbid feeding of baboons and monkeys.

Baboon raiders

In 2006, after receiving relief food at a distribution centre in Garissa District, close to the Kora National Game Reserve in north-central Kenya, three people were attacked and injured by raiding baboons. *The East African Standard* reported that many other people had food snatched from them by a troop of baboons, estimated to be 70 members strong. In non-habituated baboons this sort of behaviour is unusual, but this raid took place under exceptional circumstances. The area had been in the grip of severe drought for three years, and the baboons were driven by their near starvation.

Rats and mice

Anything edible, sometimes even items that seem inedible, will be devoured by some rat species, including human flesh, living or dead. Many species are specialist feeders and of little or no direct threat to man, but some exotics can be very damaging to human interests. All rodents can give painful bites, even the smallest species, and they can spread disease.

Three species that have been spread by man around the world – the brown rat, black rat and much smaller house mouse – are public enemies. The two rat species are believed to have originated in Asia, and were transported around the world in early sailing ships. Some may have spread along the very earliest trade routes from Asia to the eastern reaches of Europe. Apart from the 20 or more diseases that they can spread to humans, they eat up to a fifth of the world's grain crops each year, contaminate food stores with their droppings and urine, wreak billions of dollars worth of damage to our structures and possessions, and will on occasion bite us and nibble at the flesh of helpless invalids and tiny infants.

The two exotic rat species occurring in Africa are generalists. They can eat almost anything and live almost anywhere, especially in human dwellings and structures. Rats have survived radioactive fallout that would kill humans, can stay afloat in water for up to three days and can inherit genetic resistance to common anticoagulant poisons such as warfarin, enabling them to eat as much as 100 times more poison than non-resistant rats. On top of this they are prolific breeders, with the black rat female usually producing five to six litters, each with five to 10 pups, in a single year.

Cases of rat bites in humans are little documented in Africa and very few are treated in medical facilities. There are anecdotal reports of babies having ears, cheeks and noses eaten away, but we have not been able to authenticate any such case for southern Africa, although several cases have been reliably confirmed in Nigeria. However, there are numerous reports from other parts of the world of rats biting and feeding on dead and immobile people, as well as on babies, who can more easily succumb to such ravages by rodents.

Although none of Africa's indigenous rats and mice has been implicated in such attacks, if handled, most can defend themselves well with their sharp incisors. These teeth are continuously growing and to a large extent self-sharpening as the edges of the upper and lower rub against each other. Unless you try to hold or handle indigenous rats and mice it is highly unlikely that you will get bitten. Unlike the exotic rat species, none of the locals really live in close association with man, although some – such as the four-striped grass mouse and Namaqua rock mouse – may take up temporary abode, especially during population 'explosions'. They are easy to control with traps or poison.

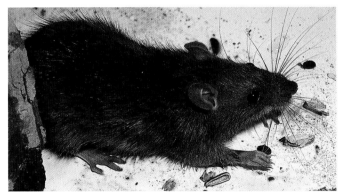

The black rat (Rattus rattus) poses a threat to humans in several ways, especially as it contaminates or devours food supplies and spreads disease.

Rodent bites

- If you are bitten by a rat or mouse, the chances are that the bite will turn septic if left untended. If you have access to a medical facility – doctor, hospital or clinic – it is best to have the wound treated. If not, it is essential to clean the wound thoroughly with water and antiseptic.

Avoiding trouble

Here we refer to the exotic rats and house mice.

- Rats thrive where there is clutter, piles of rubbish and heaps of garden debris. Remove these and in most cases you can prevent rats from joining you as housemates.
- Avoid leaving food in places that rats can reach, remembering that they are agile and active climbers. Closed cupboards and tins should generally keep them at bay, though they can easily gnaw through doors and other wooden structures.
- Act swiftly if rats and house mice move into your property. In most cases control measures are useless unless they are sustained. Traps and specific rat poisons are commercially available, but if you do not seem to be getting rid of a rodent infestation call in a pest control company. Rats have considerable learning abilities and treat any new objects along their regularly used foraging routes with suspicion. Another problem is that if a rat recovers from a poisoning episode it is highly unlikely to touch the same bait preparation again.

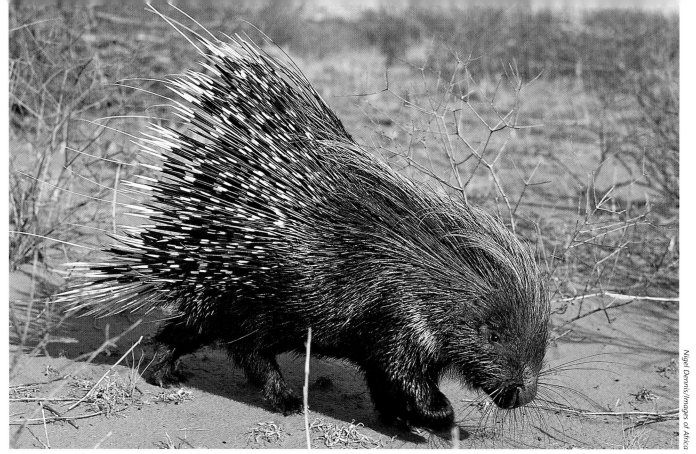

Left in peace, the porcupine poses no threat to humans, but if trapped or molested it can deliver a number of sharp, painful surprises.

Porcupine

Left alone, this 'iron pig' (from the Afrikaans *ystervark*) will do you no harm, but if molested or cornered it can cause serious injuries.

Although others occur in East and North Africa, one species of porcupine, *Hystrix africaeaustralis*, occurs in southern and eastern Africa, where it is by far the largest rodent, carrying a formidable armoury of sharp-pointed spines and quills. Although the average weight is around 10 kilograms, some may reach 24 kilograms. The spines are up to 50 centimetres long and the quills 30 centimetres. These distinctively banded, black-and-white quills cover and protect much of the back and flanks. When the porcupine is relaxed and undisturbed the quills and spines lie flat along the body, but if it is alarmed or threatened they are raised so that the animal appears to double in size.

Porcupines are highly successful mammals that occupy almost all terrestrial habitats and eat a wide range of plant food, from bulbs and tubers they dig up, to fallen tree fruits, even tree bark. They also carry bones to their shelters and chew on them. This may serve to boost calcium intake to aid regrowth of quills, but is probably also important for honing the long, continuously growing incisor teeth. In some studies they have been found to occur at a density of eight porcupines to one hectare of land where food is abundant. Porcupines are only rarely seen during the day, preferring to forage under cover of darkness. They live in monogamous pairs that usually share a burrow and defend a territory against intruding porcupines. Porcupines clash with man's interests when they feed on crops such as potatoes, burrow under fences and into dam walls, and chew on pipes to access water.

If cornered, injured or threatened, the porcupine raises its sharp-pointed quills and spines, stamps its hind feet on the ground, and may make grunting noises and rattle the hollow, open-ended tail quills. It will then rapidly move backwards or sideways towards the perceived threat. Do not be fooled by the short legs and bulky body – it can move rapidly and hit you with considerable impact. The tips of the sharp quills and spines may penetrate deeply and because they are loosely attached in the porcupine's skin, they detach and remain embedded in your flesh. Deeply embedded quills, with their microscopic barb-like projections, may need to be removed surgically to prevent tearing of the flesh.

Predators such as lion and leopard sometimes get quills embedded around the mouth and in the paws. Even if only the quill tip remains in the flesh, these wounds usually turn septic and may eventually kill the predator. Some cases of man-eating in lion have been ascribed to animals that have had festering sores in and around the mouth from porcupine quills, making it difficult or impossible for them to hunt their normal prey. Strangely, in some areas such as the Kgalagadi Transfrontier Park, both lions and leopard regularly hunt porcupines, but usually avoid getting seriously impaled by quills and spines. It seems that these cats have learned to flip the porcupines on their backs and attack the unprotected belly. Porcupines have rather delicate skulls for their size and a blow from a powerful lion or leopard paw could very easily kill them, though this would take skill and experience.

Smaller predators rarely attack porcupines, but domestic dogs frequently 'rush in where angels fear to tread'. We have witnessed a quill penetrating the heart of a border collie on a farm in the Eastern Cape. The dog was dead within seconds. In another incident, a Jack Russell terrier bled to death within minutes after a quill penetrated a carotid artery.

We know of no case of human fatality, but have seen some unpleasant injuries. Quill injuries are not restricted to when a porcupine is present. Because the quills and spines are so loosely attached in the porcupine's skin they are often shed as the animal moves around. Children may pick these up as playthings and they may become stuck in their flesh.

 Quill injuries

- A deeply embedded quill needs to be surgically removed to avoid further injury and infection. In some cases victims may require antibiotics as well as a tetanus vaccination if they are not already immunised.

Do they shoot their quills?

There is a persistent myth that a porcupine can 'shoot' its quills. It cannot. When confronted it reverses and moves sideways at a predator or man with great agility. Then it rapidly moves away, leaving quills behind. It is this rapid sequence of events that may give the impression that the porcupine 'shoots' the quills, but in fact it can only transfer them on contact.

In many parts of Africa quills are used as ornaments and as a good luck talisman. There is also a belief in their ability to protect against a variety of diseases. Many local people hunt porcupines for their tasty meat, but always show great respect for their formidable armoury.

Seals

The Cape fur seal (*Arctocephalus pusillus*) is the only seal you are likely to see off the coasts of southern Africa. On land, bull seals protecting their harems can be savage and will attack anyone approaching too closely. Elsewhere along the African coastline seal species are extremely rare vagrants.

Although most breeding colonies of Cape fur seals are on offshore islands, a few are situated on the mainland. The largest land-based colony is found at Cape Cross on the Namibian coast, home to over 100 000 seals at peak times. Solitary seals, especially pups, bulls and injured or sick animals, may come onto mainland rocks or beaches anywhere between East London, South Africa, and the Cunene River in Namibia. Some animals may be encountered along the Angolan coastline outside the breeding season, with vagrants extending to the Gulf of Guinea.

Adult seals have a substantial set of teeth and can deliver serious bites. The weighty adult bulls are able to use their bulk to great effect during conflicts, and can easily break human limbs, or worse. Fur seal bulls may be as heavy as 300 kilograms in summer, but this may drop to under 200 kilograms at other times. Adult cows weigh in at some 75 kilograms. Bulls are at their most dangerous from mid-October until into the month of December when they are defending territories and harems, but it is unwise to approach these animals at any time. If you are visiting a colony or encounter an animal on the shoreline, keep at a safe distance.

There are cases of swimmers and divers being bitten by Cape fur seals, mostly in Cape Town's False Bay. No fatalities in such attacks have been recorded. It is difficult to explain these attacks, but it is possible that swimmers are mistaken for other seals. As seals never take prey the size of humans it is unlikely to be a case of 'test feeding'. However, given the small number of recorded cases and the large number of people swimming, it is not a significant threat.

The other seal species that have been recorded on the southern African coastline are rare vagrants and because they do not breed here are much more placid and do not really pose much of a threat, although they are still potentially dangerous.

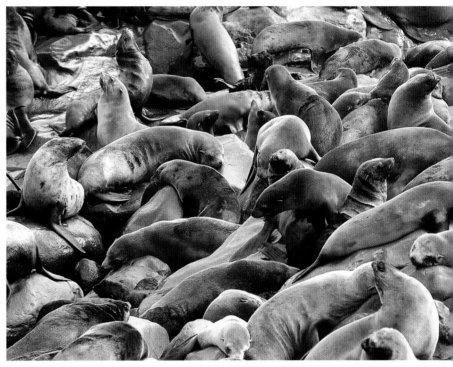

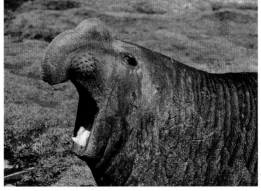

ABOVE: Cape fur seals are largely harmless if left alone, but can deliver painful bites if molested. Always keep your distance; their sheer weight can cause injuries.
BELOW: Southern elephant seals rarely land on African shores but are present on a number of the continent's sub-Antarctic islands.

John Carlyon

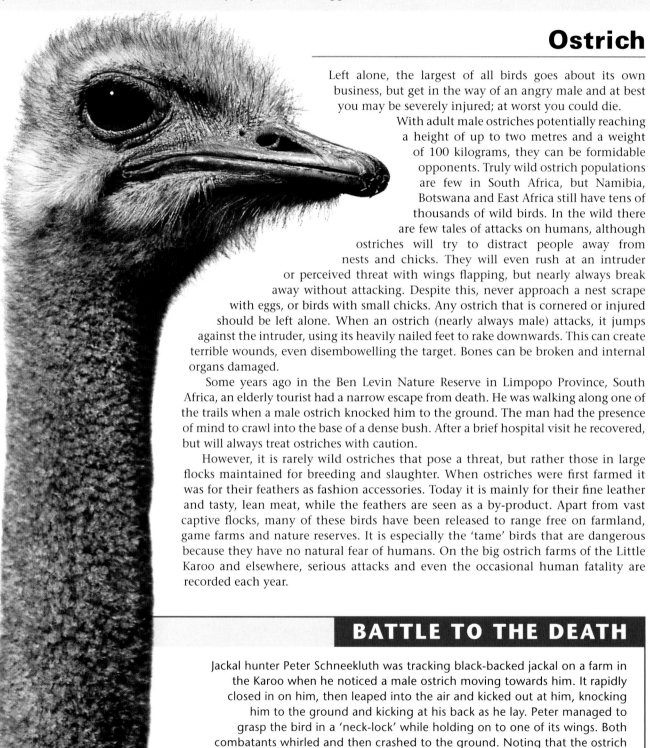

BIRDS

The concept of killer birds is limited mostly to the realm of fiction. Alfred Hitchcock brought the concept vividly to life when he made his famous horror film, *The Birds*, based on a short story of the same name by Daphne du Maurier. But in real life, only the ostrich has the power to kill humans. Several other birds can deliver painful wounds, but they will attack only in very particular circumstances, and then usually to protect their eggs or chicks.

Ostrich

Left alone, the largest of all birds goes about its own business, but get in the way of an angry male and at best you may be severely injured; at worst you could die.

With adult male ostriches potentially reaching a height of up to two metres and a weight of 100 kilograms, they can be formidable opponents. Truly wild ostrich populations are few in South Africa, but Namibia, Botswana and East Africa still have tens of thousands of wild birds. In the wild there are few tales of attacks on humans, although ostriches will try to distract people away from nests and chicks. They will even rush at an intruder or perceived threat with wings flapping, but nearly always break away without attacking. Despite this, never approach a nest scrape with eggs, or birds with small chicks. Any ostrich that is cornered or injured should be left alone. When an ostrich (nearly always male) attacks, it jumps against the intruder, using its heavily nailed feet to rake downwards. This can create terrible wounds, even disembowelling the target. Bones can be broken and internal organs damaged.

Some years ago in the Ben Levin Nature Reserve in Limpopo Province, South Africa, an elderly tourist had a narrow escape from death. He was walking along one of the trails when a male ostrich knocked him to the ground. The man had the presence of mind to crawl into the base of a dense bush. After a brief hospital visit he recovered, but will always treat ostriches with caution.

However, it is rarely wild ostriches that pose a threat, but rather those in large flocks maintained for breeding and slaughter. When ostriches were first farmed it was for their feathers as fashion accessories. Today it is mainly for their fine leather and tasty, lean meat, while the feathers are seen as a by-product. Apart from vast captive flocks, many of these birds have been released to range free on farmland, game farms and nature reserves. It is especially the 'tame' birds that are dangerous because they have no natural fear of humans. On the big ostrich farms of the Little Karoo and elsewhere, serious attacks and even the occasional human fatality are recorded each year.

BATTLE TO THE DEATH

Jackal hunter Peter Schneekluth was tracking black-backed jackal on a farm in the Karoo when he noticed a male ostrich moving towards him. It rapidly closed in on him, then leaped into the air and kicked out at him, knocking him to the ground and kicking at his back as he lay. Peter managed to grasp the bird in a 'neck-lock' while holding on to one of its wings. Both combatants whirled and then crashed to the ground. Noting that the ostrich was becoming limp Peter slackened his grip, but the bird attacked more fiercely than ever and he was forced to strangle the ostrich. A heavy leather belt Peter was wearing was cut neatly in half – probably what saved him from serious injury in the initial attack. He escaped with extensive bruising and minor cuts.

Hein von Hörsten/Images of Africa

⚠️ Avoiding trouble

- Do not stand next to a fence with ostriches on the other side; we have seen them lash out with their formidable feet through the fence at people and dogs.
- Never enter a paddock where ostriches are present. This applies to all ostriches but especially males when there are eggs or chicks.
- Look for the warning signs. When in breeding condition, the males develop bright red colouring on the skin of the shins and this is when they are at their most dangerous.
- If you ever find yourself facing an attacking ostrich, remember you cannot outrun it. If you have a thorny branch to hand you may be able to keep it at bay while you retreat to a safer position. Your next safest alternative is to lie flat on your stomach with your hands locked over the back of your vulnerable neck. You will be bruised and scratched but chances are that you will not be killed.

TOP: *Beware of captive farmed ostriches, particularly males in the company of chicks.*
ABOVE: *Truly wild ostriches are seldom a threat, except when they are protecting eggs or chicks.*

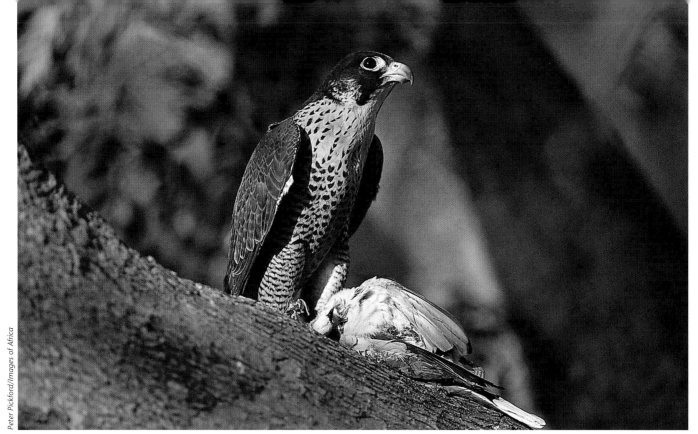

Birds of prey are equipped with long-clawed talons and sharp beaks, but only a few species, such as this peregrine falcon (above) and black sparrowhawk (below), pose a threat when defending an active nest.

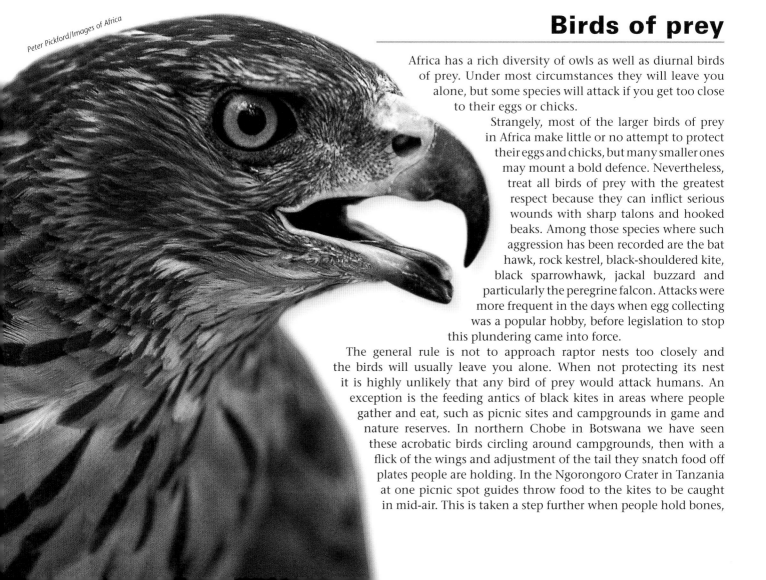

Birds of prey

Africa has a rich diversity of owls as well as diurnal birds of prey. Under most circumstances they will leave you alone, but some species will attack if you get too close to their eggs or chicks.

Strangely, most of the larger birds of prey in Africa make little or no attempt to protect their eggs and chicks, but many smaller ones may mount a bold defence. Nevertheless, treat all birds of prey with the greatest respect because they can inflict serious wounds with sharp talons and hooked beaks. Among those species where such aggression has been recorded are the bat hawk, rock kestrel, black-shouldered kite, black sparrowhawk, jackal buzzard and particularly the peregrine falcon. Attacks were more frequent in the days when egg collecting was a popular hobby, before legislation to stop this plundering came into force.

The general rule is not to approach raptor nests too closely and the birds will usually leave you alone. When not protecting its nest it is highly unlikely that any bird of prey would attack humans. An exception is the feeding antics of black kites in areas where people gather and eat, such as picnic sites and campgrounds in game and nature reserves. In northern Chobe in Botswana we have seen these acrobatic birds circling around campgrounds, then with a flick of the wings and adjustment of the tail they snatch food off plates people are holding. In the Ngorongoro Crater in Tanzania at one picnic spot guides throw food to the kites to be caught in mid-air. This is taken a step further when people hold bones,

bread and the like to be snatched from the fingers. This is highly irresponsible because it can result in serious injury and sets a bad example for children.

Likewise, owls near a nest should be left alone. Eric Hosking, the well-known bird photographer who was based in England, lost an eye to a tawny owl defending its nest. Confirmed cases of African owls attacking intruders near breeding sites are difficult to come by, but all owls have the potential to cause injuries. Spotted eagle-owls and the African wood-owl can be vigorous in nest defence and will readily attack humans and dogs.

If you happen upon an injured raptor or owl, most frequently encountered as road casualties, and you have the opportunity to take it to a rehabilitation centre, handle it with care. It is best to cover the bird with a folded blanket, sack or towel, always ensuring that it cannot get hold of you with its talons. Sometimes these birds may take hold of your hand or arm and can be very difficult to dislodge. Precautions can save you a great deal of pain.

Blows to the head

John Carlyon, vet and bird photographer, recalls two experiences with owls. 'At Entabeni in northern Limpopo Province I was examining a spotted eagle-owl nest which had a single chick in it. It was at night and I had been photographing the birds from a hide. As I bent over the nest to look at the chick one of the adults flew up, unheard, from behind me and with a startling thud struck me on the back of the head. In a similar incident I climbed into a camel thorn tree in the Nossob Camp, Kgalagadi Transfrontier Park, to look at the nest of a pair of white-faced scops-owlets in the late afternoon. In the open hollow of a fork in the tree was a newly hatched chick and an egg. Within seconds of peering into the nest I was struck on the back of the head with what felt like a thorny branch. It was a very irate adult that had raked my scalp with its talons.'

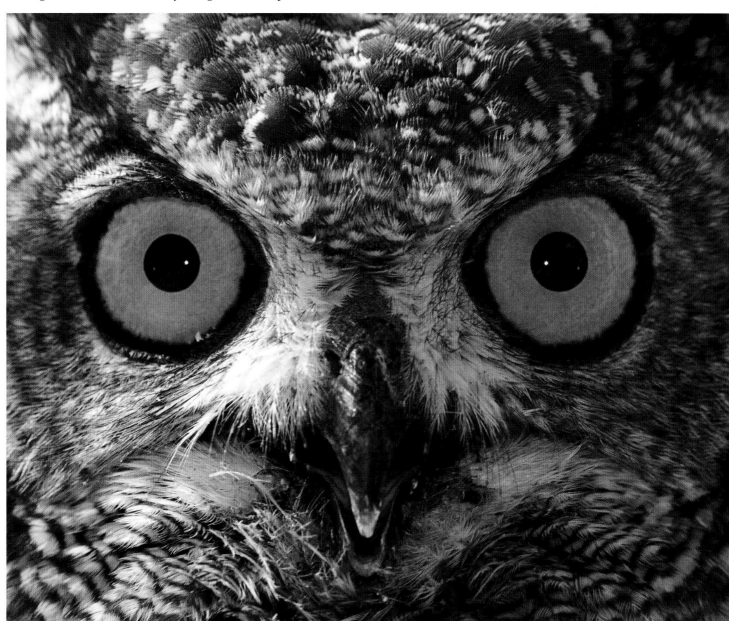

Some owl species, such as this spotted eagle owl, will valiantly defend a nest-site and can deliver painful wounds with their talons.

African penguins may appear to be clumsy and comical, but, if handled, can deliver painful bites that inevitably turn septic.

Other birds

Many birds have the ability to cause injuries but very few do so unless tormented or handled.

One of our quaint coastal birds, the African (or black-footed) penguin, can deliver a very painful, cutting bite. From time to time oiled or injured birds are seen on rocks and beaches, but unless you have experience handling these birds call somebody who does. The beak edges are like razors and bites quickly become septic. People who work for rehabilitation centres such as SANCCOB can verify that they handle these birds very carefully, not only for the bird's well-being but also their own. One of the authors still bears a scar from a bite inflicted by one of these birds 38 years ago. Other species you may encounter injured or sick on the beaches, such as the Cape gannet and cormorants, can also deliver painful bites or jabs. If you have to handle any of these birds hold them well away from your face because your eyes are always vulnerable. Under normal circumstances none of these birds would deliberately attack humans.

Other groups that pose no threat in the wild can prove dangerous when kept in captivity. These include such tall species as blue crane, grey crowned crane, herons and the storks, with sharp-pointed dagger-like beaks that may peck without provocation. Eye injuries can be particularly serious, so keep children out of pecking distance of these birds as they often stand at eye height to the beak.

Many other birds will actively defend nests, but few can do any real damage. Usually they indulge in threatening displays, such as dive-bombing, but avoiding physical contact. Swallows and martins of different species will do this, as will some starlings, terns and gulls. Physical contact in these cases is rare, but some terns, gulls and skuas at breeding grounds may hover or dip in flight and peck at an intruder's head.

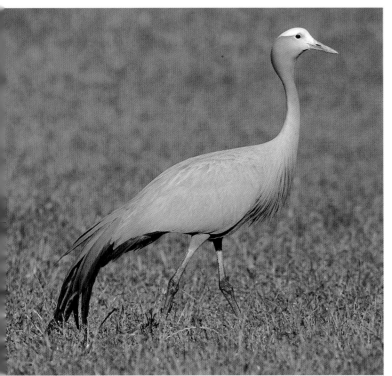

Blue cranes are commonly kept in captivity. Children should be kept clear of their dagger-like beaks.

DANGEROUS REPTILES

Reptiles tend to get a very bad press, and to be viewed with deep fear and suspicion by the general public. While some species of snake, lizard and chameleon can certainly inflict serious bites, they are mostly shy creatures and do not seek out human victims, biting instead as a means of defence. Perhaps only the crocodile deliberately hunts human prey, and is deserving of its alarming reputation. However, we must take care that in our management of the crocodile threat, we never become vindictive and exceed what is required for our essential safety. Over-reaction to their reputation can result in our needlessly endangering these creatures, and seriously impacting on the long-established – and delicate – balance of predator and prey in the natural world.

Crocodiles

The ancestors of the crocodiles were among the most successful vertebrates that have ever lived.
The crocodiles we know today – some 22 species are recognised – started their evolutionary ascendancy more than 200 million years ago. Through the centuries crocodiles have been misunderstood and vilified, and in many cases ruthlessly hunted. Having said that, the Nile crocodile probably kills more people in Africa than all other wild animals combined.

The first crocodiles that we would clearly recognise as crocodiles appeared about 80 million years ago. The name crocodile is derived from the Greek '*krokodeilos*' which simply means 'lizard'. The crocodilians are the most advanced of all reptiles, having a four-chambered heart and a diaphragm. All crocodilians are poikilothermic, meaning that they are cold blooded and require an external heat source. This is why you often see crocodiles basking in the sun, and it helps to explain why most of their activity takes place in the hottest months.

The Nile crocodile is responsible for more cases of man-eating than any other predator on the African continent. Waters known to hold these massive reptiles should be avoided.

Africa is home to three species of crocodile, but only the Nile crocodile (*Crocodylus niloticus*) has a reputation as a man-eater. The Nile crocodile may reach more than five metres in length, is heavily built with a broad muzzle, and ranges in colour from almost black to dark yellowish-green. Unlike the other two species, the Nile crocodile female excavates a hole in which she lays her eggs; the other two construct mounds of vegetation in which the eggs are laid.

The African slender-snouted crocodile (*Crocodylus cataphractus*) may reach four metres in length, is of relatively slender build and has a narrow, elongated snout. In the tropics its distribution overlaps with that of its Nile cousin.

The third species, the dwarf crocodile (*Osteolaemus tetraspis*), rarely exceeds two metres in length. It has a somewhat shortened head with a slightly upturned snout. This crocodile is restricted to aquatic habitats in the tropical forest zone.

Although all three African crocodile species are capable of inflicting serious injury, it is only the Nile crocodile that has a justified reputation as a regular man-eater. Both the dwarf and slender-snouted are well equipped with teeth and powerful tails but the only time they are likely to attack is if they feel threatened or have been trapped.

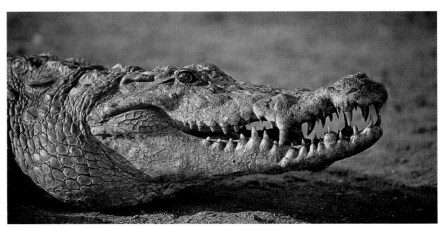

Nile crocodile (Crocodylus niloticus)

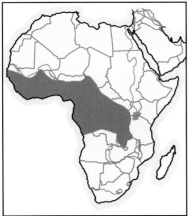
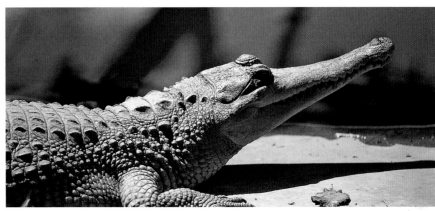

African slender-snouted crocodile (Crocodylus cataphractus)

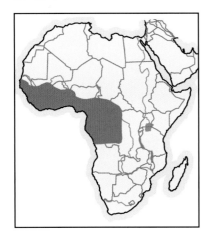
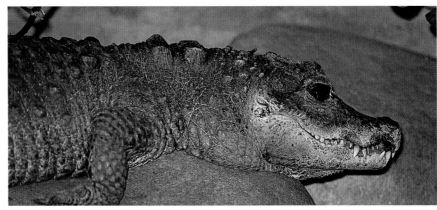

Dwarf crocodile (Osteolaemus tetraspis)

Distribution

The Nile crocodile has a wide African distribution and numbers have increased dramatically in the past two decades. This followed wholesale slaughter of crocodiles for their hides and to rid regions of what was perceived to be a pest species.

In part, the crocodile's success and recovery has much to do with its adaptability. It occupies rivers, lakes, swamps, man-made dams and estuaries, and will readily enter the inshore ocean. It is around these habitats that man and his livestock tend to cluster, but it is not only in poor countries where crocodile/human conflict occurs. In the northeast of South Africa many people use aquatic habitats for recreation, often ignoring warning signs and being ignorant of crocodile hunting behaviour.

Human lives are lost to crocodiles in most areas where they occur. The Nile crocodile is one of the most aggressive of all crocodilians, the master predator of the aquatic ecosystems of Africa.

Hunting season

Not all crocodile attacks start as hunting forays; they may involve defence of territory, nest or hatchlings, or self-defence. Tony Pooley, Africa's crocodile man, studied these giant reptiles for many years in southern Africa and concluded that most attacks on man took place between November and early April. This is when males are defending their territories and both sexes are protecting nests and hatchlings. It is also the time when the water is warmest and these cold-blooded creatures are most active. Water levels are at their highest during the summer rains, and summer is the peak feeding time, whereas little active hunting takes place in winter.

Pooley documented many instances of man-eating in KwaZulu-Natal and adjacent areas of Mozambique. In recent times researchers have collated and studied crocodile attacks in the Caprivi of northeastern Namibia, and to a lesser extent in northern Botswana and Zimbabwe. Elsewhere in Africa records are incidental and documentation is poor, but the number of people deliberately hunted as a food source is probably in the thousands each year.

Crocodiles under 2.5 metres long and weighing around 100 kilograms do not often succeed in killing human prey, but wounds can result in broken limbs, severe lacerations and bruising, and the loss of hands, feet and breasts. Children, of course, can simply be carried away. Once a crocodile has prey in its grip, little other than its own death will force it to release its next meal. If you consider the length and weight of an adult crocodile, a human in its powerful jaws has virtually no chance of escape.

Crocodiles attack with great stealth and in silence, making no sound at all. The final lunge is incredibly swift, so sitting several metres from the water's edge is no guarantee of safety. An attack on a tourist causes an outcry, yet many millions of rural Africans have no choice but to take their chances with crocodiles because they rely on the crocodile-inhabited waterways for their everyday needs. Livestock often graze and drink here, water has to be collected, clothes must be washed and fish caught for food.

Death by drowning

Death by crocodile attack is usually mercifully fast and the victim invariably drowns. Once the crocodile has a grip on the prey, it pulls it under the water, frequently spinning its body in order to tear off chunks of flesh. It is a fallacy that crocodiles must first allow their prey to rot before they can eat it. Crocodiles are not fussy when it comes to feeding off a rotting carcass, but they have no problem in devouring freshly killed prey. They cannot chew, but tear off chunks and swallow them whole.

Nile crocodiles have an extraordinarily broad food base, which changes with size, age and habitat. Young crocodiles concentrate on frogs, tadpoles, snails, crabs and fish, among others. As they grow, they include more fish in their diet. Once they become adults they tend to take larger prey although fish usually remains a large part of their diet.

Nile crocodiles have a formidable array of teeth as well as immense physical strength.

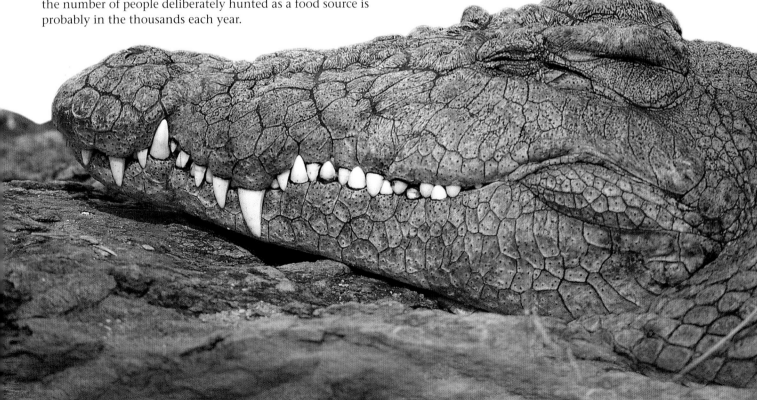

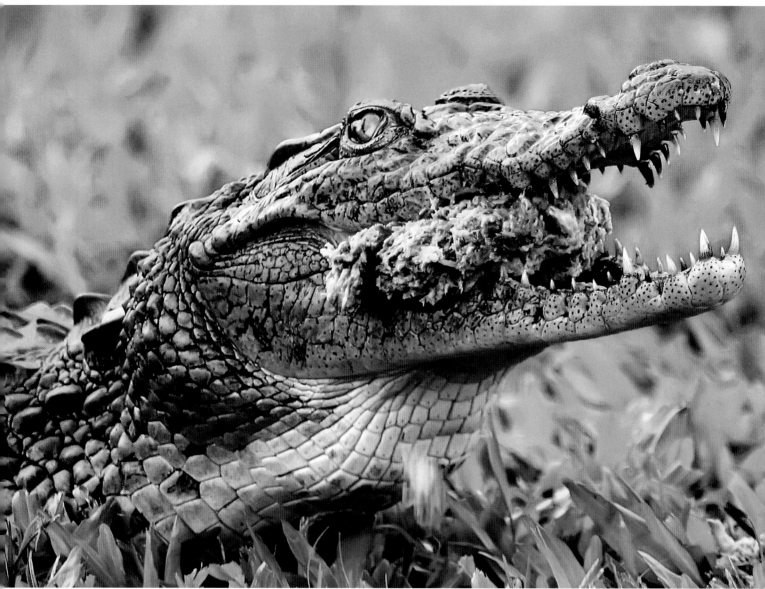

Crocodiles will tear off chunks of flesh from prey, or a scavenged carcass, by grasping it with the teeth and spinning their body until a bite-sized piece breaks away.

Sias van Schalkwyk

Mammals may form a major part of the diet of some individuals or populations. This may include species from six-kilogram cane-rats to African buffalo weighing as much as the crocodile itself. Nile crocodiles sometimes include livestock and humans in their diet.

Opportunistic hunters

In Zambia's Kasanka National Park during November and December there is an influx of between five and ten million straw-coloured fruit bats (*Eidolon helvum*). They roost in low swamp fig trees that grow on the edge of and over the Kasanka River. Nile crocodiles move here at this time to snatch bats from about one metre above the water, and to range over the adjacent forest floor for bats injured when branches break under the sheer weight of the bats.

In Lake St Lucia, South Africa, annual migrations of fish, especially striped mullet (*Mugil cephalus*), arrive to spawn or feed between mid-April and mid-May. At this time large numbers of crocodiles move from other parts of this large wetland towards the estuary to feed. They concentrate in what is known as The

Narrows, a channel less than 500 metres wide. The crocodiles form a line, and no individual breaks from its position, each taking only the fish that come within its reach – an indication that crocodiles can hunt co-operatively.

When feeding at large carcasses many crocodiles may gather, the record being 120 feeding on a hippopotamus carcass in the Luangwa River of Zambia. Those in the feeding circle would spin and tear off a chunk of flesh and make way for a crocodile in the outer circle. In this and other instances there was no sign of animosity between the feeding animals.

Opportunism can even lead to human deaths in unusual circumstances. In November 2006 massive flooding across large swathes of southern Somalia and adjacent areas of Kenya allowed crocodiles to swim into inundated villages. It is known that nine humans were killed and eaten by crocodiles, but it is believed that many more deaths went unrecorded. Similar deaths were recorded during extensive flooding in Mozambique, but no mortality figure is known. It is also likely that many people who drowned, but whose bodies were never recovered, were eaten by crocodiles.

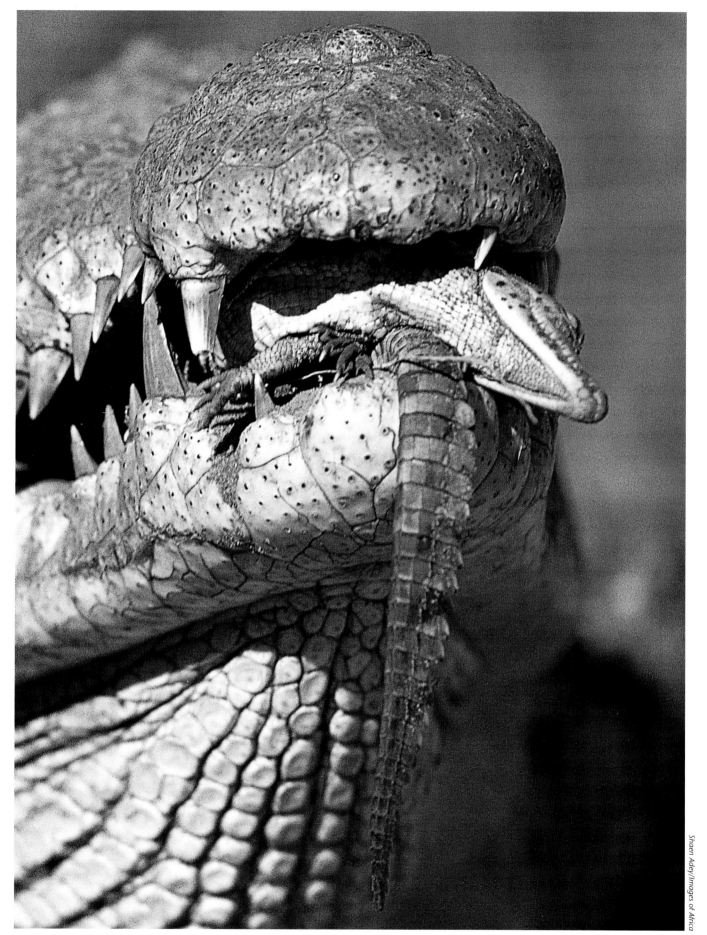

Crocodile females are protective, caring mothers, often helping their newly hatched young to water.

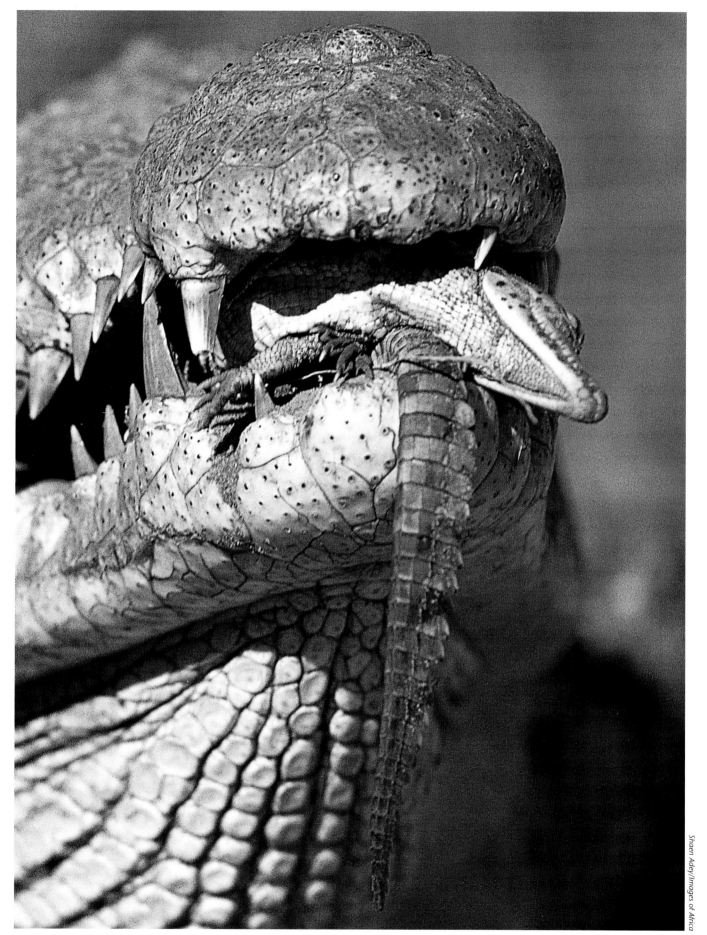
Shoen Adey/Images of Africa

A MOTHER'S CARE

After mating, the female Nile crocodile selects her nesting site and excavates a burrow into which she lays 16 to 80 eggs, or more. The number varies according to the age of the female. During the 84 to 90 days before the eggs hatch she remains close to the nest and will even cover it with her body during heavy rain. Although her presence is important to foil egg predators, many clutches are lost to monitor lizards, various mongoose species, otters, bushpigs and even savanna baboons.

The female opens the nest when she hears the young begin to call from inside the eggs. She removes the sand with her front feet and once the eggs are exposed the hatchlings break out of the eggs. The female carefully picks hatchlings up in her mouth, which can hold up to 20, and carries them to the nearest suitable pool, where she opens her mouth and the hatchlings swim free. She takes hatchlings having difficulty freeing themselves from the eggs into her mouth and rolls the eggs between palate and tongue to crack them so the young can wriggle free. The female and parental male remain as their guardians for several weeks after hatching. Only when they have dispersed will the female, who has during this time been fasting, move away to hunt.

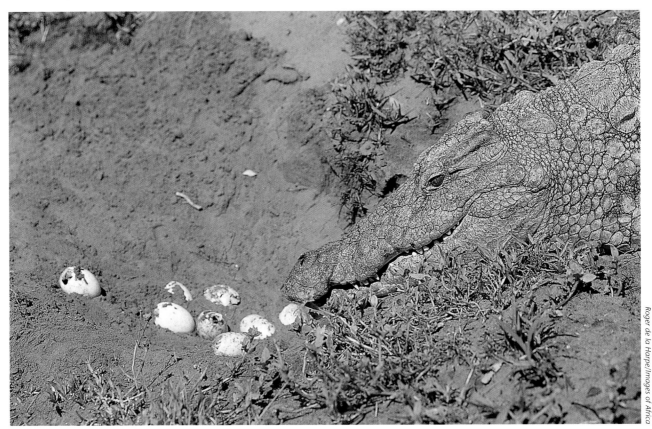

Roger de la Harpe/Images of Africa

A female Nile crocodile helping fully developed hatchlings to get out of their eggs.

Crocodile attacks

Attacks on humans are frequent in Zimbabwe, especially in the north and southeast, among the principal river systems. In April 2007 a fish poacher was taken by a crocodile in the Mutirikwi Dam near Masvingo. His remains were not found. His fishing companion reported the incident to the police and was arrested for fishing without a permit. Many cases along the Zambezi River and Lake Kariba are believed to go unreported, or at least attract no media attention.

In one week in March 2007, three people were killed in other parts of Zimbabwe. In one case, a girl was taken while collecting water near Glendale; the torso was later found with one leg attached, but the other limbs and head were missing. Two months later, a boy was taken while swimming in the Mwenezi River, and villagers recovered only one leg, the head and intestines.

Reported cases of crocodile attacks in Zimbabwe range from 15 to 50 cases each year, but many are difficult to verify. There were nine fatal attacks on humans by crocodiles in the first quarter of 2007 alone. It is deemed likely the total is higher as in the more isolated regions attacks go largely unreported.

Uganda's *New Vision* newspaper reported that Nile crocodiles killed and ate 13 people in the first five months of 2007 – all around Kityerera and Malongo along the shore of Lake Victoria. The victims included fishermen, and women and children collecting water or firewood along the shore. Some people were taken on dry land several metres from the water's edge.

Most cases of crocodile attacks in South Africa take place in northern KwaZulu-Natal, but increasing records of man-eating by crocodiles are being reported in Limpopo and Mpumalanga provinces. Growing human populations

Killer Caprivi crocodiles

The Zambezi River in the Caprivi Strip of Namibia is the setting for numerous tales of man-eating crocodiles. Playing the good Samaritan does not always pay, as the postmaster of Katima Mulilo was to find by paying with his life. He noticed a family picnicking on the river bank and went to warn them to move away from the water's edge because large crocodiles inhabited the area. As he spoke, a large crocodile torpedoed out of the river, grabbed him and was gone. By all accounts the postmaster was a large man, but the crocodile had taken him as easily as an agama snatches up an ant.

Researcher Patrick Aust has compiled a database of known Nile crocodile attacks in the Caprivi Strip. Many attacks probably go unreported, but between 2001 and 2005 he recorded 478 cases of crocodile attacks on livestock and humans. The most active attack sites were along the Chobe River. Some 445 of the attacks were on cattle and 19 fatal attacks on humans; at least four other attacks on people did not result in death. Almost half of the attacks took place in the hot months of September to November, before the onset of the rains. From October to December 2006 in the same region six people were killed by crocodiles, all of them children swimming in the river.

To try to reduce this mortality, some areas have constructed crocodile-proof enclosures in which people can swim, wash clothes, and so forth. Six crocodiles believed to have been involved in these attacks have been shot. At least two had human remains in their gut. Although it is not known whether crocodile attacks have increased in the area in recent years, it is known that large-scale fishing and netting have greatly decreased fish stocks. Fish make up the bulk of the crocodile's diet and this drastic decline may have resulted in increased attacks on livestock and humans.

are living and fishing along river plains, lake edges and in the vicinity of swamps, so instances of attack and man-eating by crocodiles are bound to increase. These people have little choice but to take risks with the crocodiles because they depend on the water for drinking, washing and food.

What is inexplicable are the activities of tourists who enter these waters and sit or stand along the water's edge despite numerous signs warning of the dangers of crocodiles. In the Greater St Lucia Wetland (Isimangaliso) in KwaZulu-Natal visitors are now even deliberately throwing food to crocodiles. A spokesman for the conservation authority has said that crocodiles already follow people who walk on trails alongside the water, expecting food. The next step will be a crocodile helping itself to a tourist.

Crocodile conservation

Crocodiles in the wild were heavily hunted for their skins, greatly depleting populations in many areas. In the mid-1950s almost 60 000 Nile crocodile skins were exported from East Africa each year. Heavy levels of hunting continued into the 1970s. Legislation and fashion changes largely halted the indiscriminate slaughter, and crocodile farms emerged, especially in South Africa and Zimbabwe, but also in other countries. For a period there was a decline in demand for crocodile skin in the fashion industry, which gave crocodile populations chance to recover. Some captive-raised crocodiles have been, and still are, used for restocking. The limitation on hunting was not only to protect the crocodiles but because the slaughter was upsetting the delicate ecological balances of the freshwater systems.

Crocodile survival and conservation hinge on finding a balance between preserving the aquatic ecosystems in which they live and reducing conflict between humans and crocodiles. In cases where man-eating crocodiles are active, they are trapped and transported to farms as breeding stock. The use of traps has been particularly successful in KwaZulu-Natal. Attempts to translocate problem crocodiles to natural habitats usually fail as these reptiles have a strong homing instinct and will even make long journeys overland to return to their original home range. In isolated areas where capture and transport is not practical their depredations are usually halted with a bullet.

 ## Avoiding trouble

- Do not swim or fish close to the water's edge (never closer than four metres and even that may not be enough) in areas where Nile crocodiles are known to occur. Even on the hottest day do not be tempted to cool off – it may be the last thing you do.
- Take heed of signs warning of the presence of crocodiles. Remember that in many African countries there are no signs even though crocodiles are present.
- Ask locals about the crocodile situation in areas that you visit.
- Making a great deal of noise is more likely to attract crocodiles than scare them away.
- Even small, isolated water bodies can hide very large crocodiles.
- If you are fishing from a boat or close to the water never gut fish and throw the entrails into the water. This can attract crocodiles that may take more than a passing interest in you as their next meal.

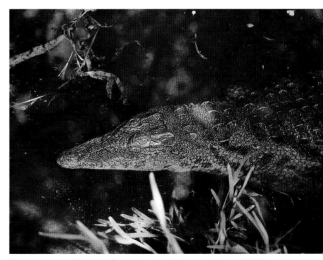

Young crocodiles feed on insects, frogs and small fish.

Lizards

No lizard is likely to attack and bite unless you try to catch or handle it, but bites or scratches have a high risk of resulting in tetanus or septicaemia. Apart from the Nile crocodile and the array of venomous snakes in Africa, few reptiles hold any serious problems for man.

Southern Africa's largest lizards, the monitors or leguaans, belong to the family Varanidae, and in Africa there are just three species, which also occur widely on the rest of the continent. The largest is the Nile, or water, monitor (*Varanus niloticus*), which has been recorded as reaching a total length of 2.42 metres, though specimens up to two metres are more common. The white-throated or rock monitor (*Varanus albigularis*) rarely reaches more than 1.7 metres. Both have long, whip-like tails that can deliver painful lashes if they are cornered. They can also deliver painful bites and will hang on without wanting to let go. Lashes from monitor tails can knock a child off its feet and have been known to break the legs of attacking dogs, and their sharp claws can produce nasty scratches. Unless you are experienced at handling these reptiles, it is best to leave monitors alone.

Neither species is inclined to be aggressive towards humans under normal circumstances and will first attempt to flee if frightened or molested. Hard pressed, they will climb into trees to escape danger. If they cannot escape they may raise themselves on the legs, puff up the neck and throat, all the time emitting a deep hissing sound. This is the time to beat a retreat.

As its alternative name implies, the Nile monitor is closely associated with watery habitats, including rivers, lakes and swamps. It swims well and has a varied diet that includes frogs, fish, crabs and birds, and will dig out the eggs of crocodiles and terrapins. The white-throated monitor is more an inhabitant of savanna woodland and bush country throughout east, central and northern southern Africa. It eats mostly invertebrates but will kill and eat whatever it can overpower and will readily feed on carrion, including road kills. This is why it is not unusual for it to be hit by speeding cars.

NO POISONOUS LIZARDS IN AFRICA

There are only three species of poisonous lizard in the world, the gila monster, the Mexican beaded lizard and the Komodo dragon, and none occurs in Africa. But throughout Africa, beliefs persist that a number of lizard groups can deliver a fatal bite. Chameleons come in great diversity, especially on the island of Madagascar (which has the most known species), and at least 20 species occur in southern Africa. The larger species can deliver a painful bite, but no permanent damage is caused. Agamas are greatly feared in areas such as the Karoo and Namaqualand. Again, larger specimens can deliver a painful bite, but they have no venom. Likewise, geckos in many regions are believed to deliver a venomous bite and certainly larger species can draw blood.

It is possible that this fear derives from the fact that lizard bites, where skin is broken, carry a fairly high risk of tetanus and septicaemia. Perhaps the myth of poisonous lizards was born in times when medical treatment was limited and not readily available (in fact, still the case in many parts of Africa) and infection and illness developed following a lizard bite.

Lizard-inflicted wounds

- Treat bites and scratches resulting from conflicts with monitors and other lizards seriously. There is a high risk of contracting tetanus, so ensure your anti-tetanus injections are up to date.
- Since there is a high risk of septicaemia, thoroughly clean scratch or bite wounds with water and then disinfectant. In the case of serious bite or scratch wounds seek medical advice.

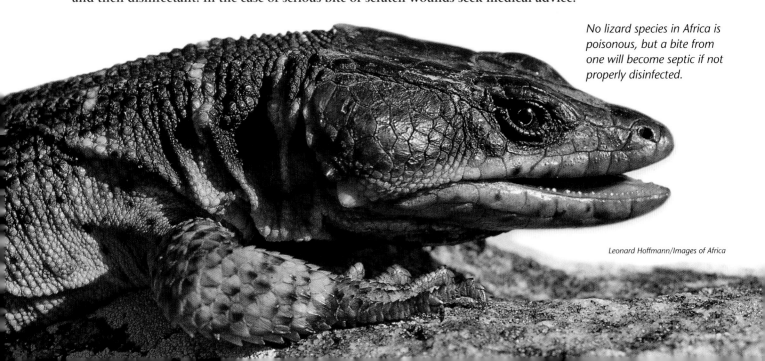

No lizard species in Africa is poisonous, but a bite from one will become septic if not properly disinfected.

Leonard Hoffmann/Images of Africa

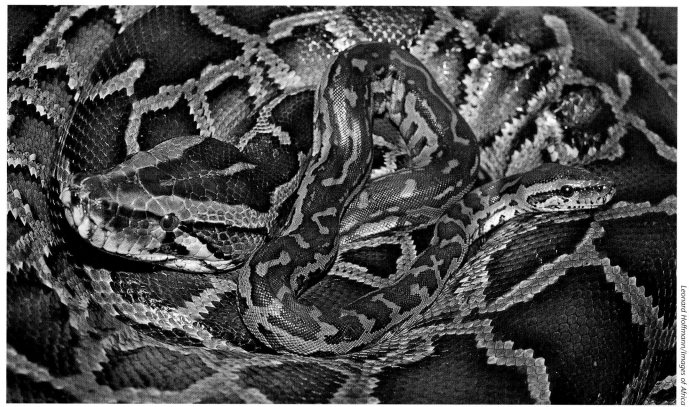

There is little danger of being killed and eaten by a python; the danger lies mostly in sustaining severe bites that may become septic.

Pythons

Unlike the cobras and mambas, the African rock python (*Python natalensis*) has no venom glands, but can deliver painful and slashing wounds. Very large pythons can kill by constricting.

Africa is home to three species of python, the royal python mainly from West Africa, Anchieta's dwarf python in western Namibia and Angola, and the African rock python. Bites from any of the pythons can result in serious wounds, but it is the larger and widespread rock python that you are most likely to encounter.

In southern Africa the rock python seldom reaches five metres long, but specimens elsewhere in Africa may reach six metres. Two specimens measured in Ivory Coast, West Africa, were said to be 9.8 metres and 7.3 metres. A python of even three to five metres can exert massive power as it throws its constricting body coils around its prey.

It is commonly believed that pythons and other constricting snakes crush their victims, but this is not the case. Normally, a python will lunge forward and grasp prey with its numerous sharp teeth and rapidly wind its body around the victim. Death results from suffocation of the prey, which cannot move its ribs or breathe during constriction. With each exhalation of breath the python tightens the grip of its coils until the prey loses consciousness and dies. As with all snakes, the python cannot chew, but uses its teeth to draw the dead prey into its mouth, and then swallows it whole. The great elasticity of the jaw connections allows it to consume prey that would at first seem too large to be swallowed.

Mammals make up the bulk of their prey, including cane rats. Larger pythons take antelope such as duiker, steenbok, impala and bushbuck. They will sometimes take birds, monitor lizards and even smaller crocodiles. The largest prey item on record is a 59-kilogram impala.

Pythons of more than five metres long would have no trouble overpowering a child, or even a lightly built adult. But although numerous tales of man-eating have been bandied about, nearly all are difficult to verify. In isolated areas such events would probably be unrecorded. It is unlikely that a python would become a serial 'man-eater' in the manner of lions and spotted hyaenas.

The rock python has numerous sharp, back-curved teeth.

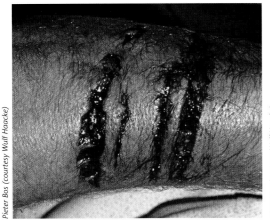

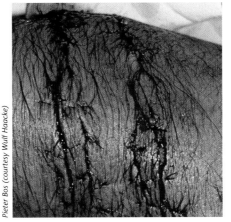

Pieter Bos (courtesy Wulf Haacke)

Pieter Bos (courtesy Wulf Haacke)

✚ Python bites

- Any python bite, even where tissue damage is slight (unlikely), should be thoroughly cleaned and disinfected and it is wise to seek prompt medical attention. In serious cases stitches and further cleaning may be required. A tetanus toxoid booster is advised.

ABOVE: *A fresh python bite before treatment (left) and after cleaning and stitching (right).*
BELOW: *The royal python* (Python regias) *is restricted to Africa's western tropical forest.*

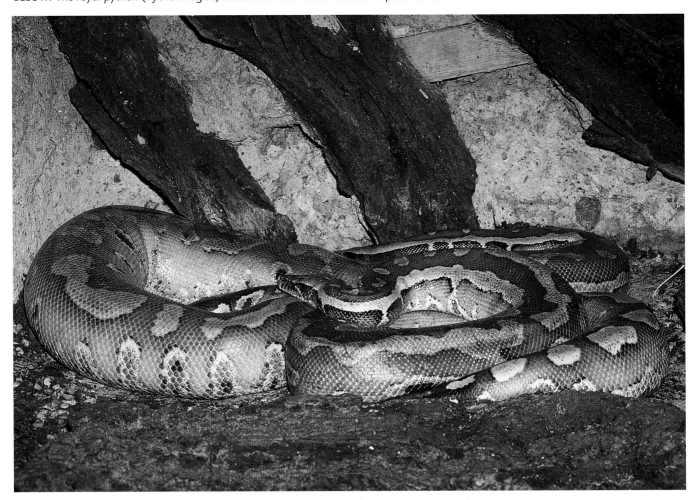

Python kills boy

Attacks by pythons on humans are extremely rare worldwide, though media hype tends to distort the situation by misrepresenting the actions of snakes trying to protect themselves.

However, two of Africa's top herpetologists, Bill Branch and Wulf Haacke, documented a case of deliberate attack on a human by an African rock python in South Africa's Limpopo Province in 1979. Two Tswana herd boys were chasing cattle along a trail when one of the teenagers was grabbed on the calf by a python. The other boy ran back to raise the alarm. Elders arrived 20 minutes later to find the boy completely entwined by the python. After being pelted with stones the snake uncoiled and moved away. The boy was already dead, his head wet with the snake's saliva, so it had probably started to swallow him. The coroner's report indicated that 'death resulted from suffocation and internal injuries'.

DOMESTIC ANIMALS

Even the tamest pet or the most tractable farm animal has been known to turn on its owner or strangers for no apparent reason. Many such attacks are the result of people not understanding animal behaviour. The attack might be prompted by jealousy when a new baby enters the household, by a child teasing a dog or cat, by a maltreated dog or horse retaliating against the guilty party or even an innocent one. Startling or frightening an animal can prompt an attack, as can coming between a cow and its calf. Although domesticated animals have shared home and hearth, barn and field with humans for thousands of years, there is still an element of wildness in all of them.

The dog

Man tamed the wolf, and from it all domestic dog breeds descended, from the smallest terrier to the largest great Dane. Archaeological evidence indicates that the divergence between the wolf and the domestic dog goes back some 15 000 years. It seems likely that the dog was domesticated from different wolf populations in different parts of its distributional range. The advent of the agricultural and urban revolutions provided opportunities for selective breeding of dogs for specific tasks and purposes.

When we researched the incidence of dog bite injuries in South Africa, we found that at one hospital group (Medi-Clinic) countrywide, no less than 81 % of all mammal bites were from dogs. In the year to April 2007 there were 355 cases where bites were considered bad enough to admit the patient to hospital; how many bites were seen in outpatients units is unknown. In the same period, just six rat bites required hospitalisation at Medi-Clinic.

The Red Cross Children's Hospital in Cape Town saw 200 children bitten by dogs between January 1998 and January 2000, and 92 from January 2005 to January 2006; 72 % of all cases occurred either inside or outside the victim's own home or at the home of friends and family. Slightly more than half of the children were less than six years old, and many were bitten about the head, neck and face. Similar findings were made in studies undertaken in Australia and the United States. A 1997 report published in the *Medical Journal of Australia* concluded that each year some 100 000 people are bitten by dogs, of which 13 000 are treated in hospitals. A 1994 United States report concluded that dog bites and deaths due to dog attacks were probably under-reported by at least 25 %. Given South Africa's population size, we could expect that as many as 250 000 people would be bitten by dogs in any given year, although most would probably not seek hospital treatment.

You just have to look at media reports to realise how serious and pervasive this problem is. 'Pitbull terriers maul Durban security guard', 'Pet dog savages toddler', 'Dogs savaging game and sheep', and 'Dogs bite 80 lambs to death'. Not only are there problems with attacks on humans, dogs are responsible for the deaths of and serious injuries to thousands of head of livestock every year in South Africa. No figures are available for any other country in Africa but anecdotal reports indicate that losses are probably substantial. Many blame stray or underfed dogs from squatter camps

and townships, but this is not always true. We have watched two boxers, in fine health and both happy 'homebodies', chasing and attacking a flock of ewes with lambs, biting indiscriminately. These dogs were shot, but the blame should be placed squarely on the owners of such dogs.

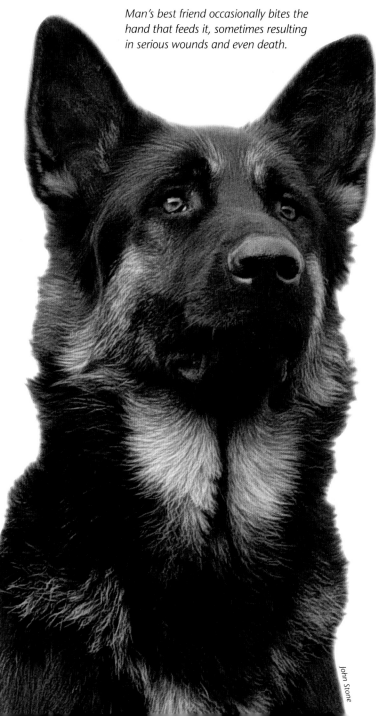

Man's best friend occasionally bites the hand that feeds it, sometimes resulting in serious wounds and even death.

John Stone

GUEST'S NOSE BITTEN OFF

During a dinner party, the host's Scottish terrier wandered into the dining room and moved around between the guests under the table. A young woman bent down low to fondle it, her face close to the dog's. As she did so it snapped, its teeth closing over her nose, pulling back at the same time as she did. Her nose was cleanly bitten off to the bone. Bleeding and shocked, she was rushed to hospital with her nose lying forgotten under the dining room table. One of the other guests discovered the nose, put it on ice and rushed it to the hospital, where surgeons were able to reattach it.

Is it in the dog's breed or size?

An ongoing debate, sometimes heated, revolves around whether particular dog breeds are more prone to attack humans than others. Certainly at some time or another every dog breed has bitten the hand that feeds it, but some breeds seem to top the charts in every country where studies have been undertaken.

In 1995 and 1996 rottweilers in the United States were responsible for more human deaths than any other breed, but from 1979 to 1996 overall it came second to the pitbull. The pitbull was responsible for 60 deaths; the rottweiler for 29. Third was the German shepherd. An Australian study found that five dog breeds were responsible for almost 75 % of attacks – Doberman pinscher, German shepherd, rottweiler, bull terrier and blue heeler (an endemic breed with dingo genes). In South Africa the situation is probably similar, but detailed figures are not available. All the above are large and/or powerful dogs and many are kept as guard dogs. However, even small dogs can give a good account of themselves, as in the case of the Scottie biting off the dinner guest's nose

The question arises as to whether the dog breeds responsible for most of the attacks are inherently liable to attack humans or, as the various breed associations say, the fault lies with the owners, or in some cases unregistered breeders who deliberately select vicious bloodlines as attack and guard dogs. In general, big dogs are no more or less aggressive than smaller dogs, but they may well react in different ways. A dog is, through its ancestry, a pack animal, a descendant of wolves. A dog that is tethered on its own and only sees its owner at feeding times will become frustrated. This is why guard dogs are potentially dangerous, though it is not only guard dogs that are treated in this way.

Dogs need to be trained and schooled, and they have to learn how to fit in to their human pack. They are not human, nor are they human substitutes; they are domesticated 'wild' animals. The hunting instinct is ever present and owners should never forget this. We have seen a Jack Russell and fox terrier, which have only known an urban existence, taken for the first time into a rural environment where there were populations of rock hyrax. Their first instincts take them off in pursuit and the owners have great difficulty controlling them.

There are legal implications if your dog bites somebody or attacks livestock. If a dog can escape from your property and attacks someone, you could end up with a dead dog, or could face expensive legal proceedings. You are well within your rights to protect yourself and your livestock against an attacking dog, but if you shoot one in the urban environment you will be charged with discharging a firearm in a municipal area. Part of the problem on farms where livestock is killed or maimed is that it is difficult to establish the ownership of marauding dogs.

Some dog breeds, such as the pitbull, attack humans more frequently than others. However, in at least some cases, unscrupulous breeders select vicious bloodlines.

Pitbull terrier attack

In April 2007 security guard Bethuel Vilakazi was mauled by two pitbull terriers, which broke through a gate in the Crestholme suburb of Durban, South Africa. He had been responding to a burglar alarm when he was attacked, apparently the second such attack by these dogs in the space of three months. Vilakazi had one of his ears partly ripped off and suffered several bite wounds. His companions remained in the vehicle, hooting until a neighbour arrived to assist – and he was also mauled. It was only when the dogs' owners came to the scene that they could be subdued.

Avoiding trouble with dogs

- If a dog growls or snarls there is one simple rule: leave it alone and move away.
- Never approach or pat a strange dog, especially if the owner is not present.
- Teach children that even the tamest dog should be left alone when it is feeding or sleeping.
- Avoid sudden movements that can initiate an attack – some dogs are very protective of their owners and may see a friendly slap on the back as aggression towards their master or mistress.

DOGS KILL SHEEP

In April 2007 three dogs attacked the flock of farmer Johan Steyn of Wellington in the Western Cape. Four ewes and 120 lambs were bitten and mauled; and the ewes and 80 of the lambs died. This was wanton killing, as the dogs ate from one of the ewes only, and even then just a small amount of flesh.

The incidence of dog attacks on livestock has been increasing steadily, both by kept animals and feral packs. *Die Burger* reported in September 2006 that packs of stray dogs were targeting sheep flocks in the Sterkstroom district around Dordrecht, Eastern Cape, with more than 140 killed on different farms within a few weeks. Although the report referred to stray dogs, many are kept dogs that are underfed and left to their own devices. Feral packs of dogs are now known to hunt widely in the eastern sector of the Eastern Cape and in KwaZulu-Natal and have been implicated in killing several people.

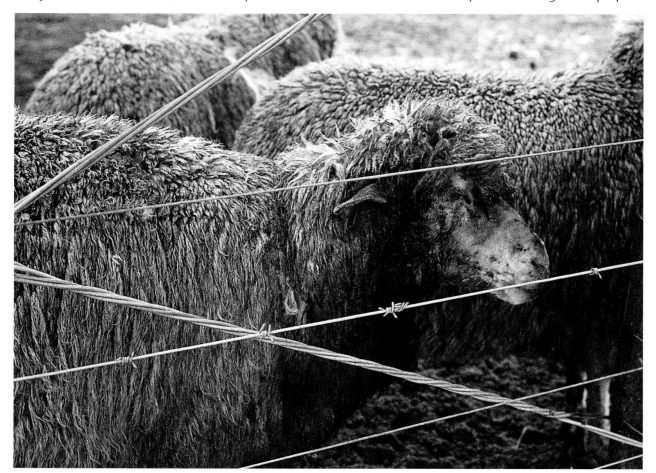

Farm animals are sometimes attacked by roaming packs of feral dogs.

Domestic cats

Because no licensing system is in place for cats, it is not known how many cats are present in Africa. Many are kept as pets, but many others have taken to a feral way of life and can often be spotted many kilometres from towns or farmsteads.

With sharp teeth and tearing claws, cats could cause serious injuries, but this is seldom the case. A cat will sometimes retaliate when children become too rough, but a light clawing is usually the only result. Rarely, a cat will become very aggressive for no apparent reason, and in Africa the first thought should always be rabies. All domestic dogs and cats in the region should be vaccinated against rabies, but this rarely happens. Cats and dogs are also sources of parasites and diseases (see Part Four).

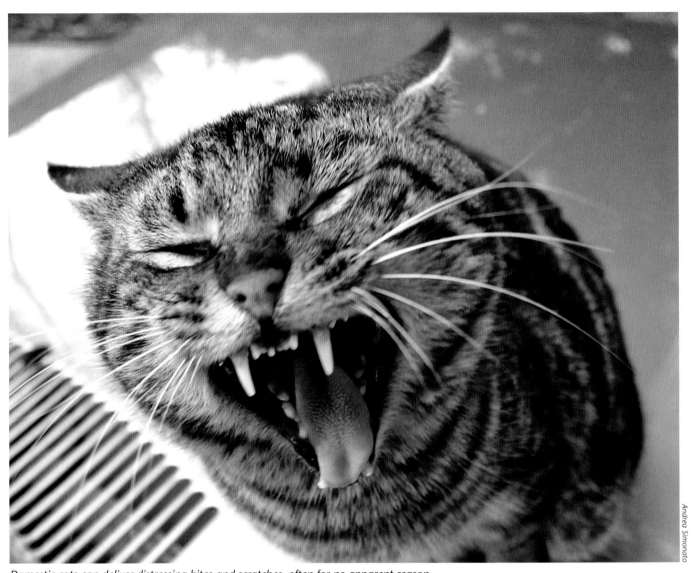

Andrea Simonato

Domestic cats can deliver distressing bites and scratches, often for no apparent reason.

Cat scratches

- Cat scratches should be thoroughly cleaned and disinfected.

Feral cats

The independent nature of cats allows them to adapt quickly to a non-domestic setting. They can hunt successfully, they can breed and, if necessary, interbreed with the African wild cat. They do control rats and mice in and around buildings, but, whether domestic or feral, they also hunt away from the home. Being highly efficient hunters, they kill vast numbers of indigenous non-problem mammals, reptiles and birds. Even the well-fed cat that stays close to home is a frequent hunter.

Although the predatory habits of cats have barely been studied in southern Africa, cats on South African territory Marion Island, brought in to control accidentally introduced house mice, preferred the local birds. In 1976 an estimated 2 000 feral cats roamed the island, with each cat killing an estimated 213 petrels every year. This translates to the death of 400 000 birds per year.

Rabbits, parrots and horses

Children should be taught at an early age how to behave with pets and how to handle them, as this can save a great deal of trouble later. If handled correctly, rabbits, guinea pigs, rats, mice and hamsters seldom cause injuries, but if they are frightened, held incorrectly or threatened in any way they can deliver nasty wounds. Rabbits, especially, can cause painful scratches with the claws of their hind feet. Any bites or scratches by these animals should be thoroughly cleaned with water and soap and disinfected.

Other pets that should be handled with care are members of the parrot family. Larger species have powerful, sharp beaks that can deliver unexpected and very painful flesh-cutting bites.

It is surprising that horses, with their great strength, do not cause more human deaths and injuries. Most injuries are a result of riding accidents, with horses falling, stumbling or reacting in fear. Horses can, however, be dangerous in certain circumstances, both by kicking and biting. A mare protecting a small foal may attack an intruder, especially a stranger, and a stallion in the vicinity of a mare in oestrus may attack with great determination.

Horses that have been maltreated may bite for no apparent reason. This is always an issue when buying a horse, so check the credentials of the seller and the breeding of the horse. You do not want to discover problems after you have bought the horse – the horse that falls over backwards once the rider is mounted, the gelding that has been badly abused by farm workers and will not take the saddle. In most cases the problem is traceable to breeding, training or abuse, but, having said that, some horses are simply difficult.

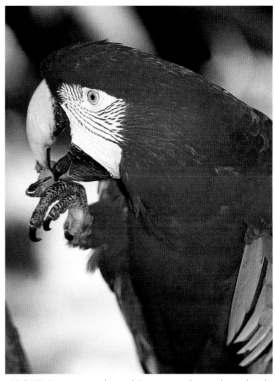

ABOVE: Parrots, such as this macaw, have sharp beaks that can inflict painful bites.
BELOW: Small children should always have an adult present when working with horses or ponies.

Down on the farm

In Africa, extensive rather than intensive farming reduces the risks of injury and death from domestic farm stock, but incidents do occur. Some breeds of cattle tend to be more aggressive than others, such as the Jersey bull and Afrikander cows with young calves. Yet even breeds with mild reputations, such as Dexters, have unexpectedly turned on people. Adult pig boars and sows with small piglets must also be treated with caution. In the case of pigs, which are omnivores, if they attack and knock you down there is always the risk that they may try to devour you. The ostrich-farming industry also has its human casualties, with several deaths and many injuries each year (see page 48). Game farming, especially under intensive conditions of high-value species such as buffalo, has also accumulated quite a long list of casualties (see page 24).

Visitors to farms should never wander through paddocks without establishing what animals are present and without the express permission of the farmer. You would be surprised how easily a Jersey bull, a stallion or an ostrich can remain out of sight until you are well into the field or paddock. Then it might very well be too late.

Domestic pigs, especially adult boars and sows with small piglets, can inflict serious injuries, and even kill.

Sheep rams are rarely responsible for injury to humans, but have been known to break a man's leg.

Many human injuries occur when cattle are handled.

SEA CREATURES

Sharks have the reputation as the most terrifying sea creatures we are likely to encounter, and every year a minute percentage of people around Africa's coasts do fall victim to these powerful and efficient machines of the deep. Images of their vast gape and their armoury of ragged teeth strike fear in the hearts of fishermen, surfers and even occasional swimmers. Evidence suggests, however, that attacks on humans are likely to be accidental, and that we are not necessarily the chosen prey of sharks. Yet even an accidental 'tasting' – and spitting out – can result in fearful injury or gruesome death. Other sea creatures that can also inflict physical injury (and occasionally cause deaths) are billfish, sawfish, rays and eels. And while we need to keep ourselves safe from attack in the oceans, our responses should be measured rather than hysterical, and always with a view to protecting the tenuous chain of life.

Shark! Shark!

Research shows that sharks are not the ruthless, indiscriminate killers they are commonly believed to be. Humans kill many tens of millions of sharks every year, yet sharks account for an average of only five recorded human fatalities a year worldwide. Nonetheless, one human death due to a shark attack provokes a media 'feeding frenzy', and tourists often desert the beaches in hordes.

There are some 354 species of shark and probably more awaiting discovery. Sharks, rays and skates belong to a group known as the elasmobranchs. Unlike bony fish, they have skeletons that are made up of rubbery cartilage, which is flexible and very light. Older sharks do, however, have cartilaginous skeletons that gain increased levels of calcium over time. The jaw of this group of fish is believed to have developed from the first gill arch and it is not attached to the skull.

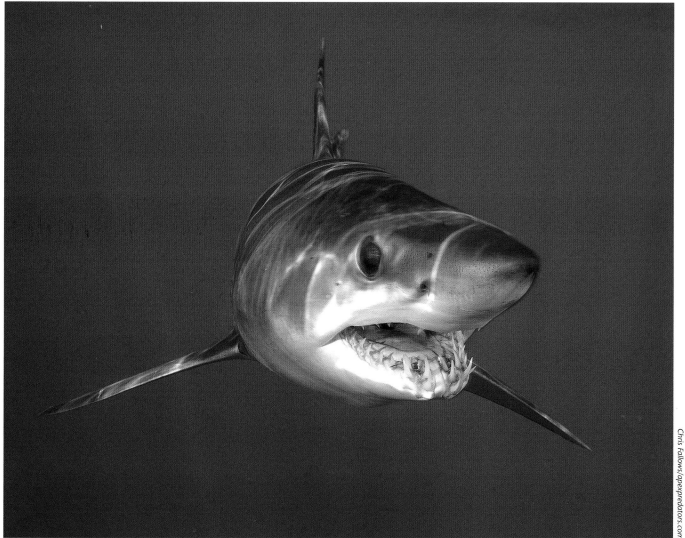

The mako shark is one of just a few species that have been implicated in unprovoked attacks on man.

Chris Fallows/apexpredators.com

TEETH ON A 'CONVEYOR BELT'

The teeth of sharks come in a great variety of form and structure and are regenerated indefinitely. Those of the great white shark are large, erect, triangular and serrated like a bread knife, whereas those of the sand tiger (or spotted ragged tooth) narrow distinctively towards the tip to give it a truly menacing appearance.

The teeth of these and other carnivorous sharks are embedded in the flesh rather than attached to the jaw like our teeth. All sharks have multiple rows of teeth along the edges of their jaws and new teeth are growing constantly behind them on a sort of conveyer belt. For each tooth at the front there may be another four or five in waiting. Some species may replace a full set of teeth every 10 days, in others they may last for several months. It has been estimated that some shark species may use as many as 30 000 teeth in their lifetime.

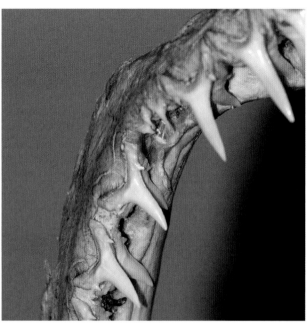

ABOVE: Sharks grow new teeth throughout their lives.
RIGHT: Some sharks have large jaws with a massive gape, such as these from a mako shark.
BELOW LEFT: The bronze whaler has wedge-shaped teeth.
BELOW RIGHT: The narrow, slightly angled teeth of a mako shark.

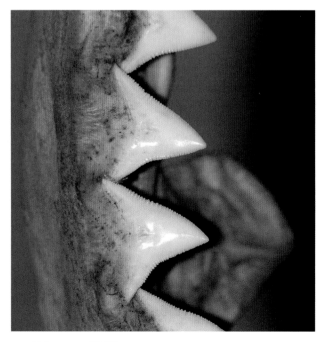

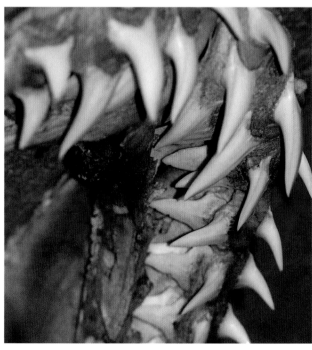

Most of the true sharks have streamlined, torpedo-shaped bodies, and their skin is covered with tiny dermal denticles instead of the scales carried by most bony fish. These protect them from serious damage and the attentions of parasites. In days gone by, before the advent of sandpaper, shark skin served the same purpose for smoothing and shaping wood.

Sharks range in size from the 22-centimetre deep-sea pygmy shark (*Euprotomicrus bispinatus*) (some give the smallest as *Squaliolus laticauda*) to the truly giant whale shark (*Rhincodon typus*), which can reach a length of 18 metres, or more. The two largest sharks, the whale shark and basking shark, feed on the smallest prey, principally plankton and sometimes small fish.

Not all need to swim to breathe

Most members of this fish group have five gill slits (a few have six or seven) behind the head and they are exposed, not covered by a 'hinged' plate, or opercle, as in bony fish. Quite a few species also have a spiracle, or opening, just behind the eye, which is used in breathing. As the shark swims, water passes through the mouth and over the gills before returning to the sea – a method scientists call ram ventilation. A few sharks have to swim constantly because they have lost the ability to pump water through their gills to extract oxygen. For many years it was believed that all sharks had to keep swimming for this reason, but this is not the case. Many species of shark are now known to rest on the sea bottom, often in shallows or in underwater caverns and caves, although they do not sleep, in the sense that humans do, because the eyes are open and they remain aware of what is going on around them.

Unlike bony fishes, sharks do not have gas-filled swim bladders to give them buoyancy. Instead, they have very large livers, which may weigh as much as a quarter of their total body mass. These are filled with oil that includes squalene and provides for some buoyancy, but because this is not as efficient as the swim bladder, sharks do sink if they stop swimming.

Differences between cartilaginous fish and bony fish

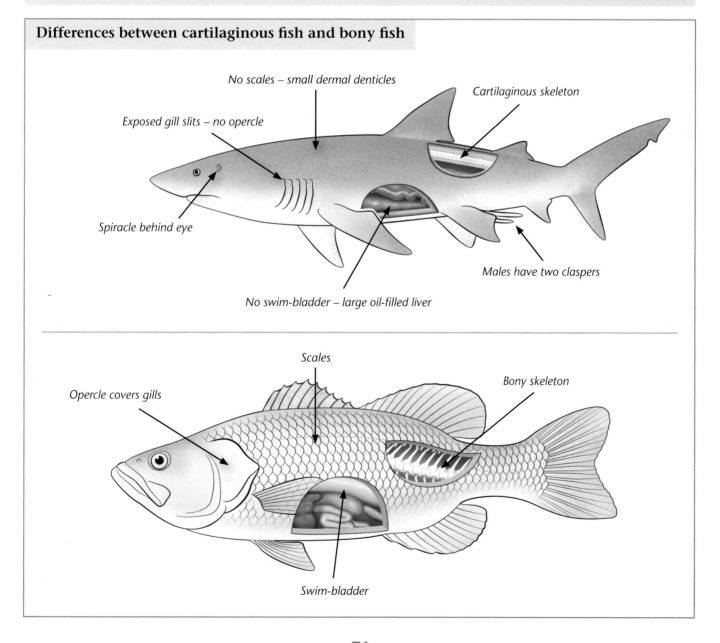

No scales – small dermal denticles

Cartilaginous skeleton

Exposed gill slits – no opercle

Spiracle behind eye

Males have two claspers

No swim-bladder – large oil-filled liver

Scales

Bony skeleton

Opercle covers gills

Swim-bladder

SHARK SENSES

Sharks have evolved incredibly fine senses of smell, electro-reception, sight and hearing. They are able to home in on a potential prey animal from a great distance using just their sense of smell. Some species can identify the presence of blood in sea water at levels of just one part per million, from several hundred metres. They can do this because the two large nasal sacs are lined with very sensitive cells and sea water washes over them constantly. It is something to remember when next you are cleaning your fish catch in the sea or towing your catch after a spear-fishing venture. Once the shark has picked up the scent it swims along this chemical stream to the source, and when it gets closer it also uses sensory pores on its head and body to pick up water pressure variations and hence movement.

Sensory pores on the head, known as the 'ampullae of Lorenzini', may be present in the hundreds and even the thousands. They are specialised electro-receptor organs that pick up electrical fields given off by prey that may be hidden under sand, or schools of fish in the open ocean. Sharks have the greatest electricity sensitivity of any living animal and can be attracted over great distances. The smooth dogfish, a small shark, is said to be able to detect an electrical field 25 million times weaker than the faintest field that can be detected by man.

Sharks also appear to use electrical fields as a navigational tool. Although many sharks are, to a large extent, sedentary, or undertake only local movements, a few undertake trans-oceanic journeys. Oceanic currents that move in the magnetic field of the Earth also generate electric fields, and it is believed that migratory sharks use them for navigation.

Sharks have good eyesight. The eye structure is similar to that of other vertebrates, but with the addition of the tapetum lucidum – a tissue that lies behind the retina and reflects light back to the retina to increase the visual stimulus, functioning in much the same way as a mirror. It is most highly developed in sharks that hunt in deeper, darker water and at night. Some sharks have a nictitating membrane, or third eyelid, that protects the eyes when they are attacking or being attacked. A few, such as the great white shark, lack this membrane and roll the eyes backwards to protect them before biting prey.

This combination of senses and structures is what puts sharks among the supreme predators of the seas. But how intelligent are they? We know that sharks have greater brain weight to bodyweight than any bony fish – similar to those of mammals and other higher vertebrates. Sharks are not just eating-machines, but creatures that have problem-solving skills at least equivalent to those of laboratory rats. Some species engage in a social complexity that is still not fully understood.

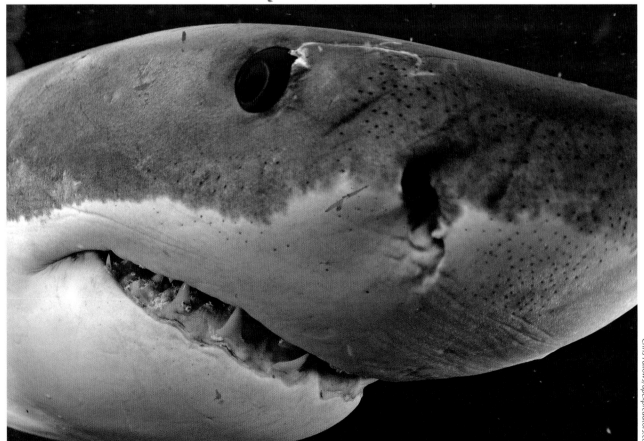

Chris Fallows/apexpredators.com

Sharks have excellent vision and can see just as well at night as during the day.

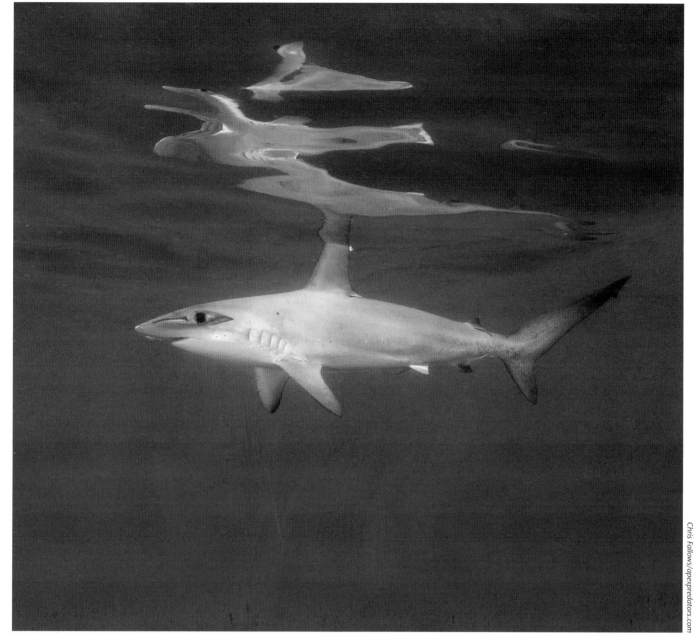

The smooth hammerhead (Sphyrna zygaena) *may reach a length of four metres. This species has been implicated in attacks on humans, but solid evidence is lacking.*

Now you see it, now you don't

Some shark species have wide oceanic distributions, others are restricted to relatively limited areas; some are migratory and others rarely move far from their birth grounds.

There are shallow-water sharks, oceanic or pelagic sharks, and sharks that cruise at up to 1 500 metres below the surface – but seldom deeper. A study by the Census of Marine Life group revealed that as much as 70 % of the oceans are 'shark-free' but this simply means that they are largely absent from the waters below 1 500 metres. Some sharks, such as the great white, occupy shallower waters for much of the year but then migrate across great expanses of open ocean. This was graphically shown in recent times when a female great white, named Nicole by researchers, was tagged in South African inshore waters and regularly journeyed to Australia and back for several years. Each

journey was estimated to cover some 22 000 kilometres. What still eludes researchers is whether these journeys are guided by electromagnetic fields, or whether they are combined with visual navigation by the celestial systems. Also what remains unknown is why these great journeys are undertaken in the first place. There is much that remains to be understood about these keystone predators.

Pelagic, or open-ocean, sharks are influenced by warm and cold oceanic currents in their movements, with a trend in summer towards the poles and in winter in the direction of the tropics. Those sharks that remain in the inshore shallow waters in the tropics, where water temperatures tend to remain pretty uniform throughout the year, seldom move from their range. But at least some of those that seasonally occupy colder waters appear to be migratory to a greater or lesser extent, moving to warmer waters in winter.

EGGS OR BABIES?

Unlike bony fish, but similar to the practice among mammals, sharks copulate. The male has a pair of claspers, one of which is inserted into the female's oviduct to transfer sperm. (How the name clasper came about is unclear because they are not used to clasp, or hold onto, the female.) A number of shark species are 'rough lovers'. After a bout of courtship and mating the female can be left with numerous bite wounds and gouges, but nature has provided her with thicker skin than that of the male, so the damage is limited.

Sharks have evolved three different breeding strategies, depending on the species. There are those that lay single eggs in tough, leathery cases that may be attached to seaweed or lodged in rock and coral crevices. Sharks that employ this strategy – called oviparity – include some of the dogfishes. Other sharks have a reproductive system called viviparity, in which the female shark maintains a placental link to the developing young, in much the same way as mammals. Young are born looking like small adults and are fully functional. These include the hammerheads, as well as some of the most dangerous sharks to man, the bull, or Zambezi, shark and the tiger sharks.

Most sharks are ovoviviparous and the pups are nourished by the yolk of their egg and by fluids secreted by special glands in the oviduct wall. Eggs hatch within the oviduct and they continue to be nourished and grow within it. Pups are born well developed and able to look after themselves.

In December 2001 a female hammerhead shark kept in captivity gave birth to a single pup, although she had not had contact with a male for more than three years. At first it was thought that she had held sperm for all that time before she released it to fertilise eggs. But in May 2007 it was shown that the pup had no paternal DNA, so no mating process had taken place at any time. Asexual reproduction had been discovered in sharks for the first time. Scientists believe that such reproduction in wild sharks would be extremely rare.

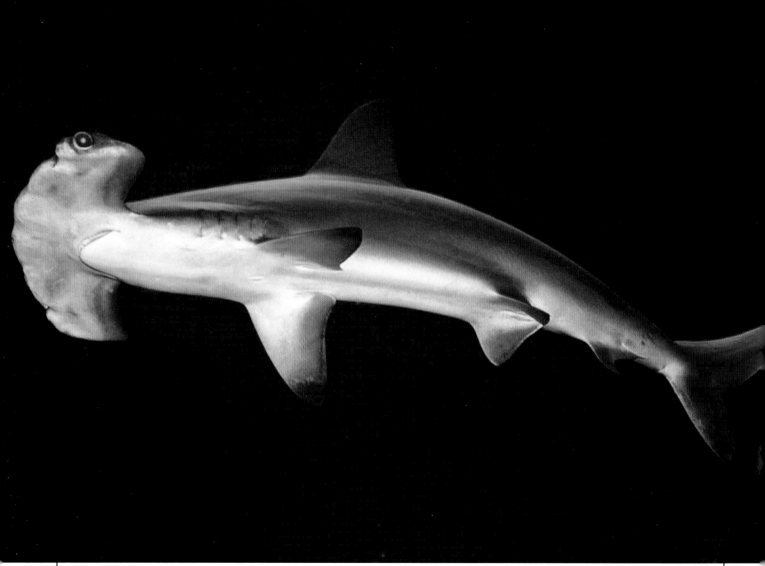

Hammerhead shark young develop in the body of the female, in much the same way as placental mammals.

Dennis King

Picturenet/AP Photo/Schalk van Zuydam

Some holiday locations resort to using shark nets and drumlines to manage sharks. However, in areas around Cape Town, South Africa, teams of observers are used to keep an eye on the coastline from a high vantage point and warn of the presence of sharks.

The risk of shark attack

The movie blockbuster *Jaws* probably did more damage to the shark's reputation than any other single event. At least, to his credit, the author of the novel dealing with that monster great white shark, Peter Benchley, later tried to rectify the damage he had wrought by taking up the cause of shark conservation.

One shark attack, whether fatal or not, is all that is required to get headline treatment. Yet the numbers are not as huge as the headlines lead us to believe. The International Shark Attack File undertook a survey of 105 shark attacks on humans worldwide in 2005. Of these, 58 attacks were unprovoked and just four resulted in deaths. In 2006, 78 shark attacks on humans were recorded worldwide. Again, a fairly high percentage are referred to as 'provoked', that is, while sharks are being fed or touched, or the shark felt cornered or threatened.

There are numerous documented cases where sharks have attacked, killed and eaten sailors and airmen after disasters at sea. Such disasters should be seen as unusual and rare feeding opportunities and something that does not occur inshore.

One can presume that in such situations there are dead, wounded and injured humans, perhaps bleeding heavily, and many sharks are attracted from considerable distances.

Simply put, if you want to avoid getting bitten by a shark do not enter the sea. But the risk of such attacks is so low that it would make no sense, especially when you have a far greater chance of being killed or injured in a motor vehicle accident on your way to the beach than you have of even seeing a shark.

There is much debate about why sharks bite people and experts are divided on the reasons. Certainly in a few cases humans are seen as legitimate prey. The curiosity theory surmises that a shark takes a bite to better decide whether an object is suitable prey or not. Then there is the mistaken identity theory where the shark, usually a great white, attacks a human in the belief that it is perhaps a seal or dolphin. After taking a bite, many of which are relatively minor, the shark usually but not always lets go. If you consider that a great white has absolutely no difficulty in slicing a human in half in a full-blown attack, this theory makes sense.

75
ANIMALS THAT CAN WOUND

How to recognise signs of an imminent attack

In much the same way that a lion or elephant may (though this is not always the case) give off certain behavioural signals that warn of an impending attack, certain sharks give similar warnings. If you recognise these signs, you should back off, always facing towards the shark. Pointing the pectoral fins downwards has been observed in 23 species, including those considered most dangerous to humans – the great white, tiger and bull (Zambezi) sharks. A second warning sign is known as the 'hunch', in which the snout is held upwards, back hunched, or arched, and pectoral fins held downwards. Jaw gaping, similar to a yawn, and giving a full view of the impressive teeth, and slow, deliberate swimming, turning sideways to you, can also serve as warning. In the words of shark behaviourist Peter Klimley, 'If it arches its back, bares its teeth and pulls its fins down, it's not a good situation.' This is a clear indication that it is time to depart from the scene. The trouble is that these signals are often brief and you need to be alert for them.

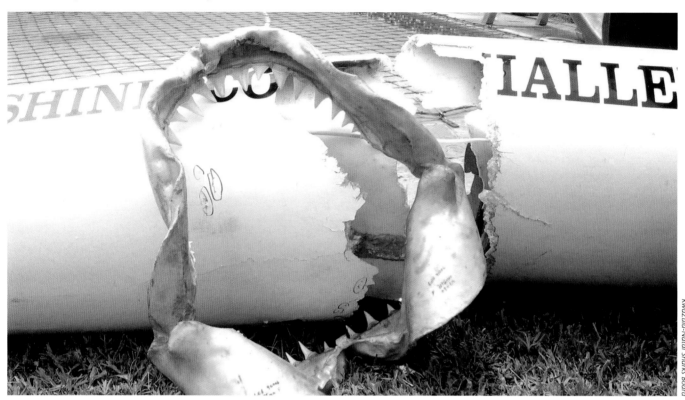

A double surfski that was damaged by a great white shark off the south coast of KwaZulu-Natal, South Africa. The jaws shown with the surfski give an indication of the shark's massive gape.

⚠️ Avoiding trouble with sharks

- Avoid swimming in murky water with low visibility, or at dusk, dawn or at night.
- Do not swim, or wade, in areas where effluent such as sewerage or food factory waste is known to be released because these may attract sharks. Also avoid swimming in or near fishing harbours, or where fishermen/anglers are present or cleaning their catch.
- In South Africa, never swim near Cape fur seal colonies on the south and west coast because they are often frequented by large sharks, especially great whites.
- Avoid prime shark feeding areas such as river mouths, steep drop-offs at reefs and sandbars.
- Leave shiny objects such as jewellery at home because these may attract sharks.
- Choose protected beaches for swimming and surfing. Many beaches in KwaZulu-Natal are protected by shark nets and drumlines, and around Cape Town a number of beaches are under surveillance for the presence of sharks.
- Do not swim in the sea with pet dogs because they could attract the interest of sharks in the vicinity.
- Leave the water if large numbers of squid or fish (such as the famous sardine run) are seen close inshore, or appear to be moving in an erratic manner. Chances are predators such as sharks are following them.
- It is always safer to swim in groups rather than head out towards the horizon on your own. This also applies to surfing and other sea activities. If you are unfamiliar with local conditions ask people with knowledge of that section of coast which places to avoid and where it is considered to be safe.
- Avoid potential danger spots and do not panic if you encounter medium-sized and large sharks.
- Do not urinate in the water or enter the sea if you have fresh cuts, or are menstruating; these chemical signals could attract sharks. Although there is some controversy as to what scents influence shark behaviour, erring on the side of caution is wise.

Much controversy swirls around the different methods used to keep sharks away from bathing beaches. Shark attacks in southern Africa specifically, and worldwide generally, are very rare. In South African waters over the past 40 years there has been an average of only six incidents each year. According to the Natal Sharks Board, along the 2 000 kilometres of South African coastline between the Mozambique border and Cape Town's Table Bay, only 26 % of shark attacks on humans since 1990 have resulted in serious injury and only 12 % were fatal. This amounts to one serious shark attack injury each year and a human death every 1.7 years, despite hundreds of thousands of people using these beaches and the adjacent ocean.

Until recently, the Natal Sharks Board relied almost entirely on shark nets placed offshore from the most popular beaches. The nets are laid in two parallel rows approximately 400 metres offshore, in water depths of 10 to 14 metres. Durban, one of South Africa's largest cities and holiday destinations, has 17 nets, each 305 metres long, from the Umgeni River mouth to the harbour entrance. Many people believe that these nets form a complete barrier but they do not, and sharks can swim over, under and around the nets. Their purpose is to *reduce shark numbers* near protected beaches, but those who argue against the nets point out that not only sharks die in the nets. Other marine creatures such as dolphins and turtles also drown. In Durban from 1943 until the nets were installed in 1952 there were seven human deaths due to shark attack. Since the nets were put in place no fatalities have occurred at Durban beaches as a result of sharks.

However, conservation concerns have led to experimentation with alternative methods. Drumlines, a single baited hook suspended from a float, are aimed at catching larger sharks. Obviously, this is not a barrier to sharks, but it is said to reduce shark numbers near protected beaches and at the same time have minimal impact on other marine creatures such as turtles and dolphins. In the United States, South Africa and Australia research continues on electrical shark repellents, but nothing has been developed yet to protect recreational beaches.

Popular beaches around the Cape Peninsula have moved in a more conservation friendly direction, using neither nets nor drumlines, but instituting a shark-spotter programme. The mountainous shoreline of the Cape Peninsula lends itself to spotting large sharks that approach the popular bathing beaches. People equipped with radios and binoculars are employed to raise the alarm at the relevant beach – a shark flag is raised to indicate that people must immediately leave the water and return to the beach. Obviously the method is not foolproof, but neither are the nets and drumlines of KwaZulu-Natal.

A shark spotter raises the flag, warning bathers to stay out of the water due to the presence of a shark.

Yvonne Kamp

Shark tourism

In South Africa, shark watching has taken off in a big way, especially in False Bay, off Gansbaai and in Mossel Bay in the Western Cape. Along with whale and dolphin viewing, watching great white sharks, in particular, has become a major contributor to tourism revenues in some coastal communities. In most cases it helps foster a better understanding of these supreme predators and plays a role in diminishing the fear so many humans have of sharks.

There are two main elements to this tourism: boat-top viewing of baited sharks (the correct term is 'chumming') and cage diving, where you climb into a protective cage to view the sharks underwater and in their element. It has been implied that chumming increases the chances that sharks will attack humans, but evidence indicates that this is not the case. Experts say that baiting is not ideal, but at this stage other options are limited. Only around Seal Island in False Bay can great white sharks be observed relatively easily without chumming.

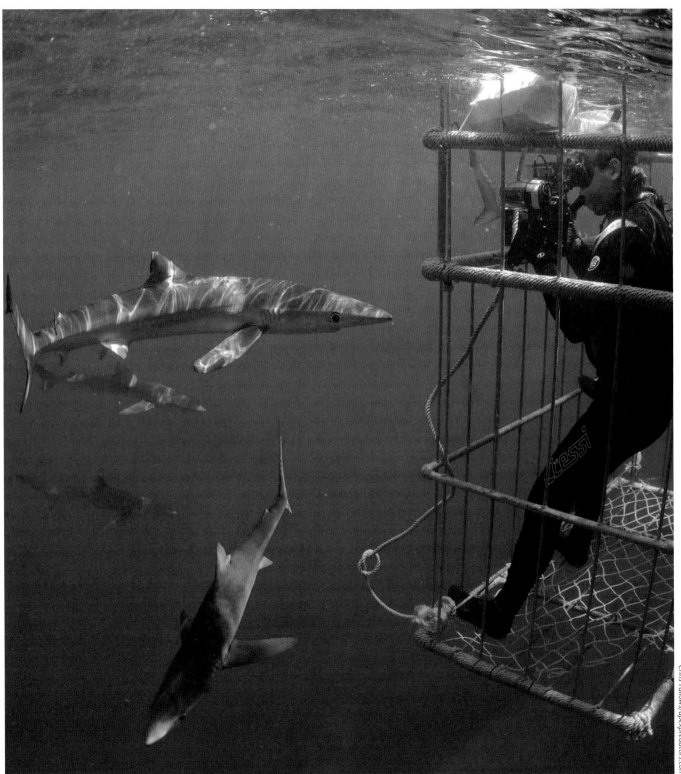

Shark viewing, whether from above or below water, continues to grow in popularity.

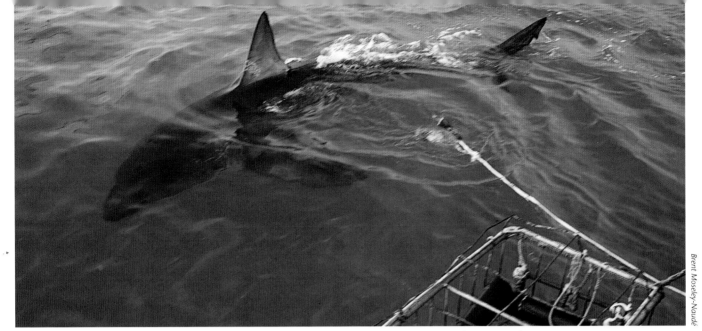

The great white shark draws the largest number of tourists.

Brent Moseley-Naudé

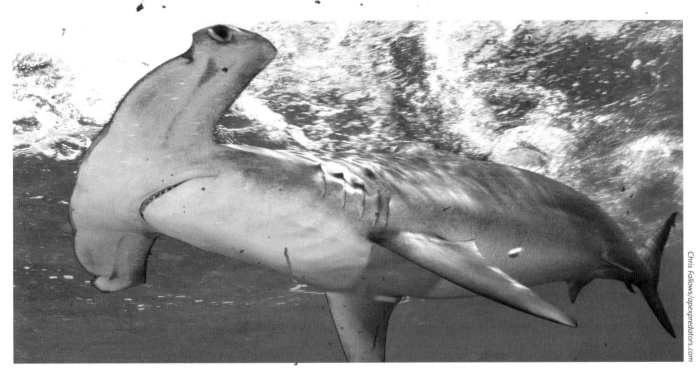

Hammerhead sharks, along with many other species, are hunted for their fins – a popular dietary item – for export to Asia.

Chris Fallows/apexpredators.com

Who needs protecting – humans or sharks?

Sharks are at the top of the food chain and play a critical role in the health of the oceans and seas. Yet they are a major commercial commodity, alive or dead. Humans kill huge numbers of sharks – estimates range from 25 million to 100 million – each year for their commercial value. Experts believe that shark fishing is maintained at an unsustainable level and a number of species may already be seriously threatened, or endangered.

Why do we kill so many sharks? Many species have tasty flesh and you would be surprised how many times you have eaten it when you order fish and chips. As commercial fish catches of more traditional bony fishes diminish, more efforts are made to increase harvests of sharks. Some countries favour shark meat over that of most bony fish.

The most controversial aspect of the shark fishery is the lucrative market in Asia for fins for the production of shark-fin soup. A shark is caught alive, the fin is cut off with a metal knife, and in most cases the shark is thrown back overboard to bleed to death. Shark liver oil is also much sought after for its various components, many of which end up in capsules or in other forms in health shops and as traditional medicines in Asia, as well as in a range of cosmetics.

There is growing concern that this industry is rapidly pushing many sharks, including pelagic or oceanic sharks, towards extinction. There are few regulations and they are difficult to enforce. A few countries have instituted controls and quotas, but it would seem that many countries ignore these.

SOUTH AFRICA'S FATAL SHARK ATTACKS

According to the International Shark Attack File based at the Florida Museum of Natural History in the United States, South Africa recorded 216 incidents of unprovoked shark attack between 1905 and 2007, which resulted in 42 human deaths. Worldwide, and probably in South Africa, three species – the 'Big Three' – were responsible for the majority of attacks and fatalities. These are the great white shark (*Carcharodon carcharias*), tiger shark (*Galeocerdo cuvieri*) and the bull, or Zambezi, shark (*Carcharhinus leucas*). In part this is because these are large species with the ability to inflict serious wounds and are commonly found in relatively shallow water where large numbers of humans gather.

However, there are cases where the identity of the shark is in question, or is not known. Certainly in southern African waters there are other shark species quite capable of attacking and seriously wounding or killing humans and which have been implicated in attacks in other parts of the world. In fact there are more than 100 species of shark along Africa's Indian and Atlantic oceanic coasts. Figures for shark attack and fatalities in other parts of Africa are probably underestimates, because many areas are isolated and such deaths go largely unrecorded, or they may be ascribed to drowning and other causes. In the Mascarene Islands of Mauritius and Réunion some 19 attacks have been recorded up to 2006, 12 of which proved fatal. In Mozambique three out of 10 attacks were fatal. These records cover more than 150 years, but in earlier years most, if not all, attacks probably went unrecorded.

Great white shark attacks by activity for South Africa 1922 to 2005

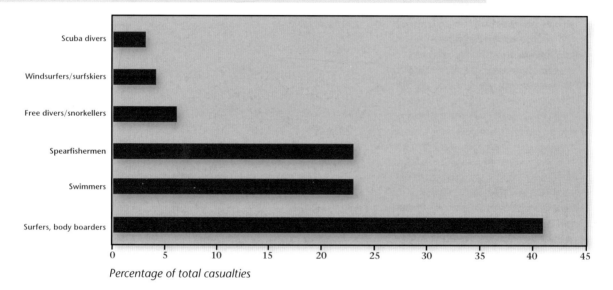

Percentage of total casualties

Percentage fatal attacks per province (1922 to 2005)

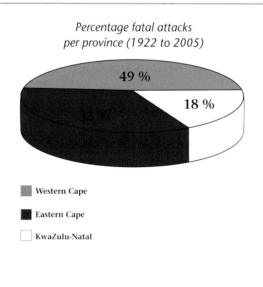

49 %
18 %
13 %

■ Western Cape
■ Eastern Cape
□ KwaZulu-Natal

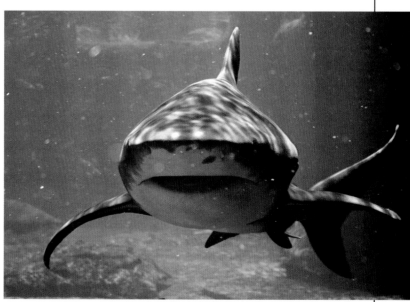

Tash Whiteley

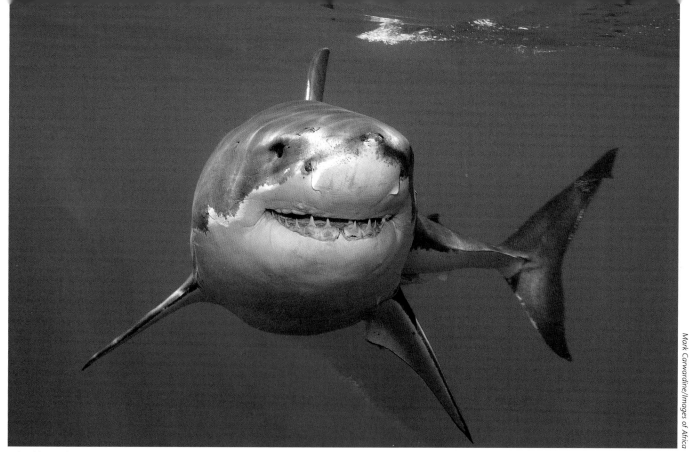

The film industry has given the great white shark a reputation as a ruthless man-eater, which is very far from the truth.

Mark Carwardine/Images of Africa

Great white shark

This is the shark of *Jaws* infamy and probably the most vilified, feared and maligned of all sharks. Although it *is* recorded as killing more humans than any other species, it does not normally see people as its principal prey. In South Africa, Australia and the United States it is now a protected species and can no longer be commercially exploited, although some poaching occurs.

The great white shark (*Carcharodon carcharias*), also known as 'white pointer', 'white death' and just plain 'man-eater', is responsible for about a third of all identified shark attacks in the world's oceans. Claims have been made of nine-metre monsters, but the maximum length these sharks reach appears to be 6.1 to 6.8 metres, with weights of almost two tons. Males are smaller than females. These sharks have embryos that develop in the uterus and feed on unfertilised eggs. At birth they measure from 1.2 to 1.5 metres long and closely resemble the adult. Their coloration is variable with the upper, or dorsal, surface ranging from almost black to slate-brown to a leaden blue, but the ventral surface is predominantly dirty, to bright, white. Although by no means the only large shark that is white below, it is believed that its name was derived from dead specimens lying on a ship's deck with white belly uppermost.

Although this shark is sometimes referred to as warm blooded, as is the short-fin mako, this is somewhat misleading because they are only mildly homeothermic, enabling them to maintain a body temperature up to 14 degrees centigrade higher than that of the surrounding water. This is a distinct advantage for a shark often found in relatively cold waters. They can do this because of the presence of a counter-current exchange mechanism, the 'rete mirabile', which reduces loss of body heat. This differs from true warm-blooded creatures such as mammals and birds, which generate heat that is maintained and regulated by metabolic activity.

Selective hunters

In South Africa, offshore and coastal populations of Cape fur seals are found from Port Elizabeth westwards and extending up the west coast of southern Africa. These mammals seem to provide a large percentage of the food of great whites, though the sharks also eat other fish. Different hunting strategies have been recorded at different locations. At Seal Island in False Bay the sharks frequently breach, or leap out of, the water when hunting; around Dyer's Island they seldom put on this spectacular display. Scientists are still trying to discover why.

Along much of the Eastern Cape and KwaZulu-Natal coasts Cape fur seals are largely absent and here a variety of bony fish, sharks, skates and rays make up the bulk of the great white's diet. They occasionally hunt dolphins, though these do not seem to feature highly in their diet. Great white sharks scavenge from dead whale carcasses, taking mainly the high-energy fatty blubber and rarely the flesh. Marine birds may occasionally be bitten and killed but are invariably abandoned uneaten. Given the massive power of these sharks, if man were high on their menu there would be few human survivors. Only about a quarter of attacks from 1922 to 2005 resulted in fatalities, and not all of these victims were actually eaten. It is surmised that 'test bites' indicate to the shark whether the intended prey will provide a good energy return. If not, the shark moves on to seek out a more suitable meal.

Where do they call home?

The great white has a very wide distribution in all the world's oceans, but it is most at home in temperate regions, although incursions are made into tropical waters. It lives mainly in the upper ocean levels, although on trans-oceanic migrations individuals may dive to considerable depths at times. Although the great white shark is known to make deep-water crossings, it is usually found close, or fairly close, to the shore. It frequents the surface to depths that exceed 200 metres but spends little time in the waters in between. In South Africa great whites reach some of their highest densities around the small coastal islands that are home to their principal prey, the Cape fur seal. They also favour locations where deep water comes close to rocky headlands, as well as offshore reefs and shoals. As far as is known, South Africa has one of the largest populations of great white sharks in the world.

■ *Frequent presence* ■ *Occasional presence*

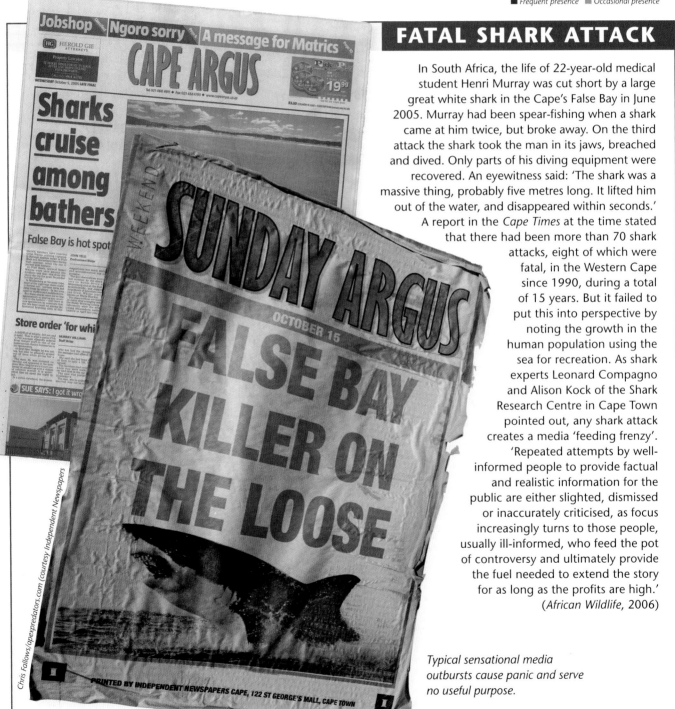

Chris Fallows/apexpredators.com (courtesy Independent Newspapers)

FATAL SHARK ATTACK

In South Africa, the life of 22-year-old medical student Henri Murray was cut short by a large great white shark in the Cape's False Bay in June 2005. Murray had been spear-fishing when a shark came at him twice, but broke away. On the third attack the shark took the man in its jaws, breached and dived. Only parts of his diving equipment were recovered. An eyewitness said: 'The shark was a massive thing, probably five metres long. It lifted him out of the water, and disappeared within seconds.'

A report in the *Cape Times* at the time stated that there had been more than 70 shark attacks, eight of which were fatal, in the Western Cape since 1990, during a total of 15 years. But it failed to put this into perspective by noting the growth in the human population using the sea for recreation. As shark experts Leonard Compagno and Alison Kock of the Shark Research Centre in Cape Town pointed out, any shark attack creates a media 'feeding frenzy'. 'Repeated attempts by well-informed people to provide factual and realistic information for the public are either slighted, dismissed or inaccurately criticised, as focus increasingly turns to those people, usually ill-informed, who feed the pot of controversy and ultimately provide the fuel needed to extend the story for as long as the profits are high.' (*African Wildlife*, 2006)

Typical sensational media outbursts cause panic and serve no useful purpose.

Tiger shark

This is the most easily recognised of the requiem sharks (a name that derives from the belief of sailors in times gone by that these sharks followed ships, waiting to feed on dead sailors buried at sea). Unlike the selective feeding of the great white, it has a reputation for eating almost anything.

The tiger shark (*Galeocerdo cuvieri*) is considered one of the most dangerous species of shark in the inshore waters of the world's warmer oceans and seas. It may reach a length of 5.5 metres and weigh over 900 kilograms, though most specimens are from 3.2 to 4.2 metres and weigh 385 to 635 kilograms. The tiger shark takes its name from the dark spots and vertical bars over the length of its body, which become less distinct as the shark ages. The overall colour on the shark's upper body is usually blue-green, but can also be dark grey or almost black. Underparts are cream to off-white in colour.

The tiger shark's teeth are very different from those of other large sharks. They are large, each having a deep notch on the outer edge, and fully serrated like a bread knife along the edges. Female tiger sharks give birth to between 10 and 80 pups after a gestation period that may be as long as 16 months.

Methodical hunters and 'goats' of the sea

The tiger shark is second only to the great white shark in the number of recorded attacks on humans. Although they are curious and can show aggression towards human swimmers or divers, they will not normally rush in to attack. They tend to be cautious in their approach, moving in relatively slowly and first taking a small sample bite. But, as with any large, flesh-eating shark, they should be awarded the greatest of respect.

Tiger sharks, unlike great whites, are indiscriminate feeders and there seems to be little that they will not eat. They take a variety of bony and cartilaginous fish, marine turtles, dolphins, squid, birds and carrion, such as dead whales. The form and structure of the teeth allow them to saw at and tear off large chunks of flesh. One specimen caught at Durban in KwaZulu-Natal was found to have the head and forequarters of a crocodile in its gut, as well as the hind leg of a sheep, three gulls, two intact tins of green peas and a cigarette tin. Their habit of frequenting harbours and estuaries results in their consuming human rubbish that is of no nutritional advantage to the shark. Human prey is largely incidental and we are certainly not very high up on their menu. Much of their hunting is undertaken at night when they move inshore and feed close to the surface.

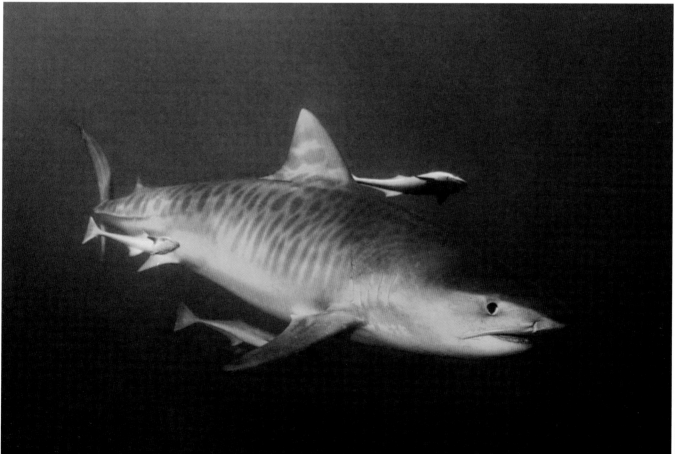

It is now generally believed that the tiger shark has been falsely blamed for attacking people at various locations around the world.

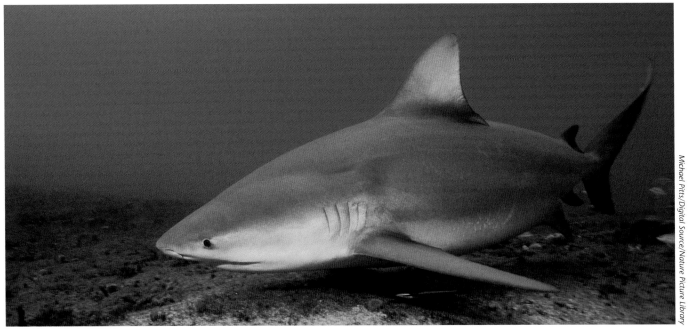

The bull shark is credited with the third highest number of attacks on humans.

Bull, or Zambezi, shark

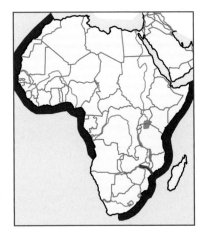

The bull shark (*Carcharhinus leucas*) takes its name from its stout appearance and its reputation for being pugnacious. Many authorities classify this shark as the most dangerous in the world. Although it is credited with the third highest number of attacks on humans, after great white and tiger sharks, its victims may be more numerous than statistics show.

In southern Africa most people know this requiem shark by the name Zambezi shark. It is a shark of tropical and subtropical waters throughout the world but also ascends rivers, the only shark to do so over such great distances. Frederick Courteney Selous (of elephant hunting fame towards the end of the 19th century) recorded a one-metre long shark that was caught at the junction of the Ruenya and Mazoe rivers in Mozambique. It was almost certainly this species. They are known from the Limpopo River at Pafuri in the Kruger National Park, and have been recorded harassing hippopotamus in the Zambezi and Shire rivers. In some regions they are known to undertake seasonal migrations, but this is poorly understood for African populations. These sharks favour shallow coastal waters to a depth of about 30 metres but have been recorded at 150 metres and will readily swim in water just one metre deep.

It is a fairly large shark, with the greatest length recorded being 3.5 metres (though the average is 2.2 to 2.4 metres) and a weight of 230 kilograms. Females are larger than the males. In dorsal coloration they range from pale to dark grey, though some take on a bronze hue. The underside is white.

Where the diet has been studied, bull sharks have been found to live mainly on bony fish, small sharks and rays, but from time to time they take marine turtles, dolphins, crustaceans, squid, birds and dogs. Human prey may be more frequently taken than records indicate as the bull shark occurs in marine and freshwaters throughout the tropical and subtropical developing world, where many such attacks frequently go unreported. It is possible that some disappearances ascribed to Nile crocodiles, for example in the Zambezi River, could be the result of encounters with bull sharks.

An unusual shark attack

Richard Tebbut was paddling his canoe up the Nahoon River, East London, South Africa, in November 2006 when he saw an angler on the bank struggling to land a big fish. The fishing rod was bending dramatically and Tebbut jumped out of his canoe to help by grabbing the fish's tail. As he did so he realised he was holding a shark almost two metres long. The fishing line snapped and the shark went on the attack. Tebbut thrust his left arm into the predator's open mouth and as it held on he started to hit the shark on the snout. It released his arm but circled back to attack. Luckily he managed to scramble onto some rocks. He lost a great deal of blood and required 50 stitches. The account in *Rapport* identified the shark as a bull, or Zambezi, shark, although this remains unconfirmed.

Ragged tooth sharks

Ragged tooth sharks (Odontaspididae) have been implicated in a number of attacks on humans worldwide, and several species occur in African waters. The perpetrators of many such attacks are believed to have been misidentified and were most likely to have been requiem sharks, such as the sand tiger (*Carcharius taurus*), which occurs around much of the coastline of southern Africa. Elsewhere, the ragged tooth shark is also known as the grey nurse shark, spotted ragged tooth shark and ground shark.

The ragged tooth shark is a species of shallow waters, including the surf zone, and migrates seasonally between warmer and cooler waters. The maximum length is around three metres and it has an impressive set of narrow, sharp-pointed teeth. The name ragged tooth is said have been derived from the terrible wounds that a bite from one of these sharks can cause, though generally they will leave you alone if you leave them alone. They feed mainly on fish but will also take squid and crustaceans. They have a ruthless cannibalistic breeding system in which one pup eats its smaller siblings in the uterus.

Cage-diving to observe sharks in their own environment is becoming increasingly popular.

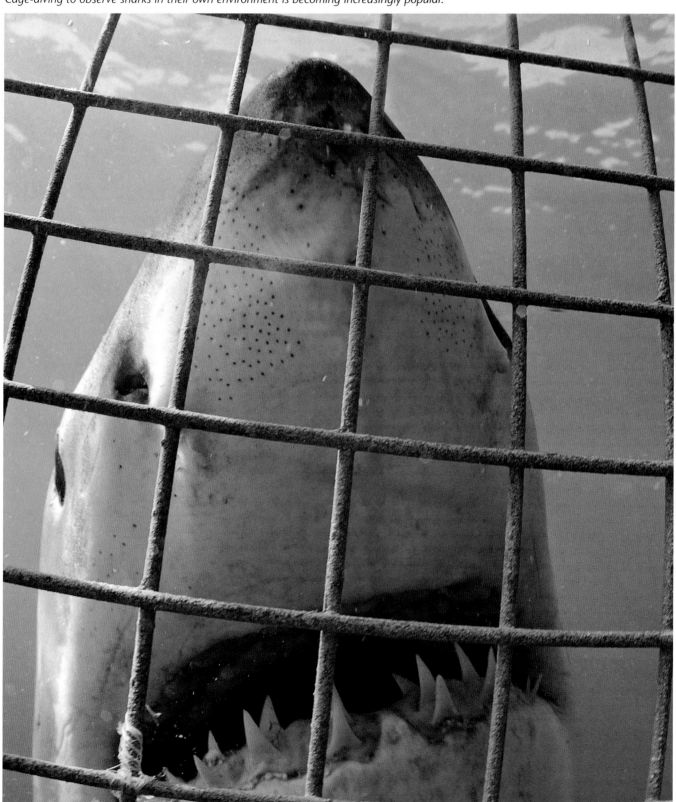

Hammerhead sharks

The most bizarre of all large sharks are the hammerheads, of which there are about 10 species. With their characteristic hammer-shaped heads, known in scientific parlance as a 'cephalophoil', they cannot be mistaken for any other shark. The eyes are located at the outer edges of the hammerhead. Why this bizarre shape? Scientists would love to know. Perhaps the peculiar head structure gives the shark some sensory advantage, or it improves the manoeuvrability of this strange fish?

The common hammerhead in southern African waters is the smooth hammerhead (*Sphyrna zygaena*) that occurs around much of the coastline, showing a preference for inshore waters less than 20 metres deep. Average lengths of this shark range from 2.5 to 3.5 metres but some individuals reach five metres. The bulk of its diet consists of a variety of fish, including small sharks and stingrays. Because of their size all hammerheads are considered to be potentially dangerous to humans, but only two fatalities have been verified worldwide. The great hammerhead (*Sphyrna mokarran*) occurs along the Mozambique coast and in tropical waters.

The biggest sharks of all are no threat to man

The three shark giants, whale shark (*Rhincodon typus*), basking shark (*Cetorhinus maximus*) and the megamouth shark (*Megachasma pelagios*), are no threat to man and exist on a diet of small organisms such as plankton and krill. The whale shark is known to reach 18 metres long, the basking shark can reach 13 metres or more, and the megamouth exceeds five metres. All have been recorded in African waters, but the megamouth only once. The very first megamouth was captured only in 1976 and a new family, genus and species had to be created for it.

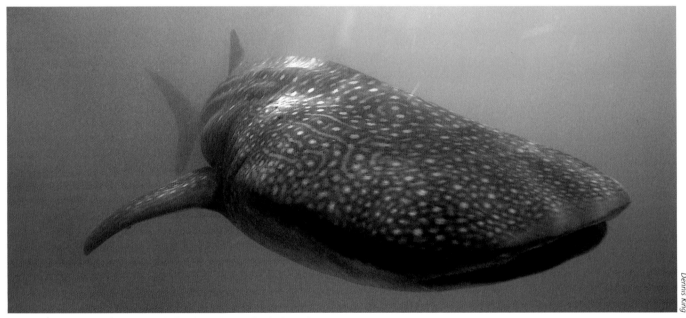

Dennis King

The whale shark is the largest of all fish and completely harmless to man.

GREASED LIGHTNING

Mako sharks are said to be the swiftest of all sharks, able to reach 40 kilometres per hour (some records claim as high as 50 kilometres per hour) in surface leaps and 35 kilometres per hour in straight swimming. Game-fish anglers claim they are on par with marlin in fighting ability.

The short-fin mako (*Isurus oxyrinchus*) occurs in South African waters. It is found in warm and relatively shallow to deep waters and reaches about three metres in length, though larger specimens are claimed. Like its relative, the great white shark, the short-fin mako is 'warm-blooded', allowing its muscles to function more efficiently than most other sharks. This is why it can display such impressive bursts of speed. It is a hunter of fast-moving prey fish, including tuna and mackerel, so speed is an essential element of its hunting strategy.

This shark seldom comes close inshore and attacks on humans are few, and possibly a case of mistaken identity. Incidents are on record of hooked mako leaping into boats or following hooked fish into shocked fishermen's boats. An incident in South Africa in 1977 resulted in a mako joining a fishing party in their boat in a conflict of ownership over a yellowtail. The shark tangled itself into sets of fishing lines after biting one of the anglers severely on his thigh. The injured angler threw himself into the water, without considering the possibility that the mako might not have been alone.

Billfish, sawfish and rays

These fish have an array of means to protect themselves. Rays have whip-like tails and long, serrated spines that often carry venom in the covering sheath; sawfish are actually stingless rays with a long upper jaw that resembles a chainsaw; and billfish can inflict terrible wounds with their sword-like upper jaw.

Billfish – supreme game fish

Injuries due to interactions between sawfish or billfish and humans are very few in Africa and invariably occur when the fish are caught by sport anglers. The average person is unlikely to come into conflict with them. In Africa the billfish are represented by several species that include the marlin (*Makaira herscheli*), swordfish (*Xiphius gladius*) and sailfish (*Istiophorus gladius*). All billfish are bony fish, they are hunters of other fish and they are big: marlin at times exceed four metres in length; swordfish have been measured at 4.5 metres.

These are supreme athletes, said to be faster than the fastest land mammal, the cheetah. Marlin have been clocked at 80 kilometres per hour and hunting runs of swordfish are estimated to reach at least 90 kilometres per hour. But the sailfish is the fastest, at over 100 kilometres per hour. These fish are certainly built for speed, with long, slender, streamlined bodies and long, deeply forked tails – in many ways like a missile.

Ordinarily the sword-like projection on the upper jaw is used as a hunting tool, not to impale their prey, as is sometimes believed. It is slashed from side to side, stunning and hitting mainly shoaling species of their fish prey.

Why should it pose a threat to humans when it can make away at speed if disturbed? Generally this only happens when a billfish is hooked or netted and the fisherman is inexperienced or not sufficiently alert when handling it. There are records of fishermen being skewered and badly injured, and on rare occasions killed, by a thrashing billfish on deck. In recent years, with growing recognition of the magnificence of these fishes, sport fishermen are increasingly releasing them at boat side without landing them unless they may be setting a new record. Not only is this a good conservation move, it also means that fewer fishermen are at risk of stab wounds.

Billfish are still commercially fished in some regions, but there are valid reasons for not eating their admittedly delicious flesh – they have been found to contain high levels of substances that are detrimental to our health, including mercury.

Erwin Bursik/Ski-Boat Magazine

The Indo-Pacific sailfish (Istiophorus platypterus) *has a sharp, sword-like bill and can deliver severe wounds to incautious anglers.*

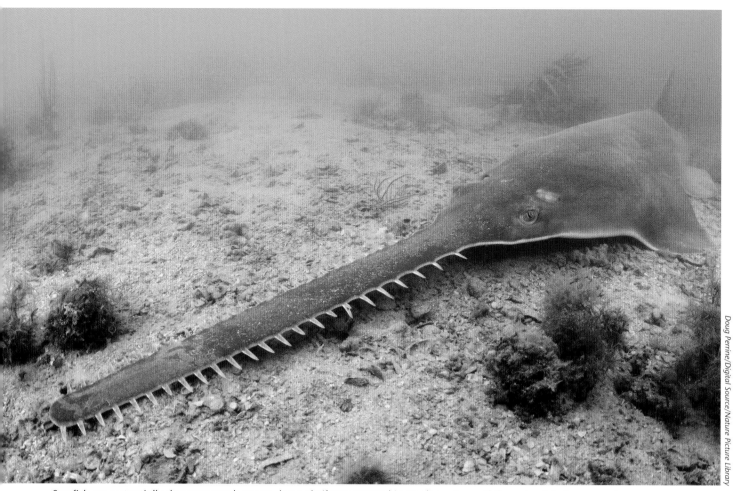

Sawfish are potentially dangerous to humans, but only if encountered in murky water or if the animal feels cornered.

Sawfish

These peculiar cartilaginous fish are in fact large, stingless rays with a difference. The long, blade-like snout, with its two rows of sharp, peg-like teeth, ensures that you cannot mistake them for any other fish species.

Two species occur quite commonly on the east coast of southern Africa, and further north into the tropics. One is the green sawfish (*Pristis zijsron*) that grows to a length of at least 7.3 metres, the other, the so-called freshwater sawfish (*Pristis microdon*), which reaches at least six metres. The saw takes up some 25 % or more of the fish's total length. Both species are known to occupy coastal shallows, penetrating quite deeply along rivers and entering other water bodies during rainy periods. Freshwater sawfish have been recorded inland along the Zambezi River as far as Tete, the lower Shire River, as well as the Sabi and Lundi rivers, where they penetrate as far as the major waterfalls that bar them.

The saw, or rostrum, is a long, flat blade, with a row of tooth-like structures lining each outer edge. It is used as a hunting tool, slashing from side to side to dislodge invertebrates from sand, silt and among vegetation. The saw is also used to stun and maim fish, which can then be eaten with ease. If left in peace they are no threat to humans, but a sawfish caught on a line or in a net should be handled with great care as they may slash the rostrum from side to side and could cause serious injury.

If you encounter a sawfish when swimming, back away from it because it could retaliate if it feels threatened or cornered. Some references claim that humans have been cut in half, though there appears to be no solid evidence to confirm this. This is highly unlikely to occur in the marine environment, and as they share African rivers with Nile crocodiles and bull sharks, the sawfish would be the least of your worries.

Stingrays or stingarees

Related to the sharks, rays also have skeletons of cartilage, but very different body shapes. They all have a flattened appearance, with the side fins (pectorals) being modified almost into rounded or triangular-shaped 'wings'. The stingrays of the family Dasyatidae mostly have long, slender and whip-like tails and no fins in the conventional fish sense. Other rays and the similar skates belonging to the family Rajidae occur throughout African waters, with several appearing in the commercial fish catch. Many species have rows of spines along the tail but their venom is rarely as serious as that of the 'true' stingrays. Nevertheless, treat larger specimens with respect.

Rays spend much of their time lying partially buried in sand or silt on the sea bottom and have spiracles, or openings, on the top of their head through which water is

drawn in and passed over the gills. The mouth is located on the ventral (lower) surface, so if they were to use it to draw water they would end up ingesting large quantities of sand or silt. Rays swim elegantly, with a slow beating of the 'wings', or modified pectoral fins.

Unlike most of their shark relatives, the rays are bottom-feeders. Instead of cutting and flesh-tearing teeth they have flattened teeth that form a crushing, scroll-like bed. It is with these crushing and grinding plates that they deal with their mainly hard-shelled crustacean and molluscan prey.

But the reason we discuss them here is because they possess formidable weapons in the form of one or two heavily serrated spines. Some species have spines near the base of the tail; others have them midway along the tail. Although in most species the spines are of moderate size, some are as long as a bread knife. The longest verified spine length we have been able to trace was 37 centimetres. Many are backed up with venomous glands or there are poisonous substances in the sheath that covers the spine.

Considering how common rays are, it is surprising that they do not injure more people. By nature they are timid and will usually move away from a perceived threat or disturbance, but if they lie on the bottom and if you inadvertently stand on one the chances are good that you will be stabbed. The tail will whip around, the spine will penetrate flesh and the pain will begin. People who have been stabbed often suffer tearing wounds as the spine penetrates and is then torn away. Should the spine break off and remain embedded in flesh, this should be removed as soon as possible, preferably by a medic. If a ray loses a spine in this way it is a minor inconvenience because a new one will grow in its place.

Although stingray venoms are not life threatening under normal circumstances, they can be extremely painful. The main danger lies in the aftereffects, which is why it is important to clean and disinfect wounds thoroughly. Divers moving along slowly just above the seabed are at greatest risk because a frightened stingray will lash out and the spine may penetrate the heart. There have been a number of such fatal incidents, the most celebrated being Australian wildlife showman and conservationist Steve Irwin. The spine broke off in his chest, he pulled it out and died of cardiac arrest. Apparently Irwin had swum directly over the ray and it retaliated as it felt threatened.

⚠ Avoiding trouble

- If you are wading in water with a sandy or silty bottom, shuffle your feet rather than walk, to create disturbance and noise. Invariably this will be enough to ensure rays move away from you.
- If you are swimming close to the seabed check ahead for any signs of rays partially buried, remembering that many are experts at camouflage. If you see one, veer away or vigorously disturb the water and chances are it will depart.
- If you are fishing and have little experience handling rays, the safest option is to cut it free before landing it.
- If you find a fresh ray on a beach leave it alone because its spines can remain dangerous for some time. If you must cut off a spine as a souvenir, never put it in your pocket, where you might prick yourself on it.

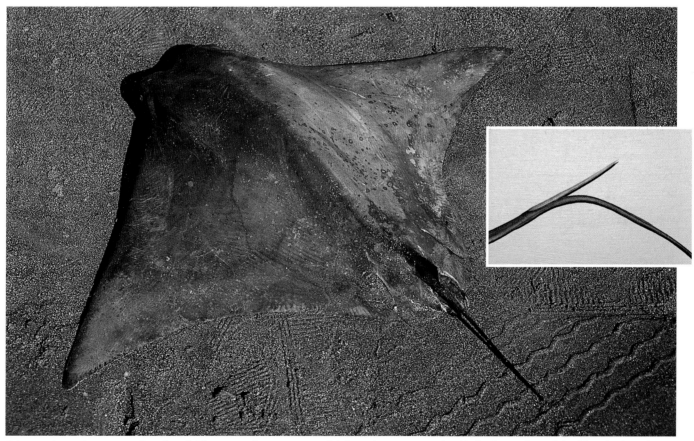

Stingrays have dangerous spines (inset). They not only pose a potential threat in water; one should also be cautious of dead beached specimens.

Spine injuries

- If the spine is embedded in a limb, remove it if you can, though in many cases this is not possible. Clean out visible material that entered with the spine. Wash the wound with sea water and apply a clean dressing. If available, apply hot (not scalding) water to ease the pain by denaturing the venom protein. Pain levels can be extreme – worst in the first hour, but taking between 24 to 48 hours to ease completely. Seek medical attention because of a high risk of infection.
- If the spine is embedded in the chest or abdomen, treat it as an emergency even if the wound seems superficial. Do NOT attempt to remove the spine. Get medical help as soon as possible.

Electric rays

Unlike their streamlined cousins, the electric rays are rather flabby in appearance and somewhat sluggish in movement. A shock, or electric discharge, alone will not kill an adult but could be enough to cause a child to drown. The main purpose of these electric impulses is to stun prey, mainly small invertebrates and fish. The rays also use these electric impulses to electro-locate and navigate.

There are four species in southern African waters, ranging in habitat from inshore shallows to greater depths. All belong to the family Torpedinidae. Unlike other rays, they tend to lie on the bottom when approached and do not move away readily. The electrical impulses are produced by large, paired organs behind the eyes. These organs consist of cells that have positive poles on the upper surface and negative poles below. The cells are abundantly supplied with nerves.

Although up to 200-volt impulses are claimed for some species, 100 volts seems to be the norm. The first impulse is the strongest and after each successive impulse the electrical output becomes weaker. The ray then takes some time to recharge its 'battery pack'. Under most circumstances the shock will not incapacitate a human, but there is always the risk that cramping may occur on contact, and you could fall face forward into the water and drown. This is particularly possible if the victim is a small child or someone with heart problems. We have not been able to trace any fatality from such an encounter in African waters.

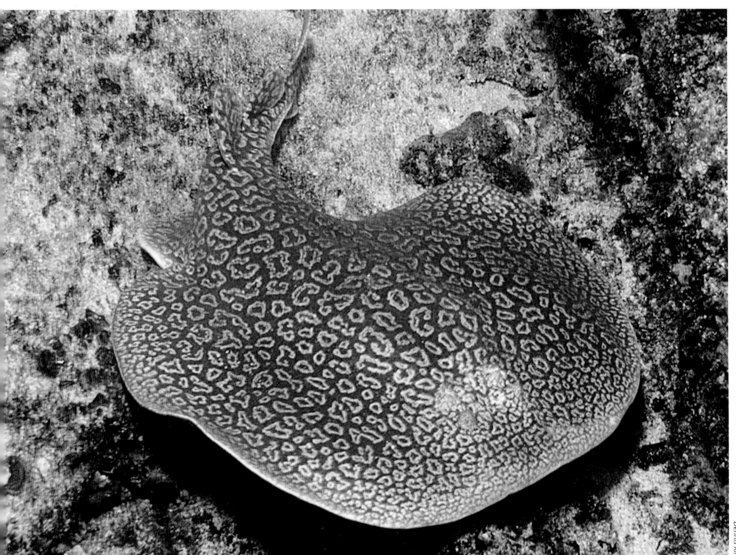

Dennis King

The marbled electric ray (Torpedo marmorata) *has a wide African coastal range, and is also found in the Mediterranean Sea.*

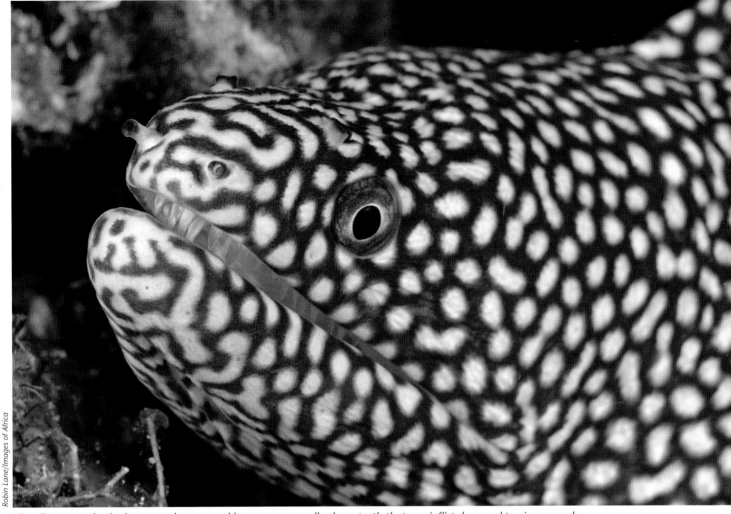

Like all moray eels, the honeycomb moray eel has narrow, needle-sharp teeth that can inflict deep and tearing wounds.

Fish that bite

A number of fish species can deliver painful bites that easily become infected, but these incidents are nearly always associated with fish that have been provoked in some way. Those most at risk are anglers and net fishermen, but swimmers and divers are not immune.

Moray eels

Moray eels' reputation for aggression and attacking without provocation is simply not true, but try to touch or disturb one, inadvertently brush near an individual in its rock or coral lair, and you could be in for a nasty surprise.

There are about 14 species of moray eel (family Muraenidae) in the warmer waters of the south and east coast of southern Africa, with most species measuring between one and two metres, but the largest may exceed three metres. They have a snake-like appearance but are quite heavily built. Their heads are quite big, with an impressively large mouth that comes with an array of potentially damaging teeth. The skin is tough and strong and the gill openings are small for the size of this elongated fish.

They are sedentary creatures, rarely moving far from rock or coral crevice or hole, emerging to snatch at passing prey. Some species will also hide among seaweed or other cover, and enter estuaries. During the day they seldom venture from their lair as they mostly hunt in the hours of darkness. Diet varies between species and includes fish, squid and crustaceans. The teeth are designed to hold prey and tear off large chunks of flesh in the case of larger prey items.

In areas where moray eels are known to occur, it is never wise to insert an exploratory hand into a hole or crevice. If they are disturbed or feel threatened they will not hesitate to retaliate, and bites from these eels can result in deep, tearing wounds that bleed readily. It has been claimed that the bites of some species are venomous, but no scientific evidence for this has been found. Moray eel bites invariably result in infection, so get prompt medical attention even if the bite does not appear to be particularly severe.

In some dive areas large moray eels have become used to divers and, as a tourist-pleasing 'trick', large specimens become habituated and are fed pieces of fish. Some allow themselves to be stroked, but this is not an activity that should be condoned. Never try this on a moray eel that has not been habituated.

Other eels

A number of other eel species in Africa can deliver nasty bites, but this occurs only when they are caught on hook and line, or in nets.

The conger eels, of which about five species occur in Africa, are of little threat unless caught and handled, but since large specimens can exceed two metres long and have tremendous strength, they can be dangerous. The teeth are not fang-like as in most of the morays, but a bite can be unpleasant nonetheless. The largest species in southern Africa is the conger eel (*Conger conger*), which may reach a length of 2.4 metres. Another large eel is the conger pike, or silver conger (*Muraenesox cinereus*), which just exceeds two metres, and has a reputation of being a nasty customer if taken on rod and line. The conger pike is considered dangerous to handle and certainly has an impressive set of long, sharp teeth. It occurs as far west along the south coast as Knysna.

All eels should be handled with care; they are strong and agile, and larger specimens can bite and leave serious wounds. Most eels, with the exception of the morays, have one thing in common: they make delicious eating. The moray eels are an exception because they accumulate the toxin that results in ciguatera food poisoning.

Dennis King

Barracudas and others

Barracudas (family Sphyraenidae) are streamlined, torpedo-shaped fish that are aggressive and possess many sharp, fang-like teeth. As with most fish, however, if left alone they will generally leave you alone.

They hunt in 'packs', moving at great speed into shoals of fish, slashing with their needle-sharp teeth, then turning back to feed on their victims. Bearing in mind that adults can reach two metres long, treat them with caution because attacks are always possible. Spear-fishermen with a catch should be alert, as barracudas can move in rapidly, snapping at the catch. Injuries might be sustained in the turmoil.

A number of species of fish that are part of the commercial fishery, or taken on rod and line, do not pose a threat in the natural environment, but will bite and leave nasty wounds when caught. Probably the best known of these fish is the snoek (*Thyrsites atun*), an icon in Western Cape, South Africa. They run in large shoals and have to be handled with care because their long, curved teeth can inflict serious wounds.

Species to be wary of on line or in net are the snake mackerel (*Gempylus serpens*) and the lancet fish (*Alepisaurus ferox*), among others. This is by no means a comprehensive list of fish that can inflict painful bites, and many if not handled properly will retaliate with an array of spines, toxic and otherwise. Any wounds caused by fish, whether through bites or spine pricks, should be thoroughly cleaned and treated with antiseptic.

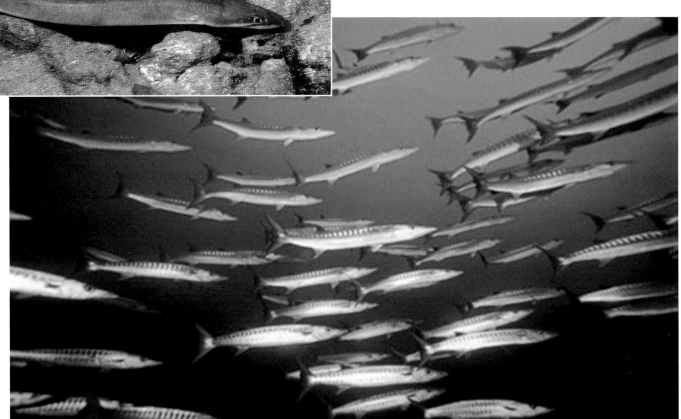

Andrew Woodburn/Images of Africa

TOP: *The black-edged conger* (Conger cinereus) *has a wide range in the Indo-Pacific region, occupying shallow waters and is usually associated with coral reefs.*
ABOVE: *Barracudas run in shoals that can move at great speed and seemingly in perfect synchrony.*

FRESHWATER FISHERMEN NOT IMMUNE

Lurking in the rivers, lakes and swamps of Africa are quite a few fish species that can deliver painful bites, or carry an armoury of barbed spines that can inflict painful wounds. We cannot list all these species here, but only the angler or fisherman is likely to be injured if these fish are carelessly handled. People who swim in subtropical and tropical freshwaters have much more to concern themselves with, such as Nile crocodile, hippopotamus and – in still shallow waters – bilharzia.

The ordinary fin-spines in many species of fish are often sharp and can inflict a needle-prick wound, but with little aftereffect if the site is cleaned and disinfected.

Any of the larger eels, such as the African mottled eel (*Anguilla bengalensis*) and Madagascar mottled eel (*Anguilla marmorata*), should be handled with great care when landed because they are powerful and will bite viciously.

That famed fighter, the tigerfish (*Hydrocynus vittatus*), may reach a length of 70 centimetres and a weight of over 15 kilograms and comes armed with a rather impressive array of long, sharply pointed teeth. Quite a number of fishermen have suffered injuries due to lack of caution while handling these fish. The goliath tiger fish (*Hydrocynus goliath*) of the Congo River system may even be implicated in some attacks on humans where the Nile crocodile has been blamed.

Another species that should be landed with care is the African pike (*Hepsetus odoe*). Although not particularly large at less than 50 centimetres, this fish has long, sharp canine teeth. A host of species carry formidable barbed spines on the dorsal and pectoral fins. Wounds can be very painful and easily turn septic, with fragments often left behind in the wound. These species include the squeakers (genus *Synodontis*), most species of which are small, the butter catfish (genus *Schilbe*) and the catfish in the genus *Clarias*. Because they are often large, difficult to handle, and have substantial serrated fin spines, these fish need to be handled with care. Some of these species have toxic mucus that will enter any wound made by these barbed spines.

Another unusual fish to be wary of is the electric catfish (*Malapterurus electricus*), which can push out 300 to 400 volts, much more than marine electric rays. This catfish has a wide tropical African distribution, occurring as far south as the Zambezi, Pungwe and Save rivers. The electric catfish is generally considered dangerous by both subsistence fishermen and anglers.

Anglers should take great care when handling tigerfish. These large specimens have impressively armed jaws and can inflict nasty bites.

INVERTEBRATE BITERS

The majority of non-venomous invertebrates can do humans no direct harm, but a few sometimes let us know of their presence and ability to defend themselves in a painful way. In most cases they will only bite or injure if they are handled or teased, but a few relish human blood.

ABOVE: Although crayfish (rock lobsters) do not bite, they can inflict wounds with their sharp spines.
RIGHT: The larger species of sesarmid crab can deliver a painful nip.

Crabs and crayfish

Most of us know these mainly aquatic creatures from the culinary point of view, or from watching them in rock pools or scuttling along beaches. Crabs and crayfish, or rock lobsters, belong to a large invertebrate group of animals known as crustaceans. Africa has a number of species of crab that can deliver finger-crushing pressure with well-developed pincers, or nippers. Anecdotal tales talk of fingers being neatly amputated, but we have not been able to verify any such cases in Africa, although one or two species may have this ability. Even some of the smaller crabs can give a good account of themselves if carelessly handled.

Two of South Africa's best-armed and largest crabs are the mud crab (*Scylla serrata*) and the three-spotted swimming crab (*Ovalipes punctatus*). Even if they do not remove a finger, they can certainly do much damage. Both species are capable of crushing the shells of molluscs, which form the bulk of their diet, although those taken by the mud crab are surprisingly small. Some of these shells are very hard and you would need a hammer to get at the animal within.

The mud crab can measure 20 centimetres across the shell, or carapace. The pincers are massively built and should be handled with the utmost caution. These crabs are usually encountered in estuaries and as far upriver as sea water penetrates, from Knysna, South Africa, eastwards up into East Africa, where they are commonly found in mangrove swamps. They have succulent and tasty meat so are eagerly sought after. If you are not familiar with handling these crabs, get somebody knowledgeable to show you how to handle and restrain them. We have seen the aluminium handle of a scoop-net crushed by a mud crab pincer as easily as you could crumple a sheet of paper.

Many other crabs in Africa are capable of delivering a painful and blood-drawing wound if handled. These include the larger sesarmid (*Sesarma* species) crabs, such as the red mangrove crab with its large and sturdy pincers, the ghost crabs you see scuttling along beaches on the south and east coasts, and several of the swimming and rock crabs. Warn children unfamiliar with any of the larger crabs to leave

Leonard Hoffmann/Images of Africa

them alone. Even smaller species will latch on if handled and can draw screams and tears. Apart from the pincer weaponry, some species – especially the swimming crabs – have sharp spines around the edge of the carapace and the pincers, making it difficult to pick them up safely.

Crayfish or rock lobsters (also known as spiny lobsters in other parts of the world) are well known to lovers of seafood, although in recent years they have drifted out of the financial reach of many. Several species are commercially harvested in southern African waters. None of the rock lobsters in our oceans has pincers, unlike true lobsters that occur elsewhere, but they still require careful handling because of numerous sharp spines on the body.

Octopus and squid

No octopus or squid occurring in African waters can cause serious injury, but always take care when handling them.

Octopus and squid belong to the taxonomic class Cephalopoda, which is considered to be the highest level of molluscan evolution. Cephalopod translates as those animals whose 'feet' are attached to their heads. They include the largest invertebrate ever known – deep-sea squid that can reach a total length of 25 metres, including the tentacles – but most species are much smaller. Many cephalopods, especially squid, are among the fastest animals in the oceans. They have evolved eyes similar to those of vertebrate animals and most can change colour to match their background. Squid and cuttlefish have 10 arms (tentacles), two of which are longer and are used for grasping prey, whereas the octopus have only eight arms. Most squid and cuttlefish are free-swimmers, but octopus are usually found crawling on the seabed, or hidden away in rock crevices or holes in coral. The tentacles of all cephalopods have flat inner surfaces with rows of cup-like suckers. A mechanism has evolved in most species that allows them

The sucker-studded tentacles of the octopus are used to cling to and overpower prey such as hard-carapaced crabs and rock lobsters.

to escape from predators unseen – by producing an 'ink-screen'. The dark substance is expelled from a special sac and spreads rapidly in a dense cloud when it enters the water. This confuses a predator and allows the cephalopod to escape.

Early illustrations of giant squid and octopus with immensely long tentacles show them dragging sailing ships under the sea and wrestling with humans. None of the inshore squid or octopus in African waters grows particularly big, but giant deep-water squid have been trawled in South African territorial waters. In theory, these giant squids could overturn small boats and attack humans in the water.

Authenticated tales of attack rare

Tales and myths abound in the literature and folklore of attacks by giant cephalopods on humans, but pinning down true accounts is difficult.

One incident that took place off the West African coastline seems to bear the hallmarks of truth. Twelve sailors from a British troopship that had been sunk were clinging to a small life raft. After darkness fell one of the sailors was wrapped in a cephalopod tentacle and dragged under water. That alone might have been ascribed to stress or delusion on the part of his fellow shipmates, but another sailor was briefly grasped around the leg by a tentacle and released. On being rescued, the sailor was treated for ulcers where the squid's suckers had held him.

It has also been suggested that boats found adrift with crew missing, but otherwise all in order on board, may have encountered a giant squid. At this stage this remains only a suggestion until hard evidence is forthcoming. There are some verified tales of octopus grasping human legs or arms. It is generally believed to be a case of 'mistaken identity', the octopus mistaking moving human limbs for the tentacles of another octopus. If you do not panic and keep still the octopus apparently realises its mistake and lets go; panic and flail around and it may connect with more tentacles. Probably the worst you will suffer is shock and perhaps reddened rings left by the suckers. Certainly, octopus do not see humans as part of their diet.

➕ Octopus and squid bites

- Octopus and squid have beaks similar to those of parrots, and bites from larger specimens are executed with a snipping action. Although none of Africa's species is dangerously venomous, the painful puncture wounds usually result in local swelling, numbness and intense itching around the bite site. Normally these symptoms do not last long and can be relieved with the application of heat, such as hot water. If symptoms persist seek medical advice.

INSECTS THAT BITE

Apart from those insects that bite us and suck our blood, transferring parasites and disease, and those that poison us in self-defence, there are few that can cause serious harm. A few species of beetle, bug and grasshopper secrete blistering or smelly chemicals when handled. These chemicals are purely defensive, to prevent them being eaten or otherwise mishandled, and seldom have any serious or lasting medical effects. If an insect secretes a fluid or foam, wash your hands thoroughly as soon as possible and avoid rubbing your eyes or mouth. In general, if you leave these insects alone they will leave you alone.

Then there are the biters. Most have jaws that can give a nip, while some are quite capable of drawing blood, but in the majority of cases this will only happen if you handle them.

Alan Weaving

Termites and ants

Several of the soldier caste of the larger termite species (*Isoptera*) can certainly draw blood in defence of the colony and they hang on like bulldogs. Ants are masters of nearly all habitats, and many species have a battery of defences that include painful bites, stings or the ability to spray noxious chemicals. If you were dealing with one or two ants that would be manageable, but many species arrive in hundreds, thousands and even tens of thousands. If they feel threatened, they react to chemical signals, and certain species swarm over the threat and torment it until it flees. They may even kill their tormentors. Among Africa's most feisty ants are the red driver (*Dorylus helvolus*) workers, which are aggressive, bite vigorously and exist in large numbers. The tailor ants (*Oecophylla longinoda*) are extremely aggressive if their arboreal nests are disturbed. After biting, they inject formic acid into the bites. The pugnacious ant (*Anoplolepis custodiens*) is widespread in the eastern and central regions of South Africa. They form vast colonies underground and hunt on the surface, rushing in the thousands at prey or a perceived threat. Their bite is more than an irritant!

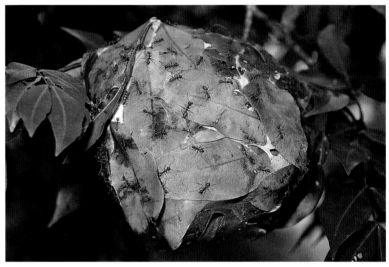

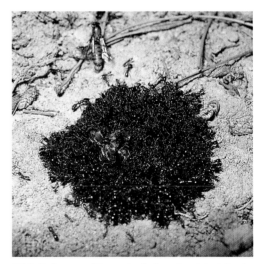

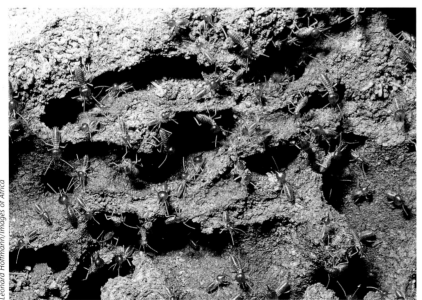

Leonard Hoffmann/Images of Africa

TOP: *Tailor ants* (Oecophylla longinoda) *defend their nests aggressively, biting the invader and injecting formic acid into the wound.*
ABOVE: *Red driver* (Dorylus helvolus) *ant workers are aggressive biters.*
LEFT: *Snouted termite* (Trinervitermes spp.) *soldiers cannot bite but can squirt an irritating fluid from the snout. It can be an irritant to humans only if it enters the eyes.*

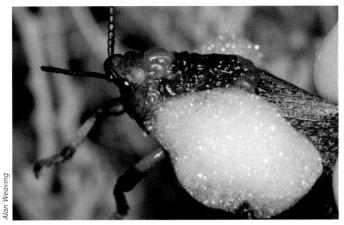

Koppie foam grasshoppers (Dictyophorus spumans) *do not bite, but exude cardiac glycosides, potent enough to kill a dog if ingested.*

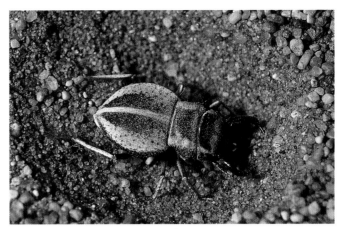

Some beetles have large jaws that can deliver painful bites if the insect is disturbed.

Other insects

Assassin bugs (family Reduviidae) have a short, curved and segmented beak that can deliver a painful puncture wound. None of South Africa's species is known to transmit disease, but should be treated with respect and not handled because bites can be very painful, and allergic reactions and secondary infections are possible.

Another bug to handle with care is the so-called water scorpion, which is not related to terrestrial and arboreal scorpions. Water scorpions have a short, curved beak that can deliver a painful bite. Others to avoid are the giant water bugs belonging to the Belostomatidae group. One African species may reach a length of 10 centimetres, and can cause a very painful wound.

Several beetles are quite capable of delivering a painful bite if they are molested. These include ground beetles in the family Carabidae, some of which may exceed five centimetres long and have substantial jaws or mandibles.

Some species of louse, bedbug and flea feed from humans and not infrequently pass diseases to us through their saliva when sampling our blood. Their bites, as with those of mosquitoes, horseflies and other biting diptera, are usually little more than irritating and itchy in most cases, but the disease factor is the biggest worry.

Some large insects do not bite but are armed with sharp spikes or spurs on the legs that can scratch, puncture and draw blood. Some of the larger praying mantises fall into this category, as do certain katydids, locusts and grasshoppers.

In many cases, if you leave insects alone you will not be bitten, scratched or have noxious fluids burn your skin or assault your nasal passages. In all cases, clean the insect bite or scratch thoroughly to prevent infection.

Many insects are 'dangerous creatures' in the sense that they are destructive to our agricultural crops and livestock, which can result in food shortages that directly affect mankind on a local or regional level. This, however, is beyond the scope of this book and deserves a volume of its own.

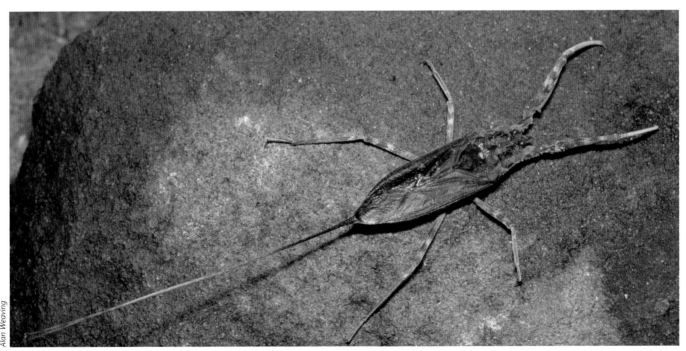

The so-called common water scorpions (Laccotrephes spp.) *are large, reaching more than 100 millimetres in total length.*

Richard Boycott

PART TWO
Venomous Animals

Venom is a poisonous fluid secreted by certain animals and usually delivered by a bite or sting. Venoms come in a confusing variety but serve just two purposes in nature: to subdue prey and to repel, incapacitate or kill enemies. Many venoms cause little more than a short period of pain without lasting damage, but several can seriously maim or even kill humans. An added complication is that if you are bitten or stung by an even slightly venomous creature you may react with an allergy that could kill you.

Records of envenomation and injury inflicted by some of the creatures discussed here can be scant, particularly in central Africa and towards the north. Where this is the case, the authors have been forced to rely on those records that do exist, often from within southern Africa.

TOP LEFT: Opistophthalmus karrooensis
LEFT: Boomslang
RIGHT: Horned baboon spider

Nigel Dennis/Images of Africa

SNAKES

At least 400 species of snake occur in Africa, of which about a quarter can be considered to be dangerous, or potentially so, to humans. Within southern Africa there are over 140 species, 37 of them potentially dangerous although only 15 have been implicated in human mortalities. In East Africa about 40 species of snake are known to have venom, while West Africa has some 29 venomous snake species. In Africa north of the Sahara Desert the 11 species of snake that are potentially dangerous to man are all vipers.

Unless you are bitten while in a very isolated area, death is unlikely these days if you follow the correct first aid procedures and have access to anti-venom. Unfortunately, in many parts of Africa, people bitten by snakes do not have easy access to adequate treatment centres and mortality is quite high. Traditional medicine is of little or no practical value in cases of serious snakebite.

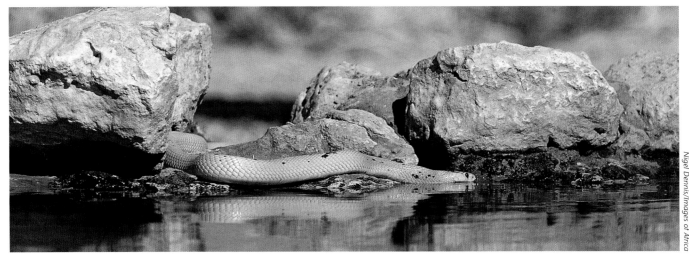

Nigel Dennis/Images of Africa

The Cape cobra occurs in a wide range of habitats, including around streams and pools, where it hunts toads and frogs.

Mistaken identity

Some years ago when one of the authors was doing her internship in a rural hospital in what is now Limpopo Province in South Africa, she had her first encounter with snakebite. 'I looked at the patient's left foot, the toes were swollen and stiff, the skin felt cold and hard to the touch, the colour of the whole forefoot was pitch black, not the middle brown of the rest of the leg. I really started to worry, until I heard the calm voice of the nursing sister: 'We will just give the leg a good scrub with warm water to get rid of the sticky black substance the witch doctor put on ...'. It turned out to be a non-poisonous snake and the patient experienced no ill effects.

But one of the dangers of snakebite became apparent when a foreign-trained doctor initially believed from the description that the woman had been bitten by an eastern green mamba (although it does not occur in that area and was more likely to be a green water snake). Injection of anti-venom certainly could have endangered the patient's life.

Snake evolution

The first snakes are believed to have evolved some 125 million years ago and this evolution has produced a highly specialised group of cold-blooded vertebrates. Over time these descendants of ancient lizards lost their limbs, their bodies became elongated and supple, and they adapted to almost every habitat from rain forest to desert, mountains to coastal plains, lakes to the oceans.

The shorter-bodied snakes such as vipers have up to 180 vertebrae, whereas 400 or more may be found in the pythons and a number of the colubrid (back-fanged) species. Each vertebra has a mobile rib attached with a ball and socket joint, and numerous muscles that give the snake considerable flexibility and mobility. This allows snakes to enter small burrows and crevices in search of their prey.

How fast can snakes move?

Complicated sets of muscles allow a snake to 'wriggle' along. The body is thrown into a series of horizontal waves, with the muscles pulling from one side to the other. This form of locomotion is effective only on surfaces that are rough enough to provide resistance: even slight irregularities on the ground, such as small sand grains, provide enough traction. Place a snake on glass and it will fail to make much progress. Long, slender snakes can move more efficiently because they have more body loops for pushing against the ground at any one time.

Most snakes use this type of locomotion, but others have evolved movements to fit particular habitats – for instance, the side-winding actions used in soft sand by several viper species, or the rectilinear movement of certain heavy-bodied

snakes such as the puff adder and the pythons, achieved by using ripples of belly scales to lift and propel the snake forward. When in a hurry, however, even large pythons will revert to the 'traditional' undulatory movements.

Although snakes may seem to move rapidly, even the fastest snakes barely reach five to seven kilometres an hour at top speed, which corresponds roughly to that of a human walking at a brisk pace. The common human fear that snakes will chase them is entirely unfounded – snakes never chase after people. Furthermore, they do not attack stationary objects, so the safest strategy if confronted with a snake is to freeze until the snake has moved away, or to retreat very slowly, making no sudden movements.

Skinned alive

Snakes shed, or slough, their entire skin several times each year. Unlike human skin, which is in a continuous state of shedding and replacement in small fragments, snake skin is sloughed in one piece. When the outer skin of a snake becomes worn, a new skin begins to form below the old. Just before the old skin is shed a thin layer of fluid is secreted between old and new. When sloughing is imminent the milky fluid covers the eye between the new and old eye-covering scale,

causing the snake to become almost blind. During this time the snake usually retreats into cover to avoid the attentions of predators. As the milky fluid begins to clear, the snake is almost ready to 'skin itself alive'. The skin at the edge of the lips begins to crack, assisted by opening and stretching of the mouth. With a combination of rubbing and wriggling the skin is slowly peeled off from head to tail and usually turned inside out. In many cases the skin is complete and it is often possible to identify the species of snake that has left its dermal calling card. The sloughed skin has little colour but the snake is now at its brightest and most attractive.

Slimline

How does a snake fit its organs into such an elongated and slender body without compromising on efficiency? The stomach has evolved to become a simple enlargement of the relatively straight gut. The kidneys are arranged one behind the other and are elongated, as is the liver. Most snakes have a highly developed, elongated right lung that extends up to half the length of the body, whereas the left lung is largely non-functional. Only the heart is similar to that of other reptiles, but there are additional blood vessels to serve the other elongated organs efficiently.

Harmless legless lizards appear snake-like and are commonly killed as a result of this.

Snakes regularly shed, or slough, their old skins, and it is sometimes possible to identify the species by the shed skin.

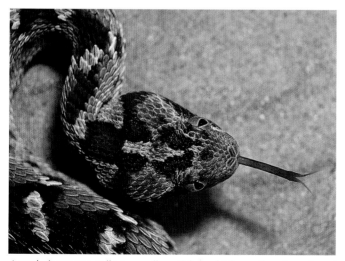

A snake's tongue collects small particles, which are then transferred to the Jacobson's organ in the roof of the mouth.

Many snakes, such as this puff adder, are cryptically coloured and blend into the background.

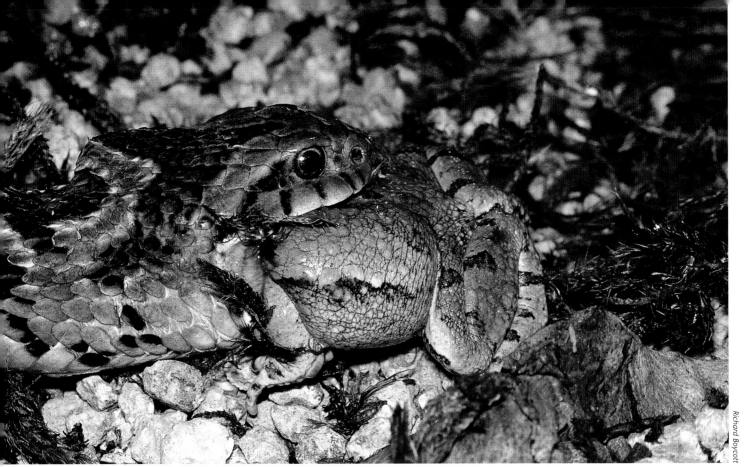

The night adder is one of several snake species that include toads in their diet. Toads are distasteful and poisonous to mammalian predators.

Detecting predators and prey

Snakes have fixed-focus vision and little perception of detail. The eyes seem to function mainly as detectors of movement, rather than providing detailed images. Snakes are completely deaf to sounds that travel through the air because they lack eardrums. They can discern vibrations on the ground, but it is the forked tongue and special paired sensory pits in the roof of the mouth (known as Jacobson's organ) that make the snakes such a successful group of animals. Most snakes probably have a fairly good sense of smell in the traditional way, through the nostrils, but evolution has improved on this with the forked tongue.

Contrary to popular belief, the forked tongue cannot sting and is completely harmless. The tongue moves in and out of the mouth through a notch in the lips, allowing the mouth to remain closed. The tips of the tongue pick up minute particles from the ground and the air and transfer them into the sensory pits in the roof of the mouth. The paired sensory pits are lined with extremely sensitive cells. Analysis of these particles allows the snake to follow the scent trail left by potential prey, as well as to track down mates and avoid threatening predators. So the snake's senses are dominated by chemical messages. Some snakes, such as vipers and adders, have heat-sensing pits at the front of the head that help to track prey they have envenomated with relatively slow-acting venom.

Activity periods

Snakes are cold-blooded, or ectothermic, vertebrates. Unlike their mammal and bird counterparts they cannot compensate internally for changes in air temperature. Therefore, if the air temperature drops too low, or rises too high, the snake becomes sluggish and must retreat to shelter, or risk death. Peak snake activity occurs in weather that is warm, but not too hot. During the hot summer months snakes may become more active between sunset and sunrise, when it is cooler. Unlike many snakes in the northern reaches of the Earth, those in southern Africa and the African tropics do not hibernate during the cooler months. They may retreat into a hole or crevice or under debris during inclement weather, but are unlikely to remain there for more than a few days. It is not unusual on cool mornings to encounter snakes warming themselves in the sun. Remember that a snake encountered under such circumstances is just as likely to bite, if provoked or threatened, as when it is actively moving during warm weather.

The snake menu

Snakes have widely varied diets, but they all have three things in common: they are carnivores; they swallow their prey whole; and their prey is nearly always living – carrion feeding is extremely rare. Snakes often feed on prey that seems to be impossibly large, but special 'elastic' ligaments attached to the joints in skull and jaws allow them to swallow prey much larger than their heads. Evolution has resulted in a strengthened windpipe that is positioned at the front of the mouth to facilitate breathing during prolonged ingestion of prey. The opening of the windpipe can even be moved out to the side of the mouth to ensure a constant flow of air to and from the lungs.

The variety of snakes is matched by the variety of their prey and the methods they use to subdue it. Some snakes, such as the pythons and some colubrid (back-fanged) snakes,

wrap coils of the body around their prey and constrict it. Each time the prey exhales, the snake tightens its coils until the prey can no longer draw in enough oxygen and dies from asphyxiation. There are also snakes that rely on venom to incapacitate their prey, while others swallow small prey without constricting (such as those that specialise in feeding on termites). All snakes manoeuvre their prey in order to swallow it head first. This prevents legs, feathers, scales or fins from pointing in the wrong direction, thereby inhibiting ingestion. The snake's jaws then proceed to 'walk' over the prey, pulling it into and through the mouth, into the gullet. First the teeth on one side of the mouth are lifted and moved forward, then those on the other side repeat the exercise, slowly but surely drawing the prey inwards.

Some snakes are highly selective feeders. The common or rhombic egg-eater feeds exclusively on the eggs of birds. Most of the harmless blind and thread snakes feed mainly on ants, termites and their eggs. Some snakes eat centipedes, slug eaters prefer slugs and snails, and many water snakes live on a diet of frogs. Still others feed on rats and mice, and there are some that eat other snakes.

Snake venom

Snake venom is highly evolved, toxic saliva consisting mainly of unstable proteins. The poison glands can be likened to our own salivary glands. Snakes have just one venom gland, which extends behind the eyes, on either side of its head or neck. The sharply pointed teeth, including the poison-delivering fangs, have no roots and are rather loosely attached to the jaw. They are replaced regularly throughout the life of the snake. Fangs are special teeth that have evolved to deliver venom from the poison glands. Each fang is curved around to form a groove or a tube, running from near its base to close to the tip. Venom is pumped along this tube to be delivered into the prey. Those snakes with the longest fangs, such as the puff adder and gaboon adder, can swivel these poison delivery systems both forwards and backwards, so that the fangs can be folded away when not needed. Without this ability the fangs would have to be much shorter.

Venom is squirted into the prey or enemy at the moment of striking. Even a glancing wound can result in envenomation. In a few snakes – such as the Mozambique spitting cobra, spitting cobra and the rinkhals – the exit hole in the fang faces forward. This means they can spray or 'spit' the venom for two to three metres as a defensive mechanism, usually with considerable accuracy. They can also deliver the venom by biting, which is how they attack prey.

Combating snake venom

The first anti-venom for snakebite was produced by a scientist working at the Pasteur Institute in Paris in 1895, to treat bites of the common cobra (*Naja naja*). In 1901 a Brazilian researcher developed both monovalent (counteracts a single type of snake venom) and polyvalent (combats multiple snake venoms) anti-venoms to protect against several South American snakes. Snake anti-venom was produced for animal use in South Africa in 1901. Only in 1928/9 was an anti-venom produced that was fit for human use. In the 1940s Dr Paul Christensen introduced globulin-refined anti-venom, which still remains the most effective and purest, based on World Health Organisation (WHO) standards.

Types of venom

There are three main types of venom.

1. Neurotoxic – affects the nervous system and causes paralysis, resulting in difficulties with breathing and swallowing. This type of venom is delivered by snakes such as the mambas and most cobras. It is also cardiotoxic because it blocks calcium channels in the cell walls, which leads to disturbance of the electrical impulses and the heartbeat.
2. Cytotoxic – attacks the blood vessels and tissues, damaging cells. Snakes that carry this type of venom include most of the adders, burrowing asps and the spitting cobras.
3. Haemotoxic – disrupts the blood-clotting mechanism and can lead to profuse internal bleeding. The best-known deliverers of this type of venom are the twig snakes and the boomslang.

Until the end of the 20th century, the South African Institute for Medical Research (SAIMR) produced and supplied both monovalent and polyvalent anti-venoms for South Africa and other regions of Africa, but these are now produced by a nominally private company. Currently this is the only organisation producing anti-venoms on the continent, but similar bodies in Europe do make supplies available for certain species.

Anti-venom production

Snake venom can only be collected in one way – by an expert catching a snake and 'milking' it. In some snake serum production facilities snakes are kept in captivity in pits. The snake is held securely and made to bite through a latex membrane that is stretched and secured over a glass container. The venom glands are massaged to encourage the snake to release the maximum quantity of venom.

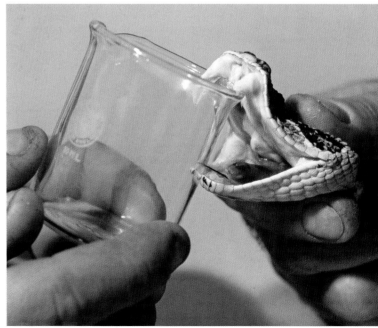

A puff adder being milked of its venom. John Visser

The site of a bite from a burrowing asp does not look particularly impressive but the resulting pain can be excruciating.

The next stage is to inject the venom in solution into animals, usually horses. Initially, very small amounts are injected, gradually building up to amounts that would ordinarily kill any other horse. In this way, antibodies are formed as the horses build up resistance to the venom. The horses are then bled periodically, and the serum extracted from their blood is put through painstaking processes to isolate the single component required for the anti-venom. Glass ampoules are filled with dried, powdered venom, ready to be sent where they are needed.

Simon Wagstaff and his co-workers at the Liverpool School of Tropical Medicine have managed to produce anti-venom without using snake serum. They extracted active parts of a specific gene in the venom glands of the West African carpet viper (*Echis ocellatus*) and, through a complex process, have produced an immunogen that can trigger an immune response in an animal. There are numerous advantages to this method because it is more potent yet purer and less likely to provoke an allergic reaction in the patient, which can happen with the use of anti-venom, sometimes proving fatal. Whatever the method of production, this is an expensive and limited-profit business, so that many international drug companies have stopped producing anti-venom. This has caused a shortage in a number of regions, especially in large areas of Africa.

Prevalence of snakebite

Obtaining accurate figures for the number of snakebites in Africa is not easy because it is under-reported, underestimated and the recording systems are often inaccurate. Many snakebite victims never reach a hospital or clinic and either die or recover without ever receiving treatment. A further complicating factor is the often inadequate and incorrect management of snakebite patients.

A study undertaken in the Benoue Valley in Nigeria put the annual incidence of snakebites at 600 out of 100 000 people, with a fatality rate of 12.3 %. Many of the fatalities were as a result of bites from the West African carpet viper (*Echis ocellatus*). In rural Kenya some 150 people are bitten annually for every 100 000 of the population, with death resulting in about seven cases. It is estimated that in Kenya up to 70 % of the population does not have access to health centres capable of dealing with serious snakebite cases, and resorts to the attentions of traditional healers.

The World Health Organisation (WHO) estimates that there are about one million snakebites each year in Africa, of which half involve injection of venom (envenomation) and 40 % of these cases are hospitalised. Some 50 % of all defensive bites are 'dry' bites, meaning that the snake has not injected venom – something that snakes can control. Although only some 10 000 deaths resulting from snakebite are reported by the health authorities in Africa each year, it is likely that the real figure is at least double this. However, when compared to other causes of death, such as car accidents, malaria or HIV/AIDS, snakebite is not a significant cause of mortality.

How snakes multiply

Although certain snakes are viviparous, meaning they give birth to live young, most are oviparous, meaning they lay clutches of eggs. The eggs are oval, with a tough, but not hard shell, unlike the eggs of birds. The number of eggs laid in a clutch varies considerably between species; it may be as low as four or as high as 100. Females of most species abandon their eggs, and the hatchlings are left to their own devices. In a few species, such as the python, the female coils her body around the clutch, but this is primarily a protective behaviour rather than incubation.

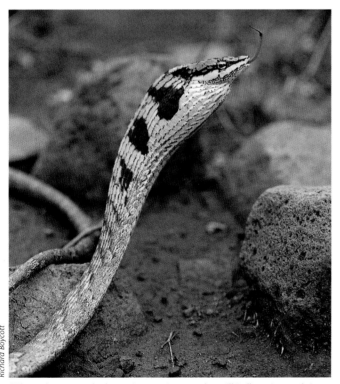

When threatened, the twig, or vine, snake will inflate its neck in order to appear larger and more intimidating.

The time between egg laying and hatching varies considerably in different species and is strongly influenced by environmental conditions. When the young are ready to emerge they develop an 'egg-tooth' at the tip of the snout, which they use to tear an escape slit in the parchment-like eggshell. But whether hatched from eggs or born alive, young snakes soon disperse and the female takes no interest in them. In some cases she may even eat some of her offspring if she encounters them.

RIGHT: The Cape cobra comes in several different colour forms.

Identifying snakes

Fewer than 20 snake species in southern Africa have been implicated in the death of humans. Accurate figures are not available for other regions of Africa, but a further 10 species have been implicated in human mortalities elsewhere on the continent. Occasionally, other snake species have been involved in fatal bites but these are the exception rather than the rule. Despite this, many harmless snakes are killed, as well as a number of legless lizards that at first glance resemble, and move like, snakes. Never handle a snake unless you are entirely sure of its identity and that it is harmless – and even then, only if handling it is necessary.

A few snakes are easily recognisable, such as the cobras that raise the neck in a hood when alarmed or threatened, and the coral snake with its distinctive coloration and markings. However, others can be much more difficult to identify. For instance, the completely harmless common egg-eater adapts its coloration and patterning to that of poisonous species in the areas where it occurs. In the west of southern Africa it mimics the horned adder, whereas in other areas it resembles the rhombic night adder. To confuse things further, the Cape cobra comes in a range of colours that include black, yellow and speckled, and a snake close to sloughing its skin may have the colour of a totally different species. The red spitting cobra, despite its name, may also be pink, yellow or steel-grey – to give just a few of the variants.

In the following species accounts, the most venomous snakes in southern Africa are detailed, with selected species from other parts of the continent. Many of Africa's most dangerous snakes, such as the puff adder, black mamba, black-necked spitting cobra and the boomslang, occur widely across sub-Saharan Africa. There is also brief coverage of a number of snakes that are not considered to be dangerous to man, but which can still cause pain and illness.

The only sure way to identify many snakes is to count the scales on certain parts along the body– scale diagrams can be found in some specialist guides to snakes of the region (see 'Bibliography' on page 232).

Nigel Dennis/Images of Africa

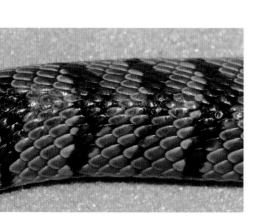

FAR LEFT AND LEFT: Dorsal and ventral scales, respectively, of a coral snake. Sometimes the only way to positively identify a snake is to count the body scales.

Front-fanged snakes (Elapidae)

This group of snakes, known as elapids, is found throughout the world's warmer regions and includes a large collection of the most venomous species. They all have venom-delivering fangs at the front of the upper jaw. This family includes mambas, cobras, harlequin, coral and shield-nose snakes, and garter snakes. All have potentially lethal venom, but only the mambas and cobras can be considered to be extremely dangerous and usually deadly if you are bitten and do not get treatment.

The venom of other elapids is poorly known and these snakes are rather secretive and seldom encountered, but any bite should be taken seriously. The danger to someone who has been bitten, even by a mildly venomous species, lies not just in the venom itself – some may suffer an extreme allergic reaction that could lead to death.

The mamba duo
Black mamba

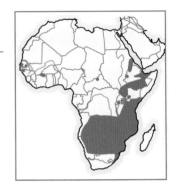

Description: Long, slender body, coffin-shaped head and blue-black mouth lining. Despite the name it is not black but may be brownish, dark to lighter grey or olive-brown with a paler belly. Posterior half of snake may often be black-speckled on sides.
Length: 2.2–2.7 m; maximum 3.5 m (unconfirmed to 4.3 m)
Scales: Mid-body 23–25; belly scales 242–282; under tail 105–131
Breeding: 6–17 eggs
Venom: Neurotoxic
Anti-venom: Polyvalent

The black mamba (*Dendroaspis polylepis*) is Africa's most feared snake – with good reason. The description of the 'coffin-shaped' head is ominously appropriate. This is the longest venomous snake on the continent and it produces copious quantities of potent venom. However, it is not as aggressive as is often believed. There are tales of black mambas chasing humans, even chasing riders on galloping horses, but these are myths. Invariably, snakes attempt to escape from humans, and only bite if attacked or cornered.

Nevertheless, if threatened, the black mamba can raise about a third to half of its body length vertically off the ground. It opens its mouth, swaying its head from side to side and hissing – this is one of the very few snakes that can deliver a bite on the upper leg or above the waist. If the threat persists then the mamba will strike, rapidly delivering venom in a series of bites because it does not hold on with the fangs as some snakes do. Before the days of anti-venom a person bitten by a mamba invariably

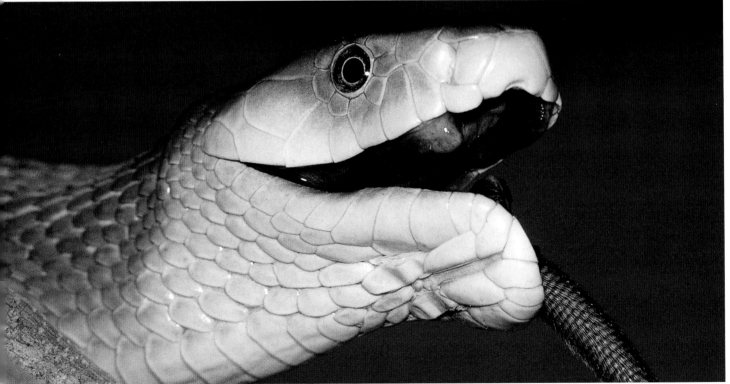

The black mamba is Africa's most feared snake.

died. Today, with correct first aid and access to anti-venom within a reasonable time there is a chance of survival, but mortality is still quite common. Without adequate treatment death can be expected within five to 17 hours, though there are records of death within less than one hour.

The black mamba is most common in low-lying woodland savanna, often associated with rocky outcrops and low rock ridges. It is frequently encountered in riverine woodland and on the fringes of swamp forest, but is also recorded from relatively dry country in some parts of its extensive range. Although widespread in the north of southern Africa, central Africa and East Africa into Ethiopia, records are scattered and few through West Africa, where it occurs as far west as Senegal. It is mainly a ground-living and hunting species, but it will readily climb trees too. When on the move it is graceful, the neck and head often raised above the ground.

The skull of a black mamba showing the sharp, curved fangs.

Most feeding records for this snake are of small mammals and fledgling birds. It is mainly active during the day, and retreats at night to a fixed den, which may be in a rock pile, hole in a termite mound, a burrow dug by species such as porcupine, a hole in a tree or even an abandoned hamerkop nest.

Closed window saves the day

The small Ben Levin Nature Reserve to the south of the Soutpansberg in South Africa's Limpopo Province is dominated by dense woodland savanna, with a scattering of small rocky outcrops – ideal black mamba habitat. We were undertaking a wildlife survey in the reserve and frequently saw these elegant snakes. At the time good rains had fallen and the grass was standing tall. One morning the ranger's wife drove into our camp, flustered and upset. A mamba had struck at her head as she was driving slowly along a rough track. It was fortunate that the window had been closed, because the snake struck twice and venom was running down the glass. If the window had been open she would almost certainly have been bitten at least once. We measured the height of the strike and it was approximately 1.4 metres above the ground. The snake had perceived the vehicle as a threat and had attempted to defend itself.

Green mambas

There are three other mamba species in sub-Saharan Africa: eastern green (*Dendroaspis angusticeps*), Jameson's (*D. jamesoni*) and West African green (*D. viridis*) – all green mambas. Arguably, the venom of these mambas is not as potent as that of the black mamba, but volumes are large and lack of treatment following a bite from any of them would almost certainly result in death from collapse of the respiratory system. In the case of the eastern green, the venom yield may be as high as 100 milligrams, significantly higher than the 15 milligrams believed to be lethal to humans. However, none of the green mambas is believed to attack as readily as the black mamba.

These snakes are all slender and long, though never reaching the length of their black cousin. Their dominant colour is green and the heads are 'coffin-shaped'. In the south of the continent, you will encounter only the eastern green, but even here its range is limited to the low-lying coastal plains of KwaZulu-Natal, northwards into Mozambique and in the forests of the Zimbabwean Highlands. It extends into Tanzania and Kenya, where it is mainly found on the coastal plains, with a few isolated populations inland. Jameson's mamba is found right across the Congo Basin, with the West African green mamba occurring across that region in forest and wet woodland. All are much more arboreal than their 'black' cousin.

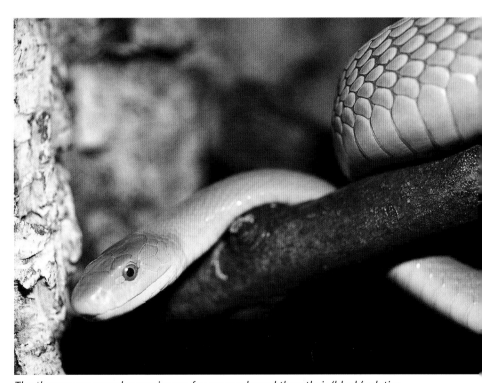

The three green mamba species are far more arboreal than their 'black' relative.

The cobras

There are seven species of typical cobra (*Naja* species) across Africa – that is, snakes that are readily recognised as cobras. Four further species carry the name cobra but are placed in non-*Naja* genera. Four of the African *Naja* cobras can spit their venom in defence or deliver it in the conventional way by biting. What sets most of the cobras apart from other snakes is their ability to spread a hood when annoyed or frightened. This may have evolved to intimidate predators. The cobras have long, movable ribs in the neck and this, combined with inflation of air from the lungs, enables this distension of the neck.

Cape cobra

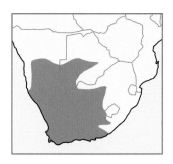

Description: Relatively small cobra with broad head. Several distinctive colour forms in different regions but varied, from yellow to black, reddish-brown or heavily speckled. Different colour forms may be found in same area, but a particular skin colour may be dominant in a particular region.
Size: 1–1.5 m; maximum 1.7 m (up to 2 m has been claimed but not verified)
Scales: Mid-body (smooth & glossy) 19–21; belly scales 195–227; under tail 50–68
Breeding: 8–20 eggs laid in summer
Venom: Neurotoxic
Anti-venom: Polyvalent

The Cape Cobra (*Naja nivea*) is the deadliest of Africa's cobras – just 15 milligrams of venom is enough to kill a full-grown human if the victim is left untreated – and it is responsible for most snakebite fatalities within its range. The toxicity of its venom puts it in the same league as the black mamba.

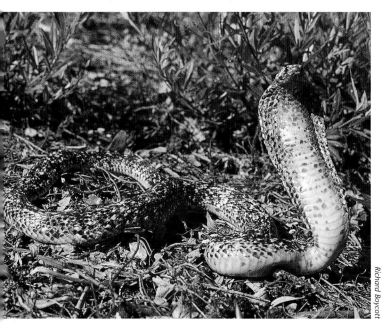

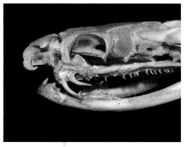

TOP: The speckled form of the Cape cobra in threat posture.
ABOVE LEFT: The site of a Cape cobra bite.
ABOVE RIGHT: The skull of a Cape cobra.

Because of its many colour forms it has differing names according to region – in Afrikaans the yellow form is known as Geelkapel, the brown form Bruinkapel, the black form Swartkapel, and so on. Many people are not aware that they are all the same species, the Cape cobra.

This is the only cobra that occurs over much of the southwestern quadrant of southern Africa and it has by far the most potent venom of any African cobra. It can be found in the suburbs of Cape Town and in and around most towns and villages within its range. Cape cobras are common residents or visitors in farmyards, especially where there are drystone walls and cluttered outbuildings that shelter rodents.

The Cape cobra reacts rapidly to any disturbance. It spreads its hood and will bite readily if approached and provoked, but will quickly move away if given the opportunity. Although it is responsible for several bites each year, given its relative abundance and proximity to people, it is surprising that they don't occur more frequently. It is said to be more aggressive during the months of September and October, which is the principal time of mating and egg laying.

Within its range the Cape cobra occupies virtually every geographical region, from mountain ranges to sea-level plains, and from dense vegetation cover to sparse scrub. It appears to reach its highest densities in drier country, such as in the Kalahari and the Karoo. Although this snake is mainly diurnal, nocturnal activity has been recorded, especially during the hottest summer months. Much of its hunting is done on the ground, but it will climb into trees to prey on fledgling birds in nests. This is best documented in the Kalahari, where this snake readily climbs trees to raid sociable weaver nests.

One of the secrets of its success is that it has a very catholic diet, which includes small rodents, birds, frogs, toads, lizards and other snakes. It is not averse, even, to snacking on its own species if the opportunity presents itself. Surprisingly, many rural folk believe that the Cape cobra will suckle milk from a cow or nanny goat that is lying down. Not only is this untrue but it is also physically impossible for the cobra to do so.

Leave snakes alone

A report in Cape Town's *Cape Times* in 1955 shows that it is always best to leave snakes alone. Two men in Namaqualand found a cobra in an outhouse and sprayed it with paraffin and put a match to it. Their clothing caught on fire, one jumped into a nearby dam and both were taken to hospital! Although not certain, it seems that the cobra perished in the fire.

Snouted cobra

Description: A large, relatively stout cobra that comes in two races in southern Africa. Although coloration is variable, the dominant ground colour is usually yellowish-grey, brown or blue-back. The underparts are variable yellow with darker speckling, and there is a dark band across the throat. A fairly high percentage have between seven and nine yellowish bands on the body and two on the tail, far fewer than those of the Namibian form of the black-necked spitting cobra.

Length: 1.3–1.8 m; maximum 2.5 m (possibly larger)

Scales: Mid-body 17–21; belly scales 179–214; under tail 48–66

Breeding: 8–20 eggs

Venom: Neurotoxic

Anti-venom: Polyvalent

The snouted cobra (*Naja annulifera*) is a big, powerfully built snake, the largest cobra in southern Africa, and also known by other names, including banded cobra and bushveld cobra. Despite its size it is not particularly aggressive, but if angered or unduly frightened it can move and strike with surprising speed. It can deliver a substantial quantity of venom in a single bite with fangs that may be as long as 10 millimetres; less than 35 milligrams of its venom could kill an adult human. In some areas, northeastern Namibia for example, bites by this cobra are relatively common. In the east of its range it tends to be less aggressive and more retiring, but in the west it is prepared to stand its ground and defend itself against a perceived threat. On occasion it may choose to sham death. (Only one other snake – the rinkhals – does this with any frequency in southern Africa.) The snouted cobra occurs in savanna woodland and grassland but extends into the northern fringes of the Kalahari. It is also a tropical cobra that is restricted to the north and northeast of the region, but extending into southern Angola and Zambia.

Although it is said to be a mainly nocturnal hunter, it can be seen, on occasion, in daylight and may bask in the early morning sun at the entrance to its retreat. This may be in a termite mound, hollow log or occasionally in the burrow of mammals such as the springhare. It has a varied diet, which may include rodents, birds' eggs, toads and other snakes (even fairly large puff adders).

The banded form of the snouted cobra in defensive posture.

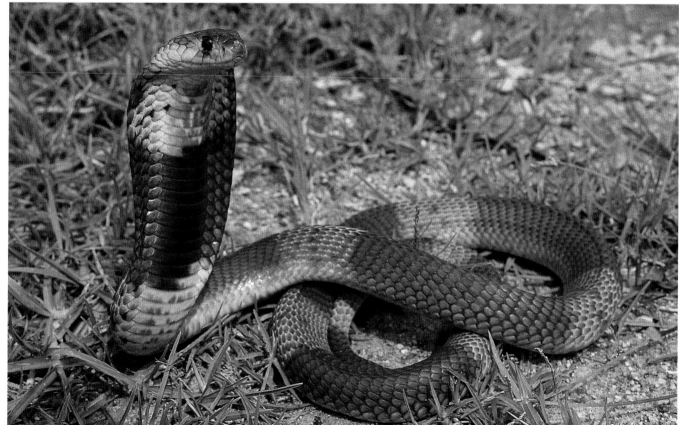

Richard Boycott

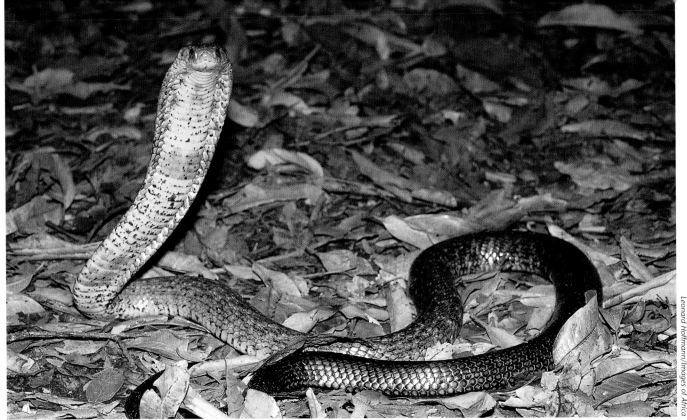

The forest cobra may hunt on the ground, in trees and bushes, as well as in water. It is alert and will usually move away from disturbance.

Egyptian cobra

The Egyptian cobra (*Naja haje*) may reach a length of at least 2.5 metres and has the widest distribution of any African cobra. Yet this distribution is patchy across the south of central Africa and across eastern Africa to the Horn. It is also known from the Atlas ranges in the northwest and extensively across the dry savanna belt of West Africa. This cobra is never encountered in true forest but shows a preference for drier habitats, although not true desert.

Behaviour and venom are much the same as that given for the snouted cobra (see page 109). The Egyptian cobra is the snake that was revered as a god in Ancient Egypt and is commonly depicted in temples and other buildings.

Forest cobra

Another non-spitting cobra that occurs in southern Africa is the forest cobra (*Naja melanoleuca*). It may reach nearly 2.7 metres in length but is generally somewhat shorter within its limited range in the south, the coastal plain of northern coastal KwaZulu-Natal and into Mozambique. Elsewhere it occurs widely through the tropical forest belt, with small isolated populations scattered across eastern Africa.

It is an alert snake and moves quickly. Some experts consider it rarely aggressive, but others claim it will strike readily. There are no human fatalities recorded from the south and, in fact, very few bites. Nevertheless, being such a large snake with a substantial venom yield (up to 500 milligrams) it should be shown respect if encountered. It has a diverse diet that includes fish, birds' eggs and rodents. Some authors have commented on its apparent cunning and intelligence.

Spitting snakes

These snakes may bite and inject their venom, or spit/spray the venom at an attacker. Their copious quantities of venom are generally directed at the eyes. This results in severe and immediate pain and can lead to blindness and severe tissue damage if left untreated. Despite their name, these snakes do not actually spit the venom from the fangs. Venom is ejected from the hole on the lower front-face of the fangs by rapid muscular pressure on the venom glands and comes out in the form of a spray.

Four true cobras within the genus *Naja* are classified as 'spitters' in Africa. Apart from the two dealt with in more detail below there are the West African brown spitting cobra and the red spitting cobra.

The West African brown (*Naja katiensis*) rarely reaches one metre in length and it is usually reddish-brown in colour with a distinctive dark ring on the neck. This is most clear in young snakes. It occurs across the dry savanna of West Africa and, although it is said to feed mainly on amphibians, its habitat indicates that it probably also feeds on rodents. This cobra is also known to feed on other snakes. Little is known about its venom and no recorded bite case histories are known to exist.

The red spitting cobra (*N. pallida*) occurs from northern Tanzania, through the Horn of Africa, and penetrates Sudan and Egypt along the Nile River valley. It reaches a length of 1.5 metres and its body coloration is variable, with the 'classic' red form occurring in East Africa. Most specimens have a dark throat band. Mostly found in dry savanna, it also occurs in riverine vegetation, such as that found along the Nile. It has a fairly broad diet. Little is known about this cobra's venom or its toxicity, but it is generally believed to be similar to that of the Mozambique spitting cobra.

Black-necked spitting cobra

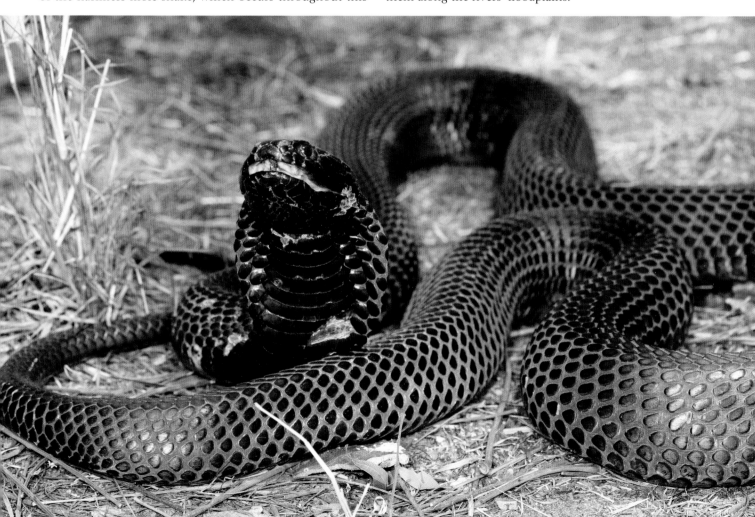

Description: Three distinct races, or subspecies, occur in southern Africa, but the black-necked spitting cobra is widespread further north, from Eastern Caprivi. The western barred spitting cobra (zebra snake; *Naja nigricollis nigricincta*) of northern Namibia is distinguished by numerous black bands – often more than 100 – on the body and tail. Background colour is usually pale greyish, sometimes brownish-pink. The race occurring southwards in the west of the region is the black spitting cobra (*N. n. woodi*), which is black above, with a dark grey belly that is streaked with black.
Length: 1.5–1.8 m (most specimens smaller; *woodi* averages larger than *nigricincta*)
Scales: Mid-body 17–21; belly scales *woodi* 223–228, *nigricincta* 192–226; under tail 52–69.
Breeding: 8–22 eggs
Venom: Apparently both neuro- and haemotoxic, but the latter gives rise to more severe symptoms
Anti-venom: Polyvalent

In parts of its range, the black-necked spitting cobra (*Naja nigricollis*) may reach lengths of 2.7 metres, but in southern Africa the recognised subspecies rarely reach 1.8 metres. Apart from the ability to spray its venom, this cobra will bite readily and rapidly if cornered or threatened. It has a large venom yield of up to 350 milligrams and it takes as little as 40–50 milligrams to kill an adult human. The south of its range overlaps with that of the Cape cobra and it can be mistaken for the black form of the Cape cobra, which lacks markings. It can also be confused with the black form of the harmless mole snake, which occurs throughout this cobra's southern African range, but the mole snake has a small head and lacks any obvious markings.

These cobras are active both day and night, but this varies between the races and under different weather conditions. Certainly the *woodi* race in the south is commonly seen hunting during the day. Diet is varied and includes rodents, lizards, frogs and snakes, including quite large puff adders. The race *nigricincta* penetrates into the Namib Desert along the various river courses, including the Kuiseb and Swakop rivers. Here they include horned adders in their diet, hunting them along the rivers' floodplains.

The black-necked spitting cobra delivers its venom by spraying it under pressure or injecting it with a direct bite.

Johan Marais

Mozambique spitting cobra (m'fezi)

Description: Quite small for a cobra. Its back is usually olive brown to reddish-brown, or any shade of brown in between. Larger specimens sometimes grey. Their underside is a lighter colour. Black bars and partial barring of variable width on throat, neck and onto lower belly, but some specimens with mainly black mottling. These markings are particularly obvious when hood is spread, otherwise it could be mistaken for other cobras within its range.
Length: 0.8–1.3 m (maximum 1.5 m)
Scales: Mid-body 23–25; belly scales 177–215; under tail 52–69
Breeding: 10–22 eggs (laid December/January in southern Africa)
Venom: Mainly cytotoxic; neurotoxic effects limited
Anti-venom: Polyvalent

Much of the Mozambique spitting cobra's (*Naja mossambica*) range is restricted to the more tropical areas of southern Africa, extending onto the coastal and adjacent plains of Tanzania. In some parts of its range it is commonly found around and in rocky hill country, but it seems to be most common in low-lying areas, especially where there is water. It shares its southern African range with the snouted and forest cobras.

This small cobra is responsible for many bites across its range. This can be attributed in part to its occurrence in and around towns, villages and homesteads, where it sometimes enters houses and huts in search of rodents and other prey. Another factor is that, while adults are mainly nocturnal, juveniles are largely diurnal, which may reduce food competition and ensure that they do not become part of the adults' diet. Apart from snakes they also eat lizards, toads, rodents and even insects. In some areas toads are preferred prey, even though these amphibians have poisonous skin secretions that repel most predators. Prey is bitten and injected with venom, but copious quantities of venom can also be sprayed at an enemy.

This cobra is alert and fast moving, and so usually retreats; but, if forced to defend itself, it will spray venom from either a raised or prone position. Venom in the eyes is reported to be excruciatingly painful. If this is left untreated, or inadequately treated, the victim can go blind – but this is rare. Although bites are not as serious as those of the Cape cobra, and fatalities from bites are fairly rare, 40 to 50 milligrams of venom delivered in a bite can kill an adult human.

Richard Boycott

ABOVE: The site of a bite delivered by a Mozambique spitting cobra. The lower leg is one of the most common bite sites.
RIGHT: As with snakes in general, even very young Mozambique spitting cobras are able to deliver venom.

Fight for a chair

A man who sat down in his usual armchair one day in his home in Mpumalanga, South Africa, was bitten on the hip by a Mozambique spitting cobra that had been resting under an armrest flap. 'As I sat down, so I shot up again. The power of the strike was incredible,' he said later. He was whisked off to hospital and the fire brigade was called in to catch the snake for identification. No anti-venom was required but he spent three days in hospital on antibiotics and painkillers. He later returned to hospital for surgical removal of dead tissue resulting from the cytotoxic venom.

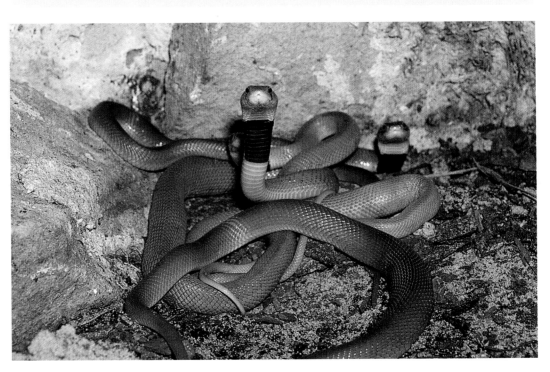

Rinkhals

Description: A small, fairly stout species. Upper body and tail scales are strongly keeled. Upper coloration is variable from dark brown to black, and may be plain or have a few to numerous black and yellow bands. Belly scales usually black with two light to yellow throat bands, upper of which is narrower. Spreads neck into a hood as with the cobras.
Length: 1–1.2 m (1.5 m recorded but rare)
Scales: Mid-body 17–19; belly scales 116–150; under tail 34–37
Breeding: about 20–30 young; births mainly January to March
Venom: Neurotoxic, but often unspecific symptoms
Anti-venom: Polyvalent

Although the rinkhals (*Hemachatus haemachatus*) is closely related to the cobras, it differs in having keeled or ridged scales, whereas cobras have smooth scales. Another difference is that the rinkhals gives birth to live young. But, like the cobras, the rinkhals spreads a hood when threatened, and can both spit its venom or deliver it by biting.

When threatened, it will first spread its hood, then spray venom at the attacker if the threat persists. The venom yield is up to 120 milligrams, but the lethal dose for humans is probably just 50 to 60 milligrams. Venom in the eye will cause severe pain, but the chances of lasting damage are not as common as in the case of the black-necked spitting cobra. However, treatment is essential.

If spraying venom does not repel the attacker, the snake will roll over entirely or partially onto its back, mouth open, and sham death. If you look closely you will see that the eyes are concentrating on what is going on around it. The 'dead' snake should not be touched as there is a good chance that it will bite.

The rinkhals is a mainly nocturnal snake with a varied diet, but shows a strong preference for toads. Despite the fact that this is a common snake in parts of its limited range, there are very few records of bites and no recent cases of fatalities.

Age is immaterial

Always remember that even newly hatched or newborn young of poisonous species of snake are already kitted out with fangs and venom glands, and are more than ready to defend themselves.

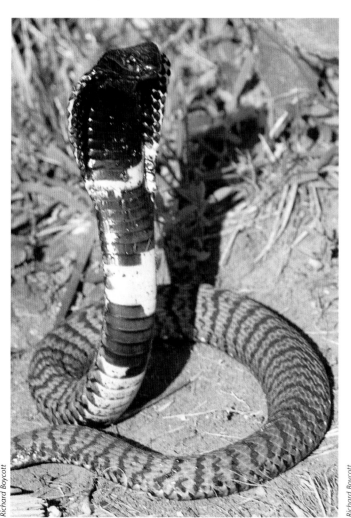

The rinkhals, despite its cobra-like appearance, differs in several ways from the true cobras.

The rinkhals is one of the few snakes that will sham death if it feels threatened.

Cobra quartet with a difference

Apart from the cobras within the genus *Naja* there are four cobras that follow distinctly different lifestyles not normally associated with cobras. The quartet is restricted to Africa's tropical forest belt, two species being largely aquatic and two spending much of their time in trees. The aquatic duo, banded water cobra (*Boulengerina annulata*) and Congo water cobra (*B. christyi*), are known from the Congo River and its tributaries, with the banded also being present in Lake Tanganyika. The banded water cobra is longer, with specimens known to reach 2.7 metres. Those from the north of the range are particularly attractive with overall orange-brown coloration and numerous black bands. The Congo water cobra is smaller, with duller brown coloration and minimal banding, except for a few narrow yellow bands on the throat.

As their names imply, both snakes spend a lot of time in the water where they hunt mainly fish. Nothing is known of their venom or its toxicity, but given their large size, bites could have severe consequences. However, the more widespread and abundant banded water cobra is said to be non-aggressive.

The two cobras that spend much of their lives aloft in the forest trees can spread only a very narrow hood. They are Gold's tree cobra (*Pseudohaje goldii*) and the black tree cobra (*P. nigra*). Little is known of their diet, although it is assumed that squirrels, chameleons and birds appear on their menu, as well as amphibians. Both species are glossy black above and characterised by their very large eyes. Gold's tree cobra is restricted mainly to the Congo Basin and the black tree cobra is known from isolated records within the tropical forest belt of West Africa. They are both large snakes, with Gold's tree cobra reaching 2.7 metres. It has potent neurotoxic venom; a test on a sample of its venom raised the comment that it was 'probably the most toxic venom examined'. Although both snakes do come to the ground, bites are unlikely for those who do not clamber around in tropical forest trees or try to catch these snakes.

Other dangerous elapids

There are several smaller elapid (front-fanged) snakes that have potentially dangerous venom, but generally little is known about them. Within southern Africa there are two harlequin snakes, one coral snake, one shield-nose snake and four species of garter snake. Elsewhere on the continent there are several additional species of garter snake, some with very localised ranges. The half-banded garter snake (*Elapsoidea semiannulata*), however, occurs widely in sub-Sahelian Africa. As with other elapids, they have fixed front fangs and venom glands. Fortunately, harlequin and garter snakes have small heads and limited gape, are usually reluctant to bite and are seldom seen. All species are predominantly nocturnal, spending the day underground or under some form of cover. Most species are small to moderate in length at 30 to 80 centimetres but one race of Sundevall's garter snake may reach almost 1.4 metres. All venom appears to be mainly neurotoxic and can potentially kill, although only the coral snake (*Aspidelaps lubricus*) and shield-nosed snake (*Aspidelaps scutatus*) are known to have claimed human victims.

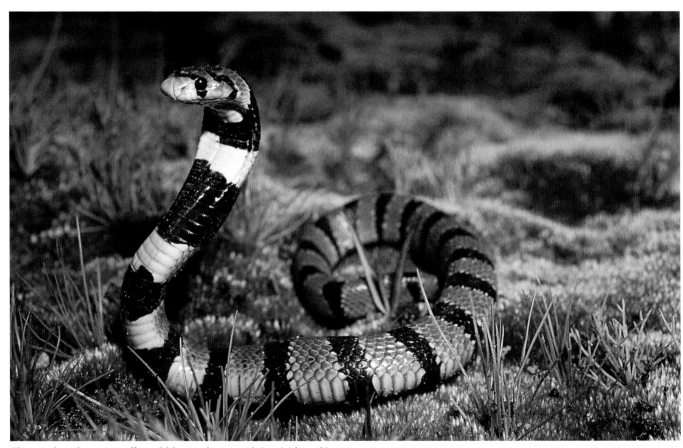

The coral snake warns off would-be predators with its vivid markings.

'HARMLESS' SNAKES

Australian snake-venom researcher Bryan Grieg Fry says the majority of snakes worldwide are venomous. He has found that supposedly non-venomous colubrid snakes (the majority of snake species) that were believed to have just mildly toxic saliva do, in fact, have true venom. As bad as that may sound, all these snakes are back-fanged so unless you let one of these snakes have a good chew on you, you have little to worry about. Nevertheless, the venom of some of the colubrid snakes is as potent as that of the cobras, so it pays to treat them with respect. Large colubrids of several species may well kill if they manage to secure a good bite, and no anti-venoms are available.

Sand snakes (*Psammophis*), of which several species are common and widespread in Africa, are agile and fast. Large specimens have a wide enough gape to give a good bite. Symptoms range from mild pain and local swelling to conditions that take several days to clear up. Other relatively common and widespread species, including spotted skaapsteker, striped skaapsteker, red-lipped snake and the tiger snakes, also have mild venom. Bites from any of these snakes are unlikely to result in death or serious long-term effects, but there is always a danger of adverse reactions to their venom or toxic saliva. The general rule is to leave handling of snakes to the experts, who not infrequently get bitten.

MILDLY VENOMOUS COLUBRIDS

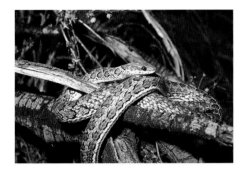
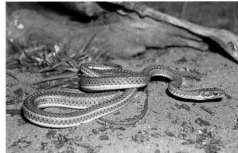

FAR LEFT: Spotted skaapsteker (Psammophylax rhombeatus)
LEFT: Karoo sand snake (Psammophis notostictus)
BELOW LEFT: Red-lipped snake (Crotaphopeltis hotamboeia)
BELOW RIGHT: Common tiger snake (Telescopus semiannulatus)

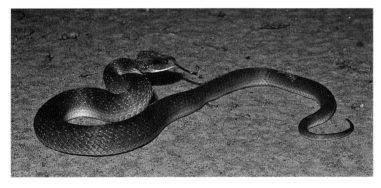
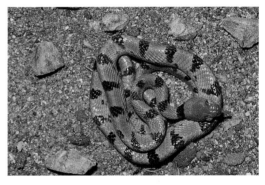

TOTALLY HARMLESS SNAKES

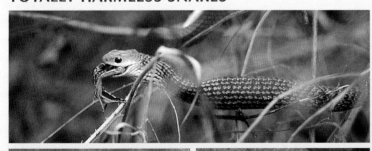
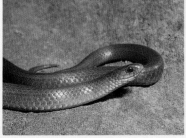
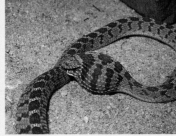
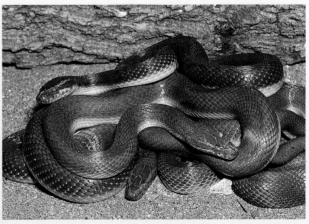

TOP LEFT: Green snake (Philothamnus *sp.*)
ABOVE: Brown house snake (Lamprophis capensis)
FAR LEFT: Common slug-eater (Duberria lutrix)
LEFT: Common egg-eater (Dasypeltis scabra)

Back-fanged snakes

Long held to be harmless, the boomslang and the savanna twig (vine) snake – known as colubrids – are now known to be highly venomous, even though they are back-fanged. They can, and have, killed humans. Their venom is haemotoxic, and frighteningly potent, although produced in very small quantities.

Boomslang

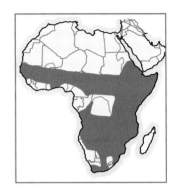

Description: A long, relatively slender snake, with characteristic short head and large eyes. Scales narrow, strongly keeled. Coloration varies at different ages, sexes differently coloured, with much regional variation. Females usually drab olive, olive-brown or brown; males range from brown to black, bright green to reddish. When skin extended usually shows green to blue between scale folds.
Length: 1.4–2 m
Scales: Mid-body 17–21; belly scales 164–201; under tail (divided) 87–131
Breeding: 10–15 eggs (up to 25); incubation 2–3 months
Venom: Haemotoxic
Anti-venom: Boomslang monovalent

The boomslang (*Dispholidus typus*) has quite large back fangs. Although a minute quantity of venom (as little as one milligram) may be delivered in a bite, death is likely within two to five days if the victim is left untreated. Despite this frightening prospect, the chances of being bitten by this largely arboreal snake are small, and limited mainly to snake-handlers and catchers. Left alone and in its natural environment, this snake is not aggressive, although if threatened it will inflate its neck and front of the body, revealing the brighter coloured skin between the scales. This warning should ward off all but the most determined snake-catcher.

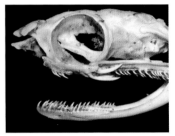

The skull of a boomslang showing the large eye cavity.

As its name implies (boomslang = tree snake), this species seldom descends to the ground, except when moving between trees, during male combat rituals in the breeding season, or when females lay eggs. The boomslang moves with considerable grace and ease through the trees, where it hunts chameleons, tree agamas and birds, including nestlings. The prey is grasped and 'chewed' by the back fangs until the venom, which acts swiftly, kills. The boomslang occurs throughout the African savannas.

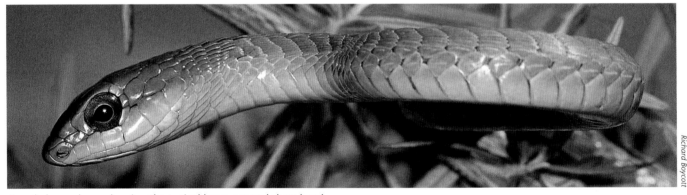

Richard Boycott

A male boomslang, showing the typical large eye and short head.

Savanna twig snake

Another snake found in the savannas of Africa is the savanna twig snake (*Thelotornis capensis*), while the similar forest twig snake (*T. kirtlandi*) is restricted to the equatorial forests. There have been few reports of twig snakes claiming human victims. Although their venom is similar to that of the boomslang, the boomslang anti-venom is ineffective and treatment consists of blood and plasma transfusions. Twig snakes are very slender, have lance-shaped heads with keyhole-shaped eyes and are well camouflaged. They are found in the far north and northeast of southern Africa, extending into East Africa.

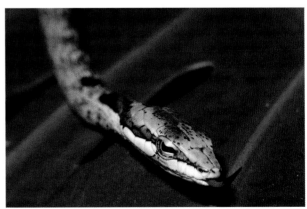

The savanna twig snake has pupils shaped like a keyhole.

Burrowing asps, stiletto or side-stabbing snakes

These slender, burrowing snakes, once thought to be specialised vipers because of their long, movable fangs, are now believed to be an ancient group unrelated to the vipers. All 15 species belong to the genus *Atractaspis*, are restricted to sub-Saharan Africa and in some areas may be the commonest source of snakebites. Spending the day underground they emerge at times, especially in warm weather and following rain, to hunt or to seek out a mate.

These snakes should definitely not be handled – their small heads, strong neck muscles and fairly long fangs make it nearly impossible to hold them safely. The fangs rotate forwards out of the mouth and stab in a downward and backward motion. Bites from the three species in southern Africa are not known to have caused any deaths and only

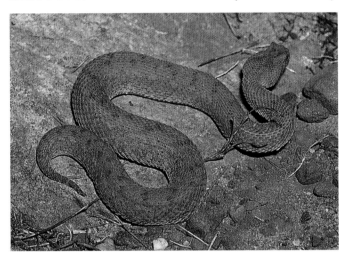

ABOVE: The mildly venomous red adder has a restricted distribution in the extreme southwest of the continent.
BELOW: Puff adders are very dangerous and some 10 % of bite victims die.

Bibron's burrowing asp has a wide distribution in southern Africa. Although data is lacking, the burrowing asps may be responsible for most snakebites in some regions: eastern southern Africa, Nigeria and Somalia have been named in this regard. The injected venom causes severe pain and swelling around the bite site, but has no long-lasting effects. Most bites have been recorded from the South African provinces of KwaZulu-Natal and Mpumalanga. However, two species to the north are known to have claimed a small number of human victims. These are the small-scaled burrowing asp (*Atractaspis microlepidota*), which has a wide distribution across the Sahel, through the Horn of Africa and much of Kenya, and the variable burrowing asp (*A. irregularis*) of the tropical forest belt. None of the available anti-venoms works on the toxins of burrowing asps.

Vipers and adders

These snakes are generally of stocky build with scales that are keeled to a greater or lesser extent and have long, erectile fangs at the front of the mouth. In theory, most have the potential to kill if their bites are left untreated, but only the puff adder is responsible for many bites across its African range. At least 43 species of adder and viper call Africa home, of which some 16 occur in the south, eight in the west, 14 in central, 17 in the east, and 11 in the north. These snakes have adapted to a broad range of habitats, from tropical rain forest to desert sands, mountain ranges to the coastline. Some dwell in trees, others swim readily or are desert dwellers that bury themselves in the sand. Some of the most dangerous in this group are the carpet vipers of the west and north. The true giant member of this group is the gaboon adder, which can be deadly, although it is habitat-restricted and placid.

There are many other types of African vipers and adders, and some of them are numerous. Few pose any real threat to life, although in most cases the aftereffects of bites can be very unpleasant. Many are secretive, have very limited distributions and occur in areas inhospitable to man.

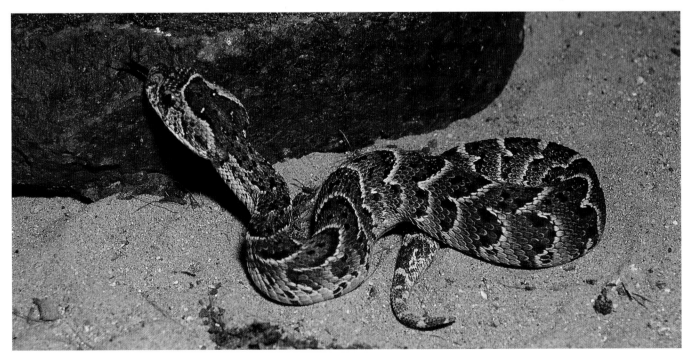

Puff adder

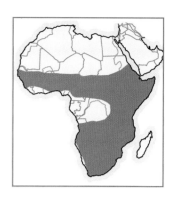

Description: The only common large adder in southern Africa, this is a stoutly built snake, with large broad head and strongly keeled scales. Overall dorsal colour is pale to dark yellowish-brown with up to 22 brown to black, back-pointing chevron marks and several dark rings on the tail. Should not be mistaken for any other species in Africa.

Length: 0.7–1 m (grow larger in northern East Africa, with record at over 1.9 m)
Scales: Mid-body 29–41; belly scales 130–143; under tail 16–37
Breeding: As with all adders in the region, puff adder produces live young (20–40; record 156)
Venom: Cytotoxic
Anti-venom: Polyvalent

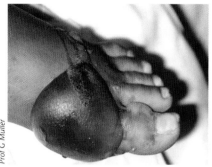

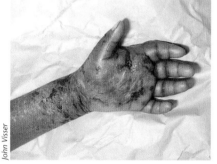

TOP AND ABOVE: Puff adder bites cause considerable tissue damage.
BELOW: The puff adder is well camouflaged and reluctant to move when disturbed.

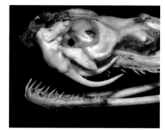

The skull of a puff adder.

Puff adders (*Bitis arietans*) are the most widely distributed poisonous snakes in Africa and are responsible for many bites throughout their range. They have adapted to most habitats and can reach relatively high densities where their mainly rodent prey is abundant. Areas of highest densities lie along the south coast of South Africa, where the four-striped grass mouse and the vlei rat can reach super-abundance. These rodents prefer areas of dense scrub and grass cover, ideal hunting grounds for the puff adder. At one location the authors counted 17 puff adders along a densely grassed riverbank over less than 600 metres; given the nature of the habitat there were surely more.

As is common with the adders, the puff adder bites its prey, releases it and then follows it for a short distance until it collapses and can be swallowed, head first.

The danger with this snake is its reluctance to move away from disturbance. The approach of a human usually causes it to lie motionless, relying on its excellent camouflage to avoid trouble, and not to retreat as many snakes do. It may give a series of warning hisses, or puffs, from which it takes its name. This puffing often gives potential victims time to escape. If a person approaches too closely or, as frequently happens, treads on the snake, it draws the front part of its body into an S-shape ready to strike. The strike is sudden and swift. The fangs, 10 to 18 millimetres long, inject 100 to 350 milligrams of venom with a single quick-release bite. Following a bite, the victim will experience pain, swelling and blistering. Lymph glands become very sore. If treated correctly, necrosis and tissue damage may be limited, but this can be severe in badly treated cases. Perhaps as many as 10 % of puff adder bites result in death after two to five days – usually from inadequate or incorrect treatment of the patient.

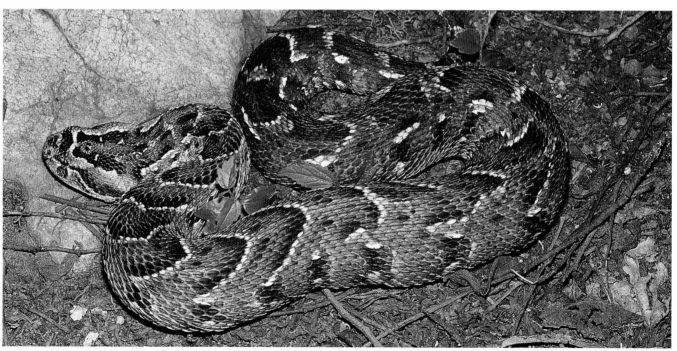

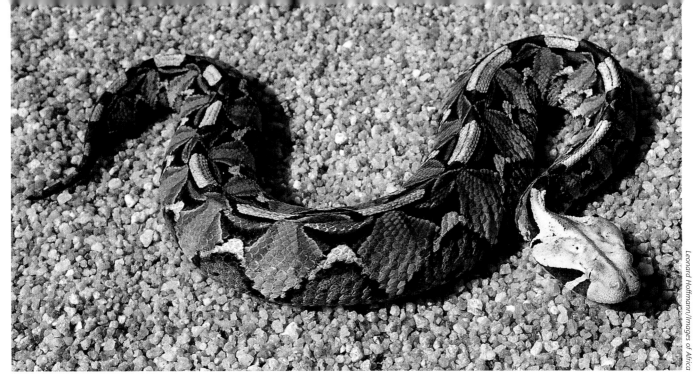

Gaboon adders are seldom seen, despite being common in some regions.

Leonard Hoffmann/Images of Africa

Gaboon adder

Although the gaboon adder (*Bitis gabonica*) is widespread through the African tropical forest belt, this large, colourful snake is only found in a few small, isolated forest blocks in southern and eastern Africa, where they average 1.2 metres in length. In West Africa they can reach a very respectable two metres. This large snake has its principal range across the Congo Basin and the tropical forests of West Africa. The head is proportionally large and the poison-delivering fangs can be 40 millimetres long, but have been measured at 55 millimetres along the curve. In fact, everything about this snake is big, and it can deliver as much as 600 milligrams of venom in a single bite.

The gaboon adder is intricately and colourfully patterned, allowing it to 'disappear' from view among dead leaves on the forest floor. Although this snake feeds primarily on rodents, larger specimens will take prey up to the size of genets and mongooses.

Few bites on humans are recorded, but bites should be taken seriously and treated promptly to avoid inevitable death. Even with treatment, serious tissue damage may result and limb amputation may be necessary. This snake is placid and rarely bites, even when trodden on accidentally.

The gaboon adder has a very limited range south of the tropical forest belt, but has a wide distribution within the Congolean and West African forest belt, where it may reach quite high densities, as does its close relative the rhinoceros viper (*B. nasicornis*).

BITTEN BY A BERG ADDER

The berg adder (*Bitis atropos*) is restricted to a few isolated locations in South Africa and eastern Zimbabwe. Unlike most other adders and vipers, this snake has neurotoxic venom. Biologist Guy Palmer caught one for research purposes in March 1971 in the mountains above Hermanus, Western Cape. It was cold, windy and wet, yet the snake was extremely active. The following day the 45-centimetre adder gave birth to 12 young.

In a moment of carelessness Guy was struck by the snake. Initially, he felt no unusual pain. 'After ten minutes my finger started to swell and I felt as though I was about to faint. My eyes could no longer focus and I went pale,' he said. He felt a slight loss of balance as he was walking into the Stellenbosch Hospital. The first anti-venom was administered intravenously and consequent doses were given intramuscularly.

By the following morning his entire arm was extremely swollen and the elbow joint was immovable. The glands in his armpit were swollen and tender, and the inside of the upper arm and the front of the forearm were extremely painful. After five days the swelling decreased and the arm was almost back to normal, although the finger remained swollen for almost four weeks. The blurred vision was gone after six days. 'Four days after the accident, I got out of bed for the first time and felt extremely unsteady. This feeling continued for another five days,' Guy said. It is now known that no available anti-venom is effective against the neurotoxic venom of the berg adder.

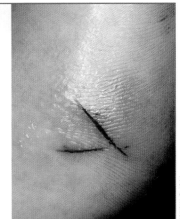

The site of a bite wound inflicted by a berg adder. Anti-venom should not be administered for bites by this snake as it is not effective and could be dangerous.

Prof G Müller

Rhinoceros viper

One large and heavy relative of the gaboon adder is the rhinoceros viper (*Bitis nasicornis*), which takes its name from the horn-like structure on the tip of its snout. It can grow to a length of 1.2 metres and has a similar distribution to the gaboon adder, but is not found outside the tropical forest belt. The rhinoceros viper also has intricate patterning and coloration that make it all but invisible among the leaf-litter of the forest floor.

Some reports state that it has the loudest hiss of any African snake. As with most adders and vipers, it is a lie-and-wait predator, relying on camouflage, then lunging at passing prey, which includes a range of small mammals, as well as amphibians. It has a fairly high venom yield of some 200 milligrams, but it is considered to be slightly less potent than that of either the gaboon or puff adders – though that is not much consolation if you are bitten. As with the gaboon adder, the rhinoceros viper is not considered to be particularly aggressive.

Bush vipers

A group of nine species known as bush vipers, in the genus *Atheris*, have several members that spend their lives in trees, although two spend much of their time on the ground. All species are small (less than 80 centimetres in length) and their body scales are strongly keeled. Only the green bush viper (*Atheris squamiger*) is known to have caused a human death. This is mainly a species of the forests of the Congo Basin. Because of their habitat and cryptic coloration they are seldom encountered.

DANGEROUS EXOTIC SNAKES

As if South Africa did not have enough venomous snakes of its own, collectors and dealers sometimes illegally import snakes from other regions. For many of them, anti-venom is not available locally – a problem in the event of a bite.

In May 2007, environmental management inspectors (Green Scorpions) seized 13 venomous snakes (of which 10 were exotics), which had all been sent by ordinary parcel post from Australia and the Czech Republic. The snakes were identified as taipan (a subspecies from New Guinea that can deliver deadly bites), Palestinian saw-scaled vipers, a Nubian spitting cobra and a monocle cobra from Asia. A potentially disastrous situation could have arisen if the flimsy packaging had been damaged and the snakes had escaped.

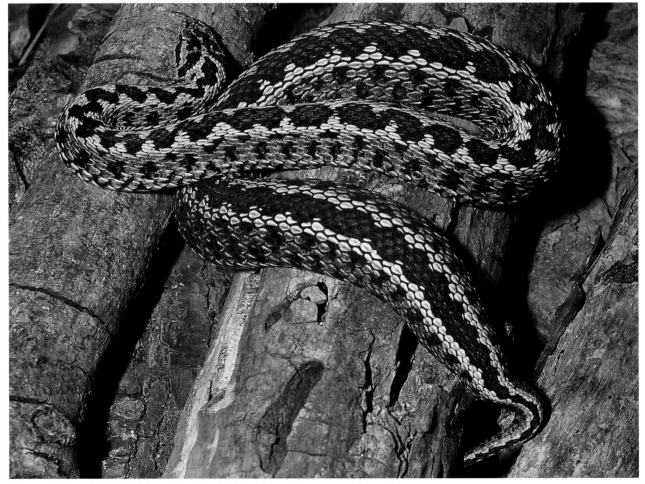

Hungarian meadow viper (Vipera ursinii rakosiensis), *a venomous exotic species.*

SNAKE FACTS

(fang-length measurements are made by different researchers)

SPECIES	TOTAL LENGTH	FANG LENGTH	VENOM TYPE	VENOM YIELD	FATAL DOSE
Boomslang	1.4–2 m	6 mm (2.5 mm)	Haemotoxic	1 mg	1 mg
Snouted cobra	1.3–1.8 m	8–10 mm (5.5 mm)	Neurotoxic	175–300 mg	25–35 mg
Forest cobra	1.5–2.7 m	6.5 mm	Neurotoxic	Up to 500 mg	Uncertain
Cape cobra	1–1.5 m	5 mm (1 specimen)	Neurotoxic	120–250 mg	15–20 mg
Mozambique spitting cobra	0.8–1.3 m		Mainly cytotoxic	200–300 mg	40–50 mg
Black-necked spitting cobra	1.5–1.8 m	6 mm	Neuro- and haemotoxic	200–350 mg	40–50 mg
Rinkhals	1–1.2 m	4 mm	Neurotoxic	120 mg	50–60 mg
Black mamba	2.2–2.7 m	3–6 mm	Neurotoxic	100–400 mg	10–15 mg
Green mamba	1.8–2.7 m	6.5 mm	Neurotoxic	60–100 mg	15 mg
Puff adder	0.7–1 m	12–18 mm (10–14 mm)	Cytotoxic	100–350 mg	100 mg
Gaboon adder	1.2 m	Up to 40 mm (29 mm)	Cytotoxic	450–600 mg	90–100 mg

Carpet vipers

The carpet vipers, in the genus *Echis*, comprise four species known to occur in Africa, all to the north of the equator. Most measure less than 90 centimetres and they have pear-shaped heads and small eyes. Although all have cryptic coloration they can be distinguished by their threat display, when they form C-shaped coils with their body, and rub their scales together to create a hissing sound. (Interestingly, the harmless common egg-eater has the same threat display as the carpet vipers and often bears a strong resemblance to them.)

For such small snakes, they have very potent venom and are responsible for many snakebites. The northeast African carpet viper (*Echis pyramidum*) is known from Egypt and Sudan to northern Somalia, with a few outlying populations in Kenya. West African carpet vipers (*E. ocellatus*) are responsible for many snakebites in that region, but exact figures are unknown. Anti-venom is available. This is the only African carpet viper that occurs in well-wooded areas and forest margins. The white-bellied carpet viper (*E. leucogaster*) occupies more arid areas of West Africa and extends to the southern Sahara fringes. Painted carpet vipers (*E. coloratus*) in Africa are only known from the Red Sea Hills and the Egyptian Sinai but occur widely through the Arabian Peninsula.

Desert vipers

There are three species of desert viper, all in the genus *Cerastes*, which occupy the desert lands. Because of the inhospitable habitat and low human populations, bites, and corresponding deaths, are few. As with most vipers and adders, their venom is cytotoxic.

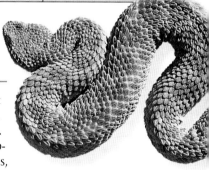

The Sahara sand viper is found in sandy areas.

Two species occupy a variety of habitats, but the Sahara sand viper (*C. vipera*) is largely restricted to sand areas. It frequently buries itself in the sand, leaving the black tail tip exposed, probably to lure lizard prey. The Sahara horned viper (*C. cerastes*) and Arabian horned viper (*C. gasperettii*) are distinguished by 'horns' on the head, formed by one or more scales.

Five species of viper within the genera *Vipera* and *Macrovipera* occur in far northern Africa, associated with the Mediterranean seaboard and the Atlas ranges, but they are poorly known and little studied. The three *Macrovipera* species in particular should be treated with caution because of their large size (1–1.8 metres).

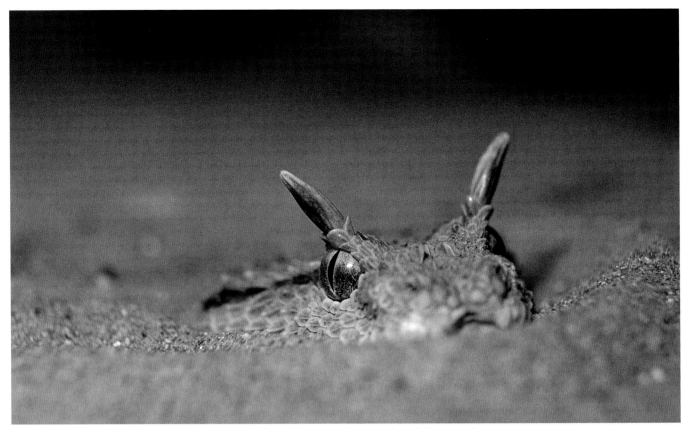

Saharan horned vipers are common across North Africa, occupying desert and semi-desert environments.

⚠ Avoiding trouble

No snake is normally inclined to attack anything it cannot eat or against which it doesn't need to defend itself. Most cases of snakebite involve people inadvertently standing on snakes in dense vegetation, or walking at night without adequate footwear. Many others result from acts of bravado, stupidity, fear and straightforward carelessness.

- Leave snakes alone and in nearly all cases they will leave you alone. Unless you know snakes well, never try to catch them. Remember that even experienced snake handlers are sometimes bitten.
- Get to know the snakes that occur in your home area and learn about their behaviour. Knowledge not only helps us to avoid trouble, it also dispels our fears.
- Make sure you do not have piles of wood, rubbish and open compost heaps in your garden that might encourage snakes to set up home. Drystone walls offer ideal retreats for several snake species. Dense vegetation near doors and windows can also encourage unwelcome visitors.
- External doors should be relatively tight fitting and kept closed; in the case of stable doors, keeping the bottom closed is sufficient. If you encounter a snake in the house call an experienced snake handler or other local authority.
- If you do encounter a snake, especially a large one, that appears to show aggression (for example, a cobra spreading its hood) remain still and calm. Do not make an attempt to attack it. Invariably

the snake will move away, but if you seem to be in its path of retreat, back away slowly, keeping the snake in sight if possible.

- If you do find yourself in the rare situation where you are forced to kill a snake make sure you do so swiftly and cleanly. An injured snake can be infinitely more dangerous than an unharmed one. One of the few occasions when this could be helpful is for identifying a snake that has bitten someone, thus ensuring swift, targeted treatment in hospital.
- Snake experts, however, advise that people should not try to catch or kill the snake that has bitten them, as this will only place them or their friends in further danger. While positive identification of the snake can be helpful, it ultimately makes little difference in the choice of treatment, which is usually determined symptomatically.
- When walking in bushy or grassy terrain, or in rocky areas, wear boots or strong, closed shoes. Most snakebites occur on the foot, ankle or lower leg.
- It is advisable to step onto rocks, logs, etc, and never over them, which is where a snake may be basking out of sight.
- If you walk about at night, whether in the garden or in the veld, use a torch. If you are collecting firewood, especially at night, be extra cautious.
- Teach small children to leave snakes alone and that they are not animals to be played with, but try not to teach them to fear or hate them.

 # Snakebite

Stay calm and reassure the victim. The priority is to get the victim to a medical facility as soon as possible. If private transport is available at the site, use it immediately; do not wait for an ambulance. Phone or send for help, or phone to warn the medical facility that you are on the way. While you wait for transport or during transport, do the following:

- Try to identify the bite site by looking for fang marks, but do not waste much time over it. Expose the area of the bite by cutting clothing away if necessary.
- Do not rub the bite site or cut into it. Do not apply any chemicals or ice, but remove excess venom, if visible, with plenty of water. Cover the wound with a sterile dressing. (Suction has been shown to be of no benefit, though some authorities recommend it to reassure the victim. A mechanical suction device should be used to protect against HIV infection and because venom might be absorbed through the mucous membrane of your mouth.)
- Never leave the victim alone. Be ready to ventilate or resuscitate him/her at all times.
- Pressure immobilisation with a crepe bandage in known cytotoxic snakebites (such as puff adder, spitting cobras, gaboon adder) will be harmful.
- Bandaging is only recommended for bites by snakes with neurotoxic venoms (cobras, mambas). Apply a crepe bandage around the limb well above the bite site – that is, between the bite site and the trunk because this might slow down the progress of the venom. Do not cover the whole limb. Do not waste time on this and do not delay transporting the victim to hospital.
- Do not apply bandaging to the head, neck or trunk.
- The first signs of general poisoning are drooling, nausea and vomiting, blurred vision, dilated pupils, weakness or paralysis of an arm or a leg, and difficulty in breathing. If necessary, ventilate or perform full cardiopulmonary resuscitation (CPR) on the victim until you reach medical care. This may be the only way to save their life.
- Anti-venom is not a first aid measure, but will be given in a medical facility if deemed necessary.

Important to remember:
1) **immediately transport the victim to a medical facility, and**
2) **be prepared to administer mouth-to-mouth resuscitation to the patient.**

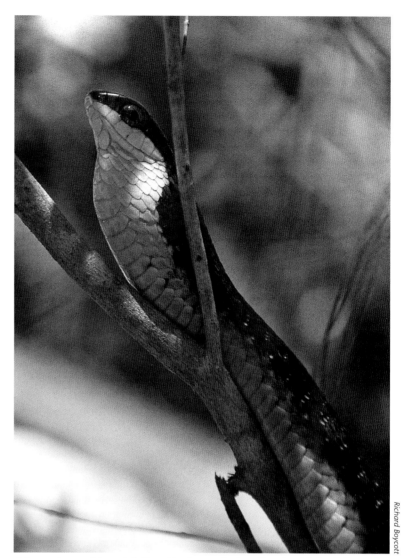

Richard Boycott

A boomslang with neck inflated in threat display. Bites by this back-fanged snake are rare but can be deadly.

Gaboon adders are denizens of the forest floor, where they blend superbly with fallen leaves.

TOADS AND FROGS

Africa is home to some 850 species of amphibian, of which 155 are known to occur in southern Africa and more than 200 in East Africa. Contrary to myth, touching toads does not result in warts, but many frogs and toads have glands that secrete toxins to ward off predators. The study of these skin toxins is very much in its infancy in Africa and in most regions of the world.

Reactions to skin toxins

When licked or swallowed, most of these toxins cause reactions with saliva and mucous membranes, leading to foaming of the mouth, as sometimes seen in dogs. Other side effects include vomiting and lowering of blood pressure. These skin toxins are often copies of mammalian hormones and include such components as peptides, amines, proteins and steroidal alkaloids. Contact with these toxins induces an aversive conditioning, or 'never touch me again' effect. In at least one African frog, the red-legged kassina (*Kassina maculata*), as little as one millionth of a gram of toxin per predator kilogram is enough to repel predators. Toads, with their rough, warty, glandular skin and large parotids (or toxin glands), are particularly well protected, especially from mammalian predators. Minute quantities of the toxin regularobufogin, from the guttural toad (*Amietophrynus [Bufo] gutturalis*), causes cats to vomit violently and often die. The water mongoose has learned how to deal with this problem. It flips a toad on its back, opens the belly, where there are no toxic glands, eats the inside and discards the rest.

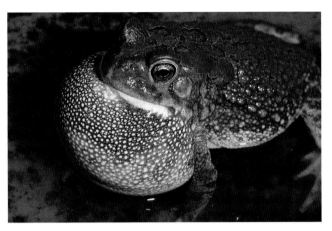

ABOVE: Male frogs and toads advertise their presence to females by calling, and a cacophony of sound can result. BELOW: A pair of mating raucous toads (Amietophrynus (Bufo) rangeri). These toads have particularly large and well-developed parotid (toxin) glands that run from eye to shoulder.

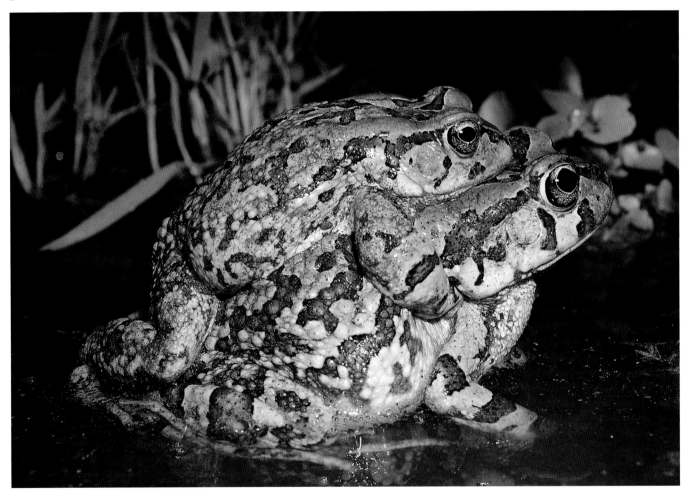

The poison-arrow frogs (family Dendrobatidae) of South America produce potent toxins and are good examples of how dangerous amphibians can be. Although they measure little more than 25 millimetres in length, their secretions smeared on arrowheads or blowpipe darts will paralyse large forest monkeys.

Frogs and toads also have other skin secretions, such as anti-microbials, that could be of benefit to the human pharmacopoeia.

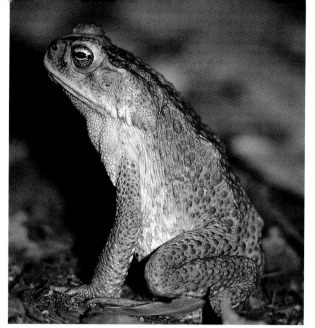

It is fortunate that the cane toad (Bufo marinus) has never touched down in Africa. In Australia, where it was introduced, it has eaten and poisoned its way across the tropical areas. This toad's skin secretions are so toxic that one ingested toad is enough to kill animals as large as a three-metre crocodile or equivalent-sized python.

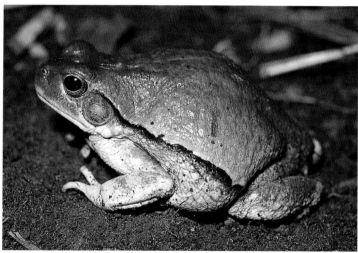

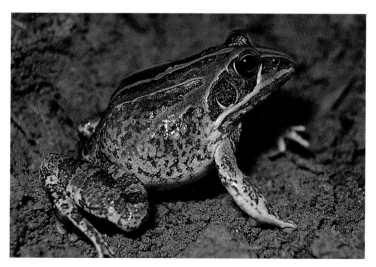

Crab cunning

In a small stream outside Lusaka, Zambia, the authors watched a gathering of hundreds of breeding flat-backed toads. Large freshwater crabs were catching toads, mainly the females, and tearing open their bellies to feed on the internal organs as well as the eggs. Obviously the belly was easier to open with the pincers, and belly skin was eaten, but the backs and sides were left untouched. It is hard to say whether this was a case of 'knowing' that the back was distasteful, or just the way the crabs normally feed. There are certain snakes that eat toads readily but show no ill effects.

⚠ Avoiding trouble

- There is certainly no need to be afraid of these amphibians; to avoid trouble, leave them alone and they will be happy to leave you alone too.
- If you have handled toads or frogs, wash your hands and do not rub secretion-smeared hands across your eyes or mouth. The effects can be unpleasant, but you will certainly not die from the experience.

TOP LEFT: The banded rubber frog (Phrynomantis bifasciatus) produces highly toxic skin secretions, which are advertised by the bright markings.
MIDDLE LEFT: Despite having toxic skin secretions, the red toad (Schismaderma carens) is the favourite prey of several snake species.
BOTTOM LEFT: The skin secretions of the ornate frog (Hildebrandtia ornata) have not been analysed.

SCORPIONS

Africa has a rich diversity of scorpions *(Scorpiones)*, especially in drier habitats; but the scorpions of southern Africa – almost 10 % of the world's 1 500 known species – are better documented than those further north. Scorpions occupy nearly all geographical regions, from sea level to mountain ranges, low- to high-rainfall areas, forests to deserts. Although commonly thought to be desert creatures, and they certainly reach their greatest diversity in arid areas, they have adapted to most conditions. They spend up to 95 % of their time hidden in burrows, under rocks, in crevices or among vegetation.

Scorpion evolution

Scorpions belong to a class of invertebrates known as arachnids, which includes, among others, spiders, sun spiders, whip spiders and ticks. All arachnids have four pairs of legs, compared with the three pairs borne by insects and, unlike many insects, no arachnids have the power of flight.

Early scorpions were aquatic arachnids, reaching lengths of up to one metre. Some 350 to 325 million years ago they started to migrate onto land. Over this period of several hundred million years, their form and structure has hardly changed. Obviously the pattern for success was already in place from the beginning. The body plan of the scorpion is very similar in all species, with variations mainly in appearance. All carry a pair of pincers (chela) that are modified appendages known as pedipalps, have eight legs as in all arachnids, and a long jointed tail with a needle-sharp sting in the last segment.

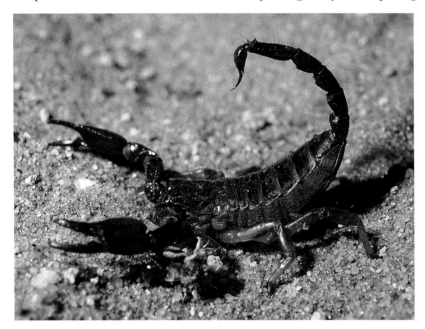

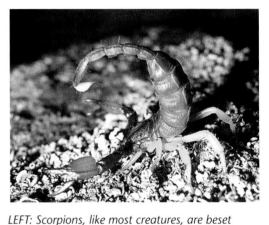

LEFT: Scorpions, like most creatures, are beset by parasites.
ABOVE: A scorpion in full defensive posture, with abdomen held clear of the ground.
BELOW: The Opistophthalmus *scorpions, the largest of which may reach a total length of 18 cm, can deliver an unpleasant but not life-threatening sting.*

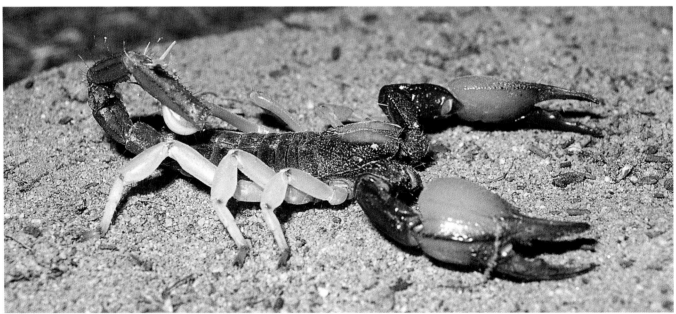

Thick- and thin-tailed scorpions

The scorpion tail is more correctly known as the telson, and the tip of the last segment has a slightly curved, needle-sharp sting.

Every scorpion has a pair of venom glands. Their venom is complex and made up of several different neurotoxins; drop for drop, it is equivalent to that of the most poisonous snake.

Scorpions with heavy pincers can usually overpower and crush their prey without resorting to venom – these are the thin-tailed scorpions. Thick-tailed scorpions, with weaker pincers, usually grasp their prey and immediately inject venom to subdue it. This enables smaller scorpions with potent venom to kill prey that may be several times their own size.

Venom is also put to use in defence against predators or a perceived threat – though, unfortunately for the scorpion, some mammalian predators like the honey badger and suricate (meerkat) are wholly or partly immune to scorpion venom. The males of some scorpion species even use venom to subdue a female mating partner. After she is stung she becomes more placid, but little is known about this aspect of scorpion behaviour.

Southern Africa's most venomous scorpions belong to the genus *Parabuthus*, and some of these can kill humans. The two most medically important are *P. granulatus* and *P. transvaalicus*, but several others have the potential to cause human casualties. All scorpions in the region have neurotoxic venom that is painful, in varying degrees, at the site of the sting, and can be extreme in the case of *Parabuthus* and *Hottentotta* species. *Hottentotta* and *Uroplectes* are responsible for very painful stings but are not of further medical importance in southern Africa, although *Hottentotta* stings require urgent medical attention in North Africa, where respiratory failure is a potential risk.

No accurate figures are available for human deaths or serious illness as a result of scorpion stings in Africa. Mortality is probably very low but stings by a range of species are frequent. It is estimated that scorpions kill around 5 000 people worldwide each year. Children and the elderly are the most vulnerable, but all stings should be taken seriously – especially because there is always a risk of serious allergic reaction.

Ansie Dippenaar-Schoeman

Ansie Dippenaar-Schoeman

Norman Larsen

Randy Mercurio (courtesy L Prendini)

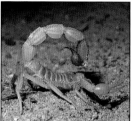
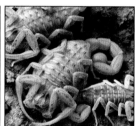

Parabuthus granulatus *Parabuthus transvaalicus* *Parabuthus villosus* *Parabuthus capensis* *Hottentotta* spp.

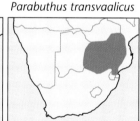
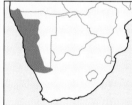
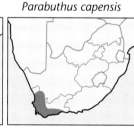

■ *H. trilineatus* ■ *H. conspersus*
■ *H. arenaceus*

REMOVING SCORPIONS

When we lived on an isolated farm on the western escarpment of South Africa, *Opistophthalmus* scorpions regularly entered the house in the evenings during summer months. Initially we caught and carried them outside, but we soon got used to them and knew they would disappear under the skirting boards or find their way back outside. Sometimes if they were alarmed they produced a hissing sound by rubbing the bristles on the inner surface of the mouthparts against ridges on the underside of the carapace.

Only twice did we hear a 'sound to scare', a distinctive 'tik-tik' produced by *Parabuthus*. They produce this sound by rubbing the rough upper surface of the first two or three tail segments with the sting. So the adage is if it hisses carry on reading; if it goes 'tik-tik' catch it carefully and take it outside.

They can safely be removed with braai tongs or long forceps. Although it is possible to pick up less venomous species by the tail and carry them outside, this is not recommended because of the risk of an allergic reaction following a sting.

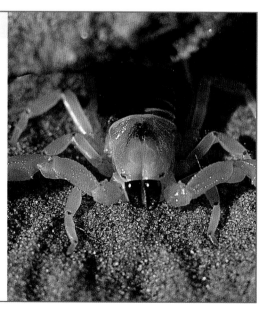

Scorpion records

Southern Africa can claim at least two records in the scorpion world: the world's longest scorpion, the male of *Hadogenes troglodytes,* at 210 millimetres from mouthparts to sting; and the largest member of the highly venomous Buthidae family, *Parabuthus villosus,* which can grow to a total length of 180 millimetres. The latter is one of the very few diurnal scorpions, and occurs throughout western Namibia and in the extreme northwest of the Northern Cape in South Africa. Despite its size the giant *Hadogenes troglodytes* is only mildly venomous, but *P. villosus* could kill with its potent venom.

The scorpion 'dance'

During spring and summer male scorpions go out in search of females with which to mate. Although the process is not fully understood, it appears that the female gives off a pheromone that helps the male in his quest. The male produces vibrations by beating his tail against the ground or tapping his pincers, thus indicating he is a mating partner and not a potential snack. The male locks on to the female's pincers with his own pair, or in some cases they may lock mouthparts. He moves her until he finds a suitable substrate where he can deposit his spermatophore (sperm sac). He positions the female over the spermatophore; she spreads her genital cover and sperm is released on contact. The male is known, sometimes, to end up as the female's post-coital snack.

The gestation period of some scorpions is surprisingly long. In *Hadogenes,* for instance, it is up to 18 months, compared with the 22 months of the African elephant. Scorpion young are born alive and for their first few days of life they are carried on the back of the female, who will protect them vigorously from potential predators.

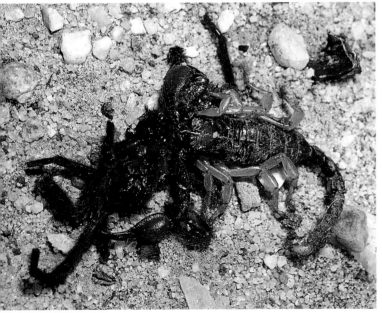

ABOVE: Scorpions are able to subdue prey equal to, or larger than, themselves. Here an Opistophthalmus *scorpion nips off the legs of a baboon spider.*
TOP RIGHT AND RIGHT: The most venomous scorpions are characterised by slender pincers and thick tails.

⚠ Avoiding trouble

- Scorpions with large pincers and slender tail are generally not dangerous to man, but they still have venom, and should be treated with respect.
- Scorpions with small pincers and robust tail can be dangerous to man, and some can kill.

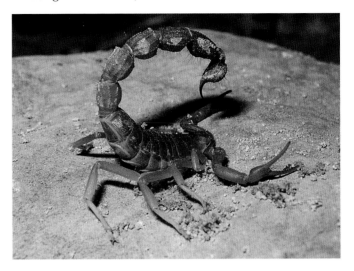

✚ Scorpion stings

- If you suspect a sting by one of the scorpions in the family Buthidae – fat tail, slender pincers – take the patient to a medical facility as soon as possible for observation (which may be necessary for up to 48 hours). Children, in particular, can be affected rapidly by scorpion venom, and it may be deadly. Parabuthid scorpion anti-venom is available in well-equipped facilities. Some private practices in areas where scorpions are abundant hold anti-venom.
- If stung by one of the less venomous scorpions (thin tail, powerful pincers), hospitalisation is not usually necessary, although there is always the risk of allergic reaction. Clean the wound, cover it with a sterile dressing and immobilise the affected part. Apply crushed ice wrapped in a cloth to the sting site early – it may be refused later by the patient because hyperaesthesia (extreme sensitivity to touch) develops.
- Take painkillers such as aspirin or paracetamol.
- Get a tetanus shot if your tetanus vaccination is not up to date.

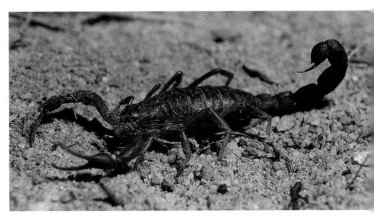

SPIDERS

Like scorpions, sun spiders, whip spiders and ticks, spiders are arachnids. Their ancestors are thought to have emerged from the sea some 374 million years ago. The spiders across much of Africa are still poorly known and not comprehensively documented; even in southern Africa, new species are regularly recorded, and it is likely that many more await discovery. Today as many as 3 000 species of spider (Aranaea) have been recorded in almost every geographical niche in southern Africa and at least 1 900 in South Africa. Spiders roam sand desert and mountains, forest and cave, they share our homes and workplaces, live underground, on the surface, cling to walls and some even live partly underwater. All are expert hunters, some using intricate traps in the form of webs while others roam in search of prey, relying on skills of detection and attack.

Many shapes and sizes

Spiders are so diverse in structure, form and habits that they should perhaps be seen as many different creatures. All spiders share a common basic structure with head and thorax fused into one (the cephalothorax, or prosoma) and an abdomen. The four pairs of jointed legs are located on the thorax. To the front of the head there is a pair of pedipalps, which are sensitive organs of touch and in some species are so well developed that they resemble a fifth pair of legs. The spider's abdomen contains most of the vital organs, and near its tip are the silk glands and spinnerets that produce 'silk'.

Most spiders have eight eyes but some have just six, four, two, or even no eyes. The layout and size of the eyes give clues to their identity. The group known as 'jumping spiders' have two enlarged front eyes, which give them an almost mammal-like appearance.

What danger do spiders present?

All spiders have needle-sharp fangs and all, with the exception of members of the Uloboridae family, produce venom, most of which is harmless to man. Venom output is minute and most spiders cannot bite humans because their fang-tipped chelicerae are too small to pierce human skin. But, as with all things, there are exceptions; a few can kill and others are capable of producing long-standing ulcerating sores that may require plastic surgery to repair. The venom toxicity to man for most of the subregion's spiders is unknown and little research is being carried out in this field, largely because of the difficulty of collecting spider venoms and the expense of analysing them. In South Africa, the only spider against which anti-venom is available is the button spider.

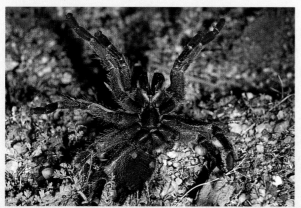

A baboon spider (family Theraphosidae) in threat posture, clearly showing the large fangs.

Burrowers or hunters

Arachnologists have divided spiders into two major groups, the mygalomorphs ('formed like mice') and araneomorphs ('formed like spiders').

The mygalomorphs incorporate the baboon spiders or tarantulas, which are distinguished by their dagger-like downward-striking fangs, two pairs of breathing apparatus known as 'book lungs' and the fact that they spin silk only to build or line permanent homes, in the form of burrows. In some species they also construct a protective lid to the tunnel. These are sit-and-wait hunters that seldom move far from the home burrow, although males do wander in search of female mates.

The araneomorphs are considered to be more advanced than their mygalomorph cousins. They have only one pair of 'book lungs', and their chelicerae/fangs have a pincer-like

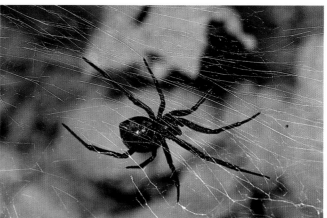

False button spiders (family Theridiidae; Steatoda sp.) are often mistaken for venomous button spiders but are smaller and have slightly different coloration.

Norman Larsen

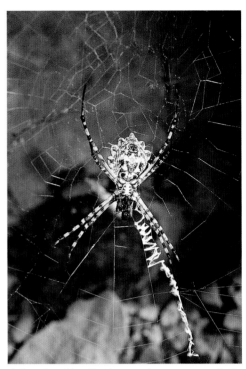

The web-and-leaf brood nests of harmless rain spiders (Palystes sp.) are common in bushes and trees.

Newly hatched nursery-web spiderlings (Pisauridae) will remain within the web until they are ready to disperse.

Orb-web spiders (Argiope sp.) construct typical spiral webs and are found in many different habitats, including suburban gardens.

appearance. They can be divided broadly into two separate groups, the weavers and the ground hunters. The hunters include species that are arboreal, living and hunting in grass, shrubs and trees. Weavers spin sticky webs and wait for their prey to ensnare itself. These are the spider webs, of infinite variety and form, that we find on vegetation or fences and in the corners of our living rooms and garages. Hunting spiders are the arachnid version of the wolf, cheetah and jackal, relying on stealth or speed – or both – to overpower and kill their prey. They do not spin webs to ensnare their meals, but may spin a small web as a temporary protection/ retreat, or females may construct cocoons for their eggs and young.

None of the orb-web, or classical, spiders are known to be venomous to humans, even the largest specimens. But some species, among both the mygalomorphs and araneomorphs, are venomous, as well as possibly dangerous to humans. In southern Africa very little research has been done on spider venom, and even less elsewhere on the continent, although the venom of several spiders has been implicated in severe toxic reactions.

Spider soup

Although insects make up much of the prey of spiders, some spiders will snack on other spiders, and others will eat small vertebrates such as geckos and frogs. Some have even taken to 'angling' for small fish.

This is where spiders bring their venom into play. Venom is produced in twin glands. Spiders cannot chew their prey so they have evolved a way of pre-digesting the innards of the prey by regurgitating digesting enzymes into fang puncture holes. The resulting 'tissue soup' is then pumped and sucked down into the spider's main gut, where it goes through the final digestive processes. This would be akin to our injecting a prime steak with hydrochloric acid and then sucking up the resultant soup through a straw. Prey items captured by most of the web-weaving spiders retain their outer form once sucked dry, but those taken by the mygalomorphs and hunting spiders are generally crushed and broken as each drop of organ soup is squeezed out.

Lifespan

The majority of spiders have a lifespan of only a year or less, but some trapdoor and funnel-web spiders can live for 16 to 25 years in captivity. Male baboon spiders mature in about 12 months and die shortly after mating; females mainly mature at between 18 months to three years. In many of the spiders, especially the weavers, the male is much smaller than the female and frequently bears no resemblance to her. These differences are sometimes so great that in the past related males and females have erroneously been classed as being from entirely different species.

A growing spider will moult from three to 10 times, shedding its skin in its complete form. These are the 'skeletons' you see hanging in the corners of your home. During the hours immediately following the moult, before its exoskeleton has hardened, a spider is at its most vulnerable to predators and desiccation, and will take cover. If a spider loses a leg, a new one will grow after the next moult – a useful evolutionary advantage.

A male spider must be cautious when approaching a female in order to mate, because he can easily end up as a pre- or post-coital meal. The trick is to fertilise her eggs before he becomes a potential meal. Males of different species have evolved interesting ways of controlling their mating partners. Some tie their mate down with silk, transfer sperm and then leave her to struggle free of her own accord; others wait until she is pre-occupied with a

meal, or mesmerise her with an elaborate 'dance' that involves waving the sperm-laden palpi. Some take their chance while the female is moulting and others develop spines and hooks on the legs so they can take a firm grip to transfer their sperm.

Before finding a suitable mate, the male spider spins a small silken pad onto which he deposits his sperm. He then draws the sperm into the swollen tips of his pedipalps. He approaches the female in a cautious process that may take minutes or even hours. Once she is ready to receive him, he dashes in and transfers the sperm from his palps to an aperture in her abdomen. Then comes the tricky bit – escaping without being eaten.

The female spider lays her eggs in a silken den that may be fixed to almost any surface, or in a ball that she may carry with her to protect it from predators. Female spiders of most araneomorph species lay large numbers of eggs in silken nurseries and then leave them to their fate, so few nymphs/spiderlings survive to adulthood. The mygalomorphs, however, lay few eggs, which benefit from the shelter of their mother's den and, on hatching, may remain with her for several months, sharing her food.

Young spiders disperse in a variety of ways. The funnel web and trapdoor species' young establish their own dens nearby. Many spiderlings of the web-weavers and some of the ground hunters disperse on air currents: they climb to a vantage point – the tip of a grass stalk or a twig – and exude strands of silk that are caught by the breeze or rising warm air, carrying the small arachnid up and away. After a major hatching, 'clouds' of glistening silk catch the light and make a spectacular sight. This gossamer riding, known as 'ballooning', may carry the spiderling a mere 100 metres or as much as 300 kilometres from its hatching site. At this time they are particularly vulnerable to the attentions of aerial predators.

SILK OVER STEEL

All spiders have the ability to make silk. It is produced in liquid form in special glands and then extruded through spigots at the ends of their spinnerets, where its diameter is regulated. It passes through an 'acid bath' of sorts and is released as a water-insoluble, dry, hardened silk. The number of silk-producing glands varies with the species, ranging from three to six.

Some spiders, such as the web-weavers, have separate silk glands that can produce either dry or sticky strands. Spider spinnerets have numerous spigots and each produces a strand of silk. The spinnerets can also contain up to three different types of spigots, producing three different types of silk. In many species the hind legs come equipped with special bristles that aid in laying and spacing the silk.

An amazing feature of this fine silk is its extraordinary strength. Tests have shown that steel 'thread' of the same thickness as the silk is weaker and cannot stand up to the same stresses. Anyone who has walked into the web of a large orb spider can testify to the strength of the web, and the difficulty of getting untangled. It has been estimated that spider silk (of average thickness) long enough to encircle the world would weigh less than 200 grams.

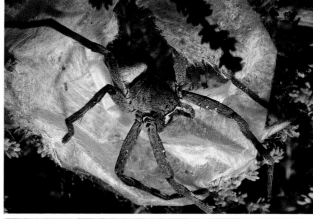

Spider webs come in different forms:
ABOVE LEFT: Theraphosid spiders live in silk-lined burrows.
ABOVE RIGHT: A female rain spider (Palystes sp.) *guards her silken egg-cocoon.*
RIGHT: A female black button spider (Latrodectus indistinctus) *with a freshly spun egg-cocoon.*
FAR RIGHT: The classic silk spider web.

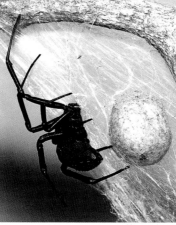

Norman Larsen

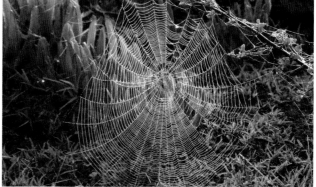

Neurotoxic spiders
Button spiders

Known as button spiders in southern Africa, these creatures go by names such as red backs, night stingers and black widows in other parts of the world. Despite their small size, their potent neurotoxin is feared.

Six species of *Latrodectus* button spider are known in southern Africa. Although the black button spider (*L. indistinctus*) is considered to be the subregion's most potently venomous spider, all four of southern Africa's black button spider species and two brown button species should be considered equally venomous. Many bites occurred in the days when grains were harvested by hand, and sheaths were carried over the shoulder. During this time a number of deaths were attributed to spider bites. The black button spider is the only spider for which anti-venom is available. Its venom is virulently neurotoxic and a bite seriously affects the human respiratory function. In southern Africa the black button spider is seldom found in homes and gardens.

Karoo black button spider
Latrodectus karrooensis

East coast black button spider
Latrodectus cinctus

Transvaal black button spider
Latrodectus renivulvatus

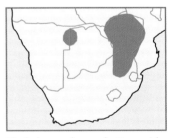
Zimbabwean brown button spider
Latrodectus rhodesiensis

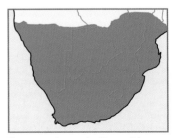
Brown or house button spider
Latrodectus geometricus

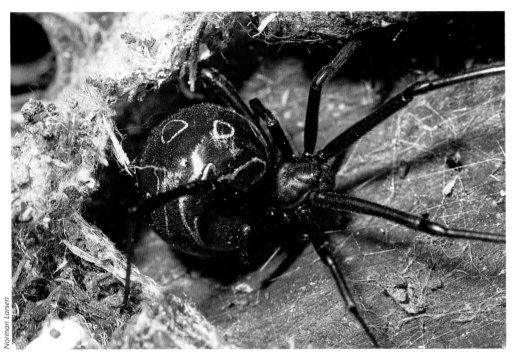

Norman Larsen

Brown or house button spider (Latrodectus geometricus) *in its retreat under bark.*

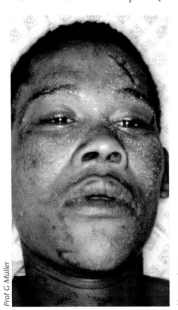

Prof G Müller

Black button spider bite victim.

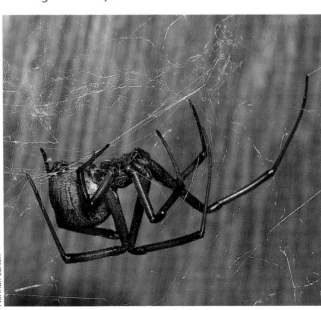

Norman Larsen

Button spiders build untidy webs anchored with guidelines.

Black button spider

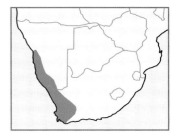

Family: Theridiidae

Size: 10–15 mm body length, males considerably smaller than females.

Colour: Female dark brown to black with rounded abdomen and distinctive red to orange mark/markings on dorsal surface, often with white speckles; if markings on ventral surface are in an hour-glass pattern it is either the brown button spider (*L. geometricus*) or Zimbabwean brown button spider (*L. rhodesiensis*). Male too small to bite humans and less distinctly coloured or marked. The females of the four black button spiders can sometimes be distinguished on the basis of red dorsal markings, but this is not easy due to overlapping variations.

Cape black button spider
Latrodectus indistinctus

Habitat: Rare in human habitation, more a species of bush and grass country. Fairly high densities in grainlands of Western Cape, South Africa. Largely absent from desert. Species most likely to be encountered in buildings is the brown button spider.

Habits: Sedentary web-building spiders; untidy structures usually with an upper retreat and egg chamber and a lower web (often roughly cone-shaped) with sticky strands that ensnare prey. When prey is ensnared the spider binds it with fine silk spread by hair-like extensions on the legs.

Breeding: Egg sacs of the black button spider are round, smooth and off-white or with a pale yellowish tinge; there are usually several in a female's retreat. Each egg sac may contain as many as 200 eggs. The egg sacs of the brown button spider are somewhat smaller and distinctly spiky.

Venom and its effects: Although all of the button spiders have medically important venom, only the black button spider is believed to be potentially life threatening. The venom is neurotoxic and has direct effects on the central nervous system. The victim experiences severe pain and muscle cramping, especially in the legs, there is profuse sweating and blood pressure rises. Anecdotal evidence indicates that fatalities resulting from bites have been recorded in the past; however, since the anti-venom was made available no human deaths are known.

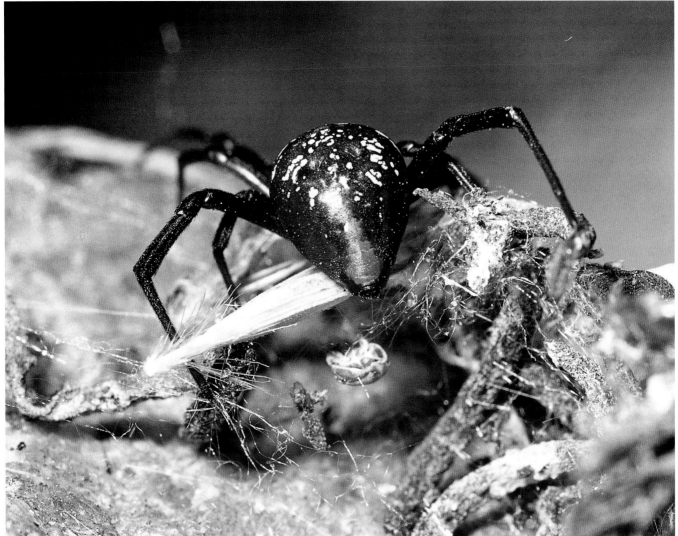

A female black button spider (Latrodectus indistinctus) *showing the distinct red/orange marking at the tip of the abdomen.*

Cytotoxic spiders

Some spiders, known as cytotoxic or tissue-destroying spiders, produce venom that eats away skin and tissue following a bite, at times resulting in such severe damage that surgery is needed. Although the bites often cause considerable stress and long-standing discomfort, they are not considered life threatening so health authorities see them as a low priority in terms of research. Spiders causing this type of wound are referred to as necrotising arachnids. Identifying the tissue-destroying spiders is difficult because bites are often painless initially, and in most cases the culprit is not seen.

Violin spiders

The violin spiders *Loxosceles* species are sometimes mistaken for the harmless daddy-long-legs spider (family Pholcidae). The latter is a web-bound species whereas the violin spider is a free-ranging hunter. Unlike most spiders, violin spiders have only six eyes, not eight. Several species of *Loxosceles* spiders are found in southern Africa, some inhabiting caves and one in open grassland. At least one species (*L. parrami*) is known to have taken up residence in buildings in Gauteng and probably elsewhere. All species are considered to be medically important in southern Africa, but no deaths have been recorded. Bites by American members of the *Loxosceles* genus have caused severe tissue damage and destruction of red blood cells, with some victims eventually succumbing to kidney failure.

Violin spider

Family: Sicariidae
Size: Body 8–15 mm; legspan to 40 mm. Female only slightly larger than male.
Colour: Overall pale brown to reddish-brown with darker violin-shaped marking on thorax. This marking not always particularly clear, but it gives them their common name.
Habitat: Open savanna, sheltering in a range of retreats from under rocks, fallen logs and sometimes in buildings. At least three species occupy caves and sometimes mine shafts.
Habits: A free-ranging ground hunter that is active at night.

■ *Loxosceles* spp. ■ *Loxosceles parrami*

Venom and its effects: Cytotoxic venom is produced and delivered by a painless and superficial bite. After about two hours a red lesion develops at the bite site, sometimes with a dark centre that superficially resembles that of an infected tick bite or blister. Within 24 to 48 hours bleeding at the bite site causes the lesion to darken. Although the swelling subsides by about the fourth day, the area of necrosis continues to spread. Over time an ulcerating sore develops and then heals slowly. Wounds are often unsightly. No anti-venom is available in southern Africa. Experimental anti-venom did not prevent the spread of necrosis in laboratory animals. Victims should seek medical help early. The administration of a tetanus toxoid is recommended for all bites and stings.

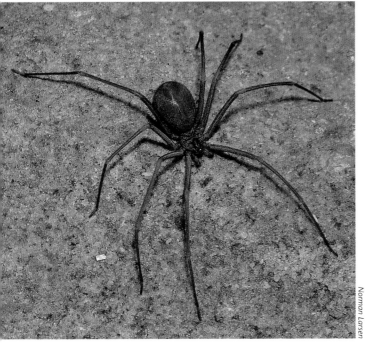

The violin spider is a free-ranging species that hunts on the ground.

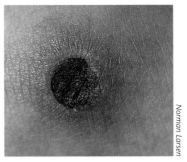

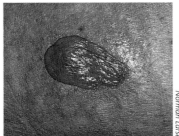
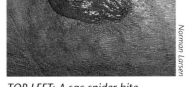

TOP LEFT: A sac spider bite.
TOP RIGHT: A sac spider bite after six weeks.
BOTTOM LEFT: A violin spider bite after three days.
BOTTOM RIGHT: A violin spider bite starting to heal.

Sac spiders

Another group of spiders in Africa that causes necrotic lesions through cytotoxic venom is the sac spiders in the genus *Cheiracanthium*. This group of spiders accounts for the majority of spider bites in the region. Although most species occur in natural habitats, some do 'invade' homes and workplaces. The sac spider most frequently encountered indoors is the long-legged sac spider (*C. furculatum*), which is responsible for some 70 % of recorded South African spider bites. However, all species within this genus should be treated with caution.

The sac spiders take their name from the small, tough silken pouches, or sacs, which they weave to use as daytime retreats. (Similar structures serve as brood chambers for their eggs.) Favourite sites in the home for these sacs are in the folds of curtains, among hanging clothing, or even on washing hanging on the line. Often the first sign of *C. furculatum* is a sac retreat against cornices in houses. Even clothing thrown on the floor for just an hour or two may serve as a retreat. In natural habitats they are found under rocks, in wall crevices, under tree bark and many other sites.

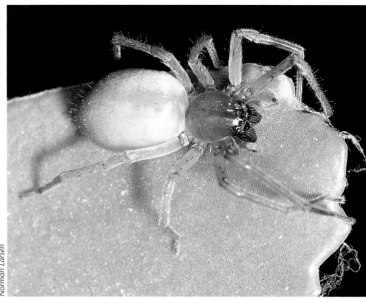

Norman Larsen

Sac spiders are characterised by light coloration contrasting with a black face.

Sac spider

Family: Miturgidae
Size: Bodies 4–16 mm; legspan averages some 35 mm.
Colour: The most important species are generally light in colour, ranging from light brown to cream. The first pair of legs is much longer than the fourth and the chelicerae 'face' is black. This distinguishes it from the similar-looking *Clubiona* spp., in which the first and fourth pairs are roughly equal in length. Both arboreal, but *Clubiona* is not found indoors.
Habitat: Wide range and some species inhabit homes.
Habits: These are aggressive and fast-moving spiders that hunt at night, lunging and grasping suitable victims with their long front legs. They are important predators of agricultural pests.
Breeding: Eggs laid in a silken sac, usually smaller than adult retreat sac.
Venom and its effects: In addition to direct bites on the skin, their relatively long fangs may penetrate thin clothing. Because they generally bite at night when we are sleeping, the spider is frequently not seen or identified. Bites are usually on the head, neck and hands – those parts exposed over the bedclothes. Being aggressive, sac spiders bite readily and may deliver several bites in quick succession. The bites are usually painless and may initially appear as one or two tiny yellow or greenish dots up to 8 mm apart. A bull's-eye lesion may form and will be red, swollen and very painful. From its centre an ulcerating wound usually develops when the two fang marks merge. Tissue around the fang marks becomes necrotic within 24 hours. How this ulcer develops is variable, with some victims suffering minimal effects whereas others may have severe ulceration. In rare cases victims may develop a rash and fever, general aches and pains and tender lymph nodes. As with all envenomations, there is a risk of an allergic reaction. No anti-venom is available. The wound is usually self-limiting and starts healing after 10 days.

Ansie Dippenaar-Schoeman

A sac spider retreat.

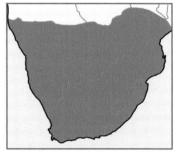

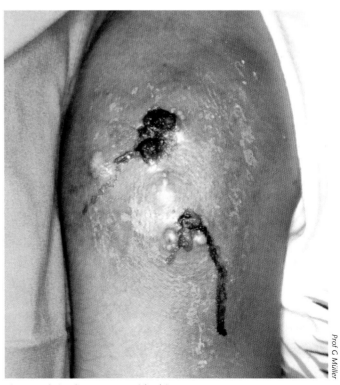

Prof G Müller

A wound site from a sac spider bite.

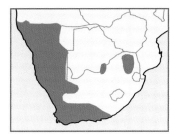

Six-eyed sand spiders

The six-eyed sand spiders (*Sicarius*) are potentially among the most dangerous spiders in Africa, although they are poorly known and occur in areas with very low human populations. They generally live in semi-arid to arid areas, where they often bury themselves in sand. Rather crab-like in appearance, with flattened bodies and six eyes, they are not aggressive spiders and will bite only if severely provoked. Research has shown that a bite by one of these spiders can have serious consequences. Fortunately, only two people are recorded as having been bitten by members of this group of spiders: one died and the other was critically ill. Venom from this spider group that was tested on rabbits resulted in massive tissue damage around the bite site and internal bleeding associated with all of the principal organs. There is evidence that there may be other components in addition to cytotoxic venoms at play. Most of the rabbits in the experiment died within four to 16 hours of envenomation. (In similar experiments, no rabbits died when injected with the venom of either violin or sac spiders.)

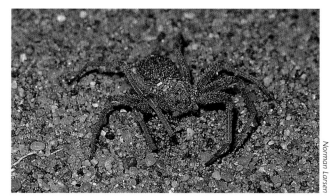

Six-eyed sand spiders occur in semi-arid to arid areas.

Other venomous spiders

Spiders from several families in Africa may still be shown to have venoms that are injurious to humans.

The house funnel-web spider (*Tegenaria domestica*), an introduced species, is known to occur in various parts of South Africa and Namibia, though its venom remains unstudied.

In the family Eresidae, the 'bokspoor' spider (*Seothyra*) is said to be venomous by the Kalahari San people, who crush the spiders and rub them on arrowheads for hunting (although this is unverified). This spider takes its name from the form of its surface web, which superficially resembles the track (spoor) of an antelope (bok).

The baboon spiders (family Theraphosidae) can give a very painful bite and deliver relatively mild venom in most cases, but at least one species, *Harpactirella lightfooti*, from southwestern South Africa, has apparently neurotoxic venom that can be of medical importance. Pain lasts for up to 18 hours after a bite, sometimes spreading to the lymph nodes, but some authorities question the claim of neurotoxic effect.

Our friends and allies

No spiders deserve persecution because in many ways they are our allies in pest control. As so little is known about arachno-venoms it is best to treat spiders with respect and caution and, in the event of a bite, to follow the first aid rules for spider bites. Even some species not known to be venomous to humans can deliver a formidable bite and there is always a risk of allergic reaction.

Much remains to be learned about all aspects of spider ecology, biology and the potency of their venoms in Africa. Wolf spiders are known to deliver a painful bite, or may in future be found to deliver venom that can result in adverse reactions in human bite victims. But we must always remember that, as far as we know, the vast majority of spiders can do us no harm.

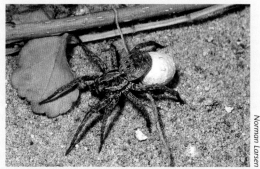

Female wolf spider carrying an egg sac.

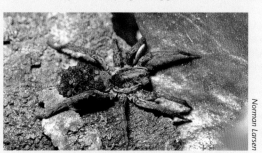

Female wolf spider with newly hatched young clinging to her abdomen.

✚ Spider bites

- Clean and disinfect the wound thoroughly and cover it with a sterile dressing. Do not apply a bandage. Ice is of little value.
- Watch for adverse effects such as headache, localised and perhaps general pain and/or fever.
- If anything more than a local reaction shows, the victim should be taken to a hospital or doctor.
- As with all spider bites, watch for infections following recovery. Although rare, some patients have an allergic reaction to the anti-venom.
- The administration of tetanus toxoid is recommended for all bites and stings.

OTHER ARACHNIDS

Sun spiders and whip spiders do not pose a threat to humans, although large sun spiders can, if handled, deliver a nasty nip. These creatures move so rapidly, however, that you would have to be fleet of foot to catch one. Ticks, of course, pose a much more serious threat as they carry and transmit disease.

Sun spiders and whip spiders

The bodies of sun spiders (Solifugae) are covered by a diverse array of spines and hair-like structures. They may be active night or day, and can move very fast. Voracious predators, they are feared by many people, but they lack venom glands and kill their prey by biting with long, curved 'fangs' (chelicerae). Although they are generally harmless and will make every effort to escape attention, large specimens can deliver a painful bite. Some rural people in parts of western South Africa believe that sun spiders cut the hair of sleeping people at night to line their lairs, but this is pure myth. Particularly in the drier parts of Africa, sun spiders are attracted to light and fire, where they catch prey that comes within striking distance.

Whip spiders (Amblypygi) are fearsome-looking, fast-moving arachnids that are completely harmless to man. They lack the tail-like appendage of the true scorpions. The pedipalps, or head appendages, are armed with spines and are used for capturing prey, and the first pair of legs is modified into whip-like 'feelers' that serve as sensors. These arachnids are rather flattened and usually live in narrow rock crevices or under the bark of trees.

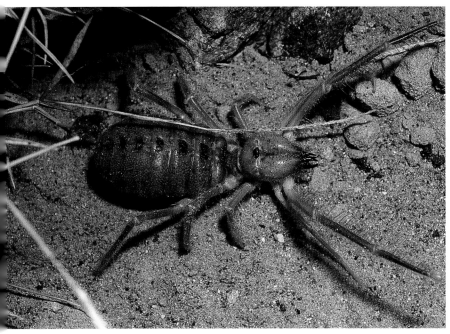

Sun spiders are harmless but can deliver a painful bite.

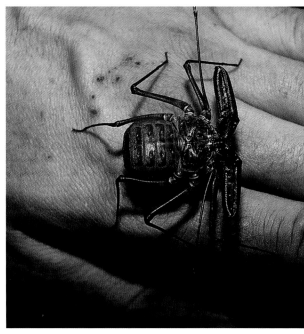

Despite its appearance, the whip spider is harmless.

Ticks

Ticks (Acari), which are also arachnids, are well known for their disease-carrying potential (see Part Four) and can be found in both the countryside and in overgrown areas in towns. They are often carried in the fur of domestic pets that have access to such areas.

Avoiding trouble

- Any tick on the body should be removed as soon as possible, preferably before it bites and sucks blood. It is essential to remove the whole head and all mouthparts because any parts left in the skin encourage infection of the bite wound.

- First, if you can, wipe the area around the tick's head with an alcohol swab. The best way to remove a tick is with a pair of tweezers with flat, blunt tips. Grip the tick with the tweezers as close as possible to the victim's skin, lift the tick's body away from the skin and remove with a sharp upward and outward pull. Applying a drop of petrol, oil or nail varnish may make this easier.
- Another way to remove a tick is to cover it with Vaseline or a similar greasy ointment (meant for use on the human skin). This suffocates the tick and it should soon drop off.
- Do not be tempted to squash the tick between your fingers to try and kill it; the virus causing Congo fever, for example, can infect you in this way.

INSECTS

Although insects form the most diverse group of visible organisms on Earth, the actual number of species in existence is not known. Insects come in a bewildering array of forms, structures and colours and use equally varied survival mechanisms. Most species are harmless, or beneficial, to humans, but some have developed potentially dangerous defence mechanisms.

Bees

Although insects are the most successful creatures on Earth, they have certain limitations. For instance, their size is limited by the structure of their breathing systems, which allows them to carry oxygen over short distances only. So in some insects, especially termites, bees, wasps and ants, individual size limitation has been overcome by the formation of colonies that are limited in size only by the availability of suitable space and sufficient food.

Many species of bee, (as well as wasps and ants) live in colonies, and all belong to the group known as Hymenoptera (which means 'membrane winged'). These insects do not hesitate to sting if they feel threatened, and are the cause of many human deaths worldwide.

African honey bee

Although there are about 20 000 species of bee worldwide, only some 2.5 % of these are social bees living in colonies. The most important of these from the human point of view is the widespread hive bee, or African honey bee (*Apis mellifera*), of which several subspecies are recognised. Their honey is an important food source for humans, and they act as vigorous pollinators in agriculture.

The earliest known records of bee-keeping go back some 6 000 years, but bees have never been truly domesticated, although humans try to control their lifestyle by providing hives in which they can shelter and establish their combs, and supplementary food when necessary.

ABOVE: Although honey is an important human food, bees are most important for the many commercially grown plants that they pollinate. BELOW: An active comb in a honey bee hive. Hives are well-ordered industrial societies.

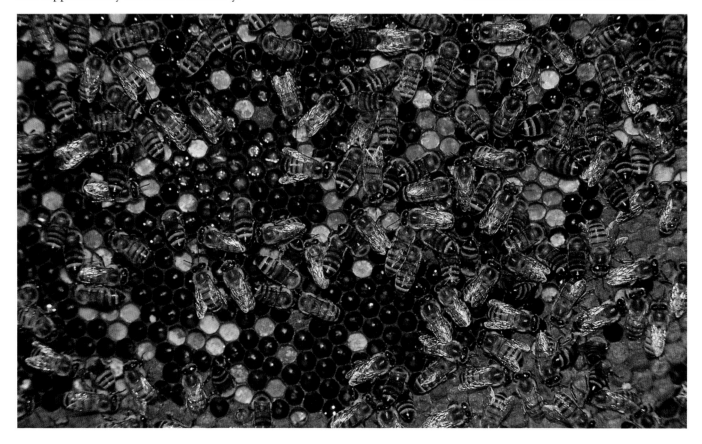

WHEN A BEE STINGS

Worker bees (all females) may sting for a variety of reasons, but only once. Immediately it has penetrated the skin with its twin-barbed 'dart', the bee struggles away (to die within two days), leaving the sting behind and the entire venom gland with it. The sting and venom sac continue to pump venom into the puncture wound, as well as driving the sting deeper.

For most humans the sting of a worker honey bee is unpleasant and produces a sharp stabbing pain, a weal and sometimes slight swelling that seldom lasts longer than a few hours. However, if a person is sensitive to allergens in the venom, a dangerous reaction and even death can occur after a single bee sting. These allergens may create a propensity to overreact and become sensitised. In such a case, another sting anywhere on the body – even months later – could be life threatening. The greatest danger is from anaphylactic (allergic) shock, when blood pressure falls and the person collapses and dies unless medical treatment is close at hand. Emergency treatment must be prompt to prevent death.

In an African honey bee colony there are three castes of adults. The queen's only role is to lay eggs. The drones, or males, hatch from unfertilised eggs and are useful for only one thing – to mate with the queen. By far the most abundant and critical to the swarm is the worker caste, infertile females that emerge from fertilised eggs. The worker bees are prevented from full sexual development by chemicals with which they are fed. A few are destined to become egg-laying queens, but most of them build the combs to hold more eggs, larvae, honey and pollen, seek out the pollen that will maintain the colony, and look after generations of larvae.

None of this is bothersome to humans and other creatures. It is the ability of the workers to deliver venom through the sting when protecting the colony that results in painful encounters that can even sometimes cause death.

Male honey bees, or drones, lie strewn beneath a hive. They have one duty in life: to mate with the queen. When they try to re-enter the hive they are stung to death by the workers.

The size of these super-colonies varies from about 40 000 to 80 000 individuals. The queen is the largest colony member and the only one with a barbless sting. The drones have no stinging mechanism, but the workers, who have special structures on the hind legs for holding pollen, also carry a sting for defence of the colony.

The drones are present only at certain times of the year and few will get to mate with a queen on her nuptial flight. Once sperm is transferred, a drone's genital organs are torn off and he soon dies. The many drones that did not mate try to return to the hive because they cannot feed themselves, but the workers drive them away and, if they persist, they are stung and die, often littering the ground below a hive.

The workers produce wax in special glands on the abdomen. When it is ready they secrete it, scrape it off with the feet and knead with their mandibles until it is ready to produce the cells of the comb. The sperm stored in the queen's abdomen allows her to fertilise up to 1 000 eggs each day, with each egg being laid in its own hexagonal cell. Within the hive a few worker larvae are continuously fed on a substance, produced by workers and known as 'queen's jelly' (or 'royal jelly'), and it is these few larvae that are destined to become new queens. Other worker larvae receive this jelly for just three days and then switch to pollen-honey. Queens can live five years and more, but summer workers seldom reach five weeks.

A deadly hen party

A bee-keeper in Zimbabwe noticed his swarms going on the rampage one day. He donned his protective gear and approached the apiary to find the area littered with dead hens, including one in the enclosure around the apiary. This hen probably started the bees on their frenzy. Sprinkling water from a hosepipe around the apiary immediately calmed the angry bees.

Avoiding trouble

- If you disturb or interfere with a hive or wild swarm – whether accidentally or intentionally – you are asking for trouble. The worker bees are geared to attack anything that they perceive as a threat to the swarm. You may also be at the receiving end if a domestic animal, such as a horse, upsets them.
- For unknown reasons, bees have a strong dislike for horses and poultry. The smell of newly mown lawns or the aroma emanating from a newly turned compost heap near a hive may also set them off, as may loud and continuous noise. Any of these triggers may cause the workers to go on the rampage and they will attack humans, dogs or any other animals nearby. These attacks can prove fatal because the bees will attack in their hundreds and only stop when there is nothing moving in the area of the swarm or hive. It is not safe to try to subdue the bees unless you have the correct protective clothing. If it is a wild swarm call in a local beekeeper (apiarist) to remove it.
- Setting up a water spray next to the hive or swarm is said to be an effective way of calming bees down.

Bee stings

- The sting may still be stuck in the skin, with the venom sac attached and venom still being released. Immediately remove the sting by scraping it off with your fingernail or the blunt edge of a knife, or the edge of a credit card. Do not try to pull it off with your fingers because this will only expel more venom into the wound.
- Cold water or ice (though rarely available in these situations) will relieve the burning and reduce the swelling after any insect bite or sting. Never apply ice directly to the skin; wrap it in a wet cloth, and apply for no more than 10 minutes continuously. Reapply only if the burning returns.
- Sprays containing aluminium sulphate can be used, as well as creams or lotions containing calamine, cortisone or crotamiton, or a combination of these ingredients, and antihistamine tablets. Seek medical advice.
- People who know they are allergic to bee stings should always carry emergency treatment with them. For people with severe allergy the best option is to carry a prefilled syringe of adrenaline ready to inject. It looks like a ballpoint pen and is held to the thigh while the button is pressed to inject the right dosage under the skin. If you are allergic, always make sure that the device is still valid.
- For less severe allergies it may be enough to carry antihistamine pills to prevent swelling, but medical attention should be sought as soon as possible because each sting will be worse than the one before.

Disturbing a honey bee hive can have serious consequences.

Desensitisation

An option to prevent severe allergic reaction to bee stings is desensitisation. This is a long process, involving exposure to minute quantities of bee venom at first, not enough for the body to react with more than a slight redness and swelling on the injection site. These injections are repeated at regular intervals, with slowly increasing amounts of venom. The process is so slow that the body becomes accustomed to larger amounts of bee venom without extreme response from the immune system. The treatment may take up to three years. Blood tests are taken regularly to assess the response to the bee venom. Although accurate figures are not available, it is estimated that between 10 and 12 people die from bee stings each year in South Africa. No mortality figures are known for other African countries. Approximately 1 % of the population is allergic to bee venom to a greater or lesser extent.

Wasps

In Africa many species of wasp can sting and deliver painful venom. Whereas a worker bee dies after stinging someone, the wasp will fly off to sting again and again. But, as with bees, only female wasps sting.

Aggressive stingers

Many wasps deliver venom to subdue prey and in defence. These include the spider-hunting wasps (Pompilidae), the mud daubers and sand wasps (Sphecidae), and the potter and mason wasps (Eumenidae). Others, such as velvet ants (Mutillidae), deliver venom purely to defend themselves and their colonies. Despite their name, these are wasps and it is the wingless female that delivers a very painful sting. Among the most aggressive are the colonial paper wasps (family Vespidae), and stings are fairly common because they often build their nests in and around buildings and other man-made structures.

Many of the naturally occurring wasps in Africa live largely solitary lives. A great number are tiny and are easily overlooked, but some are conspicuous and commonly seen and are often easy to identify by their hunting patterns and lifestyles. Spider- and caterpillar-hunting wasps do not actually kill their prey; they inject venom to paralyse it, carry it to the nest chamber and lay a single egg on it. Because some of the larger spider hunters take large prey, one victim is enough, but other species stock the nursery larder with several smaller victims. Some wasps merely dig a hole in the ground, deposit prey and lay an egg, but others construct elaborate brood chambers. Some mason wasps construct delicate rounded chambers of clay that resemble an inverted teacup without the handle. Mud wasps construct elaborate multi-chambered nests from mud and these are commonly seen on and in buildings, secured to walls and beams. Although the females of most of these wasp species can deliver a painful sting, unless you show an allergic reaction there should be no lasting effect.

ABOVE: The mud brood-chamber of a female mud dauber wasp (Sceliphron spirifex).
LEFT: Sections of a mud dauber wasp brood-chamber. Exposed on the left are a collection of living but paralysed spiders that will provide food for the wasp larva; on the right are pupae of mud dauber wasp.

Then there are the social or paper wasps, which will sting at the slightest provocation. They take their name from the construction of their nests, which are produced by scraping weathered wood, chewing it and adding it to the nest. Most species construct nests that hang from a slender but strong stalk. Their stings are very painful, and there is the added danger of attack by most of the colony, which can have serious consequences. A wasp can sting more than once, even through light clothing, and there is as always a risk of an allergic reaction to the venom.

Unlike the honey bee, wasps can sting and live to do so repeatedly. Intensity of pain from stings varies from species to species.

Rearing the young

Social wasps are very caring of their larvae. The young in the cells stick their heads out and open their mouths to receive the pulped insects collected by the carer, much as nestling birds beg food from their parents. But here there is a reward for the carer in the form of a clear liquid droplet that runs from the larva's mouth. This sweet saliva is eagerly sought by the carer and other colony members. If the larva does not deliver, the carer may take hold of its head in her jaws, draw it partly out of its cell and then roughly push it back in. This convinces the larva to deliver the desired droplet. A bit of brutality in the nursery seems to pay in the case of the paper wasp.

A female spider-hunting wasp (Tachypompilus ignitus) *dragging her large rain spider prey.*

Alan Weaving

Paper wasps construct multi-celled brood chambers and will defend them aggressively.

Mason wasps (family Eumenidae) are solitary and provision the brood chambers with caterpillars.

Caterpillars, moths and butterflies

The larvae, or caterpillars, of many moth and butterfly species are harmless to man, and rely on camouflage to escape the attentions of predators. However, quite a few have evolved active defence mechanisms: some have short, sharp spines equipped with venom, and irritant hairs – sometimes already detached and floating in the air – that can cause skin and eye disorders. Caterpillars are often brightly coloured and marked to serve as warning to potential predators.

Moth caterpillars

Slug moths, browntails, lappets and tigers – all moths – have one thing in common: their caterpillars have irritant hairs. Some even come armed with poisonous spines.

Slug caterpillars belong to the family Limacodidae and three species occur widely in Africa. The adult moths are rather small, dull and nondescript in appearance. The caterpillars have very short legs and a rather slug-shaped body, hence their name. They are more colourful than the adult moths, and this serves as a warning that they are armed and dangerous. They reach a maximum length of 30 millimetres and have tufts of short spines around their bodies. Each of the spines is hollow and sharply pointed. When a spine pierces the skin the tip breaks off and venom courses in from a venom gland at its base. This causes local swelling and irritation, but severe symptoms are restricted to the occasional allergic reaction. Nevertheless, beware of caterpillars sporting bright colours. You often find these caterpillars during summer on leaves of oak and plum trees, among others.

The caterpillars of the brown tail moths (genus *Euproctis*) are 25 to 30 millimetres long, with tufts of long white hairs along the sides of the body. There is a row of tiny barbed, poisonous hairs down the centre of the back. These hairs can penetrate human skin and may result in severe irritation. The silk cocoon is interwoven with the caterpillar's hairs, forming an effective predator-proof shelter.

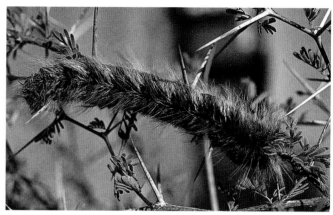

Bristles on larvae dislodge easily and can be carried by the wind.

Most 'hairy' caterpillars have no true venom, rather substances that may cause various levels of dermatitis in humans. The hairs may remain on the human skin and, when rubbed, break into short segments that can work their way into the skin. You may inadvertently brush against a plant on which these caterpillars are present, but the hairs are so light that they can be carried along on the lightest of breezes. You may not even be aware of the presence of caterpillars until exposed parts of your body start to itch and break out in a rash. These rashes and the maddening itching may persist for hours, even days. Even more serious is when the irritant hairs enter the eyes.

Many moth caterpillars carry brittle and irritant hairs to deter predators.

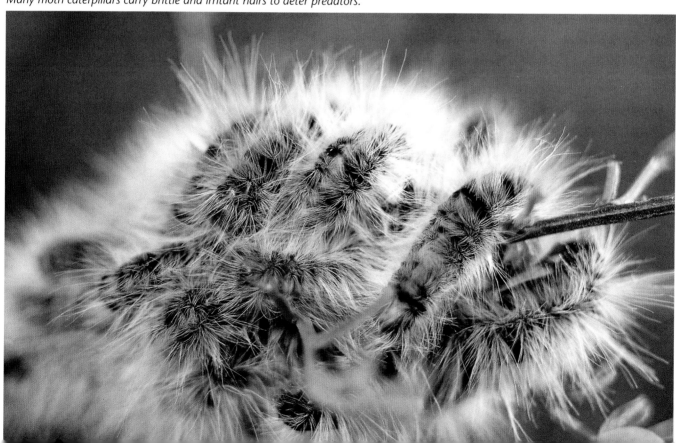

Woolly bears and hairy Marys

The 'woolly bear' caterpillars – as adults known as tiger moths (family Arctidae) – all have very hairy bodies and sharp bristles. This defence is a successful barrier against virtually all predators except for a number of cuckoos, especially the great-spotted cuckoo. The eggar, or lappet moth, caterpillars (family Lasiocampidae), sometimes called 'hairy Marys', come armed with long lateral tufts of hairs that are easily detached and can cause irritation when they come into contact with human skin. Most clothing is no barrier, and any person walking near a large numbers of these caterpillars is likely to start itching.

The Lasiocampidae caterpillars are particularly common in areas where the exotic pepper tree grows, during November–December and February to April. Apart from itching and pimply rashes, people who are sensitised to these hairs may suffer swelling on the face, neck and hands. The hairs and minute spines can cause severe irritation if they are blown into the eyes, or rubbed from hand to eye. They make the eyes stream with tears and may result in sensitivity to light. If these hairs lodge under the eyelid they can scratch the cornea. In most cases it is sufficient to flush out the eyes with water to remove hairs and spines, but medical attention should be sought if this does not work.

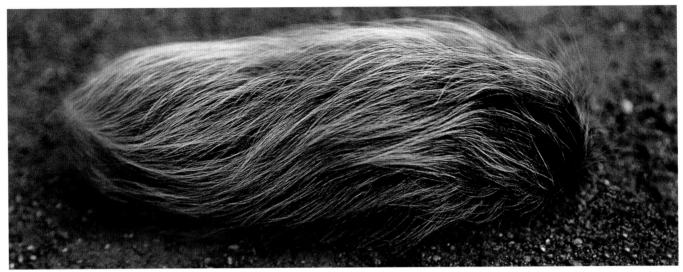

The hairs of caterpillars are very easily detached, even by wind, and cause problems when they enter people's eyes. In some cases they can cause allergic skin reactions.

Butterfly larvae

Some butterfly caterpillars have potentially irritating long hairs that form a 'skirt' towards the extremities of the body, often towards the back. Examples occur in the families Lycaenidae (blues; coppers), Nymphalidae (browns) and Acraeidae (acraeas). In the Acraeidae family the larvae have branched spines. When broken, they exude a yellow fluid that contains cyanide, but only in minute quantities.

 ## Caterpillar envenomation

- The first sign of caterpillar envenomation is a painful stinging sensation within seconds of contact, then within minutes a painful weal at the point of contact. In most cases calamine lotion or crotamiton or cortisone creams should relieve pain and swelling. If symptoms persist seek medical attention.
- The first sign of caterpillar dermatitis from non-toxic hairs is itchiness and mild pain, later a pimply reddish rash. Remove hairs with tweezers and/or clear adhesive tape placed gently over the area (the hairs will then lift off with the tape). Apply calamine lotion or crotamiton or cortisone cream.
- Always seek medical help if caterpillar hairs persist in the eyes, especially if they become lodged under the lids, if swelling around face and throat occurs, or if there is a more severe allergic reaction.

On the horns of the caterpillar

Certain caterpillars of the family Papilionidae, or swallowtails, have an unusual but harmless means of defence. When they are threatened, a bright red Y-shaped structure springs out of a pouch just behind the head. It moves and probes in the direction of the predator, or threat. Although harmless in itself, it sprays out a fine mist of droplets with an acrid citrus smell that is apparently repugnant to predators.

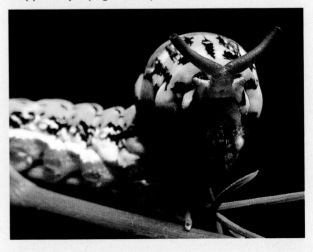

CENTIPEDES

These multi-legged hunters have fangs that can deliver venom, and bites from larger specimens can be extremely painful. Although centipedes in South America and Southeast Asia are known to have caused human deaths, no such fatalities are known from Africa. In tropical Africa there are a number of large species that could, in theory at least, kill. Most bites are on the extremities but envenomation in the head and neck region could be more serious, and there is the ever-present risk of an allergic reaction to the venom.

Centipedes are long, flattened, soft-bodied invertebrates with numerous segments, each of which carries one pair of legs. They fall within the scientific class of Chilopoda, which means 'claw-footed', because each leg has a single sharp claw on the tip. Despite their common name they never have 100 legs – usually either far fewer or well in excess of 100 in some species. The front pair of legs has been modified to serve as venom-delivering appendages. Each leg is equipped with a sharp piercing point, and a hollow duct carries venom from a venom gland. The last pair of legs is longer and more powerful than the rest and is used for grasping and fighting.

Depending on the species and its size, the centipede hunts and feeds on insects, snails and earthworms, while larger species may take small lizards, frogs and even young mice. Centipedes hunt mainly at night, seeking shelter during daylight hours under rocks, logs, plant debris, and in small animal burrows and even houses. They must be constantly alert for a range of predators, which includes birds, shrews and a group of snakes that feed almost exclusively on centipedes.

Smaller species deliver venom that, under normal circumstances, is little worse than a bee sting. Bites of the larger Scolopendra centipedes result in immediate pain, with extensive swelling that may last for a few hours to several days.

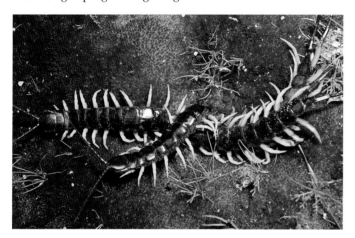
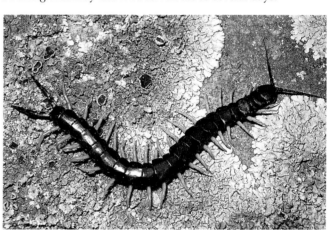
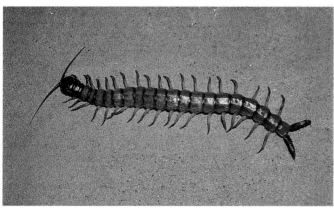
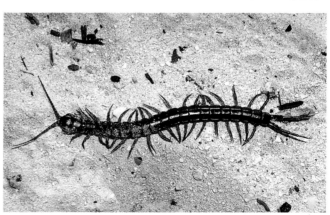

Africa has many different species of centipede and all are capable of biting and delivering venom. Most species can inflict pain not much worse than that of a bee sting, but some are capable of delivering a fatal bite.

✚ Centipede bites

- With low-level pain it is usually only necessary to take over-the-counter painkillers, but in more severe cases stronger analgesics may be needed. In extreme cases the local anaesthetic lignocaine may help relieve pain.
- No matter the level of envenomation, the wound should always be washed and disinfected because of the risk of bacterial infection.
- No matter what the bite, ensure that your tetanus vaccination is current – or have it renewed.

MILLIPEDE DEFENCE

Most millipedes have elongated, cylindrical, segmented bodies and numerous leg-like appendages (but never as many as 1 000 as the name implies). They do not have biting jaws or venom glands, as they are plant-eaters, not hunters.

Most species of millipede curl up in a clock-spring spiral if touched, whereas some wriggle in a demented fashion, presumably to confuse any would-be predator. Many predators do not eat millipedes, but some take them in large quantities, including the African civet, yellow mongoose and dwarf mongoose.

Some millipedes, including the red millipede (*Cherastus* species) of the subtropics, can eject a fine stream of repellent fluid from special pores along the sides of the body. It has a smell similar to that of iodine and produces a burning pain if it gets into eyes or a cut. The red coloration of this centipede serves to warn prospective predators that it does not taste good. Some species, such as the polydesmid millipede, have large odoriferous glands that produce and store a cyanogenic compound in an inner reservoir. When the millipede is under stress or threat, the chemical is released into a smaller reservoir where it mixes with an enzyme to produce prussic acid and benzaldehyde. This is released to repel predator or human 'nuisance'. None of the chemicals released by the millipedes is life threatening, but care should be taken to keep any contamination away from the eyes.

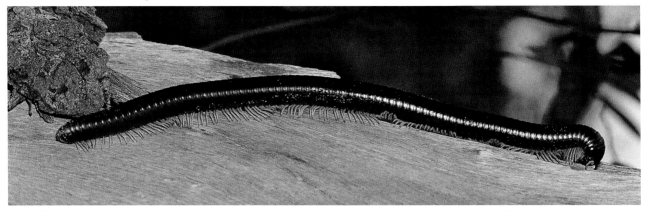

No millipede can bite you, but a few species, especially in the tropics, secrete fluids that are capable of blistering human skin.

PERILS FROM THE SEA

It is not only on the land that humans can find themselves at odds with nature. The sea is also home to a range of potentially venomous creatures, from sea snakes to the reefs of coral along some coastlines. Thus, apart from the customary perils of the restless and unpredictable sea itself, there lurk other dangers in the turbulent depths.

Marine menaces

Among the chordate creatures (creatures that have backbones) along Africa's coasts, the yellow-bellied sea snake, stonefish and scorpionfish are the most venomous. The invertebrate cone shellfish is the most venomous of the marine molluscs.

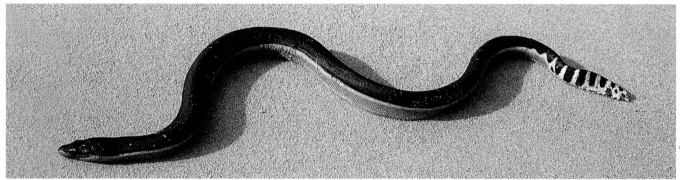

George Branch

Yellow-bellied sea snakes occasionally wash up on Indian Ocean coastlines and should be left alone as they can deliver potent venom.

Sea snakes

Unlike Australia, which has 31 species of sea snake recorded from around its coastline, the African coast is visited by only one species. But what our coasts lack in variety of sea snake is made up for by the sheer toxicity of its lone species.

Yellow-bellied sea snake

Although most sea snakes live along inshore reefs and rarely venture further out than the continental shelves, the yellow-bellied sea snake (*Pelamis platurus*) is a pelagic species that occasionally washes onto African shores. It usually lives far offshore among floating debris along slicks where surface currents merge.

This sea snake feeds on a variety of fish species that are attracted to the shelter afforded by the debris of the slicks. Females give birth to as many as eight live-born young. They reach a maximum length of one metre and, like most sea snakes, are venomous. No bites or deaths have been recorded by the yellow-bellied sea snake in southern Africa. Once washed ashore it is helpless.

However, its venom is twice to ten times as toxic as that of cobras. It is said that just one drop (0.03 millilitres) is enough to kill three adult humans. It is a potent neurotoxin, and respiratory and cardiac failure may occur. No anti-venom is available in Africa.

Cone shellfish

All cone shellfish pack a poisonous punch, delivered by sophisticated harpoons that can be called into play to capture prey or to penetrate the hand of the careless human collector.

The large geographer cone (Conus geographus) *is the most venomous of all known marine molluscs.*

These creatures have evolved an efficient poison delivery system, akin to a 'ground to ground missile'. More than 1 500 named species of cone shellfish (genus *Conus*) occur worldwide, with more than 40 in the coastal waters of southern Africa. The greatest variety of species occurs along the warmer eastern shores of Africa. Only three species are known on the cold west coast of South Africa. Although some species live in deep waters, most occur in the intertidal zone between reef and shore, in crevices in rocks and coral. Some species favour waters with sandy bottoms.

These are some of the most sought-after shells in the world, and some rare specimens change hands for thousands of US dollars. Along with the cowries, the cone shells are among the most beautiful of all marine shells. They come in a great variety of colours and patterns, and range in size from less than one centimetre to more than 13 centimetres. In many the shell patterning is covered with a horny growth, so their beauty is only revealed when they are cleaned. But handle them carelessly and they may harpoon you, resulting in mild to high levels of pain or, in the case of several species, death.

THE CONE'S KILLING MODE

The radula (or 'teeth') of cone shellfish have been modified into a few loosely connected, barbed, harpoon-like teeth. A single tooth is plunged through the extensible proboscis into the prey, which may be marine worms, other molluscs and even small fish. In large cone shellfish the harpoon, or dart, may be up to 10 millimetres long and can be delivered with considerable force and speed. Once the dart enters the prey (or a human hand) a potent neurotoxic venom is pumped into the victim, soon resulting in paralysis. Fish-hunting cones have venom so potent that the prey may be paralysed within 50 milliseconds. The harpoon is used once only, then replaced by a new one. Most cones hunt at night, emerging from the shelter of sand, rocks or coral rubble.

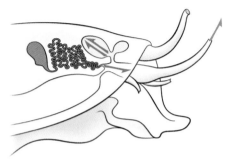

Geographer cone

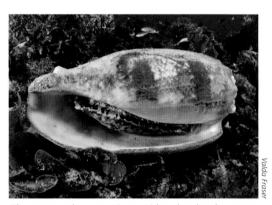

Only one species in Africa is known to have killed humans: the large geographer cone (*Conus geographus*), which may reach 13 centimetres in length. Most deaths resulting from envenomation have been recorded from islands in the Indo-Pacific oceans. It is likely to be found in southern Africa only along the shallow coastal waters of Mozambique.

Several other large species of cone shellfish occur in Africa, but nothing is known about the toxicity of their venoms. Two other species that are believed to be dangerously venomous, both from Mozambique and East African waters, are the marble cone (*Conus marmoreus*) and the textile cone (*Conus textile*). These attractive molluscs inject a potent neurotoxin. Symptoms may increase in intensity in three to six hours, and include severe pain and eventually paralysis that may lead to death.

All of the large and medium-sized cone shellfish have potent venoms, especially those that feed mainly on fish. They need to knock down their prey quickly to prevent its escape. Species that feed mainly on other molluscs probably have less potent venom because their prey cannot escape quickly.

Do not make the mistake of assuming that the harpoon can only be brought into play from the front of the animal. In fact, the harpoon-bearing snout, or proboscis, can reach to fingers holding any part of its shell. Use tongs or thick gloves if you need to pick one up. The harpoon can easily pierce ordinary clothing. In the case of smaller and less venomous species the symptoms may include severe local pain followed by itching, and full recovery may take several weeks. The species of cone shellfish is often not identified. Even if the reaction to the poison is minimal, there is always the risk of an allergic reaction.

Note that, in some countries, collecting certain species of live mollusc is either against the law or requires a permit.

The geographer cone is considered to be the most lethal of the family Conidae. Its shell pattern is thought to resemble an antique map, hence the common name.

⚠ Avoiding trouble

● A lot of pain and anguish can be prevented by not handling live specimens. Too little is known about cone shellfish and their venom and the best advice is to leave them alone. Admire them if you are lucky enough to encounter them, but do not touch them.

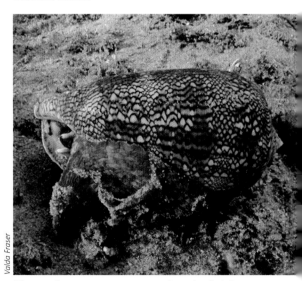

The textile cone can grow to a length of eight centimetres. It occurs very widely in the coastal waters of the Indian Ocean.

✚ Cone shellfish envenomation

- Early signs of envenomation are a numb feeling in the face, especially around the mouth. Severe cases may result in slurred speech and blurred vision.
- Take the victim to a safe place and stay with him/her.
- Organise transport to a medical facility in case severe symptoms develop.
- Severe cases may require assisted breathing. In these cases hospitalisation is essential, and the helper must be prepared to apply mouth-to-mouth breathing. In some recorded cases of respiratory failure, if breathing has been maintained artificially, the paralysis fades away after a few hours and full recovery is possible.
- In the case of minor envenomation see a doctor to check for contamination of the wound.
- There is no anti-venom for any of the cone shellfish.

Crown cone sting

About 10 years ago, shell collector Lynne Broderick was stung on the finger while handling a crown cone (*Conus coronatus*). This is one of the smaller cones in southern Africa, seldom reaching 30 millimetres in length. It occurs as far south as Port St Johns in the Eastern Cape of South Africa. She felt a sharp prick, dropped the shell and noticed a drop of blood on the tip of her finger. She recalls the following symptoms:

- A tingling (pins and needles) in her hand and up her arm
- Her mouth started to pull when she tried to speak
- Redness in her face and on her throat
- Difficulty in breathing
- Stomach cramps.

At first she was given antihistamine because she is also allergic to bee stings, but this had no effect. When she battled to breathe, emergency oxygen was given, but the symptoms and breathing difficulty increased. The symptoms eventually abated when a doctor administered adrenaline subcutaneously and intravenous morphine for the severe cramps.

Stonefish and scorpionfish

Stonefish cannot be seen as anything but ugly, except perhaps to other stonefish. Yet these masters of camouflage have an awesome defensive venom. The diverse group known as the scorpionfish, closely related to the stonefish, also use a combination of camouflage and venom. Unlike the stonefish, many scorpionfish are beautifully marked and have elaborate fins that resemble exotic bird or butterfly wings. But it is advisable to appreciate them from a distance!

Stonefish

The stonefish (*Synanceia verrucosa*) is the most venomous fish in the world. It is so well camouflaged that it is almost imperceptible in its natural habitat. It is said to be common in some parts of Mozambique and along the entire Indian Ocean seaboard as far north as Kenya and probably Somalia. In southern Africa it occurs only in far northern KwaZulu-Natal and Mozambique.

Being wait-and-grab (ambush) hunters – feeding on fish, shrimps and other crustaceans – they lie among coral and rock reefs or partly buried in sand or silt, mainly in shallow waters. When prey is within striking distance, the cavernous upward-pointing mouth opens like a large vacuum cleaner to suck in fish or shrimp. The speed with which prey is swallowed is measured in mere fractions of a second – just a blur and a disturbance of sand to the human eye.

This strange but potent fish ranges in size from 25 to 50 centimetres in length, but is often smaller. It has a very large head and large pectoral fins that it uses to dig itself partly into sand or silt. Skin colour ranges from various shades of brown to mottled green. The lumpy, warty skin structures secrete slightly toxic substances that are sticky, so that sand and other material adheres to the fish, enhancing its camouflage. The stonefish is a weak swimmer and is largely sedentary. It is sold in the fish markets of Hong Kong and Japan (skinned and with spines removed), but doesn't appear to feature on African menus.

The stonefish (Synanaceia verrucosa) *occurs on shallow reefs and sandy areas throughout the tropical Indian Ocean and western Pacific Ocean.*

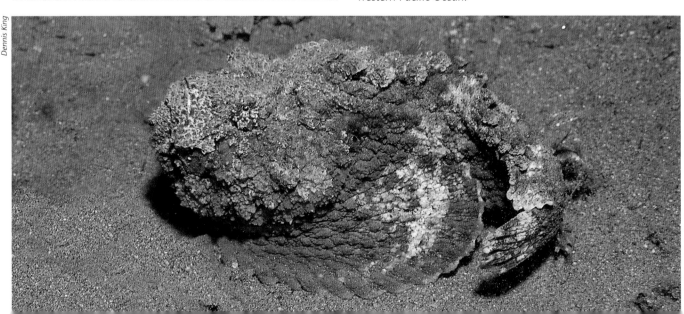

Dennis King

THE WEAPONS OF A STONEFISH

When a stonefish is alarmed or feels threatened it raises the 13 spines ranged along its back. The three longest front spines are raised almost vertically, whereas the others are angled backwards. Thick sheaths of skin cover the venomous spines and the tips are plugged.

Although it has other spines elsewhere on the body it is only those along its back that are dangerous. Each of the venom-delivering spines has a pair of bulging venom glands near its base, with grooves that extend almost to their tips.

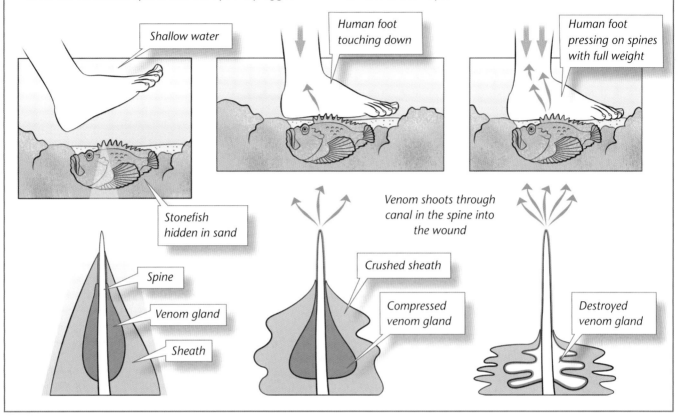

Shallow water

Human foot touching down

Human foot pressing on spines with full weight

Stonefish hidden in sand

Venom shoots through canal in the spine into the wound

Spine

Venom gland

Sheath

Crushed sheath

Compressed venom gland

Destroyed venom gland

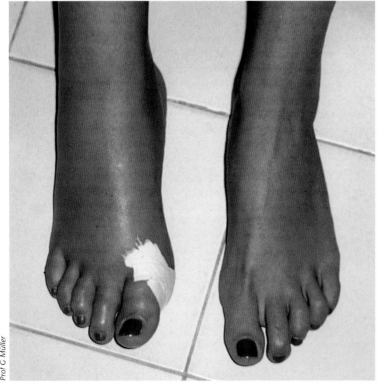

People usually sustain stonefish injuries by stepping onto fish.

The stonefish will not swim up to and attack people; it is a passive rather than an active poisoner. If you stand on a stonefish, or worse still run onto one, the pressure exerted by your foot and body weight pushes down the tissue surrounding the spine. This puts pressure on the venom glands, the plug in the tip is pushed out and venom is rapidly expelled along the grooves into the wound. Apart from the venom, pieces of the skin and tissue usually enter the wound. The depth of penetration by the spine or spines will determine the severity of the damage to human tissue. Although the venom glands that are depressed are destroyed, they regenerate and are refilled with venom within a few weeks. Stonefish can survive out of water for several hours and their venom loses none of its toxicity.

The results of envenomation are severe. Some victims have reported that the pain was so intense that they would have tried to cut off the affected limb were they not restrained.

Without prompt treatment, envenomation by stonefish can result in death. There is speculation that some unexplained drownings in shallow water may have been the result of victims standing on a stonefish and collapsing into a coma, largely from shock.

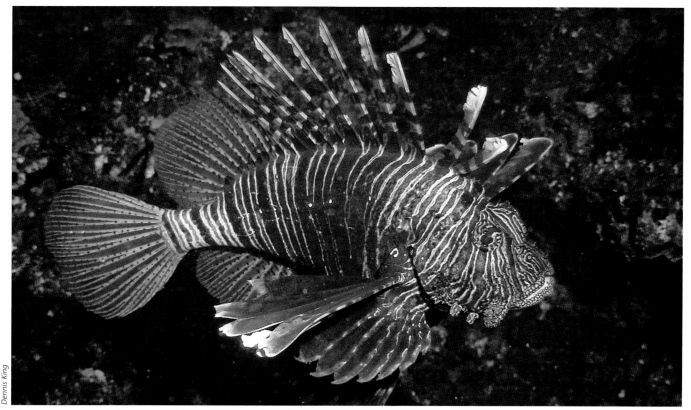

The common devil fish (Pterois miles) *is a species found in shallow, inshore waters throughout the tropical Indian Ocean.*

Scorpionfish

Scorpionfish (family Scorpaenidae) occur around all African coastlines. There are about 20 species in southern African waters and probably at least double this number along other African coastlines, most in the Indian Ocean, with diversity increasing in the warmer waters further north. Some are deep-water species, but most are found in shallows or associated with reefs. All have one thing in common, their venomous spines. The less ornate species are mostly named scorpionfish or stingfish, whereas the elaborate and colourful species have such grand names as butterflyfish, fireworkfish, firefish, turkeyfish, lionfish or dragonfish. Many species are bottom-dwellers, feeding on small fish and crustaceans, whereas some hunt near the surface, around reefs or in mangrove swamps.

The spines of the dorsal, anal and pelvic fins have venom glands at their bases, though not as well developed as those of the stonefish. The pectoral fins do not have venom-bearing spines. None of the species in this group has true venom glands, but the mucus that coats the body and spines is toxic. Stab wounds, or even pricks that break the skin, are extremely painful and deep wounds can be dangerous. Because scorpion-fish are more mobile and usually more visible in their natural habitat, chances of envenomation are low if one does not touch them. People most at risk are inexperienced anglers or fishermen taking one on a line or in a net, and aquarists. In United States studies of 146 cases of envenomation of people who kept captive lionfish (several different species), the symptoms experienced were local pain and swelling. In many cases the pain is said to be extreme, and reactions such as nausea and headaches may result from pain, rather than the effects of the venom.

Other venomous fish

There are other fish (apart from the stingrays – see page 88) that need to be treated with caution because they carry venoms in their fin spines. They are unlikely to kill you – unless you suffer an allergic reaction to components of the venom – but spine wounds can be painful and may take a long time to heal. There is, however, always the possibility that the combination of pain and shock could result in the victim drowning.

Several species of marine catfish, or barbel, are a problem mainly for the fisherman or angler. They have impressive serrated spines on their dorsal and pectoral fins that carry venom. As a rule, if you are faced with a fish with which you are not familiar, handle it with caution, especially if it has rigid, thickened fin spines. If the victim is in good health, a fin spine stab is unlikely to kill him/her, but it could cause a lot of pain, become infected, and take a long time to heal. Apart from fish species already mentioned, be wary of rabbit fish (Siganidae), toadfish (Batrachoididae) and stargazers (Uranoscopidae). The slime covering many fish species can act as an irritant if rubbed into even the most superficial cut or abrasion, or into the eyes.

A number of freshwater fish species also have fin spines that are coated with toxic slime or mucus. Although injuries from such fish are not life threatening under normal circumstances, pain levels – and the chance of infection – are high. The squeaker catfish (*Synodontis* species) and the suckermouth catlets (*Chiloglanis* species) of the family Mochokidae fall into this group and should be handled with caution. Again, fishermen and anglers are most at risk; few other people are likely to come into contact with these fish.

 # Fish envenomation

- If in the water, the victim should be moved onto land immediately.
- Wash out the wound with sea water. If possible, immerse the affected part, often the foot, in hot but not scalding water (fresh or sea). This may be necessary for between 30 and 90 minutes if medical help is too far away. Hot water helps to denaturate the protein-based venom.
- Never try to restrict venom distribution with a tourniquet or bandaging. It does not help and can result in tissue damage.

- The local anaesthetic lidocaine (without adrenaline) can help control the pain.
- Get medical attention even once pain eases because the chances are high that the wound will be contaminated with tissue from the stonefish. These wounds may take a considerable time to heal and infection is likely.
- Anti-venom is available for stonefish in Australia, but is not stocked in Africa at all, because cases of envenomation are apparently rare.

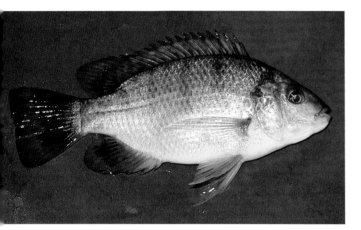

Even common freshwater angling fish such as tilapia (genus Oreochromis) can draw blood with their dorsal fin spines.

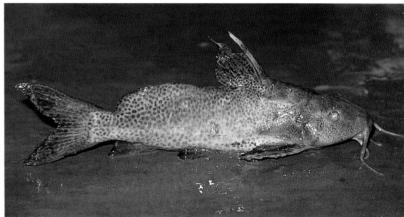

Squeakers (Synodontis sp.) come armed with three long and well-barbed fin spines.

Marine invertebrates

Some invertebrate creatures are also venomous and hence can be dangerous to humans: sea urchins, fireworms, sea anemones, jellyfish, 'blue bottles' and even coral are all capable of inflicting painful, sometimes deadly, injuries.

Sea urchins

Sea urchins, in the class Echinoidea, are simple but attractive animals that have evolved two modes of defence – spines of various lengths, and flexible arms (pedicellaria) that can deliver venom. They have globular, or pumpkin-shaped, bodies enclosed in a calcium carbonate shell known as a 'test'. From this test projects an array of spines that serve as a defence shield in most species. Some species have plain spines that contain no venom, but a few, such as the black urchins (*Diadema* species), have very long, sharp spines that can deliver venom. Backward-pointing barbs on the spines can penetrate deeply into human flesh, the spines snap off and venom is introduced into the wound through their hollow shafts.

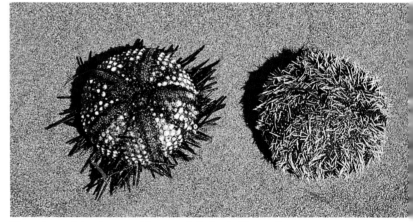

The spines of dead sea urchins, partially buried in sand, can cause uncomfortable wounds if stood on.

Most of Africa's common short-spined urchins can do little harm to humans, but there is one species that can kill. The flower urchin (*Toxopneustes pileolus*) takes its name from the closely packed pedicellaria that cover it, resembling a dense bouquet of minute blossoms as they wave back and forth. These 'blossoms' come with a punch if they touch tender skin. Each is equipped with venom glands and delivery fangs, and contact may result in muscular paralysis, respiratory failure and shock-induced coma. Poke the urchin with a stick and it will not react, but put your finger on it and it goes on the offensive in reaction to chemical messages.

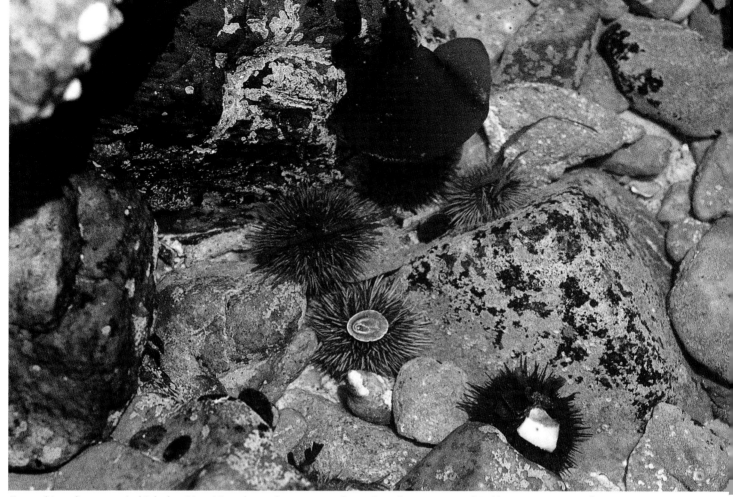

Sea urchins often occur in high densities. Most do not have venom, but spines that penetrate the skin can cause wounds.

 # Sea urchin envenomation

- The venom causes considerable pain, numbness around the wound, nausea and severe headaches. However, these symptoms are short lived and the pain can be relieved by immersing the wound in hot water.
- Deep wounds invariably have pieces and fragments of the spine embedded in them, which may require surgical removal. If the wounds are shallow and only small fragments are left embedded, vinegar may help to break them up.
- Even in non-toxic forms the puncture wounds are troublesome, the risks of infection are high and wounds may take weeks or even months to heal fully. The spines of the non-venomous forms can be picked out with a needle if they are not embedded too deeply; the body will eventually absorb any fragments left behind. If irritation persists, though, you may have to consider surgical cleaning of the wound.

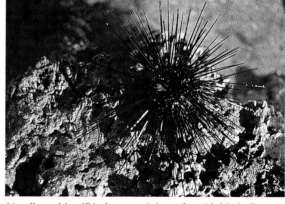

Needle urchins (Diadema sp.) have formidable hollow spines that contain an irritant toxin.

Fireworms and their kin

The fireworms and other marine segmented worms belong to the taxonomic class Polychaeta. The polychaets, or marine bristle worms, are a large group with at least 4 000 species. Although there is some variation in their appearance, all have large numbers of bristles (chaetae) on their bodies. One species, the fireworm *Eurythoe complanata*, has long, sharp bristles that induce high levels of irritation and itchiness. Some species come equipped with substantial jaws that may be backed up with venom.

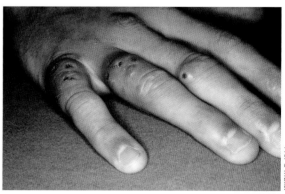

Prof G Müller

Puncture wounds caused by urchins can become infected.

These bristle worms can be divided into two groups: those species that are sedentary and may construct their own shelters, and those that are free-moving hunters. Some bristle worm species may exceed 50 centimetres in length.

✚ Bristle worm envenomation

- If bristle worm chaetae get into human skin they can be removed by covering them gently with adhesive tape and then slowly peeling it off, repeating until all are removed.
- Do not attempt to rub them off with a towel or clothing because the hairs break and cause more irritation.
- Immersing the affected body part in hot water helps relieve the irritation.

Sea anemones

The sea anemones include some of the most beautiful sea 'flowers' and belong to a diverse group of invertebrate animals known as the Cnidaria. Apart from sea anemones, this group encompasses jellyfish, corals, hydrozoans (such as the well-known Portuguese man-o'-war) and sea fans.

The typical anemone has a stalk, or bud-like stem, with a ring of tentacles around the rim. Although anemones have stinging cells (or nematocysts) with which they paralyse their prey, in most cases they can do little or no harm to humans. Stings can generally be avoided by not touching anemones, although some people seem to find it irresistible to poke them with a stick or finger to watch the tentacles withdraw. In most cases the worst you will suffer is a stinging pain that disappears after a few hours, and rarely more than a day. There is a risk of suffering adverse or allergic reactions to multiple stings, such as contact dermatitis or anaphylactic shock.

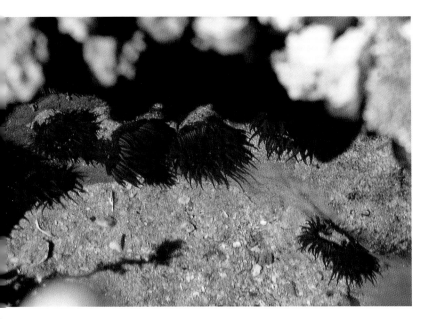

Sea anemones are unable to harm humans, but a few may deliver mild nettle-like stings. However, if stung, you should always be aware of the risk of an allergic reaction.

Box jellyfish, of which there are several species, occur in African waters. They have four tentacles, which can deliver a fierce sting.

Jellyfish

These unusual creatures come in a great diversity of forms, and range in size from just a few centimetres across the 'umbrella' to as much as four metres in some specimens. Well over 90 % of a jellyfish is made up of water similar to that of the surrounding sea, but with slight chemical differences that give them some buoyancy. Most, but not all, species have tentacles that carry numerous stinging cells, or nematocysts. Many species have multiple tentacles, a few have none at all and the box jellyfish of the group known as the Cubomedusae have just four, one at each 'corner' of the umbrella.

Probably the most venomous of all jellyfish, the sea wasp *Chironex fleckeri*, is also one of the most poisonous animals in the oceans. Species in the same order do occur in African waters, though none have such virulent and potent venom. These species are not known from southern African waters. Contact with jellyfish tentacles results in large numbers of stinging cells 'firing' on contact with the skin and they leave reddened, whip-like weals. Pain levels vary from little more than that of a nettle-sting to very painful. In most cases the effect is localised and soon clears up, but in rare cases there may be allergic reactions such as contact dermatitis and anaphylaxis. It was reported by the BBC in January 2007 that there has been a massive increase in the numbers of jellyfish worldwide. Scientists ascribe this to a combination of global warming and the reduction of fish stocks, many of which included jellyfish at various life-stages in their diet.

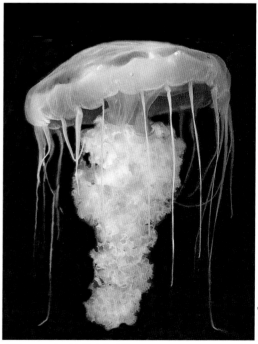

Frilly-mouthed jellyfish (Chrysaora sp.) *are common in many of the world's oceans.*

'Blue bottle' or Portuguese man-o'-war

Often confused with jellyfish, the unusual Portuguese man-o'-war (genus *Physalia*) is actually a community of different organisms and not one animal as is often thought. This colony consists of individual organisms with distinct functions, such as the float, while some concentrate on catching prey, others digest the prey, and others are involved only in reproduction. None can survive alone; remove one and the colony will die.

Unlike jellyfish, they float on the ocean surface, kept there by a gas-filled 'bladder' that also serves as a sail to carry them before the wind. The hunting sector of the colony lies in the large number of stinging cells situated along the tentacles. These tentacles reach lengths of 10 metres, but once prey has been captured they can contract to just a few centimetres so that the catch can be delivered to all the feeding organisms.

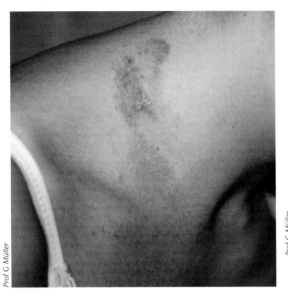

Prof G Müller

Prof G Müller

LEFT: The stinging cells of the 'blue bottle' leave painful weals.
ABOVE: Stinging cells viewed through a microscope.

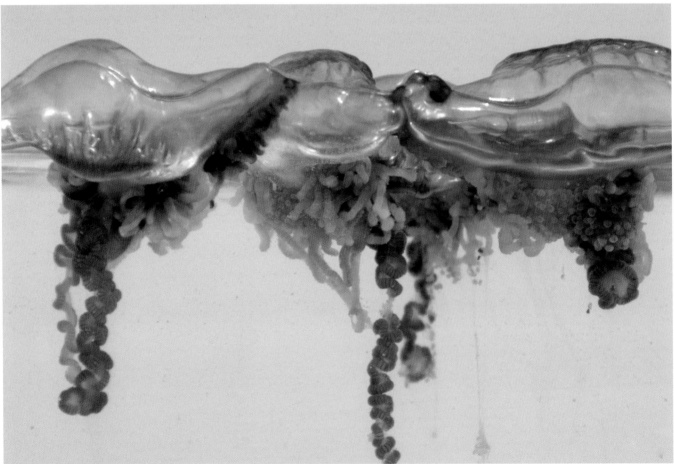

The Portuguese man-o'-war has stinging cells situated in the tentacles.

Great care should be taken when touching corals, as scrapes and wounds can take a long time to heal.

Coral

Under normal circumstances, hard corals, the reef-builders, are no threat to humans because the coral polyps inside their homes, or 'skeletons', are too tiny to do much harm. The danger arises with a fall onto coral or underwater collision with it. Any cuts or scrapes quickly become sore and often take a long time to heal. Apart from pieces of coral and other debris entering the wound, there is a risk of coral nematocysts (stinging cells) being pushed in as well.

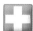 # Marine stings

The best first aid treatment includes pouring sea water (not fresh water) over the weals. If available, also use vinegar because this serves to deactivate the venom.

- Any nematocysts remaining on the skin can be removed with the edge of a knife or a credit card. Do not rub the area because this will cause more venom to enter the wounds.
- Immersion in hot water also helps to ease the pain because heat breaks down the venom.
- Avoid touching the tentacles of beached blue bottles because the stinging cells remain active for some time. These creatures may be absent from the coastline for long periods, and abundant to super-abundant at other times, when it is wise to stay out of the water.
- Thoroughly wash and disinfect any injury involving coral. If it becomes inflamed and remains painful, get medical treatment.

ANIMALS AND THEIR POISONS

SPECIES	POISONS	EFFECTS ON HUMAN BODY
Portuguese man-o'-war *Physalia* **spp.**	• Cytolysin glycoprotein – causes damage to the cell membrane disrupting the flow of electrolytes • Elastase • Collagenase	Sweating — Severe pain — Arrhythmias — Nausea and vomiting — Urticaria — Kidney failure — Skin necrosis
Jelly fish Scyphozoa	• Protein–toxin mixture	Severe pain — Nausea and vomiting — Cardiac problems — Urticaria and swelling — Skin necrosis
Sea anemone Zoantharia	• Neurotoxins • Alkaline proteins	Severe pain — Nausea and vomiting — Itchy papule — Muscle aches — Skin necrosis
Cone shellfish *Conus* **spp.**	Poison contains up to 50 different toxins, main components are: • Conotoxins • Conopressin	Speech problems — Difficulty swallowing — Respiratory paralysis — Difficulty breathing — Pain and numbness at site of contact — Muscle paralysis
Fireworm Polychaeta (*Eunicidae*)	• Glycerotoxin – stimulates the release of neurotransmitters at nerve junctions	Headache — Vomiting — Burning pain and blisters on skin
	Dr A R Picciolo/NOAA NODC	
Lionfish *Pterois* **spp.**	• Protein–toxin mixture • Acetylcholine	Nausea and vomiting — Cardiac and circulatory symptoms — Difficulty breathing — Burning pain and oedema on injury site

SPECIES	POISONS	EFFECTS ON HUMAN BODY
Scorpions *Parabuthus, Hottentotta*	• Neurotoxins • Polypeptidtoxins	Headache; Nausea, vomiting and dysphagia; Respiratory distress; Tachycardia and hyptertension; Abdominal cramps and diarrhoea; Hypersensitive skin; Intense burning pain at sting site
Black button spider *Latrodectus indistinctus*	• Latrotoxin – a neurotoxin that binds to a presynaptic receptor causing release of neurotransmitters, mainly acetylcholine and noradrenaline	Headache; Nausea and vomiting; Tachycardia and hypertension; Burning pain at site of bite; Muscle pain, cramps and weakness; Profuse sweating
Honey bee *Apis mellifera*	• Melittin – causes pain • Apamin • Histamine • Hyaluronidase • Phospholipase A2 – main allergen	Swelling at sting site; Allergic shock; Red, itchy skin; General allergic reaction on skin
Black mamba *Dendroaspis polylepis*	• Neurotoxin – blocks receptors leading to excessive circulating levels of acetylcholine • Dendrotoxin	Hallucination; Drooping eyelids; Weak pulse and low blood pressure; Shortness of breath Respiratory failure; Pins and needles; Profuse sweating; Trembling
Puff adder *Bitis arietans*	• Cytotoxic venom: • Proteolytic enzymes – lead to tissue necrosis • Collagenase – damages tissue • Hyaluronidase – damages tissue • Nucleotidase – breaks up DNA and ATP (the energy carrier in cells)	Hypovolaemia Low blood pressure; Pain, swelling, bruising, blisters and necrosis along the bitten limb
Boomslang *Dispholidus typus*	• Haemotoxic venom • Procoagulant toxins – activate clotting factors II and X which leads to disruption of blood clotting mechanism	Severe headache, dizzyness and fainting; Bleeding mucous membranes; Blood oozing at bite site; Extensive purple bruising

PART THREE
Poisonous
to eat

Some animals may be poisonous to eat at any time, while others, such as shellfish, may be poisonous only at certain times or under certain conditions. Animals may also be contaminated by chemicals introduced to the environment by man. Being informed could save you from illness and, possibly, death.

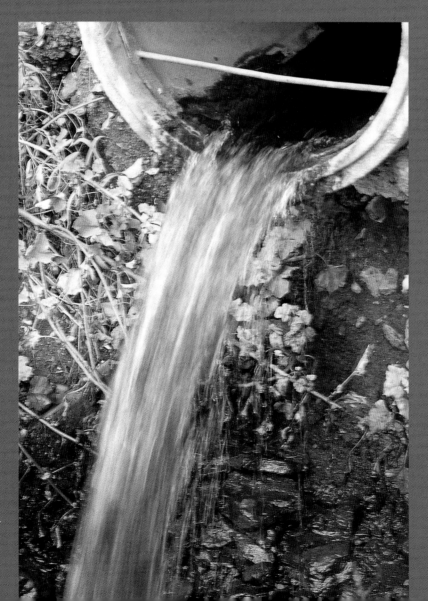

TOP LEFT: Long-spine porcupinefish (Diodon holocanthus)
LEFT: White-spotted Puffer Fish (Arothron hispidu)

POISONOUS SEA CREATURES

Some sea creatures are hazardous because they bite or sting (see Part Two) – strategies that are defensive and essential for the survival of the species that employ them. Other creatures from the oceans are apparently harmless ... until we try eating them, sometimes with deadly consequences. Astonishingly, certain cultures around the world have challenged the poisonous defence mechanisms of various fish species, whose flesh has proved too delectable to resist.

Puffer fish

A group of fish in the family Tetraodontidae – tobies, puffers and the related porcupine fish, cowfish and boxfish – can be lethal, yet in Japan and Korea they are popular in specialist restaurants.

There are probably more than 50 species in African waters, with the greatest diversity in the warmer Indian Ocean and Red Sea. A small number of species are present along the Atlantic coastline with approximately six species in the Mediterranean Sea. Although a few species are found in deep water and others occur in the open ocean, most are found in shallow coastal areas. Several species inhabit Africa's inland waters, such as Lake Tanganyika and rivers of the Congo Basin.

Their family name, Tetraodontidae, refers to the characteristic sharp-edged, plate-like teeth in the front of the mouth, used for crushing the carapaces of crabs and other crustaceans, as well as molluscs, which make up much of their diet.

For many centuries in Egypt, China and elsewhere, these fish have been known to be poisonous to eat – and left strictly alone. In some regions they are said to have been used by shamans and witch doctors as a source of poison, and to play an important role in voodoo and 'zombie' cults.

The first line of defence of many puffer species, as their name implies, is to suck air – or more usually water – into the body, causing them to swell and become ball-like in shape. The fish are thus much larger than in their relaxed form, and this confuses and deters predators. Porcupine fish have quite long spines as an additional deterrent. Once the threat has gone, puffer fish release the excess air or water until the next time they feel threatened. Puffers and their relatives use this form of defence because, although their fins are adapted to high levels of manoeuvrability, they are slow swimmers, and this makes them vulnerable.

Biters of note, too

Although incidents of this are not generally known from Africa, in several parts of the world larger puffers have been known to bite off swimmers' toes and careless fishermen's fingers. Even small specimens can deliver a painful bite. These fish range in size from a mere five centimetres to a respectable 75 centimetres in the silver-cheeked toadfish, which has a wide coastal range in the Indo-Pacific region.

Not all puffer fish species are marine; a few, such as Tetraodon mbu, *occur in the fresh waters of tropical Africa.*

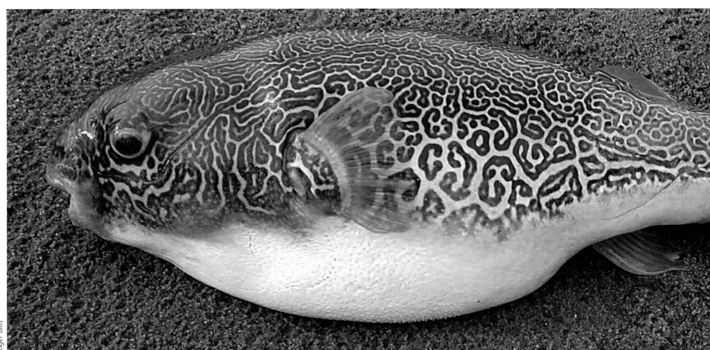

Roger Bills

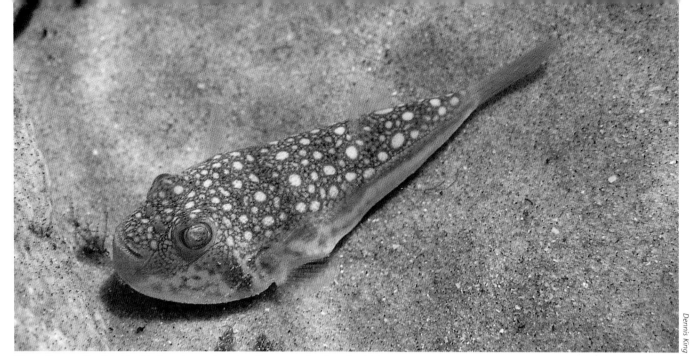

The evil-eye puffer fish (Amblyrhynchotes honckenii) *can reach a length of 30 centimetres. It is found along the tropical East African coastline.*

Deadlier than cyanide

Eating these fish can lead to a rapid death – in just 20 minutes or less, though normally it takes four to 24 hours for total respiratory arrest. The poison, called tetrodotoxin (TTX), is mainly concentrated in the fish's internal organs, especially the liver, but it is also present in smaller amounts in the skin and muscle tissue. Ovaries of the female contain substantial quantities too, and it has been surmised that toxin in the eggs serves to protect them from predators.

The poison is a neurotoxin that works rapidly and may serve to keep predators at bay. Many species 'advertise' their toxicity with brightly coloured and distinctly marked skins. They are not entirely safe from tiger sharks, however, which apparently do not suffer in any way from ingesting the poison. Tetrodotoxin is produced by bacteria that puffer fish ingest while feeding, and against which they have immunity. It is extremely potent – up to 1 200 times deadlier than cyanide. A moderate-sized puffer is said to have enough poison to kill 30 adult humans.

A meal to die for

Why should the Japanese want to eat fish that could kill them? It is eaten in two principal forms, chiri, which is a soup, and sashimi fugu, which is raw flesh. Chefs undergo several years of training before they are allowed to prepare puffer flesh. The skill is to prepare it in such a way that only a trace of the poison remains, not enough to kill but just enough to create a tingling of tongue and lips. The level of the poison is seasonal and is said to be at its lowest in some waters between October and into March, so it is permissible to serve fugu only during this period in Japan. But accidents do happen, particularly in unlicensed restaurants, and about 50 'gourmets' die from tetrodotoxin poisoning each year.

A 'zombie'-like state can be caused by near-lethal doses, where the victim appears to be dead. It is said that some Japanese victims may have been buried or cremated while in this state. With modern medical technology, however, this is unlikely to occur today. There are few documented cases of puffer poisonings in Africa, although undoubtedly they do occur.

As with many poisons, tetrodotoxin has some medical benefits when processed. Tectin, a drug derived from it, is a potent painkiller used mainly for cancer patients.

✚ Puffer fish poisoning

- Watch out for early signs, which include deadening and tingling of tongue and lips, headache and sweating, followed by vomiting and numbness spreading through the body.
- Get urgent medical attention; the victim may require mouth-to-mouth breathing during transit.

Red tide or algal bloom

The media refer to it as red tide, but scientists prefer the term algal bloom because the blooms themselves are not always red. The blooms may be red, yellow, orange, purple or a range of brown shades, and they influence water colour. They are made up of dense concentrations of certain species of phytoplankton, microscopic plant-like organisms that are mainly dinoflagellates. It is estimated that phytoplankton may make up as much as 90 % of all Earth's plant production.

Although some algal blooms are toxic to other marine organisms that eat them, others are non-toxic but still may cause huge mortalities (die-offs) of a range of creatures by depleting the oxygen in the water. This comes about when large concentrations of phytoplankton consume all the nutrients on which they feed and literally die of starvation. The dead phytoplankton sink to the seabed and are then fed upon by vast concentrations of bacteria. The massed feeding bacteria cause oxygen levels to decrease in surrounding waters, on which most other organisms rely for their survival. As the oxygen levels in the water decrease, animals become distressed and many may die. Dramatic mortalities have been observed among some creatures, including crayfish, lobster and fish. This is quite common in many of the coastal waters around Africa, but has been best documented in southern Africa, especially along the West Coast. In March 2007 large numbers of fish died and were washed on to the beaches in False Bay, Cape Town. One of the worst cases in Africa occurred at Elands Bay, north of Cape Town, in April 1997 when an estimated 2 000 tons of crayfish (rock lobster) marched out of the Atlantic Ocean due to oxygen depletion following the massive die-off of an extensive algal bloom. The deaths of these crayfish not only depleted stocks, but it is estimated that it cost the local fishing industry some US$50 million in lost exports. Because no toxins are involved in this type of die-off, it is usually safe to eat those marine creatures that die in this way.

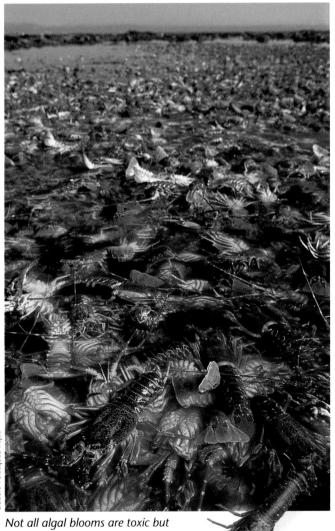

Not all algal blooms are toxic but some can deplete the water of oxygen, causing distress to many marine species such as these West Coast crayfish (Jasus lalandii) .

Claudio Velásquez Rojas

Rafael Leal

Phytoplankton toxins

Only some algal blooms pose a problem to human health. It is those phytoplankton that produce toxic accumulations in their predators, such as filter-feeding shellfish, that pose a danger. In other words, it is not the algal blooms themselves that threaten human health, but the toxins that have accumulated in the marine creatures during these algal blooms.

Many shellfish (bivalves) are filter-feeders, drawing these dinoflagellates (often the most abundant of the phytoplankton) out of the water and digesting them, causing a build-up of potent saxitoxins in their digestive systems. Build-up of toxins may kill the shellfish, causing large numbers to be washed up on the shore. Never eat these creatures even if they are obviously still fresh or alive, no matter how tempting they may look. Cooking will decrease their toxicity only slightly, and, in these circumstances, cannot be relied upon to render shellfish safe to eat.

In April 1997 saxitoxins in algal blooms along South Africa's West Coast, especially from Lambert's Bay to St Helena Bay, caused toxin accumulations in filter-feeding shellfish (including mussels). Several people who ate contaminated shellfish fell ill with paralytic shellfish poisoning. Research indicates that poisoning is likely only from eating contaminated shellfish; other organisms such as bony fish do not ingest or accumulate the toxin and are safe to eat.

Shellfish poisoning

Three forms of shellfish poisoning caused by different phytoplanktonic dinoflagellates are known from Africa.

Only one of these types of poisoning can cause death, although this is unlikely today with correct and prompt medical treatment. In spite of this, several deaths have been recorded in southern Africa. Outbreaks are known from the Mediterranean coast, but elsewhere along African coastlines information is very limited. Cases are most likely along the shores of the Atlantic. **Paralytic Shellfish Poisoning** (PSP) is caused by saxitoxin in the dinoflagellate *Gonyaulax catenella*, which disrupts normal nerve functions. The first symptoms

may arise after 30 minutes. Initially the victim will experience a tingling and numbness of the lips, head, neck, toes and fingertips, followed by general weakness. Without prompt treatment, death due to respiratory failure may occur within two to 24 hours after eating the shellfish.

Diarrhetic Shellfish Poisoning (DSP) is caused by okadaic acid from the dinoflagellate *Dinophysis acuminata*, and results in bouts of vomiting, diarrhoea, stomach ache and general shivering. The onset is usually about four hours after eating contaminated shellfish, but symptoms normally clear up completely after three days. People who fall ill from DSP may falsely assume they are allergic to shellfish, but this is not the case.

In **Neurotoxic Shellfish Poisoning** (NSP), the dinoflagellate *Gymnodinium* (probably *nagasakiense*) produces an aerosol toxin known as brevetoxin. This form of toxin is unusual in that large concentrations can be present in the air and in droplets, exposing humans close to or in the surf zone to the toxin. These toxins irritate the mucous membranes and may cause coughing, sneezing and difficulty in breathing, but are dangerous only to people with asthma or other chronic lung problems. False Bay is known as the main problem area for NSP in South Africa. It appears that NSP has not caused any cases of poisoning in humans who have eaten contaminated shellfish in African waters, although it has been implicated elsewhere.

⚠ Avoiding trouble

- In areas where algal bloom, or red tide, outbreaks occur, the authorities may put out warnings against harvesting or eating shellfish. These usually appear in the print and other media and should be heeded. If you are unsure of conditions it is always wise to seek local advice on whether it is safe to harvest shellfish. Leave live or freshly dead shellfish washed up on beaches or rocks strictly alone.
- One should be aware that documentation of health problems caused by toxins associated with algal blooms is extremely limited except in South Africa, Namibia and Africa's Mediterranean Sea coastline. If you travel to other parts of the African coastline be cautious about (or avoid) eating shellfish, especially filter-feeding bivalves.

Filter-feeding shellfish, such as these brown mussels (Perna perna) *should not be harvested and eaten when there are algal bloom alerts.*

 # Red tide poisoning

- Transport the victim to a medical facility as soon as possible.
- Watch out for breathing irregularities and cessation; mouth-to-mouth resuscitation may become necessary during transport.
- The victim should be transported in the recovery position, lying on his/her side, to prevent the danger of choking on vomited material (see First Aid page 220)

Histamine fish poisoning

Scombroid poisoning, otherwise known as histamine fish poisoning, is not a result of any particular toxin in the fish itself when fresh, but a result of late refrigeration or poor handling. Normal food poisoning from 'off' or spoiled fish can usually be avoided – the fish will clearly have a foul smell, unappetising appearance and bad taste.

But a different process is at work in the case of fish in the family Scombridae, from which the type of poisoning gets its name. Fish in this family include tuna, mackerel, bonito and Cape yellowtail. A substance in the muscle tissues of these fish, histadine, is harmless to humans unless certain bacteria enter the fish after death and convert the histadine into scombrotoxin. This is toxic to humans, although seldom life threatening these days unless other conditions, such as heart disease, increase vulnerability. Cooking does not destroy scombrotoxin, which is similar to histamine and floods our digestive and blood systems, resulting in symptoms similar to gastroenteritis after about 20 minutes. The skin flushes and may appear severely sunburned, especially on the face, head and chest. A range of other symptoms may follow. Administering antihistamines usually elicits a good response.

Hypervitaminosis A

A dish of Cape fur seal, shark, ray or red steenbras (*Petrus rupestris*) liver could leave you ill from hypervitaminosis A. In the case of sharks and rays, additional poisons may be lurking too. It has been suggested that as little as 80 grams of seal liver contains enough vitamin A to cause illness, and this alone could result in a range of nasty symptoms. Recovery from a single meal of the liver of these creatures is certain, but several meals could result in death.

Vitamin A overdose as a result of ingesting these livers leads to symptoms much like those of arsenic poisoning: vitamin A is cumulative and this makes for an unpleasant demise. In the late 18th and early 19th centuries seals were hunted for their skins and blubber. Sealers were often dropped on offshore islands and their source of protein was seal meat – and probably vitamin A-laced livers. Death rates among sealers were high and diseases such as scurvy probably took the blame, but it is now thought to be likely that many died of hypervitaminosis A.

POISONING BY HUMANS

Agricultural and industrial chemicals have a major negative impact on plants, animals and humans. These are issues for which humans must take full blame. Even after the use of some chemicals such as DDT has been banned, residues remain in circulation, or in waiting, for hundreds, sometimes thousands, of years. Not even animals in the Antarctic and Arctic are immune because ocean currents and winds disperse these toxins far and wide. Despite DDT's obvious dangers, some developing countries are starting to use it again in the fight against disease-spreading mosquitoes.

Herbicides, fungicides, insecticides

There are thousands of different chemicals on the world markets – herbicides, fungicides, insecticides – which serve to limit crop damage by perceived pests. The perfect apple, blemish-free tomato or wheat used to manufacture a crisp loaf of bread has been bombarded with poisonous chemicals from its inception to the time it is harvested. Regulatory bodies are responsible for checking chemical residues in commercially available foods, yet in most cases they do not prohibit these chemicals, but limit their presence to an acceptably low level. Certain poisons may be applied only at defined periods before harvesting to ensure that toxicity levels are acceptable by the time the produce is consumed. It is in the interests of the farmer to follow the guidelines, but, as in all enterprises, some ignore or modify them, or are sloppy in their application.

The growing impact of organic farming, which does not use chemical fertilisers or chemical control agents, is a good trend. Problems exist, however, because this type of crop and animal production is expensive, and poisons may still be present in soils from previous farming practices. Organic farms are still in the minority and are frequently surrounded by non-organic operations that continue to use chemical poisons, which may be carried considerable distances on even the lightest breeze.

Some farmers persist in using chemical poisons that have been banned, and which can be detected in their pastures or livestock feed. Such chemicals can persist in soil for years and a change in farming practice, for instance where former croplands are turned over to pasture for cattle or sheep, may mean that the meat or milk of the livestock becomes contaminated.

Hormone boosters

There are many other factors that go beyond the scope of this book, such as the controversial use of hormone boosters in food animals, such as cattle. These hormones promote more rapid growth and muscle development so the animal can be sold earlier. Because of public health concerns the use of growth hormones is now strictly controlled and limited.

ABOVE: Spraying locust swarms with pesticides is a common practice in many parts of Africa.
RIGHT: From flower bud till the time they reach the supermarket, commercial fruits are bombarded with a host of poisons.

Cumulative metal poisoning

Metals and other substances may also be present in harmful levels in our food. By-products are produced and spewed out into the air by a host of power-generating plants, factories and mines, playing a major part in world climate change, or global warming. Many pollutants also end up in our oceans and freshwater systems. It is of major concern that unacceptable levels of mercury, found most often in fish, can sometimes make their way into our pantries. It is usually those at the top of the food chain, such as marlin, tuna and shark, that carry the highest levels of methyl mercury. In small quantities mercury can do little harm, but when fish and shellfish make up a large part of one's diet the levels can become dangerous.

The Minamata disaster

An infamous case of mercury poisoning occurred in the village of Minamata in Japan during the last century, caused by the release of methyl mercury in the industrial wastewater over a period of more than 30 years. Consequent high levels of mercury in the seafood led to widespread poisoning of the local population. By the turn of the century, thousands had received compensation, and more than one-and-a-half thousand victims had died as a result of the poisoning.

Because of much greater awareness today such incidents are now increasingly rare, although serious impacts are still felt in the developing world. In February 2009 the UNO instituted a ban on all use and trade in mercury, to come into effect in 2011.

Pollution of freshwater and marine systems is on the increase, resulting in disasters such as mass fish die-offs.

⚠ Avoiding trouble

- In humans, methyl mercury affects mainly the central nervous system. The first signs are disturbance in perception of sensation, and disturbed gait and balance. Later, problems with vision and hearing may appear.

- There is no effective antidote against methyl mercury poisoning.
- Avoid eating marine organisms from known contaminated areas, especially those in the upper part of the food chain.

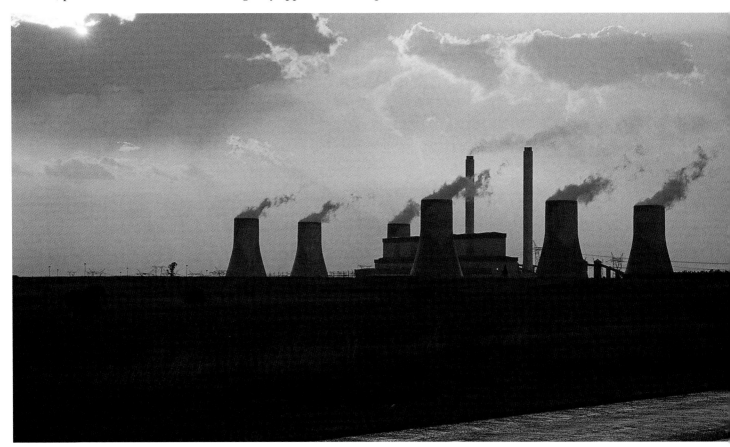

The effects of air pollution are massive, with much of the pollution ending up in oceans, fresh water and on land.

PART FOUR
Animals that cause disease

Compared to vertebrate biters, gorers, gougers and venom-injecting creatures, it is the disease carriers and parasites that head the list of dangerous creatures by a very wide margin. Yet a human killed by a great white shark, or one trampled by an elephant, is more likely to feed a media-frenzy than the millions that are afflicted by parasites and disease-causing organisms. If you die from a worm infestation, or are struck down by yellow fever, you will not hit the headlines, but will merely form a very small part of the overall statistic.

Infectious diseases are caused by pathogenic (disease-causing) micro-organisms that can belong to any of the following groups: bacteria and bacteria-like micro-organisms, fungi, viruses, protozoa and helminths (worms) – of which protozoa and worms are parasites. Infection of humans by animals is known as 'zoonosis'.

www.PHIL (CDC)

TOP LEFT: Hard tick
LEFT: Horse fly
RIGHT: Female hard tick with eggs

FLIES

Which is Africa's most dangerous creature? Most people would probably suggest a range of possibilities from the elephant or buffalo to the lion or crocodile. But they would be far off the mark because it is, in fact, that tiny aerial nuisance, the mosquito – a type of fly; in fact, 'mosquito' is the Spanish word for 'small fly'.

Flies belong to the order Diptera, which is the most successful insect order. Flies have only one pair of well-developed wings, and the second pair – which is present in other insects – has been modified into flight stabilisers. The flies that torment us are only a tiny fraction of the known species in this enormous group but, according to some estimates, diseases carried by this specialised group of flies have been responsible for killing as many as half of all humans that have ever lived.

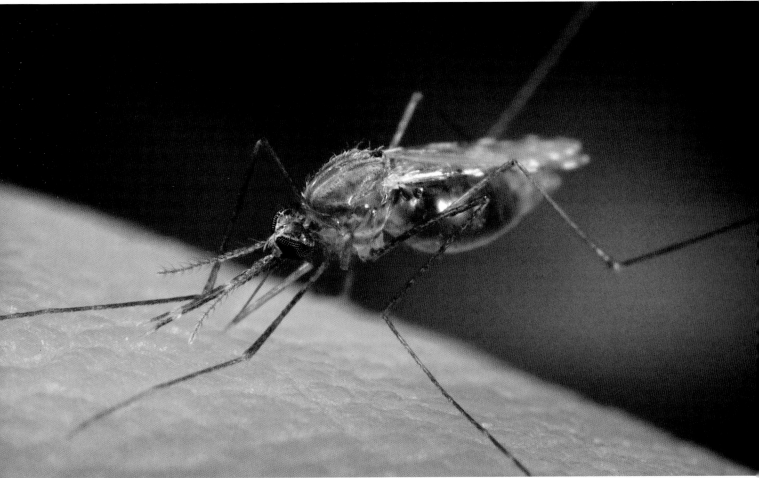

James Gathany/PHIL (CDC)

The mosquito Anopheles funestus *is one of the most important of African malaria vectors. Here the blood being drawn up through the proboscis can be clearly seen.*

Mosquitoes

Most people know the mosquito is the carrier of malaria, but few realise that it is also the carrier of a host of other deadly diseases, including yellow fever, dengue haemorrhagic fever, Rift Valley fever and Chikungunya fever. Malaria is, in fact, caused by a parasite, as is the mosquito-borne lymphatic filariasis, otherwise known as elephantiasis. Viruses, plasmodia and round worms are injected into our bloodstream via the saliva of female mosquitoes when they are feasting on our blood.

Two groups of mosquitoes are particularly important to humans because of their ability to transfer harmful parasites and diseases to us. These are the culicines (genera *Culex* and *Aedes*) and even more important the anophelines (genus *Anopheles*).

The number of species of mosquito in Africa is not accurately known but it runs into the hundreds. In the case of the anopheline mosquitoes, 430 species have been identified worldwide and no fewer than 50 of these can be considered to be a menace to humans. Even in areas where diseases such as malaria have been eliminated, such as southern Europe, mosquitoes persist, so the risk of an upsurge in the disease is ever present. Global warming will aid and abet the return of these diseases as suitable conditions provide ideal breeding grounds.

Mosquito life cycle

Despite their delicate nature, mosquitoes are a surprisingly successful group of insects. They cannot tolerate strong winds, from which they must take shelter, and are equally intolerant of high and low temperatures as well as extreme humidity. They do not usually move more than a few hundred metres from their breeding grounds. Until recently it was believed that water was an essential requirement for successful breeding, but research in Kenya has shown that the larvae of *Anopheles gambiae* can survive on damp mud for several days when they crawl away from pools sprayed with insecticide. When it is safe to return to the water they wriggle their way back.

There are several ways to tell the two main groups of African mosquitoes apart. One helpful pointer is the choice of breeding site. Anophelines show a preference for cleaner, larger bodies of water in which to lay their eggs, but the culicines are not so fussy and are happy with rain water accumulated in an empty can or old tyre in your backyard, water in a gutter, even standing drain water.

Only female mosquitoes suck blood; males feed on flower nectar and fruit sap. Females seek out their blood-feast by detecting the flow of carbon dioxide from a breathing animal. They also pick up and follow other chemical traces from their intended target. Research has shown that female *Anopheles* mosquitoes can detect malaria carriers and actively seek them out because their blood is easier to extract. This ensures that the parasite continues to move around from host to host. Female mosquitoes have highly adapted mouthparts: they operate in the manner of a hypodermic needle that cuts into the skin. The mosquitoes secrete irritant saliva to stimulate blood flow, enabling them to draw up blood into their gut. It is through their saliva that parasites and viruses are transferred into our bloodstream.

Several species of mosquito that breed close to human habitation lay eggs in containers where rain water has accumulated.

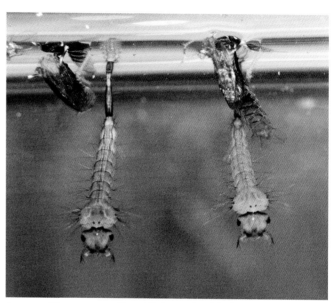

Larvae of house mosquitoes (Culex sp.) with the breathing siphon breaking the water surface.

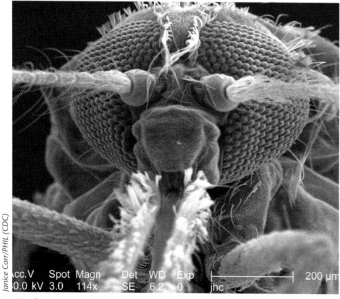

An electron microscope image of the head of the mosquito Anopheles gambiae (magnified 114 times).

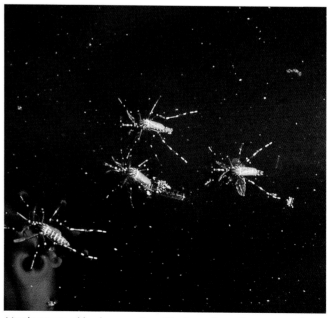

Newly emerged bush mosquitoes (Aedes sp.) on the water surface.

Female mosquitoes require a diet of blood in order to extract proteins and vitamins for the production of eggs. Most, if not all, mosquito females mate only once in their lifespan, and usually in flight. They lay their eggs in water, usually between 100 and 200 in number. After laying a first batch of eggs, the female seeks out a blood meal and then rests for several days until her next batch of eggs matures and is ready for laying.

All anopheline mosquito females and some culicine (mainly *Aedes*) mosquitoes lay their eggs singly, but most culicines lay their eggs glued together to form small rafts. A few species lay their eggs in dry hollows and cavities before the rains, where they will lie dormant until the rains begin to fall. Some of the females of these species have a slender tip to the abdomen that is used to deposit eggs in damp mud. The larvae develop within a matter of hours and can lie dormant in their eggs for long periods, apparently even for several

years, until rain falls. Time of hatching depends on a variety of conditions but is seldom more than 14 days, following such environmental triggers as adequate rainfall.

Mosquito larvae have no legs, just bunches of bristles on the maggot-like body. Eyes and antennae are well developed and tufts of bristles on either side of the mouth serve to draw in tiny food organisms. Microscopic organisms make up the bulk of the food of most species. Despite their aquatic lifestyle they have to move regularly to the surface to breathe through spiracles at the rear of the body.

Larval mosquitoes go through four moults as their bodies grow. After the fourth they cease feeding and lie dormant for several hours, but seldom more than two days. When the time is right, the back of the pupal skin splits and the mosquito emerges, using the pupal skin as a raft until it is dry and ready to take to the air. Then it is ready to mate, draw blood from unwilling hosts, and produce more eggs.

TIGERS ON THE MOVE

The Asian tiger mosquito (*Aedes albopictus*), originally imported, it is thought, in tyres from Japan to the United States, is spreading successfully. It can support the development of 24 arboviruses that are potentially harmful to humans. This super mosquito is more tolerant of both warmer and cooler climates than its original African cousins. It has now also invaded West Africa, where it is already transmitting yellow fever and other viral diseases, with the potential of it spreading further. Recently this tiger mosquito has also been reported in some of South Africa's ports.

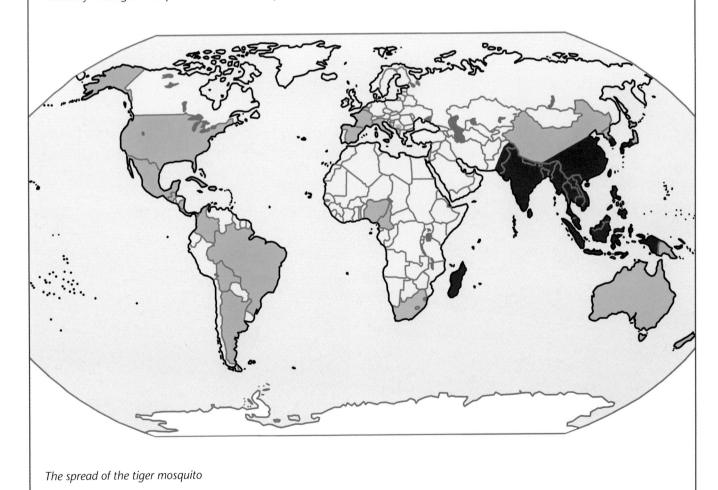

The spread of the tiger mosquito

■ native populations ■ populations established in the last 30 years ■ countries recently reporting tiger mosquitoes in ports

Malaria

Africa has the unfortunate distinction of being the malaria 'capital' of the world. How many people on the continent contract the various forms of malaria and how many die as a result is largely in the realm of the computer modeller. It is estimated that 86 % of all cases of malaria and 91 % of deaths resulting from malaria worldwide occur in sub-Saharan Africa.

The word malaria is derived from the Italian *mal aria* which means the 'bad air' associated with swampy and marshy areas. Until well into the 19th century it was believed that the disease we know as malaria was caught from the air rising from these swamps, with no association being made with mosquitoes that thrive in these habitats. It was only in 1877 that Patrick Manson described the malarial cycle showing that the mosquito served as its vector.

The carriers of the malaria parasite *Plasmodium* are *Anopheles* mosquitoes, which are found throughout the world except in Antarctica. Three species of *Anopheles* mosquitoes dominate the malaria scene. In southern Africa these are *A. arabiensis* and *A. funestus*, and in Central Africa *A. gambiae*, with all three species being disease-carriers across the Sahel belt from Senegal to the Horn of Africa.

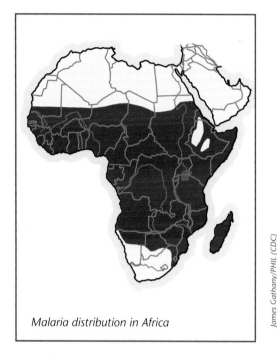

Malaria distribution in Africa

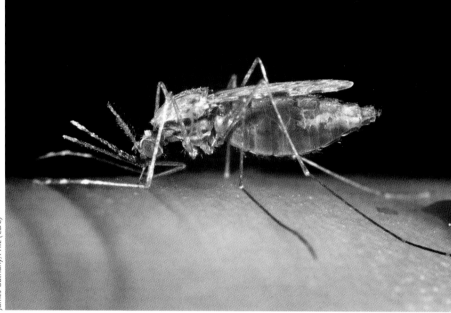

James Gathany/PHIL (CDC)

A female Anopheles gambiae, *drawing up blood, which can clearly be seen distending the abdomen.*

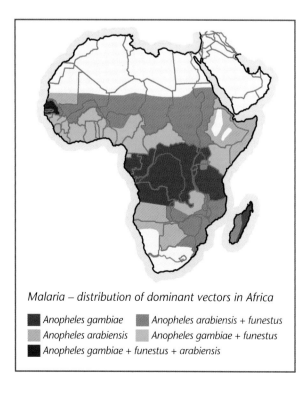

Malaria – distribution of dominant vectors in Africa

- ■ Anopheles gambiae
- ■ Anopheles arabiensis
- ■ Anopheles gambiae + funestus + arabiensis
- ■ Anopheles arabiensis + funestus
- ■ Anopheles gambiae + funestus

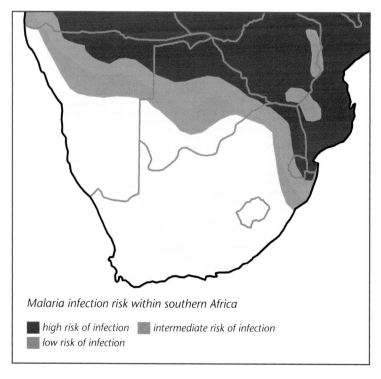

Malaria infection risk within southern Africa

- ■ high risk of infection
- ■ low risk of infection
- ■ intermediate risk of infection

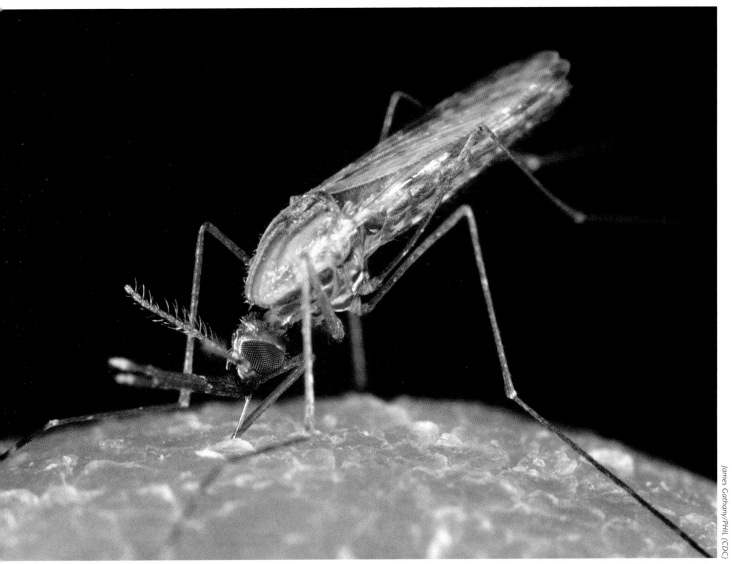

Only the female mosquitoes, here Anopheles gambiae, *suck blood. This species can transmit* Plasmodium *parasites which cause malaria.*

Life cycle and transmission

The cause of all this trouble is the microscopic, single-celled plasmodium parasite. The mosquito is the vector, or carrier, of these parasites, which find a temporary home in the mosquito's stomach. It is from here that the young plasmodia migrate to the saliva glands of the mosquito after some seven to 20 days. Some of these juvenile plasmodia are injected along with the mosquito's saliva into the human victim who is the final host. After a short time the plasmodia make their way from a human's bloodstream into the liver cells, where they remain dormant for five to 16 days. Then the parasites re-enter the bloodstream and begin to attack and destroy the red blood cells. It is at this stage that fever sets in.

The incubation periods of the different plasmodium parasites are varied and may be as short as 12 days in *Plasmodium falciparum*, 13 to 17 days in *P. ovale* and *P. vivax*, and up to 28 days in *P. malariae*. If left untreated (and the person survives) the malaria parasites can live in the body for up to two years in the case of *P. falciparum*, and up to 50 years in the case of *P. malariae*.

Symptoms

The main parasite in southern Africa is *P. falciparum* and it causes the most severe form of malaria. Cerebral symptoms such as confusion and coma can develop rapidly, also jaundice, kidney failure, shock and finally death. *P. ovale* and *P. vivax* cause a milder disease, the main features being sudden onset of chills, high fever, headache, general aches and vomiting, followed by a sweating stage of an hour or two, after which the temperature returns to normal. This cycle may occur daily or up to every 48 hours. *P. malariae* causes similar symptoms but cycles occur roughly every 72 hours, although such a clear pattern of cycles often cannot be recognised. *P. falciparum* parasites do not survive in the liver, but the other three parasites do, and this is what causes the classic regularly recurring bouts of malaria.

The particular danger of malaria caused by *P. falciparum* lies in the often beguilingly mild and unspecific initial symptoms, which could suggest influenza or gastroenteritis. Patients often ignore these and sudden, rapid progression to a severe illness can endanger their lives. Any feverish illness within seven days to three months after first arrival in a malaria area can be malaria, even when a passing traveller has already returned home again.

Diagnosis

The only way to prove and diagnose a case of malaria is with a blood test that shows parasites in the bloodstream. A blood smear (a drop of blood spread on a glass slide) is examined under the microscope in a laboratory. A technician can recognise the characteristic shape of the parasite in the red cells. In recent years rapid diagnostic tests have been developed, and these can be done outside the laboratory, although the World Health Organisation (WHO) does not yet recommend reliance on these tests by untrained users.

Immunity

Although people living in malaria areas and being constantly reinfected develop a certain immunity against the disease after some four to 10 years, this is never complete protection. On first encounter children and adults are equally and completely susceptible to malaria, and die in equal numbers. Survivors slowly adapt to the presence of the parasite and eventually develop sufficient immunity to eliminate the remaining parasites. Maternal antibodies protect newborns for about six months. Children growing up in malaria areas develop immunity by about age seven, if they survive that long.

Regular spraying with insecticides in, and around, houses helps to control malaria-carrying mosquitoes.

Public health measures

- Cover water containers inside and outside the house.
- Ensure gutters and outside areas are well drained with no residual water.
- Remove rubbish that can collect water.
- Use biological controls – with fish in ponds and lakes.
- Use chemical controls.

 ## Treatment

For many years chloroquine was the drug of choice for treatment and prevention of malaria, but widespread resistance of *P. falciparum* to this drug caused a sharp rise in deaths. *P. ovale* and *P. vivax* are still susceptible to chloroquine. Other drugs, such as Fansidar® and Halfan®, looked promising but, again, the parasite quickly developed resistance. Quinine, the very first drug to be used against the disease, still remains effective and is the mainstay for treatment of complicated malaria. Medications that contain a combination of two different chemicals stay effective longer. Recently developed drugs that contain artemisinin, a substance extracted from the Chinese wormwood (Qinghao, *Artemisia annua*), are now widely used for treatment of uncomplicated malaria and for prevention. The epidemic in KwaZulu-Natal that peaked in 2000 was successfully controlled by changing treatment from Fansidar® to artemisinin combination therapy. Malaria cases, admissions and deaths decreased by 97 % during the following summer.

 ## Prevention

Fortunately there are ways to prevent contracting malaria. You can protect yourself against being bitten by a mosquito in the followings ways.

- Wear long, loose, light-coloured clothing; the material should not be too thin.
- Avoid dark clothing, perfume, cologne and after-shave lotion, which attract mosquitoes.
- Use clothing impregnated with the repellent permethrin.
- Sleep under a mosquito bed net, preferably also impregnated with permethrin.
- Screen windows and doors with mosquito netting.
- Use insecticidal coils, vaporisers or sprays in sleeping quarters.
- Apply insect repellents to skin.
- You can also take chemoprophylaxis (preventative drugs) to kill parasites in your blood before they cause symptoms, but even combining this with the methods above is not 100 % protection against falling ill. Three main types of drug are available for prevention. They all have different side effects and indications, so consult a reputable travel clinic or a doctor trained in travel medicine for advice. None of the drugs prevents infection, but all eradicate the parasites in your body.
- A third method of prevention is to eradicate mosquitoes in and around houses by reducing the occurrence of standing water and by spraying insecticides.

MALARIA IN THE PAST

DATE	EVENT
164 million years ago	DNA sequencing has shown the ancient origins of *Plasmodium falciparum* in Africa's Great Lakes region.
5 200 years ago	Immunological tests and DNA sequencing show evidence of *Plasmodium falciparum* infection in mummies of Phaeronic Egypt.
2 800 years ago	Malarial fevers are recorded in China and their relationship with mosquito bites is recognised.
18th–19th centuries	African slave trade results in transport of malaria to South America and Caribbean.
1775–1783	*Plasmodium vivax* malaria plagues George Washington's army during the American War of Independence.
1877	Manson describes the malarial cycle with mosquito as vector.
1880	Laveran discovers causative parasite in human blood.
1934	Chloroquine synthesised by Germans and kept secret until the end of World War II.
1957	First cases of chloroquine-resistant *Plasmodium falciparum* reported from the Thai-Burmese border.
Early 1980s	Chloroquine resistance so common in Africa that it becomes a virtually useless drug.
1985	50 anopheline mosquito species are resistant to insecticides.
2001	United Nations Convention on Persistent Organic Pollutants tries to enforce ban on use of DDT, the only truly effective means of controlling *Anopheles* mosquitoes. With the banning, or limiting, of DDT use there is a resurgence of malaria in poor tropical countries; in 2007 the annual death toll will more than double from a generation ago.
2006	At least 125 species of anopheline mosquitoes are known to be resistant to one, or more, insecticide.
2002–2008	Work on a vaccine against malaria has been ongoing for as much as 50 years. From 2002 advanced methods of extracting mosquito saliva were tested and major human trials began in 2008. If they prove successful, will a vaccine be cheap enough to distribute widely in the developing world, especially Africa?

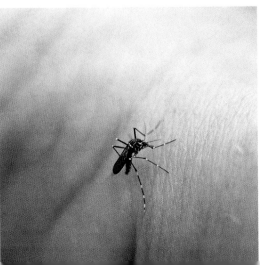

FAR LEFT: Mosquito bites are not only an irritant; in many parts of Africa they are accompanied by diseases such as yellow fever and malaria. LEFT: A female bush mosquito (Aedes sp.) enjoying a blood meal.

A rapid and reliable way of testing for the presence of malaria parasites is to take a blood sample and study it under a microscope.

MALARIA: THE FIGURES

Number of mosquito species worldwide	Approximately 3 500
Number of mosquito species that carry deadly diseases	More than 50
Number of countries with malaria risk	108
% of world's population exposed to malaria	50 %
Humans infected worldwide each year with malaria	250 million
Humans killed by malaria worldwide each year	1 million
African malaria incidence as % of world total	86 %
African malaria deaths as % of world total	91 %
Loss to African GDP per year because of malaria	US$12 billion
African malaria areas' public health expenditure on this disease	Up to 40 %
African malaria areas' inpatient admissions for malaria	30–50 %
African malaria areas' outpatient admissions for malaria	Up to 50 %
Number of children <5 years dying each day from malaria	Approximately 2 400, most in Africa
Number of malaria cases recorded in South Africa, 2007	6 615
Number of deaths from malaria in South Africa, 2007	60
Number of malaria cases recorded in Uganda, 2006	10.6 million
Number of deaths from malaria in Uganda, 2006	43 000

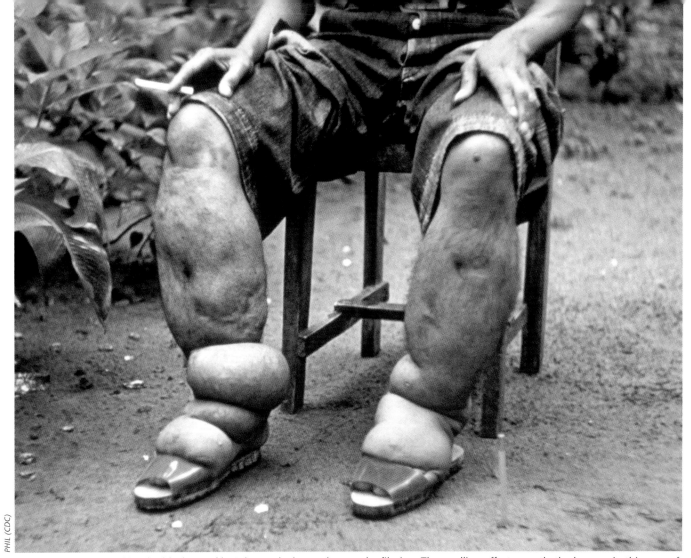

Elephantiasis is caused by the blockage of lymph vessels due to damage by filariae. The swelling affects mostly the legs, as in this case of advanced elephantiasis, and the genitals.

Lymphatic filariasis

This parasitic disease, transmitted by mosquitoes, is also known as elephantiasis, Bancroftian filariasis and human lymphatic filariasis. It very rarely causes death but is a major cause of suffering and disability. Approximately 18 % of the world's population lives in areas at risk of infection, and one third (212 million people) of those at risk live in Africa. It is estimated that around 120 million people in tropical and subtropical areas of the world are infected (CDC April 2008). Almost 25 million men suffer from genital disease and an estimated 15 million people around the world have elephantiasis of the legs, the majority of them women. It is endemic in 39 African countries and occurs all over sub-Saharan Africa down to the southern borders of Angola, Zambia, Zimbabwe and Mozambique. In Kenya, for example, out of a total population of 34.6 million, 144 000 people suffer from hydrocele and 53 000 from elephantiasis of the legs (WHO December 2007).

In Africa lymphatic filariasis is caused by *Wuchereria bancrofti*, one of the round-worms (nematodes) in the group Filaria. Several species of mosquito transmit the worms from one person to another. Unlike malaria or viruses, which may be transmitted by the bite of a single mosquito, filarial infections require repeated inoculation of

Lymphatic filariasis – endemic countries

infective larvae – perhaps hundreds per year – in order for the worms to reproduce successfully and produce the disease. Most infections appear to be acquired in childhood and slowly progress to the characteristic clinical manifestations in adults. Short-term travellers to endemic areas are less at risk.

In urban situations *W. bancrofti* is transmitted (and is becoming increasingly prevalent) by *Culex quinquefasciatus* and *C. pipiens* mosquitoes, which breed prolifically in polluted water. In rural situations transmission takes place through some of the same *Anopheles* species that are the principal vectors of malaria, *A. gambiae*, *A. funestus* and *A. arabiensis*.

Life cycle and transmission

When an infected mosquito bites you, filarial larvae enter your body and migrate to the lymph vessels, where they develop into thread-like adult worms. The females measure eight to 10 centimetres in length and 0.3 millimetres in diameter; the males are only about four centimetres long and 0.1 millimetres in diameter. The adult worms can live five to seven years in the lymph glands, where they mate and produce millions of larvae (microfilariae), which move actively through lymph and blood vessels, mainly during the night. A mosquito biting an infected person ingests these larvae with the blood it sucks up. In the mosquito the first-stage larvae develop further and as third-stage larvae are ready to infect humans again.

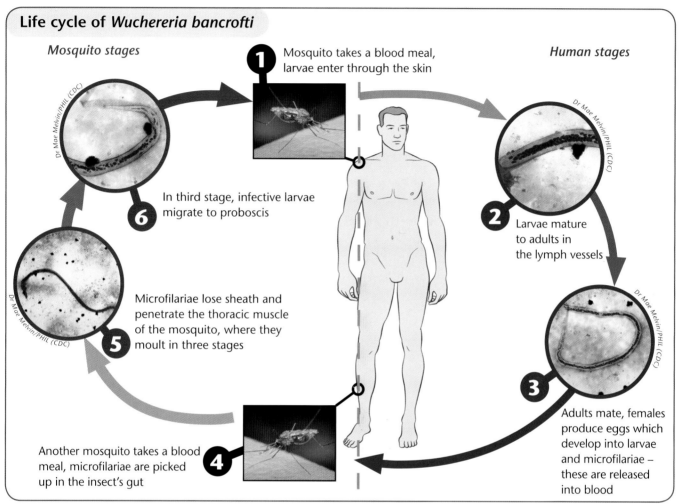

Life cycle of *Wuchereria bancrofti*

Mosquito stages

Human stages

1 Mosquito takes a blood meal, larvae enter through the skin

6 In third stage, infective larvae migrate to proboscis

2 Larvae mature to adults in the lymph vessels

5 Microfilariae lose sheath and penetrate the thoracic muscle of the mosquito, where they moult in three stages

3 Adults mate, females produce eggs which develop into larvae and microfilariae – these are released into blood

4 Another mosquito takes a blood meal, microfilariae are picked up in the insect's gut

Symptoms years later

Only the presence of the adult worms in the lymph vessels and lymph nodes causes damage. Acute inflammation and swelling of the lymph vessels and the lymph nodes, with or without fever, appears in the early stages of the disease, mainly in the legs. Over the years chronic damage leads to complete blockage of the lymph paths; the fluid retained in the tissues causes swelling and later thickening of the skin and underlying tissues.

In the end stage, which is known as elephantiasis, one leg may be grotesquely swollen and thickened, with irregular skin folds developing. The process may also involve the genital area, mainly in men, with the scrotum becoming greatly enlarged (hydrocele) and thickened. In about 40 % of the people affected lymph (milky coloured) and blood (pink) may appear in the urine, with the kidneys failing at a later stage.

Treatment

Treatment available so far does not kill the adult worms but only the larvae in the blood. This prevents the disease being spread from an infected person and, if given early, reduces the number of adult worms and prevents the development of damage of the lymph vessels that would lead to elephantiasis. But often at this early stage people do not know that they are infected.

Prevention

The only way to prevent infection is to avoid being bitten by mosquitoes. The same general measures apply as listed under 'Malaria', both on the personal as well as on the public level. The World Health Organisation initiated a global programme to eliminate lymphatic filariasis in 2000. This programme consists of massive drug administration (a two-drug combination is administered annually to populations at risk, whether the person is infected or not) and has shown success in reducing the number of people showing symptoms.

Yellow fever

Yellow fever originated in Africa and spread to the New World with European exploration and the slave trade. Once nearly eliminated, today epidemics occur intermittently in Africa and South America. The disease is seriously under-diagnosed, especially in Africa. The estimate for 2007 is 30 000 deaths and 200 000 cases of illness due to yellow fever. At least 80 % of all cases worldwide occur in 31 sub-Saharan countries.

Yellow fever is also known as urban yellow fever, silvatic or jungle yellow fever and yellow jack. In Africa it occurs roughly between the latitudes 15° North and 15° South. The southern limit includes the whole of Angola, Tanzania, Kenya and the Democratic Republic of Congo and also the northern and western parts of Zambia. An outbreak in the years 1960 to 1962 killed 15 000 to 30 000 people in Ethiopia, and the number of epidemics has steadily increased since 1980.

Yellow fever is caused by the yellow fever virus (genus *Flavivirus*, *flavus* = yellow in Latin) of the family Flaviviridae, one of the families of arboviruses. More than 150 species of arboviruses cause disease in humans. Viruses are little more than strands of DNA or RNA, the genetic building blocks, but they cannot reproduce on their own. They invade cells of a suitable host and then use the reproductive machinery of this cell to make new copies of themselves.

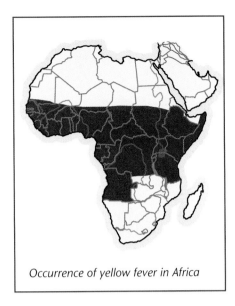

Occurrence of yellow fever in Africa

The main mosquito carrier is *Aedes aegypti*, the yellow fever mosquito, which is active and bites during the day. It survives up to an altitude of 2 500 metres above sea level. Again, only the female mosquito sucks blood, ingesting the yellow fever virus from an infected person or passing the virus into the bloodstream of a healthy one.

Three different types of transmission cycles exist for yellow fever:

- **Urban transmission cycle:** *Aedes aegypti* transmits the virus from human to human; large epidemics are possible.
- **Forest cycle** (causing silvatic or jungle yellow fever): the virus gets transmitted between different monkeys – mainly vervet monkeys, mangabeys, colobus and baboons – but the infected monkeys do not get sick; sporadic infection in humans does occur. The main vectors in this case are forest mosquitoes (*A. africanus* and *A. bromeliae*).
- **Guinea-savanna cycle:** In moist savannas of West Africa (the so-called 'emergence zones') a fever is maintained with transmission between monkeys and humans, and epidemics occur regularly in the rainy season.

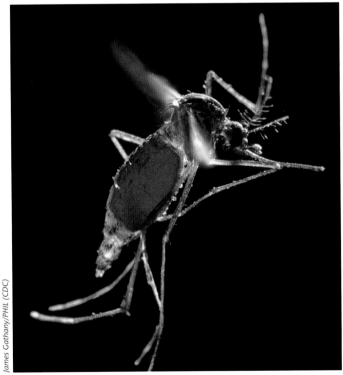

A female Aedes aegypti *mosquito in flight shortly after ingesting her human blood meal. The blood-engorged gut can be clearly seen through her transparent body wall.*

James Gathany/PHIL (CDC)

Symptoms

The main target of infection is the liver, where damage to the liver cells occurs. Three to six days after the infection the disease starts with sudden fever, chills, severe headache, muscular pains and vomiting – again, like malaria, mimicking the start of a bout of flu.

Yellow fever typically runs in two phases. After three to four days of these symptoms, a short remission may occur and the patient may seem to recover. But about 15 % of people then enter a second phase with rapid deterioration. Jaundice becomes marked and bleeding may occur from the gums, the nose and underneath the skin, causing purple discoloration. The fatality rate from this severe form is 50 %. If a person survives till the tenth day he will usually recover and the liver tissue will rapidly return to normal.

 Treatment

No specific treatment is available. Good care in a well-equipped hospital will often make the difference.

 Prevention

A very effective vaccination is available, preventing infection for 10 years after a single dose.

Dengue fever

Dengue fever was the most important mosquito-borne viral disease affecting humans in 2005. The global distribution is comparable to that of malaria. Each year (latest figures for 2007) 50 million cases of dengue fever occur worldwide, half a million of which are cases of dengue haemorrhagic fever, with 100 000 deaths, a fatality rate of 20 %. The dramatic global emergence of dengue fever and dengue haemorrhagic fever has become a major public health problem. More than 2.5 billion people are at risk worldwide in 100 countries.

In Africa epidemic dengue fever has increased dramatically since 1980 and now there is a risk of infection in Angola, the Democratic Republic of Congo, Tanzania, Kenya, Mozambique, Seychelles, Comoros, Reunion, Mauritius, Ethiopia, Somalia, Eritrea and most countries of West Africa, and it may well spread southwards to southern Africa.

The disease is caused by four closely related types of virus, dengue virus types 1 to 4, which belong to the genus *Flavivirus*, like the yellow fever virus. An infection provides immunity for life, but only to this specific type of the virus; one remains susceptible to the other three types. As in yellow fever the virus gets transmitted from man to man mainly by the day-biting *Aedes aegypti* mosquito. In West Africa monkeys function as a reservoir as well, and in a recent outbreak in the Seychelles the imported Asian tiger mosquito (*A. albopictus*) was mainly responsible for transmission.

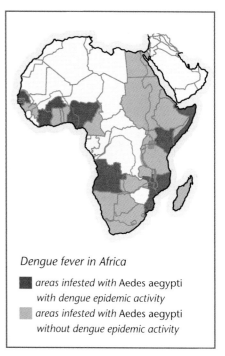

Dengue fever in Africa

■ areas infested with Aedes aegypti
with dengue epidemic activity

▨ areas infested with Aedes aegypti
without dengue epidemic activity

Symptoms

The classic form of dengue fever is a non-fatal viral disease of varying severity, but normally lasting about eight days. Full recovery may take several weeks, even months. Three to 14 days after an infected mosquito bites you, a fever starts suddenly, with frontal headache, nausea, vomiting, and the severe muscle and joint pains that give the disease the name 'breakbone' fever. After three or four days the fever typically drops for 24 to 48 hours before climbing again. Some patients develop the severe and potentially fatal dengue haemorrhagic fever, which is now thought to be the result of an excessive immune reaction to another type of dengue virus after an earlier classic illness. Symptoms are renewed fever, restlessness or lethargy, skin haemorrhages, nosebleeds and bleeding gums. This may rapidly progress to dengue shock syndrome.

 Treatment

There is no specific treatment, but good care and monitoring and adequate fluid intake are essential. Intravenous fluids and even blood transfusions can save the patient's life.

⚠ **Prevention**

Neither vaccine nor chemoprophylaxis is available. The only way to prevent infection is to avoid being bitten by mosquitoes (see prevention measures under 'Malaria' page 175).

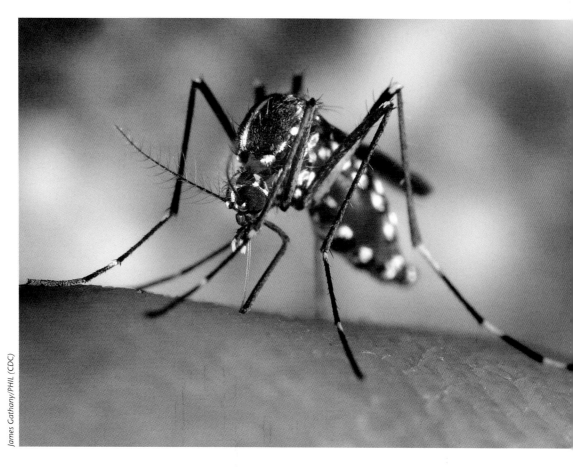

James Gathany/PHIL (CDC)

A distinctly marked female Aedes albopictus *mosquito drawing blood from her human host.*

West Nile fever

Like yellow fever and dengue fever, this is caused by a *Flavivirus* and transmitted by mosquitoes. The West Nile virus mainly infects birds, but also humans, horses, cats and other domestic or wild animals. It is mostly transmitted through the house mosquitoes *Culex pipiens* and *C. quinquefasciatus,* but direct human-to-human infection is also possible through blood transfusions, organ transplants and breast milk. The virus is now endemic in southern, East and northeast Africa.

West Nile fever virus distribution in Africa

Symptoms

Some 80 % of people who are infected show no symptoms, others have a mild flu-like illness, but in some it can progress to a serious, even fatal, disease with encephalitis (inflammation of the brain) and meningitis (inflammation of the lining of the brain). The virus can also affect the eye and lead to temporary blindness for up to four weeks.

 Treatment

There is no specific treatment for this fever.

 Prevention

The only way to prevent infection is to avoid being bitten by mosquitoes.

RIGHT: Mosquito larvae (here Culex pipiens) *can be clearly seen in this discarded jar filled with rain water. Those species that breed close to human habitation are often called domestic mosquitoes.*
BELOW: The female of the species Culex quinquefasciatus *is known to transmit the virus that causes West Nile fever.*

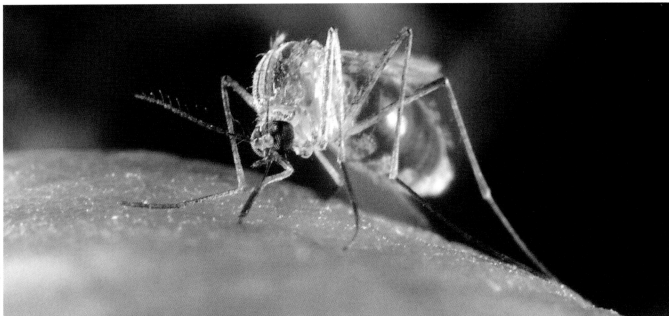

Rift Valley fever

Everybody is familiar with this name, but is it not a disease of livestock or something out of history books? No, the virus is alive and well, and although it does mainly threaten cattle and sheep it can also affect humans and cause epidemics. All it needs is good rains with some flooding of vleis and dams. The disease is found in regions of eastern and southern Africa where sheep and cattle are raised.

Mosquitoes of the genus *Aedes* are naturally infected with the virus, and the females pass it on to the eggs. Heavy rains and floods lead to an increase in the hatching of these mosquitoes. They swarm out and first feed on and infect the livestock in the area, causing an epidemic among sheep and cattle. At this stage other mosquitoes and even sand flies and midges get involved, transmitting the virus from animal to animal and to people. Direct contact with infected animals, or their blood and raw meat, can also transmit the virus and cause disease. This happens mainly among animal herders, in slaughter-houses or during food preparation.

Rift Valley fever distribution in Africa
■ countries with endemic disease and substantial outbreaks
▨ countries known to have some cases

Symptoms

Most people who are infected develop a mild flu-like illness, but up to 2 % of those infected can become seriously ill with vision loss, bleeding or meningo-encephalitis (inflammation of the brain). Some 50 % of these seriously ill patients can die. Among infected livestock the fatality rate is much higher, and in pregnant animals there is an abortion rate of virtually 100 %.

 ## Treatment

There is no treatment for humans.

Prevention

There is no vaccine available. Awareness, general hygiene and insect repellents help prevent infection.

RIFT VALLEY FEVER: FIGURES

KENYA November 2006 to March 2007	684 cases, 155 deaths, fatality rate: 23 %
TANZANIA January to May 2007	264 cases, 109 deaths, fatality rate 41 %
SUDAN November 2007 to January 2008	698 cases, 222 deaths, fatality rate 32 %
MADAGASCAR April 2008	418 suspected cases, 17 deaths
SOUTH AFRICA (KwaZulu-Natal) March 2009	3 cases

Chikungunya fever

The virus (CHIKV) was first isolated in Tanzania in 1953, but has since been identified in much of west, Central and southern Africa. 'Chikungunya' is a Swahili word meaning 'that which bends up'. Another name used in the early days of the disease was 'knuckle fever' because the pain is mainly in the small joints of the hands.

Again the yellow fever mosquito (*Aedes aegypti*) is the main culprit in transmitting the virus from human to human, but lately the Asian tiger mosquito (*A. albopictus*) is becoming a significant carrier too.

Symptoms

The disease starts three to five days after infection with the virus. Symptoms are sudden fever, headache, general fatigue, nausea and vomiting. Later a rash develops, and muscle and joint pains, when it may be confused with dengue fever. Recovery normally takes place after about a week, but incapacitating joint pains and fatigue can last for several weeks.

 ## Treatment

There is no specific treatment; general care should include treatment of symptoms and awareness of complications.

 ## Prevention

Avoid being bitten by mosquitoes by using insect repellents and sleeping nets.

A mutating virus?

In March 2005 Chikungunya fever suddenly appeared on the Indian Ocean islands of Mayotte, Mauritius, Reunion and Seychelles. It is believed the virus was brought in from East Africa. On Reunion one third (230 000 people) of the population was infected, and 174 people died – the first ever recorded deaths from this infection. This made scientists think the virus might have mutated to become more virulent. Again, these outbreaks may be linked to the further spreading of the successful Asian tiger mosquito.

O'nyong'nyong

The O'nyong'nyong virus is related to the Chikungunya virus, but it is the only virus that is transmitted from man to man by the main malaria mosquitoes *Anopheles funestus* and *A. gambiae*. The first epidemic occurred between 1959 and 1962, starting in Uganda and spreading south via Kenya, Tanzania, Malawi and Mozambique. More than two million people were affected. A second epidemic was reported in 1996 and 1997 but was restricted to Uganda and only 400 people were affected. The name for the disease comes from the Nilotic language spoken in Uganda and Sudan, meaning 'weakening of joints'.

Symptoms

People who fall ill with this disease experience fever, inflammation, aches and swelling of almost all joints, and a skin rash. So far no fatalities are known to have occurred.

 Treatment

Treatment consists of general medical care and support.

 Prevention

The only method of protection is to avoid being bitten by mosquitoes.

Tsetse flies

Tsetse flies (Glossinidae) are found only in Africa south of the Sahara. They have mouthparts that project forward from under the head and they are active during the day. Both sexes are blood-suckers. Humans are not favoured hosts and are bitten only reluctantly, as a poor second choice. *Glossina longipennis* feeds mainly on rhino, also elephant and ostrich, while *G. morsitans* prefers warthog and buffalo. Bushbuck is favoured by several tsetse fly species.

The female does not lay eggs; they hatch one by one in her uterus. The three larval stages are nurtured from a 'milk' gland and only once it is mature is the larva deposited in a moist dark place, where it immediately burrows and pupates. A female produces only 10 to 20 eggs in her lifetime.

The tsetse fly has variously been referred to as the greatest African conservationist or a ticking health time bomb. An African tyrant, the 'Idi Amin' of the fly world, the tsetse fly is a carrier of a parasite that is far too small to be seen by the naked eye, a trypanosome. Small it may be, but it has affected the economy and social fabric of the African continent.

Although several thousand humans die each year in Africa after being infected by trypanosomes, it is domestic livestock, and especially cattle, that bear the brunt. Tsetse flies reign supreme over some 15 million square kilometres of tropical Africa. Then why call it 'Africa's greatest conservationist'? Where cattle cannot penetrate because of trypanosomiasis, game and other natural wildlife continues to flourish. If you were to remove the fly, people would move cattle in, and the game would be hunted and driven out.

There are six principal species of trypanosomes carried by tsetse flies. Four attack livestock to produce a disease called nagana, which leads to anaemia, weakness and weight loss, and eventually death. Although they also bite wild animals, they rarely cause disease in them.

In attempts to eradicate the tsetse fly in various parts of Africa, mass slaughter of game animals was officially sanctioned. Hundreds of thousands of head of game were slaughtered, with campaigns in areas such as what is now South Africa's KwaZulu-Natal Province, Zimbabwe (Southern Rhodesia) and Zambia (Northern Rhodesia). These campaigns of slaughter were abandoned when it was realised that no great successes were being achieved. Later came tsetse fly spraying and trapping campaigns, resulting in some success, but these only work if the efforts are sustained. Of course, these interventions involved large quantities of potent pesticides, causing new environmental problems to raise their ugly heads.

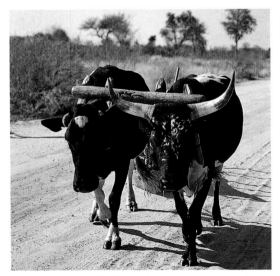

Nagana, transmitted by tsetse flies, is often fatal to cattle and where the insect still flourishes these domestic animals are kept at bay.

The tsetse fly flourishes in vegetation along watercourses and lakes.

African trypanosomiasis

Two species directly affect humans in Africa. One is *Trypanosoma brucei rhodesiense*, which causes East African Trypanosomiasis in cattle and game and acute clinical disease in humans, but makes up only 10 % of reported cases; the other is *T. b. gambiense*, which is mostly restricted to humans (the only animal reservoir is pigs). It causes the chronic West African Trypanosomiasis, also known as 'sleeping sickness'. More than 90 % of reported cases of sleeping sickness are of this type. No prophylaxis is available, so control concentrates on eradicating tsetse flies rather than trypanosomes.

The tsetse fly *Glossina palpalis* transmits mostly the West African form. *Glossina morsitans* is the main vector of the East African infection, is less dependent on moisture and occurs in savanna country. Epidemics in Africa occurred from 1896 to 1906 in Uganda and the Congo Basin and in 1920 in a number of countries, after which it was controlled by mobile teams of health workers who monitored fly populations and occurrence of the disease in the human population. In the 1960s the disease had almost disappeared. Control was relaxed and a resurgence was noticed in the 1970s. The World Health Organisation (WHO) then began reinforcing its programme of surveillance and control.

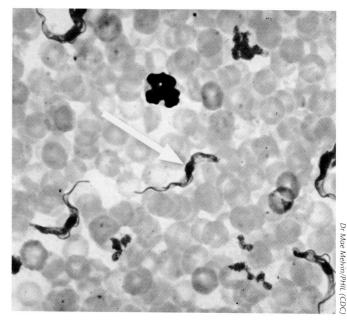

Dr Mae Melvin/PHIL (CDC)

In this photograph of a blood smear under the microscope several dark purple, snake-like protozoa Trypanosoma brucei *can clearly be seen. These protozoa cause African trypanosomiasis, more commonly known as 'sleeping sickness'.*

Life cycle

The parasite develops in the gut of the tsetse fly (*Glossina*) and the infective form migrates to the salivary glands, from where it is injected into the mammal host during a blood meal. Then it multiplies at the site of the bite in the subcutaneous tissues, blood and lymph. In time they cross the blood-brain barrier and infect the nervous system. Trypanosomes can be found in the blood and spinal fluid and this confirms diagnosis. Tsetse flies bite during the day and can easily bite through thin clothing. Standard insect repellents do not repel them.

Distribution

The disease is present in tropical and subtropical Africa, from approximately 10° North to 20° South. The West African form has a wider distribution, in western and Central Africa from Senegal to Angola. The East African sleeping sickness occurs more to the east, from Sudan to northern Botswana, including Namibia's Caprivi Strip. More new cases of both forms were reported in the 1980s than in the 1950s. Now 36 African states are affected, 70 million people are at risk; in 2007 the total of new cases reported to the WHO was 10 769. Of the countries reporting back to the WHO in 2007, Angola, DRC and Sudan reported more than 1 000 new cases, and Mozambique, Zambia and Zimbabwe fewer than 50 cases. Namibia and Botswana reported no new cases in 2007. Another recent report estimates that no fewer than 300 000 people are infected each year in West and East Africa alone. During the course of 2007/2008 tsetse flies were reported from several locations in KwaZulu-Natal, including Hluhluwe/Imfolozi, after an apparent absence of several decades.

Symptoms and disease stages

Chronic West African infection in apparently healthy individuals is possible and can be present for years. East African infection is more acute, but local people suffer a less sudden and violent disease than visitors.

People who have never been bitten by a tsetse fly may develop an acute local reaction, with itching and swelling. This is not a sign of infection with *Trypanosoma* and subsequent bites will not show this reaction.

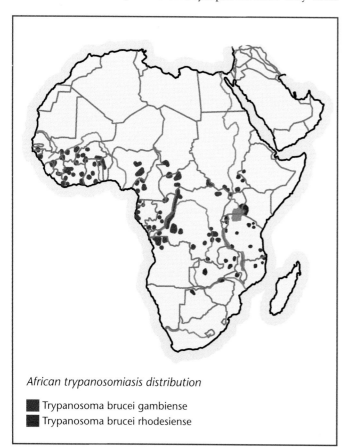

African trypanosomiasis distribution

■ Trypanosoma brucei gambiense
■ Trypanosoma brucei rhodesiense

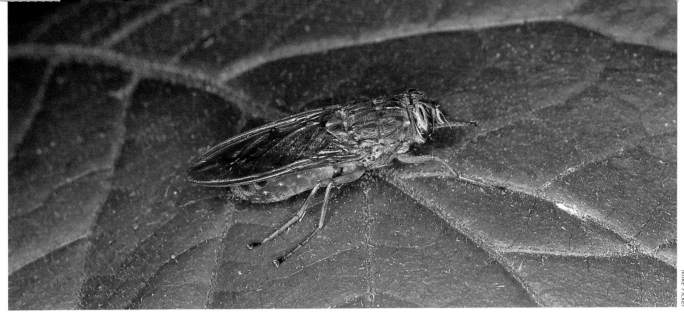

In addition to the serious disease-carrying potential of the tsetse fly, these flies deliver a painful bite, especially irritating where they are present in large numbers.

When infection occurs, a firm, painful, red or violet nodule appears several days after the bite. It is two to three centimetres in diameter and it may blister, but otherwise the person is well. Scratching leads to secondary infection and ulceration. This is called a trypanosome chancre and usually heals with minimal scarring. In the West African form there may be no obvious chancre.

Tsetse fly back in force in Zimbabwe

In the low-lying areas of Zimbabwe, such as in the Zambezi Valley, the tsetse fly was managed in such a way that by 2000, when virtually all control measures ceased, it was no longer seen as a major problem and sleeping sickness caused by the tsetse fly was extremely rare. Now, however, the disease is once again rampant across much of the area where it had been controlled, including many of Zimbabwe's premier tourist areas. And once again people are dying from the infection, including foreign visitors.

The use of tsetse fly traps was once widespread in Zimbabwe's Zambezi Valley.

African sleeping sickness presents typically in two stages. In the first, uncharacteristic symptoms such as rash, fever, malaise, joint pain and headache appear about 10 days to three weeks after the bite. Untreated bouts of fever may subside, to be followed by a symptom-free interval of weeks or months in the East African form of sleeping sickness, months or years in the West African form.

In the second stage the central nervous system is infected. In the East African form this is the classic late stage and terminal manifestation of sleeping sickness. Symptoms include altered sleep patterns (hence the disease's name), psychotic symptoms, loss of weight, confusion and poor co-ordination. Both forms of African sleeping sickness are eventually fatal.

 Treatment

Treatment should be left to the experts in an infectious disease hospital. The earlier the diagnosis is made the better the prospects of a cure.

 Prevention

Only concerted public health measures to control the tsetse fly can reduce numbers of infections.

Migrating tsetse flies?

In 2004 and 2005 two cases of African sleeping sickness were admitted to the neurology unit of the Pretoria Academic Hospital. One case was a farmer from Kariba in Zimbabwe who had East African Trypanosomiasis, and died, probably as a result of infection of the heart muscle. The second was a case of west African Trypanosomiasis, but the patient had travelled only to Malawi eight months before he was admitted, and to nowhere in West Africa. This may be a sign of cross-migration of tsetse fly species to other areas.

Sand flies

There are up to 700 species of sand fly (Phlebotominae), the scientific name deriving from the term 'phlebotomy', originally from the Greek, meaning a surgical incision into a vein. They occur almost everywhere in the world where the average temperature does not drop below 10°C, especially in the tropics and subtropics. In line with their family name, sand flies are, in certain parts of Africa, vicious blood-suckers. The mouthparts create a pool of blood, which is then sucked up, and the flies inject histamine to prevent blood clotting. Bites are usually not felt but leave small, round, reddish bumps that start itching hours, or days, later.

All sand flies are very tiny, about three or four millimetres long. They are yellow-brown and hairy, have large wings and their larvae live in dark, humid places where there is organic matter to feed on. Females lay their eggs in moving bodies of water or in moist areas of rubbish dumps, stables and sheds, or in rodent burrows.

Members of the genus *Phlebotomus* bite mammals and transmit the parasite *Leishmania*. Leishmaniasis is a serious threat to health in various regions of Africa. Humans are accidental hosts, and wild animals are the normal reservoir. In Ethiopia and Namibia some rock hyraxes have a barely visible infection of leishmaniasis at the tip of the nose, the only place where the sand fly can penetrate. Other animal hosts in Africa include gerbils, giant rats and canids, especially domestic dogs.

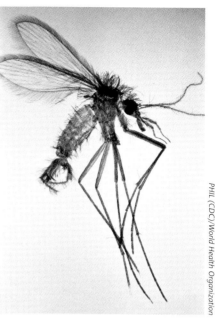

PHIL (CDC)/World Health Organization

Sand flies (here a Phlebotomus *sp.) are commonly mistaken for mosquitoes.*

Leishmaniasis

This disease is caused by parasites of the genus *Leishmania* and transmitted by the bite of certain species of sand fly. Thirty different species of *Leishmania* can infect animals, 21 of which can also infect humans. Most forms get transmitted to humans directly from infected animals, and some can spread between humans. Animal reservoirs include dogs, rodents and other mammals. This disease threatens 350 million people worldwide in 88 countries.

Since 1993 the endemic regions have expanded and there has been a sharp increase in the number of recorded cases. The spread of HIV/Aids has also caused a dramatic rise in leishmaniasis cases due to the suppression of the immune system. The latest figures from the WHO show that two million new cases are diagnosed annually worldwide and 12 million people live with leishmaniasis. These figures are all estimates, as under-reporting is substantial.

Transmission

Sand flies become infected during a blood meal on an infected host. Once in the fly's gut the parasites differentiate further and migrate to the proboscis. During the next blood meal the parasites are injected into the new host's puncture wound along with the saliva. Macrophages (infection-fighting cells in the host's blood) ingest the parasites, which develop further in those cells. Depending on which species of *Leishmania* are involved, the parasites affect different tissues. They either remain in superficial tissues (cutaneous leishmaniasis) or settle in deep organs such as bone marrow, spleen and liver (visceral leishmaniasis).

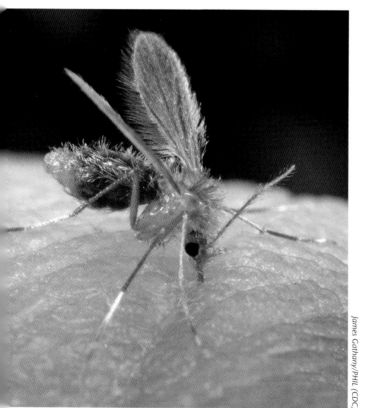

James Gathany/PHIL (CDC)

Female sand fly (Phlebotomus sp.) drawing blood from a human, in this case the photographer.

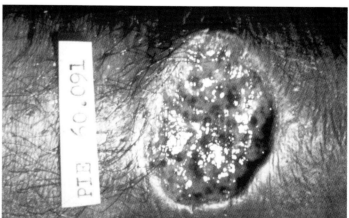

PHIL (CDC)

A typical crater lesion of cutaneous leishmaniasis. Leishmania are transmitted by sand flies.

Visceral leishmaniasis

This is also known as kala azar, dum-dum fever and black sickness. Irregular bouts of fever, substantial weight loss, swelling of spleen and liver, and anaemia are the main symptoms. Dark-skinned people also experience deepening of the skin pigmentation (hence 'black sickness'). If it is untreated the fatality rate in developing countries can be as high as 100 % within two years.

The disease occurs in Africa in northern Kenya, the eastern half of Sudan, western Ethiopia and Eritrea, and also in some isolated places in Zambia and Mozambique. Over 90 % of all cases of visceral leishmaniasis occur in Sudan, India, Bangladesh, Nepal and Brazil. Sudan saw an epidemic in the years 1984 to 1994, and in the Western Upper Nile region 100 000 people out of a population of 300 000 died. In 1997 the number of confirmed cases exploded, with a 400 % increase in one year. Migration and civil unrest had carried the epidemic into Eritrea and Ethiopia by 1998. For 2004 the WHO gave the figure of 73 000 new cases in Africa, of which 8 624 individuals died. However, yet again, under-reporting is prevalent.

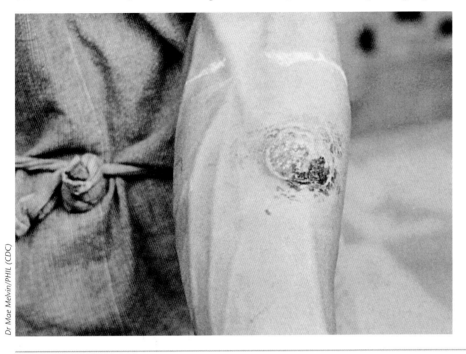

Dr Mae Melvin/PHIL (CDC)

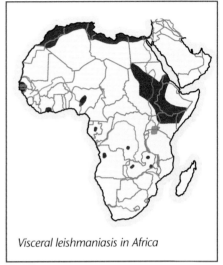

Visceral leishmaniasis in Africa

A leishmanial skin lesion on the inner side of a man's left forearm resulting from the bite of an infected sand fly.

Cutaneous leishmaniasis

This is also known as orient boil, oriental sore and Aleppo boil. Skin sores and ulcers on the exposed parts of the body (face, arms, legs) appear weeks to months after the bite of the sand fly, causing disfiguring and serious disability and social stigma. In the mucocutaneous form, involving skin and mucous membranes, lesions can lead to partial or total destruction of the membranes of the nose, mouth and throat cavities. Diffuse cutaneous leishmaniasis, causing widespread skin lesions, resembles leprosy and is particularly difficult to treat.

In Africa it occurs mainly in central Sudan, southern Ethiopia, northwestern Kenya, northeastern Uganda, western Tanzania and southeastern Namibia.

 Treatment

Two common treatments contain antimony, a grey, brittle metalloid, but the parasite has become resistant to antimony in many parts of the world. Amphotericin (an antifungal drug) is now the treatment of choice, but can only be administered by intravenous injection. A new drug, miltefosine, is being tested, and seems to be a useful alternative for both forms.

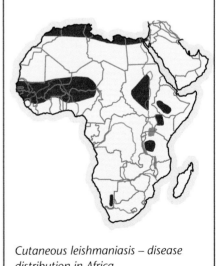

Cutaneous leishmaniasis – disease distribution in Africa

Prevention

No vaccine or prophylactic chemotherapy is available. Residual insecticide spraying can be very effective in controlling sand flies. As sandflies are not able to penetrate even thin clothing, wearing suitable clothing in the evening prevents bites. Sleeping upstairs, where possible, also protects, as sand flies have limited powers of flight. Infection in domestic dogs must be controlled.

Black flies

Black flies (Simuliidae) torment men and animals and cause river blindness (or onchocerciasis) in tropical Africa. Again, females are the blood-suckers, and the irritation can be intense. All black flies require water in which to breed. Females lay eggs in shallow, shaded, slow-running streams. They crawl down a rock and into the water to lay their eggs, enclosing themselves in an air bubble in order to breathe. The tiny larvae have a sucker at the tail end, with which they adhere firmly to a stone, sometimes even to freshwater crabs. They can survive only in running water.

In South Africa *Simulium chutteri* sporadically causes severe problems among livestock along the Vaal River. Species of the *S. damnosum* complex in West Africa and of the *S. naevei* complex in East and Central Africa transmit *Onchocerca volvulus*, which causes river blindness. *Simulium damnosum* females are powerful fliers, covering distances of up to 79 kilometres in 24 hours. In some areas they are called 'buffalo flies' because of their hump-backed stance.

Onchocerciasis

This disease is also known as river blindness and 90 % of cases occur in Africa. The disease occurs from Sudan in the north to Angola, Democratic Republic of Congo, Malawi, Tanzania and northern Mozambique in the south, mainly in mountainous

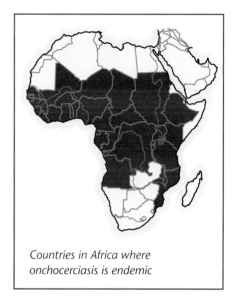

Countries in Africa where onchocerciasis is endemic

and other regions with fast-flowing rivers. In some West African countries it was estimated that some 50 % of men over 40 were blinded, and people abandoned the villages and fields close to rivers, causing severe economic losses. It is estimated that there are about 500 000 people who are blind as a result of this disease. In 2007 the WHO estimated that 37 to 40 million people were infected by this parasite. The only deaths reported (65) were all from Africa.

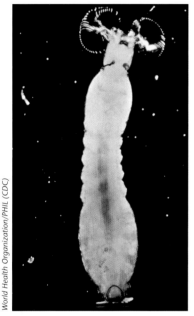

The larvae of black flies (Simulium spp.) are entirely aquatic and they also pupate under water.

Onchocerciasis is a disease of the skin and eyes caused by a roundworm called *Onchocerca volvulus*. During a blood meal the black fly transmits the third-stage larvae to a new human host. These larvae migrate through the subcutaneous tissue (just below the skin) while they mature to adults. Males and females mate in the tissue and become encapsulated, forming prominent nodes under the skin. The females produce first-stage larvae in these nodes for up to nine years. The larvae migrate out of the nodes closer to the skin surface and can be taken up by other black flies during their next meal. The larvae have a lifespan of about two years and can cause inflammation and bleeding. From the skin on the head and face they migrate into all tissues of the eye except the lens, leading to blindness over the years. Skin changes include intense itching, thickening and wrinkling (called 'lizard' or 'elephant skin'), and darkening. Swelling of lymph nodes in the groin can be severe, giving rise to the name 'hanging groin'.

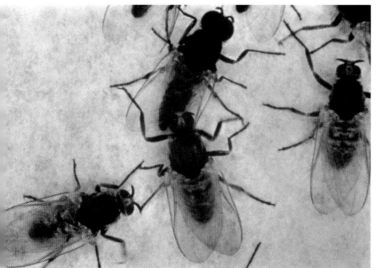

 ## Treatment

An annual dose of ivermectin treats the disease successfully.

 ## Prevention

Case numbers have been reduced through the control of black flies. Since 1996, mass treatment of people living in endemic areas with a yearly dose of ivermectin has been successful, with especially good results achieved in parts of Uganda.

Black flies (Simulium sp.) transmit the disease known as 'river blindness', which is a major medical problem in parts of Africa.

Horse flies

There are between 3 000 and 4 000 species of horse fly (Tabanidae) worldwide. These are among the world's largest flies and they have huge colourful eyes, especially the males. A flying speed of up to 70 kilometres per hour has been recorded in some species.

They are active on warm, sunny days and the females are irritating blood-suckers. The bite is painful because the large mouthparts work like miniature knives to slash open the skin with a scissor-like action. The males are harmless and feed mostly on nectar. Female horse flies of the genus *Chrysops* in west Africa are carriers of the parasitic eye worm *Loa loa*. The worms develop in the fly's muscles. Horse flies can cause anaemia in livestock, transmit anthrax (see page 211) and *Trypanosoma evansi*, which causes surra (fever, anaemia and severe wasting) in horses, donkeys and mules, and rarely *Trypanosoma brucei*, which causes nagana in cattle (see tsetse flies, page 184).

Horse flies breed in water, damp soil, moist organic matter or rot-holes in trees. Many species have only one generation each year. Various genera have evolved along with the animals they feed on. For example, horse flies of the genus *Haematopota* feed on wild antelope and cattle, and some 200 African species of this genus alone are known. There is also evidence that horse flies are mechanical transmitters of protozoan parasites of animals. If horse flies move from feeding on an infected animal directly to a healthy animal, they will carry infected blood on their mouthparts and so spread the disease.

 Prevention

General measures should be applied to prevent being bitten.

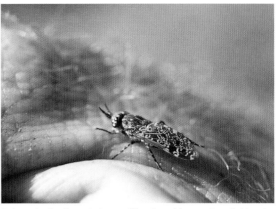

It is only the female horse flies that bite and suck blood; the males mainly feed on flower nectar and are harmless.

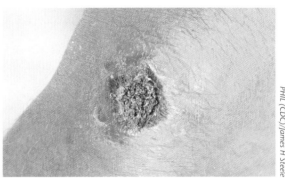

PHIL (CDC)/James H Steele

A typical anthrax skin lesion (here on a forearm) caused by Bacillus anthracis.

Houseflies

There are an enormous number of species of housefly (Muscidae), many of which breed in dung and filth, then sit on our food.

The housefly *Musca domestica* is the most common and widespread of all household pests. It feeds on human food and on excrement and may spread many human infectious diseases, such as bacillary dysentery (shigella), typhoid fever, cholera, salmonellosis, anthrax, leprosy, yaws, trachoma, poliomyelitis, infectious hepatitis and parasitic worms. But in all these diseases transmission through flies is neither the only way of transmission nor the most common. In most cases infection takes place through direct contact between people or through contaminated food and water.

The housefly has a fleshy proboscis beneath its head, four dark stripes on the thorax and two veins meeting at a point on the wing tip. It will feed on any liquid, and moves easily between the latrine bucket and the jam jar. Breeding takes place in manure heaps and in any accumulation of garbage or rotting vegetation. The female deposits a batch of 100 to 120 white oval eggs, two millimetres in length, and she lays four to five batches before the ovaries are exhausted. The larvae hatch within 24 hours and these maggots feed for five days and then pupate. After another five days the adult is ready to emerge.

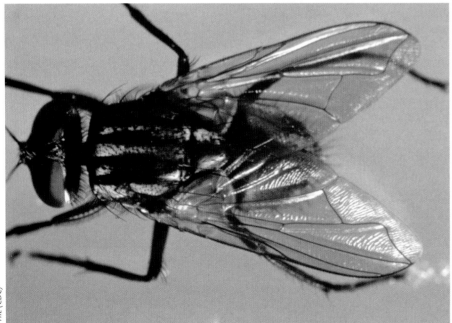

The common housefly (Musca domestica) *is a major disperser of disease, including cholera and dysentery.*

190
DANGEROUS CREATURES OF AFRICA

Trachoma

Trachoma is a bacterial infection of the conjunctiva (the inside skin of the eyelids, also partly covering the eyeball) caused by *Chlamydia trachomatis*. The disease spreads mainly through direct contact, via fingers, towels and washcloths, but is also transmitted by eye-seeking flies, mainly houseflies. Repeated infection causes scarring of the conjunctiva, which leads to scratching and scarring of the cornea (covering the front of the eye) – and eventually to blindness. It is the second leading cause of blindness worldwide but actual figures are largely unknown. Sources give 41–84 million people actively infected and 8–10 million visually impaired. The WHO gives considerably lower figures but these are held to be as a result of under-reporting.

In southern and East Africa it is present in all countries except Namibia and Madagascar. Risk factors include water shortage, flies and poor hygiene, with the poorest and most remote rural areas mainly affected. In South Africa most cases (86 %) occur in rural parts of the northern Limpopo area, although since the 1970s there has been a significant reduction thanks to control measures and education. Reported cases were high in 1998 but by 2004 fewer than 20 cases were reported. Tanzania has two million people known to be infected, with 45 000 visually impaired.

Treatment

Antibiotic eye ointments and new oral antibiotics treat trachoma effectively.

Prevention

General hygiene measures are important for prevention. Wash the hands and face regularly and control flies in and around the home.

Flies and animals

Myiasis is an infestation of live animals with fly maggots (larvae). Several fly species do this – for example, the tropical nest fly (*Passeromyia heterochaeta*), widely distributed in Africa. Sparrows, swallows, sunbirds, starlings, weavers, mousebirds, even eagles, are victims. In South Africa the word myiasis is mainly used for infection with larvae of the tumbu fly (see page 192), which afflicts humans too.

The stable fly (*Stomoxys calcitrans*) superficially resembles the housefly, but is a fierce blood-sucker, tormenting horses, cattle and dogs. Mastiffs and labradors suffer greatly when their ears become a mass of sores. *Stomoxys* species cause 'sweet-itch' in horses. The bites lead to inflammation and itchiness of the skin, causing the horse to scratch until the skin is raw. Farmers suffer considerable economic losses when flies attack farming stock. Stable flies also bite humans.

Blowflies

There are no blood-sucking adult flies in the blowfly (Calliphoridae) family, but the larvae are parasitic, developing in or on living tissue of animals and even of humans. *Lucilia cuprina*, *Chrysomya chloropygo* and *C. albiceps* are common and abundant throughout Africa. *Lucilia* ('green bottle') females lay eggs on carcasses or on meat that is uncovered. *Chrysomya* ('blue bottle') females also lay eggs on live sheep and cause considerable damage to sheep flocks in southern Africa.

The larvae are white, legless maggots. As they creep over the meat they inject saliva into the meat with their mouth hooks. This moistens and digests the meat, forming a 'meat broth' that the larvae can suck up. They only attack sheep when the wool is soiled, especially between the hind legs or near wounds. They can then cause an ugly sore, attracting more flies, and the animal may die.

In the First World War many soldiers had wounds that were infected by blowflies, but it was noticed that these wounds often healed more quickly and cleanly. The action of the larvae in the wound helped dissolve dead tissue, including bacteria and this helped heal the infection. Blowflies also play an important role in the natural breakdown of carcasses in the environment.

Where blowflies are abundant wounds should be covered to prevent contamination.

BLOWFLY HOTSPOT

In recent years the sheep blowfly (*Lucilia cuprina*) has seen a population 'explosion' in and around Cape Town. These flies are attracted by meat, carrion, animal droppings, rotting organic material and open wounds. On entering our homes they can transfer harmful organisms to any exposed foods they land on. It is believed that these flies were the cause of outbreaks of dysentery in Cape Town in the late 1990s.

A number of reasons have been put forward to explain this upsurge in blowfly populations: poor sanitation in burgeoning informal settlements; changes in the refuse collection system allowing greater access for the flies and a general increase in contaminants such as dog faeces. This is a problem in many African cities and towns.

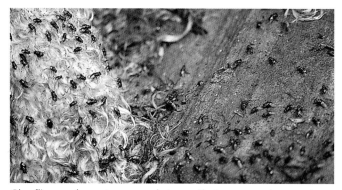

Blowflies are drawn to many substances that may serve to spread disease to humans.

Myiasis

Also known as cutaneous myiasis and mango worm, this is the infestation of living humans and other vertebrate animals (mainly dogs) with the larvae, or maggots, of blowflies and related fly families. The larvae can be laid in the skin, into wounds, intestines and even body cavities such as the nose, mouth and ear. The most common cause of cutaneous myiasis in tropical Africa is the tumbu fly (*Cordyloba anthropophaga*), also called putsi fly or mango fly. It is found throughout Africa, mainly in tropical and subtropical parts, but in wet years spreads extensively and has even been noted in the Namib Desert.

Females lay eggs in sandy soil contaminated with urine or faeces, also on clothing saturated with perspiration, soiled diapers, but sometimes on clothes hung up to dry or bedclothes left to air. When the tiny larvae come into contact with human flesh they burrow in to just below the skin and develop there. Natural hosts of these flies are rats and small carnivores, and dogs are also often infected.

The larvae penetrate the skin painlessly and within a week cause a boil-like swelling, most often on the shoulders and buttocks. There is itchiness and the feeling of movement under the skin. A small white structure protruding from the lesion can be seen, or a black spot. There is usually no pus.

 Treatment

Treatment is to remove the larvae and use antibiotics for any infection. To remove each larva apply petroleum jelly or oil to the centre point of the 'boil'. This suffocates the larva and it either comes out spontaneously or can then be gently squeezed out.

 Prevention

Prevention is to wash clothes properly, ironing them or drying them indoors or in tumble driers.

Tumbu fly spreads

In South Africa this fly occurs in the Lowveld areas of Limpopo Province, Mpumalanga and KwaZulu-Natal because of the hot and humid conditions. But there seems to be a recent tendency for the fly to spread into neighbouring areas, possibly due to good rains and humid conditions. In February 2006 six cases of myiasis in people who had not been in known affected areas were seen in Pretoria. And in March 2006 117 cases were reported in four subdistricts of the North West Province.

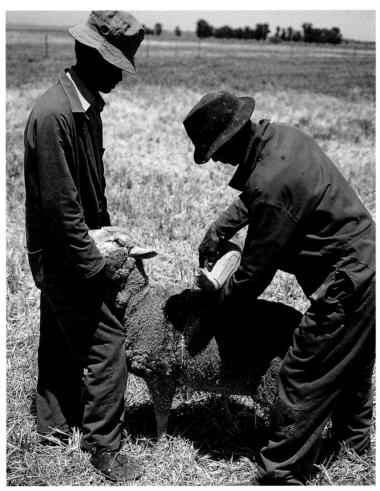

Blowflies are a major threat to sheep if they are not regularly checked and treated. Eggs are laid and the maggots feed particularly around the anus and along the back.

Blowflies laying eggs on a freshly slaughtered animal.

Blowflies and maggots on sheared merino sheep.

Larval therapy

Larvae have been used to clean wounds for hundreds of years, including by the Mayan Indians and Australian Aboriginals. The benefits of maggots in the wounds of soldiers were first observed during the Napoleonic War. Then came the development of modern antibiotics, as a result of which the use of larvae has almost been abandoned and forgotten. But several bacteria are becoming more and more resistant against antimicrobials, so interest in the use of fly larvae has revived in recent years.

The precise mechanism remains unknown, but maggots work on three levels: removal of dead tissue, disinfection and promotion of healing. Larvae applied to wounds feed on necrotic tissue, cellular debris and wound secretions, but leave viable, healthy tissue unharmed. Larvae also eliminate bacteria from the wound through ingestion and the bacteria degrade and die in their intestinal tract. The larvae also produce secretions that inhibit bacterial activity.

Larval therapy (called maggot debridement therapy in medical jargon) can be used on a variety of different wounds, especially slow-healing ones and those infected by resistant bacteria. The larvae, which are aseptically raised and sterile, are applied to wounds for three days at a time. After four weeks most wounds contain no dead material and are no longer infected; healing has been established. The use of larvae has reduced the need for amputation by 62 % in some areas.

The larvae used for therapy on wounds in humans are mainly the European green blowfly (*Lucilia sericata*), which also occurs in Africa.

KENYAN BUSH MEDICINE

In 1994 we travelled along the south coast of Kenya and stumbled on a small tourist camp. The owner, a medical doctor originally from Germany, also ran a small clinic for the people of the villages in the area. He proudly showed us one of his patients, a fisherman he had been treating for almost two years, unsuccessfully at first, for a badly infected chronic leg wound. Finally he had advised him to go to Mombasa hospital where doctors wanted to amputate the lower leg. The fisherman refused the operation and returned home.

As a last resort the German doctor gave the fisherman a jar with maggots and advised him to apply them to his wound under a thick bandage. What we were now shown was not an ugly wound but one completely healed and covered with clean, shiny, but still thin, new skin. The doctor is now collaborating with a German university on research into larval wound treatment.

Moth flies and biting midges

Moth flies (Psychodinae) are attracted to the smell of urine and damp conditions in kitchens, bathrooms, stables and bat caves. They are small, with broad hairy wings, and may occur in countless millions at sewage works, where the larvae feed on algae, fungi and bacteria. Moth flies cannot bite, but occasionally the wind-borne scales and particles from the masses of flies cause allergies and asthma.

Biting midges (Ceratopogonidae) are the smallest flies, less than one millimetre long. Not all bite, but several are parasites; *Leptoconops* species bite humans. The bite is painful and can cause itching and severe swelling. All adult males and many females suck plant juices and are important pollinators. Species of *Culicoides* transmit the virus of African horse sickness and bluetongue in sheep, which can cause huge losses to farmers.

 Prevention

General cleanliness and keeping kitchens and bathrooms dry and well aired will discourage moth flies. Insect repellents applied to skin will prevent trouble from biting midges.

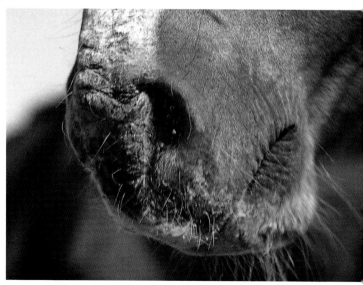

A horse suffering from African horse sickness showing clearly the lesions resulting from the associated fever.

TICKS

Ticks are the most important external parasites of domestic animals. They not only cause local irritation, loss of blood, deterioration in the animal's general condition and tick paralysis (toxicosis), but also transmit several viral, protozoal and rickettsial diseases to animals and humans.

Worldwide there are more than 800 species of tick, and they belong to the same taxonomic group as the spiders and scorpions, the Arachnids. Some 240 tick species occur in the Afrotropical region. All species of tick are parasitic and the females have mouthparts adapted to penetrate their host's skin and draw up blood, during which they transmit a wide range of organisms that are dangerous to humans and animals. Forty-three tick species have been implicated in human disease around the world and mortality is 10 to 12 % of all cases. The most abundant species are the so-called 'hard ticks' (*Ixodidae*).

Tick-borne diseases in cattle have caused huge losses through history. East Coast fever, introduced to eastern southern Africa in 1901/2, is said to have caused the deaths of 95 % of the cattle herds. Because of the massive economic impact, research on tick control got underway in earnest. Tick control is still largely managed by dipping, spraying and injecting chemical poisons. Various efforts aimed at biological control have met with limited success. However, work on immunising antibodies to combat the problem holds great potential and it is probably only a matter of time before they become the vaccines of the future.

Life cycle and transmission

Ticks go through three stages, from eggs to the 'seed' or 'pepper' ticks (the larval form), finally moulting to become eight-legged nymphs. The final moult leaves adults ready to breed. For each change to take place a substantial meal of blood must be drawn from a vertebrate animal. Most ticks prefer warm-blooded prey. A female needs a large quantity of nutritious blood in order to produce her eggs. The adult male wanders about on the host animal until he finds a female but does not draw blood directly, although he may take some from her before or during mating.

Not being a fast-moving creature, how does the tick locate and get onto its host? Generally, it climbs into bushes or grass tussocks and assumes what is known as the 'questing' pose, with front legs extended. Using pincers, or tiny claws, under its head it latches onto a passing animal brushing against the tick 'perch'. The female now seeks out a suitable location, pushes the barbed mouth tube into the skin and starts to draw out her blood meal. She may feed for several days. When fully engorged – she may increase her unfed body weight by several hundred times – she drops to the ground, taking shelter until the eggs, usually between 2 000 and 3 000, are ready to be laid. She then dies, the eggs hatch after about two months, and the cycle begins again.

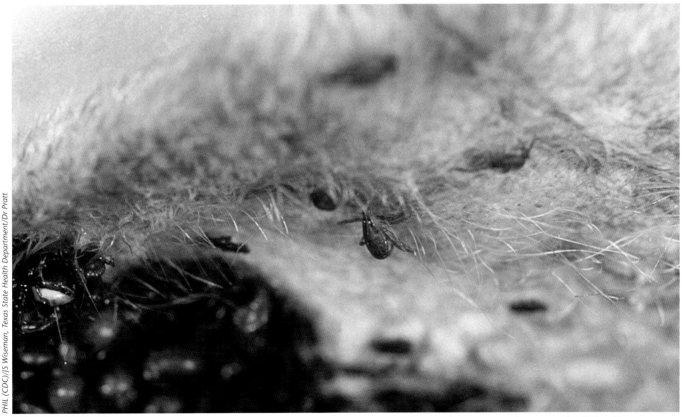

Tick infestations that reach high levels may not only present a disease threat but also weaken an animal as a result of blood loss.

Tick bites

People pursuing outdoor activities, like farming, bush-walking, hiking and hunting, as well as travellers on safari, are most at risk of being bitten by ticks. But ticks can also be brought to the people by their domestic animals, mainly dogs or horses.

A tick bite can produce local skin reactions varying from an itchy papule to a very painful lesion that can progress to tissue death (necrosis). Pepper ticks, the small dark immature forms of hard-bodied ticks, can produce extensive rashes in the summer months.

Apart from the local effects, ticks can also have general effects. Some species of the hard ticks (*Ixodidae*) contain a neurotoxin in their saliva that can cause general paralysis in animals and humans. In South Africa the Karoo paralysis tick is mainly implicated in causing paralysis in domestic animals, and human cases are rare. The ticks live in the hilly parts of the Karoo, hosts are red rock rabbits and sheep, but adults attack domestic animals – mainly sheep, goats, cattle and rarely dogs – from April to September. Tick paralysis is caused only by the blood-sucking females. Once the tick is removed the symptoms improve and recovery is complete.

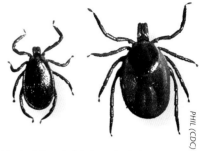

PHIL (CDC)

Typical 'hard ticks': male (left) with scutum covering the body and female (right) with small scutum covering only the front third of the body.

 Treatment

After a day in the bush it is essential to check yourself and each other for ticks attached to the body. Usually the bite itself is painless and only later may itchiness develop. Remove any ticks found attached to the skin immediately. If possible, first wipe the tick's head area with methylated spirits. Then use flat tweezers to grip the head of the tick as close as possible to the skin and give it a firm tug. If mouthparts are left behind this can lead to secondary infection of the wound and your doctor will have to remove them with a small excision.

 Prevention

To prevent tick bites wear protective clothing such as long trousers that are tucked into the socks. Insect repellents can be applied to bare skin and even to the clothes themselves. If you have removed a tick with your fingers never be tempted to squash it. Although you might kill the tick you may still get infected or absorb the neurotoxin through small cuts in the skin of your fingers.

TICKS AND ANIMALS

Tick infestation of domestic animals has a huge impact on farmers and can lead to severe livestock losses. Heavy infestation can lead to blood loss and a general deterioration of the condition of affected animals. Ticks can cause tick paralysis through a neurotoxin and this can lead to anything from a staggering gait and weakness in the hind legs to full paralysis leading to death. The following livestock diseases are transmitted by ticks: swine fever, heartwater, redwater, gallsickness, corridor disease, East Coast fever, biliary fever of horses and dogs (see table in appendix).

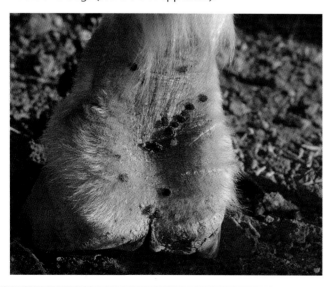

ABOVE: Regular use of tick-specific pesticides is essential if domestic animals are to remain healthy.
LEFT: Tick infestation in the hollow of the pastern on a horse's hind foot.

Tick-bite fever

Tick-bite fever is also known as tick typhus, spotted fever and boutonneuse fever. Several species of hard ticks in Africa can transmit tick-bite fever, which is caused by rickettsiae. These are micro-organisms similar to bacteria but even smaller, with a maximum diameter of 0.5 micrometre. They are exclusively parasitic and can only multiply within a host cell.

Tick-bite fever is the commonest rickettsial disease in Africa and it occurs in two forms. The first is infection with *Rickettsia conorii*, a largely peri-urban and more severe disease found in North Africa. *Rickettsia conorii* var. *pijperi* is the main cause of tick-bite fever in South Africa. The second is infection with *R. africae*, which is more common in rural areas. Mainly campers and hikers are affected, but the characteristic rash is often absent.

Various species of hard tick can transmit the rickettsiae to humans, including the South African bont tick, the brown ear tick, but also several species of the bont-legged tick and the eyeless tick. Transmission is seasonal and occurs mainly in the spring and summer months.

Symptoms

The first symptoms appear six to 12 days after being bitten by a tick. Symptoms include severe headaches, fever, nightmares, general aches and pains. At the bite site a characteristic thick blackened scab with a central ulcer will form, and lymph glands higher up on the limb from the bite will become swollen and tender. Three to five days after the first signs a rash will form on the upper body and limbs, also involving palms of the hands and soles of the feet. Sometimes stupor and confusion may develop. Very rarely the disease may be complicated by multi-organ failure.

In recent years with the increase of 'eco-tourism' African tick-bite fever has increasingly been exported to countries outside Africa.

Multiple tick bites on a man's abdomen one week after a bush outing. Tick-bite fever may have already developed by this time. These lesions are known to lead to intense itching for weeks afterwards.

Treatment

Treatment with tetracycline antibiotics should be started as early as possible. Recovery is usual and complete.

Prevention

No direct measures against the disease-causing rickettsiae exist, but careful checking and immediate removal of attached ticks may prevent infection.

Typhoid, typhus or tick typhus?

Many medical terms originate from the Greek language, *typhos* means 'stupor arising from fever'. The word 'typhoid' contains the Greek *typhos* + *eidos* = 'form' and so can be translated as 'resembling typhus'. So what are we dealing with here? These are all diseases with fever, headache and general aches, but caused by different organisms and transmitted in different ways.

- **Typhoid fever** is caused by the bacteria *Salmonella typhi* and infection occurs through eating or drinking contaminated water, milk or food. Contamination takes place when hygiene is lacking, through contact with faeces or urine.
- **Epidemic (sylvatic) typhus** is caused by the bacteria-like *Rickettsia prowazekii*, which is transmitted from human to human by the human body louse, so it is also called louse-borne typhus. The disease is typically seen in refugee and prisoner populations, during wars and famines.
- **Murine typhus** or **flea-borne typhus** is caused by *Rickettsia typhi* and transmitted by the rat flea. Rat-infested buildings near harbours and rivers pose the biggest risk.
- **Tick typhus** is another name for tick-bite fevers or spotted fevers, which occur in different forms almost worldwide. They are caused by different species of *Rickettsiae* and transmitted by various tick species.

Congo fever

Also known as Crimean-Congo haemorrhagic fever, this disease is caused by a virus. It is primarily a disease of cattle, goats, sheep and hares, but other wild and domestic animals serve as hosts too. Russian scientists first observed and described this disease in the Crimea in 1944 and 1945 and the virus was first isolated in Africa in the Democratic Republic of Congo in 1956. The first case in South Africa was diagnosed in 1981.

The virus is transmitted by several species of tick, most commonly in humans by bont-legged ticks. Tick larvae and nymphs parasitise birds and other wild animals, while adult ticks parasitise cattle, sheep and humans. The virus also gets transmitted from the adult tick to the eggs directly, creating a continuous circle. Infection can take place through contact with the blood of infected animals – mainly in abattoirs or when slaughtering on farms. In November 1996 a number of cases of Congo fever were identified in people working in an ostrich abattoir in Oudtshoorn in the Western Cape, South Africa. It is not clear if ostriches can be infected themselves or if they just carry ticks that are infected with the virus. Congo fever can also be transmitted directly from one human to another through contact with infected blood or other body fluids. Spread of the disease has been documented in hospitals due to improper infection control. In 2002 five cases of Congo fever were confirmed in Namibia and South Africa, and six cases were confirmed in South Africa in the first half of 2006.

It also occurs in the rest of Africa. Worldwide the fatality rate fluctuates between 15 and 70 %. In southern Africa the mortality rate now stands at 26 % as a result of early diagnosis through greater awareness. Survival depends on the availability of good, intensive medical care. In 2008, 11 cases were recorded in South Africa, with no mortalities.

Symptoms

Two to seven days after a tick-bite, Congo fever starts suddenly with chills, fever, severe muscle pains, headache, neck pain and stiffness, vomiting and stomach pain. From the third day bleeding may begin. Large areas of the skin may show severe bruising, nosebleeds occur, blood may appear in the sputum, vomit, stool and urine. Death occurs from massive bleeding, shock and cardiac arrest. Since patients are highly infectious in the acute stage, strict infection control measures must be in place.

Treatment

Treatment is mainly symptomatic and ideally should take place in an intensive care medical facility. An antiviral drug (ribavarin) is believed to improve the prognosis.

Prevention

Strict hygiene and the wearing of protective clothing (including gloves) in abbatoirs or when slaughtering will reduce infection.

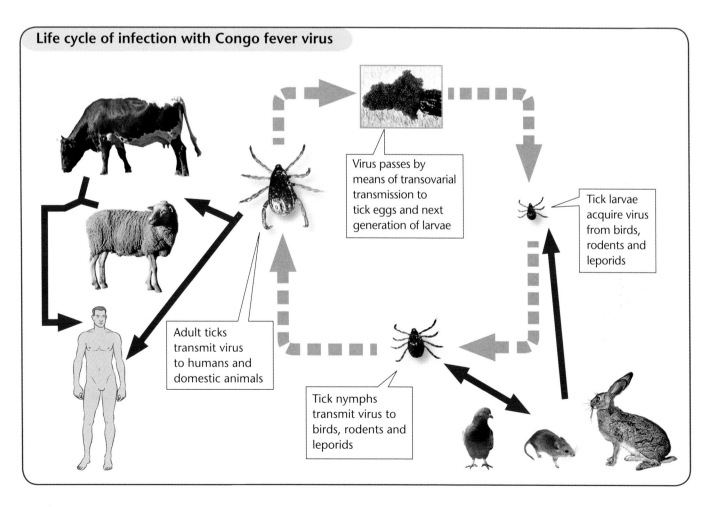

Life cycle of infection with Congo fever virus

Virus passes by means of transovarial transmission to tick eggs and next generation of larvae

Tick larvae acquire virus from birds, rodents and leporids

Adult ticks transmit virus to humans and domestic animals

Tick nymphs transmit virus to birds, rodents and leporids

Tick-borne relapsing fever

This disease is also known as tick-borne borreliosis and endemic relapsing fever. First described in Africa, it occurs in humans and rodents. It is endemic in Africa, but also occurs in many other parts of the world. In South Africa it is mainly found in the hot and humid Lowveld areas. Globally several hundred cases are reported annually, but mortality is low.

Relapsing fever is caused by the spirochete *Borrelia duttoni*, a corkscrew-shaped bacterium. The soft tick or eyeless tampan transmits the borrelia to humans through a direct bite or through infected fluid entering skin abrasions. The soft ticks act as a reservoir for the borrelia because transmission also takes place from the adult to the tick eggs. The ticks live in the soft earth at the bottom of mud-lined walls, so favoured locations for infection include huts, stables, piggeries, other animal shelters, resort cabins and caves.

Symptoms

The disease gets its name from the typical relapsing fever pattern: three to four days of fever are followed by seven to 10 days of no fever. This pattern may repeat itself over longer than three weeks. Additional symptoms may be those of pneumonia, bronchitis, meningitis and encephalitis, and nerves may be involved, even leading to partial paralysis. Rarely, coma and death may follow; fatalities occur mainly in East Africa.

 Treatment

Treatment consists of good general medical care and the use of appropriate antibiotics.

 Prevention

Avoid places where soft ticks are present, wear protective clothing and use insecticides.

Lyme disease

Lyme disease is caused by another of the corkscrew-shaped spirochetes, *Borrelia burgdorferi*. It is a disease of rodents, but is transmitted to deer and humans through the bite of ticks of the genus *Ixodes*. The disease is also known as *Erythema borreliosis migrans* and *E. chronicum migrans*. It has only recently been recognised as occurring in Africa; only sporadic cases are known and, as yet, no detailed data or localities are available.

*Female 'hard' ticks (*Ixodes *spp.) die after laying their egg batch.*

Symptoms

The illness presents in three stages. In the acute first phase there is a widespread rash on the body. In the second stage acute arthritis may occur in several joints, also meningitis and encephalitis. Paralysis of nerves, especially the nerves in the face, may become a symptom. The third stage, the post-Lyme syndrome, becomes apparent only months or years after the original infection and is characterised by chronic, debilitating arthritis.

 Treatment

Treatment with antibiotics is successful during the acute infection but not when given for post-Lyme syndrome.

 Prevention

Prevent being bitten by ticks.

Q-fever

Q-fever is another worldwide threat from animals to humans. It is caused by *Coxiella burnetti*, another rickettsia-like organism and can be expected to occur anywhere in Africa. Bont ticks, eyeless ticks and bont-legged ticks are mainly responsible for the spread of the disease among animals. Goats, sheep and cattle are infected, also domestic cats, rodents and wild ruminants. Humans can get infected through tickbites, but they mainly pick up the disease through the air, through direct contact with infected animals or through consumption of unpasteurised milk products. The *Coxiella* remains active and alive in droppings, urine, milk, blood and tissues. Mainly at risk of contracting Q-fever are farmers, veterinarians, butchers, meat packers and visitors to livestock selling yards.

Q-fever presents as an influenza-like illness with fever, headaches, sweating, cough, pneumonia and hepatitis.

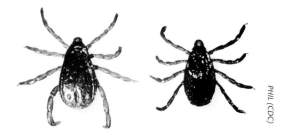

A typical example of 'brown hard ticks', Rhipicephalus *sp., that have been implicated in the spread of tick-bite fever.*

 Treatment

Treatment with tetracyclines is successful when started early, but untreated cases often become chronic, mainly affecting the liver and the heart.

 Prevention

No specific measures to prevent infection exist. Don't consume unpasteurised milk products and avoid direct contact with infected animals.

WORMS

Worms (helminths) are multicellular invertebrates and all are parasites, but only a minority are parasitic to humans. Most dangerous for humans are roundworms, tapeworms and flukes. Infestation with any of the worms is called helminthiasis.

Worms (or their eggs) can be picked up from soil, in water or through the digestive tract. Most worm infections take place directly between humans, but some – mainly roundworm infections – need a vector, or carrier, like a fly. Examples include the mosquito in lymphatic filariasis (see page 178) and the black fly in river blindness (see page 189). Around two billion people, or a third of the world population, harbour worm infections and 300 million are severely ill with worms, half of them school-age children.

Soil-transmitted worm infections

Soil-transmitted worm infections are widely distributed in tropical and subtropical areas and linked largely to lack of sanitation. They are a health problem throughout Africa. All depend for their dispersal on the indiscriminate deposition of human faeces on the ground, or when this is used as agricultural fertiliser.

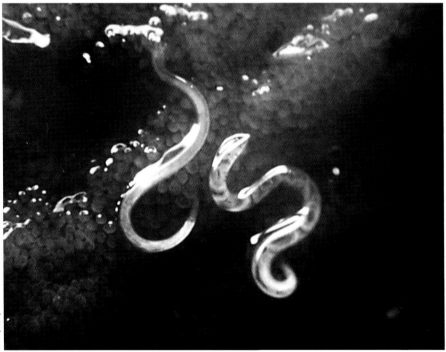

PHIL (CDC)

An enlargement showing adults of the dog hookworm (Ancylostoma caninum) *attached to the wall of the intestine.*

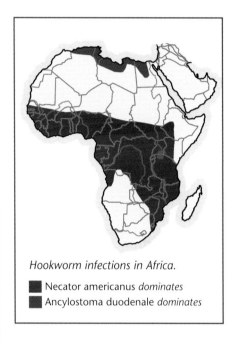

Hookworm infections in Africa.
■ Necator americanus *dominates*
■ Ancylostoma duodenale *dominates*

Hookworms

The most common hookworms infecting humans are *Ancylostoma duodenale* and *Necator americanus*. Both are minute worms belonging to the class Nematodes (roundworms). The estimated worldwide prevalence in humans is 700 to 900 million cases. One species usually dominates in any one locality – in sub-Saharan Africa, for instance, *N. americanus* is mainly present. The larvae need warm, moist soil, and eggs will not turn into embryos below 13 °C. This limits the distribution and in South Africa it occurs mainly in the Lowveld areas, including KwaZulu-Natal. Hookworms were found in 1.8 % of all screened stool samples in KwaZulu-Natal (SAMJ September 2008).

Life cycle and transmission

Adult worms are attached to the wall of the small intestine, where females lay large numbers of eggs that are passed out with the faeces. Eggs mature in wet soil to larvae, which feed on bacteria and moult twice into infective larvae that remain viable for one to three months. These penetrate the skin of a new host, usually on the feet or legs, and migrate from the skin into small blood vessels till they reach the heart and the lungs, and eventually the pharynx, from where they are swallowed and pass into the small intestine. Here they mature into adults. Wet soil at the edges of rice fields, rubber plantations and the surroundings of villages in areas of high rainfall support the maturation of hookworm larvae from eggs deposited by indiscriminate defecation. Barefoot walking makes infection easy.

The first manifestation of an infection may be an itch. Where the larvae have entered through the skin, a small, itchy, red papule

is visible. While the larvae migrate through the lungs a dry cough may be present, with wheezing, blood-stained sputum and low-grade fever. The adult worms are only about one centimetre long and slightly curved. They feed by sucking blood from the wall of the intestine. A single *Ancylostoma duodenale* can withdraw as much as 0.34 millilitres a day and can live for up to 18 years. Severe anaemia is the classical feature of hookworm disease. Abdominal symptoms may be vague pain, diarrhoea and loss of appetite.

 Treatment

Specific worm medication is available and it is effective.

 Prevention

The use of proper latrines or water-borne sewage with correct processing will reduce the contamination of soil with hookworm eggs. Do not walk barefoot on wet soil around human habitations that lack proper sanitation.

Creeping eruption

The infective larvae of several species of animal hookworm often fail to penetrate human skin. Instead they migrate through the epidermis (outer skin layer), leaving typical serpiginous tracks, known as 'creeping eruption'. This is caused mainly by dog hookworm (*Ancylostoma caninum*) and cat hookworm (*Ancylostoma braziliense*) and picked up when walking barefoot on sandy soil of beaches or playgrounds contaminated by dog or cat faeces. This 'rash' can also be caused by larvae of *Strongyloides stercoralis*, in which case it usually appears on the back or buttocks – sometimes many years after initial infection.

Creeping eruption

Mouthparts of the hookworm Ancylostoma braziliense

Strongyloides stercoralis

Infection with *Strongyloides stercoralis*, a tiny roundworm (nematode) up to 2.2 millimetres long, occurs mainly in tropical and subtropical areas, but sporadically also in temperate areas. It is estimated that there are 60 million cases worldwide. In South Africa it occurs in the northern and northeastern wet and warm areas, but is widespread from Angola, Zimbabwe and Mozambique northwards.

Life cycle and transmission

The life cycle is similar to the hookworm, but the eggs hatch in the wall of the small intestines, so larvae rather than eggs are passed in the faeces. These larvae can spread by direct contact from human to human as well. Apart from the parasitic generation, there is also a free-living generation: the larvae in the ground can develop into free-living males and females that lay eggs. The eggs hatch in the soil and eventually develop into infective larvae, which again can penetrate the skin and recommence a parasitic cycle in humans. Larvae can also develop into infective larvae in the host's intestine, where they can directly penetrate the wall of the lower intestine and/or the perianal skin. This leads to auto-infection and can cause severe 'creeping eruption'.

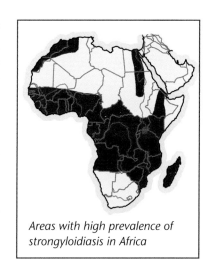

Areas with high prevalence of strongyloidiasis in Africa

In heavy infestations severe intestinal symptoms can dominate: diarrhoea or constipation, vomiting, abdominal pain, blood in stool. Severe loss of weight due to low absorption of nutrients from the intestine (malnutrition) will develop.

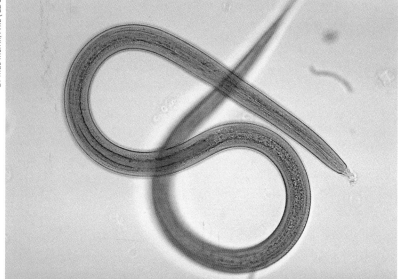

 Treatment

Specific worm medication is a safe and effective treatment.

 Prevention

Hand washing and the use of proper toilet facilities are the mainstay of prevention of infection. Do not walk barefoot on wet soil around human habitation lacking proper sanitation.

An infective larva of a Strongyloides *roundworm.*

Ascaris lumbricoides

Infection with another roundworm *Ascaris lumbricoides* is the most common of the intestinal worm infections. Some 800 million to one billion people are infected worldwide, and probably hundreds of thousands of people in South Africa. Some 10.7 % of all screened stool samples contained this roundworm in a study in KwaZulu-Natal, published in September 2008. Although not documented, it is certain that many millions of people across Africa are infected. The worm is distributed worldwide because the eggs can also survive in a cold climate, and is especially prevalent in areas with low standards of hygiene and sanitation or where human faeces is used as fertiliser. The infection is specific to humans and occurs in all ages.

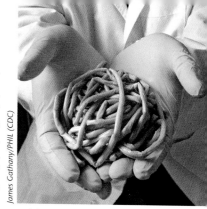

James Gathany/PHIL (CDC)

A laboratory technician holds a mass of Ascaris lumbricoides.

Life cycle and transmission
The adult worms are the largest of the intestinal nematodes, 15 to 35 centimetres long and three to six millimetres in diameter. They are smooth, white to reddish-yellow, unsegmented and can live for a year or more. The adults live in the upper small intestine, producing large numbers of eggs (200 000 each day) that are passed out with the faeces. In the soil the larvae develop inside the eggs and are readily ingested with contaminated food and water. The larvae hatch in the small intestine, then penetrate the gut wall to be carried with lymph and blood to the heart and lungs. There they grow, moulting twice, before they eventually reach the stomach via the pharynx. Once again in the small intestine they grow into adult worms.

Symptoms
Small numbers of adult worms in the intestine usually produce no symptoms, but heavy infestation may lead to obstruction of the bowel, possibly death. Adult worms may also migrate, causing gall bladder infection, bile duct obstruction, jaundice and liver abscess. They may be coughed or vomited up.

 Treatment
Anthelmintics usually destroy or expel the worms.

 Prevention
Proper toilet facilities are essential. Human faeces should not be used as fertiliser.

Dog and cat roundworm *Toxocara*

Toxocariasis (or visceral larva migrans) is the infection of humans with eggs of the dog roundworm (*Toxocara cani*) and also, but more rarely, by the cat roundworm (*T. cati*). Uncontrolled contamination of soil by cats and dogs is common everywhere, and the eggs can survive even in a cold climate. Toxocariasis occurs anywhere in Africa where there is human habitation.

Life cycle and transmission
The life cycle of these worms in their normal animal host is similar to the cycle of *Ascaris* in humans. Most eggs are passed into the environment by puppies and lactating bitches in their droppings and children easily ingest eggs from the soil. The larvae that hatch cannot mature in humans, but continue to migrate through the tissues for up to six months. Eventually they lodge in various organs, particularly in the lungs, liver, brain and eye, where the body forms a capsule around them. These granulomas may be up to one centimetre in diameter. Eventually the larvae die.

Granulomas in the eyes may cause squinting and loss of vision, though permanent visual impairment is rare. Symptoms may persist for months but usually clear within a year or two.

 Treatment
Once granulomas are established treatment is difficult and controversial.

 Prevention
Regular deworming of young and lactating dogs and cats is essential.

Whipworm *Trichuris trichiura*

Whipworm infection, also known as trichuriasis, is common worldwide, especially in tropical and subtropical areas with low hygiene levels. It is estimated that up to 500 million people are infected, mainly children.

Life cycle and transmission
Adult whipworms (*Trichuris trichiura*) are long and pinkish-grey, reaching three to five centimetres in length. The front three-fifths are slender while the back two-fifths are bulky and fleshy (the 'whip handle'). They live in the large bowel, where females lay 3 000 to 7 000 eggs daily and they are passed in the faeces. After 11 to 30 days in the soil a coiled infective larva develops in the egg. When ingested by humans (in undercooked food, vegetables, from hand to mouth) they hatch out in the small intestine and develop into mature worms that migrate down the intestine and parasitise the large intestine. Mild to moderate whipworm infections rarely show symptoms. Heavy infections cause abdominal cramps and distension, chronic bloody and painful diarrhoea and weight loss.

 Treatment
Deworming with appropriate anthelmintic medication prevents and treats infection.

 Prevention
Good general hygiene is effective.

Snail-mediated worm infections

These worm infections in humans are all caused by trematodes (flukes), which undergo a complicated cycle involving various species of land or aquatic snails. *Fasciola hepatica*, the sheep liver fluke, is mainly a parasite of sheep that infects humans when they eat watercress or other aquatic plants from contaminated, wet pastures. The most important of these trematode infections is schistosomiasis.

Blood flukes – *Schistosoma* species

Bilharzia

Schistosomiasis is more commonly known as bilharzia or bilharziosis. Over 600 million people worldwide are exposed to it and 261 million are infected, with 228 million of those in Africa, where only two of the three common species of blood fluke occur: *Schistosoma mansoni* and *S. haematobium*. Humans are the main reservoir for both species. In Africa up to 150 000 deaths a year may be the result of kidney failure caused by chronic infection due to *S. haematobium* and perhaps as many as 100 000 deaths a year result from the obstruction of the flow of blood through the liver caused by *S. mansoni*. In South Africa there are over five million people infected and over 30 million at risk, mainly children.

Schistosomes need water, so water-resource developments, dams and irrigation channels boost transmission. Between 1950 and 1990 the number of major dams increased, with a consequent rise in schistosomiasis in sub-Saharan Africa. In spite of the availability of excellent anti-schistosomal drugs and molluscicides, there has been remarkably little overall success in controlling schistosomiasis. The WHO claims great success in combatting bilharziosis and gives African figures for 2004 as low as 36 000 deaths. This may be a gross underestimate as a result of under-reporting.

There is a risk of infection when skin comes in contact with fresh water from canals, rivers, streams or lakes in all of sub-Saharan Africa, including Lake Malawi, Lake Kariba, Lake Victoria and the Nile River in Egypt. In South Africa schistosomes are present in Mpumalanga and Limpopo provinces, in Gauteng north and east of the Witwatersrand, in the lower-altitude areas of KwaZulu-Natal and along the coast into the Eastern Cape province to around Port Elizabeth. Activities such as bathing, swimming, washing or wading may lead to infection. The parasite survives for 48 hours even in containers.

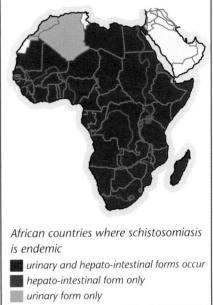

African countries where schistosomiasis is endemic
- ■ *urinary and hepato-intestinal forms occur*
- ■ *hepato-intestinal form only*
- ■ *urinary form only*

Life cycle and transmission

Schistosoma haematobium and *S. mansoni* have similar life cycles. The adult worms live in the blood vessels of the human host – *S. haematobium* in the blood vessels around the bladder, and *S. mansoni* near the rectum. The female lays eggs, which penetrate the bladder and the intestinal wall, and get excreted with urine or faeces. These eggs hatch in water bodies and release microscopic larvae. To survive, the larvae must find and penetrate an appropriate snail host. In the snail, development finally produces fork-tailed larvae called cercariae. These leave the snail and enter the water where they penetrate the skin of a new human host. Once through the skin they shed their tails and migrate through the tissues until they get to the liver. Here males and females mature, copulate and settle in pairs in the veins. Eventually they migrate to the minute blood vessels around the bladder and rectum, where they can live for many years and produce eggs. Not all eggs penetrate the bladder or intestinal walls to be excreted, but remain in the tissues.

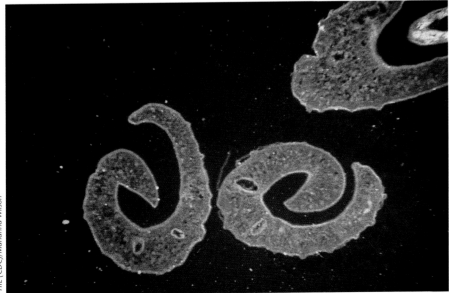

PHIL (CDC)/Marianna Wilson

The trematode Schistosoma mansoni *that causes bilharzia in man, here under the microscope at 78 times magnification.*

Life cycle of *Schistosoma mansoni* and *S. haematobium*

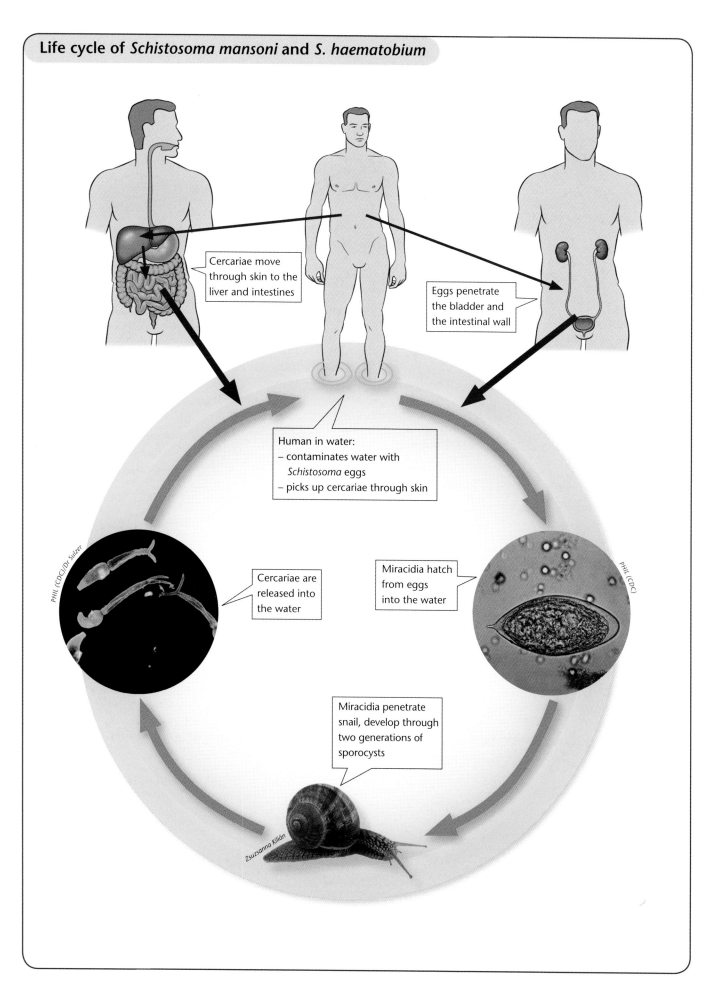

Cercariae move through skin to the liver and intestines

Eggs penetrate the bladder and the intestinal wall

Human in water:
– contaminates water with *Schistosoma* eggs
– picks up cercariae through skin

Cercariae are released into the water

Miracidia hatch from eggs into the water

Miracidia penetrate snail, develop through two generations of sporocysts

PHIL (CDC)/Dr. Sulzer

PHIL (CDC)

Zsuzsanna Kilián

Symptoms

Live worms do not do any damage and rarely cause symptoms. After the cercariae enter the skin a transient skin reaction may erupt, called 'swimmer's itch'. The eggs deposited in the tissues cause a delayed hypersensitivity reaction in the host body and this reaction causes the tissue damage. In *Schistosoma haematobium* infection, the first clinical sign is blood in the urine. In chronic infections constriction of the ureter can cause blockage of urine flow from the kidney, with bacterial infection of the kidneys. Both eventually lead to kidney failure in the late stage. The changes in the bladder wall can give rise to bladder cancer years later.

Chronic infection with *S. mansoni* classically leads to enlargement of the liver and spleen. In puberty it can cause significant growth retardation, abdominal pain with diarrhoea, or blood in the faeces. The liver function remains good for a long time, but as the blood vessels are affected, the blood pressure in the vessels of the liver rises, eventually causing damage to the heart and lungs. Death occurs through heart failure.

Most rural people, and many urban-dwellers, across much of Africa have little choice but to fish, bathe and wash clothes in waters that are host to bilharzia parasites.

 Treatment

With treatment the prognosis is excellent for light infections and those diagnosed early. Once damage is done to kidneys and liver the outlook is poor. In endemic areas the goal is for regular mass treatment of children to diminish risk of developing severe organ damage, even though reinfection is common.

 Prevention

Avoid swimming, wading or washing in infested water bodies. Leave water to stand in containers longer than 48 hours before bringing it into contact with skin.

Gastrointestinal worm infections

Tapeworms

Beef tapeworm
Taenia saginata

The beef tapeworm (*Taenia saginata*) causes the most common tapeworm infection in humans, with 76 million cases of taeniasis reported worldwide. It is the largest of the tapeworms, 10 metres long or more. Like all tapeworms it consists of a head with which it is attached to the intestinal wall, a neck, and a chain of segments. Infection occurs in most countries with beef farming and it is endemic in some East African countries. Meat inspection in abattoirs is essential to contain its spread.

Life cycle and transmission

Humans are the main hosts. Adult worms live in the small intestines and segments escape through the anus, releasing large numbers of eggs to the ground in faeces, or they can reach paddocks in sewage water. The eggs are ingested by cattle and hatch into oncospheres (embryos). They penetrate the intestinal wall and migrate to muscle tissue, where they encapsulate, forming larvae, which are about the size of a match head. When humans eat undercooked meat containing larvae, the larvae settle in the small intestine and develop there into adult tapeworms.

Usually the person affected shows no symptoms, but some nausea, abdominal discomfort and fatigue are possible.

 Treatment

Treatment consists of appropriate anthelminthic medication.

 Prevention

Avoiding undercooked meat is a key prevention measure.

PHIL (CDC)/Dr Mae Melvin

The head (on right) and neck of the pork tapeworm Taenia solium.

Life cycle of *Taenia saginata* and *T. solium*

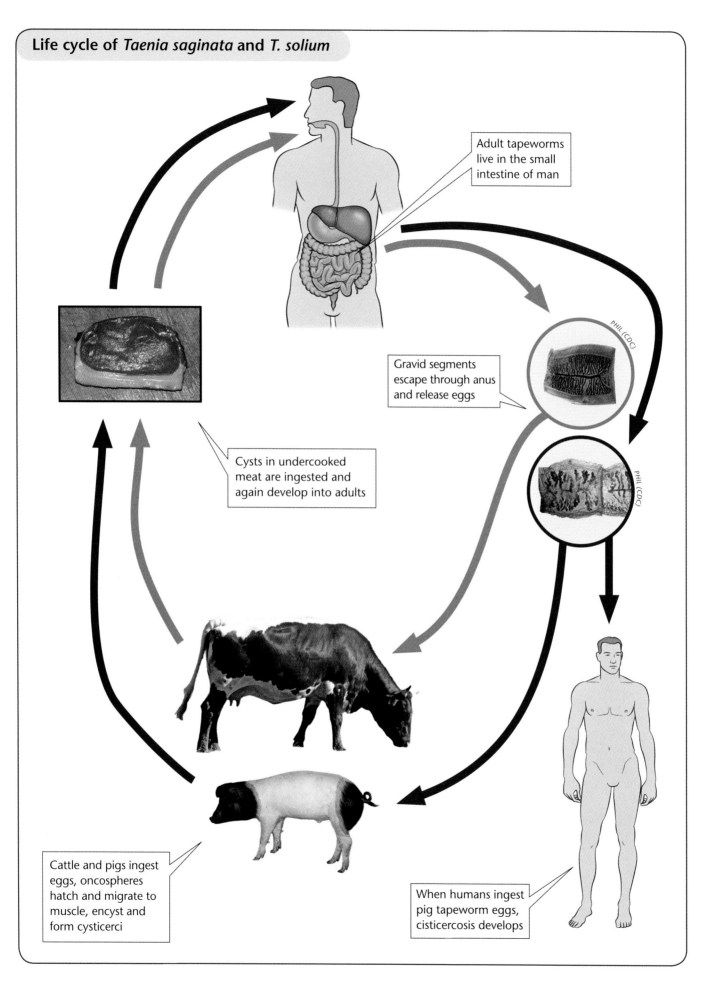

Adult tapeworms live in the small intestine of man

Gravid segments escape through anus and release eggs

PHIL (CDC)

PHIL (CDC)

Cysts in undercooked meat are ingested and again develop into adults

Cattle and pigs ingest eggs, oncospheres hatch and migrate to muscle, encyst and form cysticerci

When humans ingest pig tapeworm eggs, cisticercosis develops

Pork tapeworm *Taenia solium*

About five million people are infected with the pork tapeworm worldwide, and it is again particularly prevalent in Africa. The pork tapeworm (*Taenia solium*) may reach two to eight metres in length.

Life cycle and transmission

The life cycle is similar to that of the beef tapeworm, but the intermediate host is the domestic pig, which feeds on human faeces or in contaminated areas around human habitation. Again, humans ingest the infective larvae (cysticerci) in undercooked or raw pork (visible to the eye as 'measly pork').

Intestinal infection through the adult worm causes few symptoms, but the pork tapeworm can give rise to the fatal disease cysticercosis if humans accidentally ingest eggs rather than larvae, in which case they become the intermediate host instead of the pig. Auto-infection can also occur, when the segments rupture in the small intestines. Then the oncospheres encyst and can even calcify, and these pea-sized nodules can spread through muscles, in subcutaneous tissue and the brain, causing epilepsy, neurological symptoms and even death.

 Treatment

All tapeworms can be treated by appropriate anthelminthic medication. Once complications have occurred in the form of cysts, treatment is difficult and must be attempted in a specialist environment.

 Prevention

Cysticerci can be killed by cooking food at 65 °C or freezing at -20 °C for 12 hours, but pickling is not adequate.

Fish tapeworm *Diphyllobothrium latum*

The fish tapeworm (*Diphyllobothrium latum*) occurs in temperate and sub-Arctic fresh and brackish waters worldwide, with about 16 million people infected. In Africa it is present mainly in lakes and water bodies in the temperate zones of southern Africa. Adults parasitise humans, cats, dogs and other fish-eating mammals.

Life cycle and transmission

In its development the worm needs two intermediate hosts. When eggs in faeces reach water, free-swimming larvae are ingested by various water fleas and freshwater crustaceans, where they develop into the next larval stage. The water fleas are ingested by freshwater fish and the larvae emerge to lie in the fish muscle. When humans eat partially cooked fish, the larvae find themselves in an appropriate host and proceed to develop into adult worms.

Infection in humans often shows no symptoms, or vague abdominal discomfort. In some people it can cause anaemia, as the worm competes with the host for vitamin B12.

 Treatment

As with all tapeworms, this infestation can be treated by appropriate anthelminthic medication.

 Prevention

If fish is cooked well the larvae die and no infection takes place.

Dwarf tapeworm *Hymenolepis nana*

The dwarf tapeworm (*Hymenolepis nana*) is very common in warm areas and infection can reach high levels, especially in children in areas with poor hygiene. The adult worm is one to three centimetres long and about a millimetre wide, and several hundred to a thousand worms may live in one host. Dwarf tapeworm is estimated to infect about 36 million humans.

Life cycle and transmission

Humans can be the final or the intermediate host, since both adult and larval stages occur in humans. The adult parasitises in the small intestines and eggs are passed in the faeces. When directly eaten by another person the eggs hatch into oncospheres (embryos) that burrow into the intestinal wall; here they mature into tailless oncocysts that migrate further down in the intestines where they attach themselves, form segments and produce eggs. Eggs can also be ingested by insects such as fleas, beetles and cockroaches. Larvae hatch in the insect but only become adult worms when they are ingested by rodents or humans. Infections in children usually disappear in adolescence and are therefore rarely treated.

Symptoms

Light infections usually cause no disease, whereas heavy infections may cause diarrhoea, abdominal pain, vomiting and weight loss.

 Treatment

Treat with appropriate anthelminthic medication.

 Prevention

Simple hygiene and cleanliness in and around the house are essential.

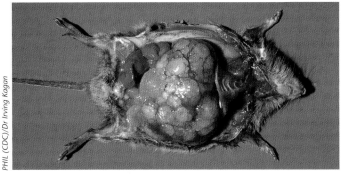

PHIL (CDC)/Dr Irving Kagan

A dissected rat showing heavy infestation by Echinococcus multilocularis, *a tapeworm mainly carried by wild members of the dog family.*

Dog tapeworm
Echinococcus granulosus

The dog tapeworm *Echinococcus granulosus* causes hydatid disease (also known as hydatidosis or echinococcosis). It parasitises the small intestine of carnivores, mainly in domestic dogs, but also in hyaenas and jackals. Human infection with *E. granulosus* occurs worldwide, and is endemic in most of southern Africa.

Life cycle and transmission

The adult tapeworm (about five millimetres long) in the dog's small intestine produces eggs that are excreted with the faeces, to be ingested by herbivorous animals, mainly sheep, but also goats, cattle, horses and other ungulates, as they graze. The eggs hatch in the duodenum, and hooked embryos enter the blood circulation where they are carried to various sites to develop into cysts, mainly in the liver and lungs. Dogs become infected through eating cysts contained in contaminated offal.

Humans are accidental intermediate hosts. Infection occurs directly through ingestion of eggs due to contact with infected dogs or contaminated dog faeces, or through contaminated water and food. Insects (flies) can also carry eggs onto food. Liberated embryos penetrate the intestinal wall, enter the bloodstream and are carried to the liver (in 65 % of cases), where they develop into hydatid cysts (hydatis = water blister). Some larvae reach the lungs and infrequently cysts form in the brain, bones, muscles, kidneys and spleen.

The cysts can grow from one to 30 millimetres in diameter per year and become enormous, up to 30 centimetres across. The cyst is filled with watery fluid and has two walls, and the host encapsulates it with a third fibrous wall. The inner wall of the cyst produces daughter cysts with growing heads.

Symptoms

For years no symptoms may be present at all. If a cyst ruptures, allergic shock can develop, daughter cysts may be spread further or spontaneous healing may follow. The most serious symptoms occur when cysts are located in the brain and the spinal cord, leading to paralysis, seizures and death. In the liver and abdominal cavity cysts mainly cause obstruction, and shrinking of an organ may occur due to pressure. About 15 % of untreated patients eventually die because of the disease or its complications.

 Treatment

Therapy has long involved surgery to remove the cysts, but recently, with the development of more effective and safer anthelmintic drugs, a combined approach is used, especially if the cysts are still small and diagnosed early. A course of Albendazole is given, and if the cyst does not disappear or die after six to nine months it must be removed surgically.

 Prevention

Prevention is essential by deworming dogs regularly and not feeding them contaminated offal. Do not let children play on ground near dog faeces.

Life cycle of *Echinococcus granulosus*

Man is infected if he ingests eggs from infected dogs

Adult tapeworm lives in the small intestine of dogs

Eggs are passed by the dog in its faeces

Cysts develop in different organs

Herbivores (domestic and wild) ingest the eggs, which hatch in the intestine, embryos enter bloodstream and form cysts in different organs (mainly liver and lungs)

Cysts (with scolex) in offal get ingested by dogs again

PHIL (CDC)/Dr Irving Kagan

PHIL (CDC)/Dr Irving Kagan

ANIMALS THAT CAUSE DISEASE

Pinworm *Enterobius vermicularis*

Humans are the only host of the pinworm or threadworm *Enterobius vermicularis,* and infection is common throughout Africa and four million people are estimated to be infected, young children more often then adults.

Life cycle and transmission

The adult worms, also belonging to the nematodes or roundworms, are eight to 13 millimetres long and inhabit the large intestine. Females migrate through the anus to lay eggs; within a few hours these eggs may infect others or be auto-infective if transferred to the mouth by contaminated food, drink or hands. The eggs hatch in the small intestine and the larvae migrate down to the large intestine.

Symptoms

The most common and important symptom is itchiness around the anus, mainly at night, due to the presence of female worms or deposited eggs. Insomnia, restlessness and irritability are common.

 Treatment

Specific anthelmintic medication is effective.

 Prevention

General hygiene prevents infection: wash your hands regularly, especially after having visited the toilet and before handling food.

Trichinella species

Trichinosis is caused worldwide by *Trichinella spiralis*. Recently three more species of this genus of roundworm were recognised, including *Trichinella nelsoni* in Africa. Trichinosis is a roundworm infection of animals that circulates between rats and various carnivores.

In humans, infection results from eating undercooked or raw pork, or pork products like sausages. Domestic pigs and bushpigs are the most important reservoirs. Recent surveys have shown that human trichinosis is increasing on all continents. Estimates speak of 49 million people infected.

Life cycle and transmission

Infection is acquired by eating meat containing the encysted larvae within. In the small intestine they develop into minute adults and in five days they are mature. Females then deposit larvae that migrate through the tissues to reach skeletal muscles in which they again encyst and finally they may calcify.

Symptoms

The disease presents in three stages. Diarrhoea, abdominal cramps and mild sickness occur during the first week. The second stage coincides with the invasion of muscle tissue from the end of the first week and lasts about six weeks. The parasitised muscle becomes inflamed, and other symptoms are fever, muscle pain and tenderness, and facial swelling, especially around the eyes. The recovery stage generally begins in the second month, though vague muscle pains and mild sickness may persist for several months more. The more important complications are pneumonia, encephalitis and heart failure.

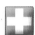 **Treatment**

Recovery is usually spontaneous. Treatment is only necessary in cases with severe symptoms and death is rare.

 Prevention

Prevention entails not feeding uncooked food scraps to domestic pigs, and adequate cooking of pork at 77 °C, or above.

The roundworm infection trichinosis results from eating undercooked, or raw, pork products.

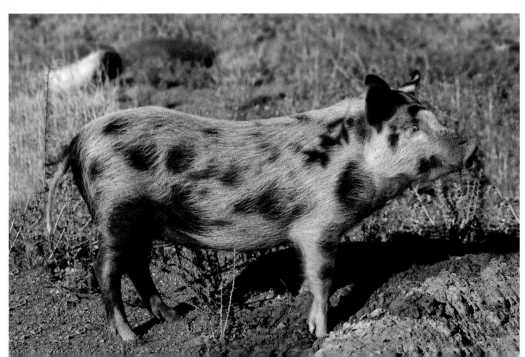

OTHER DISEASES TRANSMITTED BY ANIMALS

The collection of diseases affecting the human being is vast, with many probably still waiting to raise their ugly heads. The few that we have covered here are among the most horrible, one of which, rabies, has no known cure. We have not covered killers such as HIV/AIDS, strongly believed to have been first transmitted to humans by non-human primates in tropical Africa, as is the often fatal Ebola.

Rabies

Although there are few cases of human rabies, it is the horrible manner of death that makes this disease so terrible. 'Rabies' is Latin for 'rage', which describes some of the symptoms. Once symptoms appear the disease is invariably deadly.

The WHO estimates that there are 40 000 to 70 000 human deaths from rabies worldwide each year, 30 to 50 % in children under 15 years, 90 % caused by dog bites. Approximately 10 million people get immunised every year after being bitten. In South Africa about 600 to 700 cases of rabies are diagnosed in domestic and wild animals per year, and dogs, cattle and yellow mongoose constitute 80 % of these. An average of eight people die from rabies in South Africa every year. From 1996 to 2005 there were 93 confirmed cases in the country, and all ended in death. From January to April 2006 there were 12 confirmed cases in South Africa, 11 of them in one district in Limpopo Province. There were 23 cases in the first nine months of 2006, and in 2007 five deaths were confirmed by mid-March – three from KwaZulu-Natal, one from Limpopo and one from the Eastern Cape. In 2008, 16 deaths were recorded in South Africa, in four of the eastern provinces. Between January and March 2009 six human cases were confirmed in South Africa, three each in KwaZulu-Natal and the Eastern Cape. Each year the death toll rises because of lack of capacity and controls. The WHO has cited 'notorious lack of surveillance data' across much of Africa, including South Africa. In January 2009, a British female, who had been working as a volunteer in a South African animal shelter and was bitten there trying to separate fighting dogs, died in Northern Ireland.

Latest WHO figures for human rabies from other African countries from 2002 are 19 from Namibia and five from Zimbabwe, but under-reporting is widespread and accurate statistics in many African countries are unavailable. Rabies is present almost everywhere on the continent, but there is an almost total lack of documentation in many countries.

Rabies is transmitted in about 15 % of instances of rabid dogs biting humans. In 2006 KwaZulu-Natal had one of its worst ever rabies epidemics, with about 300 animal and four human cases officially diagnosed – more than double the number for 2005. Rabies control was difficult in that year as many veterinary officials were dispatched to man border checkpoints following the classical swine fever outbreak in the Eastern Cape. The increase in unvaccinated and unsterilised abandoned dogs has become a major problem for rabies control in KwaZulu-Natal. Trials are under way to vaccinate feral dogs using bait dosed with rabies vaccine. Financial restraints complicate the situation further.

The rabies virus does not occur in blood, but spreads along the nerves. The virus is present in the saliva of sick animals, can be transmitted through bites, but also through licking when there is a break in the human skin.

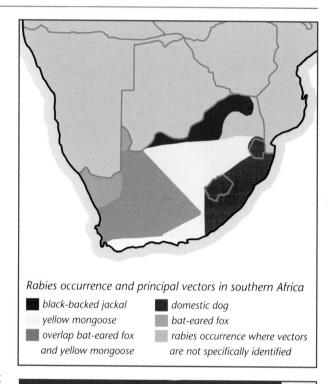

Rabies occurrence and principal vectors in southern Africa

- ■ black-backed jackal
- □ yellow mongoose
- ■ overlap bat-eared fox and yellow mongoose
- ■ domestic dog
- ■ bat-eared fox
- ■ rabies occurrence where vectors are not specifically identified

BATS AND DISEASE

Although bats have been implicated as carriers of a number of diseases that can impact on humans, this should not be overstated. Some bat species are known to carry rabies and rabies-like viruses, such as the lyssaviruses and Lagos virus. Only 1.2 human cases of rabies are recorded worldwide each year as a result of bat bites.

Lagos virus was first recorded in 1956 from Nigeria in the straw-coloured fruit bat (*Eidolon helvum*). It has since been recorded from six additional countries in fruit bats such as Wahlberg's epauletted in Durban, South Africa, and one insectivorous bat species. In 2005 a domestic dog from Richards Bay, South Africa, died from the Lagos virus.

Three species of fruit bat in Central Africa have been identified as apparently symptomless carriers of the Ebola virus. There is also evidence that has linked bats to Marburg disease. But we stress that secondary impacts on humans are miniscule and bats should *not* be persecuted.

Animal carriers

The rabies virus is a bullet-shaped RNA virus, of the genus *Lyssavirus* (family Rhabdoviridae), and there is a mongoose (herpestid) strain and a dog strain. There are also three rabies-related viruses in Africa – Lagos Bat and Duvenhage viruses, both transmitted by bats, and Mokola virus, thought to be transmitted by rodents and shrews. These three closely related viruses are rare. Duvenhage has caused two deaths in South Africa, Lagos Bat virus does not cause disease in humans, and there are a few cases of rabies-like disease reported in cats caused by the other two viruses.

The major host species in the whole of Africa is the domestic dog but jackals, mongooses and foxes also carry rabies. In southern Africa geographical variations are better known: the domestic dog (KwaZulu-Natal, eastern half of the Eastern Cape, Swaziland, Lesotho), black-backed jackal (western Limpopo, northern North West), yellow mongoose (Gauteng, Mpumalanga, southern North West, Northern Cape, western half of the Eastern Cape, Western Cape, except south coast), and the bat-eared fox (Northern Cape, Western Cape, western half of Eastern Cape). In Namibia greater kudu are an important reservoir and rabies in that country is sometimes called 'kudu pest', causing severe mortality in kudu at times.

In South Africa infection occurs either through direct contact with the wild host, or indirectly through a domestic pet or livestock intermediary, but 92 % of all rabies cases in humans in South Africa are associated with dog bites. Rats, mice and pets such as rabbits and guinea pigs do not transmit rabies. The domestic cat has often been involved in the mongoose rabies as an intermediary.

Signs and symptoms

As in humans, rabies in animals takes one of two forms, paralytic or furious. In the paralytic form many wild species lose all fear of humans and will readily approach homesteads, enter houses and interact with dogs and people (jackals, mongooses, even kudu). Late winter is the most dangerous time, with wild animals generally often moving closer to human habitation to find food and water. Those infected are usually emaciated, obviously unwell, have an erratic gait, excessive salivation and the jaw may hang open. The furious form – or 'mad dog' syndrome – is less common. The animal is alert and aggressive, will attack anything that moves and will bite even inanimate objects. It may travel great distances (25 or 30 kilometres is not unusual for dogs and jackals) before terminal paralysis sets in.

Bovine rabies is common particularly in social mongoose-inhabited regions, and is usually accompanied by severe salivation. The same symptoms may also be caused by ingestion of a foreign body, so the first thing the farmer will do is a manual examination of the oral cavity. The cow does not have to bite him; if the farmer has a small wound or cut, infection occurs through contact with the cow's saliva. There is no record in South Africa or elsewhere of rabies infection after eating the meat of a slaughtered animal that showed signs of rabies. The virus can also not penetrate intact skin.

The incubation period varies from a few days to several months – occasionally years – but averages 20 to 60 days. The illness begins with non-specific signs, such as flu, a common cold or upset stomach. One to two thirds of patients experience pain, itchiness or strange sensations at the site of the bite.

A dog in the late stage of 'dumb' paralytic rabies, where the throat and jaw muscles are no longer able to function, resulting in the death of the animal.

Next follows the acute agitated phase, with manic behaviour and hyperactive episodes, running and thrashing around and seizures. Patients progressively lose the ability to swallow, they hyper-salivate and show fear of water. When offered water, they have muscle spasms that prevent swallowing. The mental state passes through phases of disorientation, hallucinations, confusion, stupor and coma. Death may occur after one to 10 days from heart or respiratory failure during seizures, or gradual paralysis and coma until there is no brain activity.

Up to a fifth of infected people do not display agitated behaviour, but paralysis sets in early, often starting in the limb that was bitten. Once symptoms are established there is no treatment. The only hope is to be immunised soon after exposure. So if you are bitten, immediately consult a doctor or go to a hospital.

 Treatment

Viral replication occurs at the bite site before rabies invades the nerve system. This allows post-bite treatment to be effective in creating immunity before the disease can develop. The closer the wound to the head and brain, the shorter the time to invasion and development of symptoms.

Immediately clean the wound with a strong soap solution, scrub under running water for five minutes, rinse with plain water, then apply antiseptics, iodine or alcohol. Wounds should not be sutured and hyperimmune globulin should be given immediately when there is high risk. The vaccine must also be given and this will have to be repeated at prescribed intervals. In high-risk cases treatment must start immediately, even before laboratory proof of rabies has been obtained.

Prevention

Rabies vaccine is safe and effective, so if you work a lot with animals, especially wild ones, you should consider vaccination as a preventive measure. If a rabid animal bites you, you will already have some protection, but you still need further vaccine injections immediately after a bite and on day three following a bite.

All domestic dogs should ideally be vaccinated regularly (yearly) to prevent the virus from spilling over from its wild reservoir to the vulnerable human population. If at least 70 % of the domestic dog population were to be regularly vaccinated, the disease could be eradicated. Unfortunately, despite the very serious nature of this disease, it is unlikely to happen. The immunisation of horses and cats is wise in high-risk rabies areas.

Don't trifle with rabies

In 1987 a bat-eared fox entered Okaukuejo camp in the Etosha National Park, Namibia. It showed no fear of people, an immediate warning sign, and entered a tent. A young girl picked up the fox and cuddled it. An adult removed the child and called camp staff, who killed the fox. Later analysis of the animal's brain confirmed the diagnosis as rabies. The child was very lucky because the normal reaction would have been for the fox to bite her. Never approach a mammal, especially a carnivore, which enters a conservation area camp. The vast majority will not have rabies but you can never be sure.

In 2004 in one area of KwaZulu-Natal two goats, a cow and three polo ponies died of rabies, showing that dogs are not the only domesticated animals to suffer from the disease.

In February 2007 an eight-year-old child from Hibberdene, KwaZulu-Natal, was bitten by a stray dog, but the parents did not seek medical attention until 11 days after the incident. The boy was admitted to hospital, where he died.

IF A DOG BITES YOU

Here are some basic rules that may save your life.
- If a dog bites you, even if the wound is minor, try to find the owner and establish if the dog has had its yearly rabies vaccination.
- If there is doubt, or the owner cannot be traced, immediately seek medical attention and point this fact out to the medical staff.
- Any animal showing suspicious behaviour should be caught by a competent person and handed over to the local veterinary authorities for further observation or tissue culturing.
- Be aware that any wild animal that is unusually tame and friendly may be rabid.
- Remember that the suspicious animal does not need to bite you; the virus can be transmitted if the saliva touches even a small wound on your hand.

A dog believed to have rabies showing signs of aggression. When a normally placid dog exhibits unusual behaviour it is wise to have it checked by a veterinarian.

Anthrax

'Anthrax' is the Greek word for 'coal'. The spleen of infected animals is usually very dark in colour and the blood almost tar-like. Anthrax is a very acute feverish infectious disease of herbivores, especially domestic animals, although other mammals, birds and humans can also be infected. It causes blood poisoning and quickly leads to death in cattle, sheep and goats, with a more subacute syndrome in pigs and horses, resulting in fewer deaths.

Transmission

The causative organism of anthrax is the large bacterium *Bacillus anthracis*, which occurs in great numbers in the blood, tissue fluids and organs of an infected animal. Although spores are not readily produced in the body of the animal, once they are exposed to air or oxygen they are able to survive for decades in the soil and remain highly pathogenic.

Infected animal carcasses that break down in the veld are the main source of infection. Herbivorous animals in the vicinity take up the spores while grazing. Carnivorous animals get infected through the meat, blood and other body fluids of the carcasses they feed on. Spores also survive in dried-up dams and water pools, and may be washed far away with the next flood. Pastures and agricultural land can be contaminated by the use of fertiliser made from dead animal matter. Humans can be infected through direct contact with sick or freshly dead animals, or through animal products like skins, wool and leather. Horseflies (genus *Haematopota*) and biting flies (genus *Stomoxys*) can also mechanically transmit the disease, though this is rare. Cooking meat well usually kills the bacillus, but it often remains alive in bones left after a meal. Carrion feeders like dogs, jackals and vultures can carry spores to other areas in their droppings.

Distribution

Sporadic cases occur worldwide but anthrax is endemic in most sub-Sahelan countries and the reservoirs are wild ruminants. It can also be imported into any country through contaminated animal products – for example, souvenirs made from animal skins.

According to the WHO (2003), South Africa, Botswana, Namibia and Uganda have sporadic anthrax cases, Swaziland is free of anthrax, Malawi is probably free, it is epidemic in Zambia and Zimbabwe, and it is endemic in the rest of Africa. In South Africa anthrax occurs mainly in northern Kruger National Park and adjacent Mpumalanga, but cases have also been reported from the Northern Cape and the Western Cape. Mainly affected are kudu, buffalo, impala, but rarely also elephant and lion.

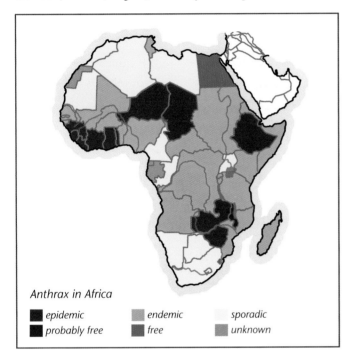

Anthrax in Africa

■ epidemic ▨ endemic □ sporadic
■ probably free ▨ free ▨ unknown

The disease in humans

The most common is the cutaneous form, where spores enter the skin through a small wound (they cannot penetrate intact skin); this accounts for 95 % of all human cases. A red papule appears at the site of entry and turns into a blister, with a purple or black centre that finally sloughs. The surrounding area is red and swollen, lymph nodes in the area can be tender and swollen, and the infection spreads along the lymph and blood vessels. Symptoms include fever, chills, nausea and headaches.

More serious is the pulmonary form of anthrax, when spores are inhaled and lead to inflammation and infection of the lungs. It used to be called 'woolsorter's disease' because these people are most exposed to spores in the air from sheep wool. The disease leads to headache, fever, general mild sickness, difficulties in breathing, and coughing. The mortality rate is high.

Anthrax infection of the gastrointestinal tract is also possible, although rare, usually through ingestion of infected meat that has not been cooked properly.

People at risk are mainly farmers, veterinarians and tannery- and wool-workers. In 2008, a drum-maker died of anthrax in the UK after handling untreated animal skins. There have been rare cases of piano builders having been infected through ivory piano keys.

The latest human infection figures for South Africa (WHO 2003) are three in 1995, 15 in 1996 and 15–23 cases in Schmidtsdrift in the Northern Cape in 2001, when a whole community was affected after eating meat from infected animal carcasses. No cases were recorded in South Africa in 2004, but 10 cases were recorded between January and June 2005. More recent statistics are not available. Occurrence of anthrax is poorly documented for the rest of Africa but there are infrequent outbreaks in countries such as Namibia and Botswana.

 Treatment

All three types of anthrax are potentially fatal if not treated promptly with penicillin, among other antibiotics, leading to dramatic recovery in humans and animals if given in time.

 Prevention

The control of anthrax in livestock is paramount. If there is suspicion of anthrax being the cause of death, it is illegal to cut the carcass open. Only a small incision should be made to take blood for a blood smear on a glass slide. Then the body must be burned so thoroughly that heat sterilisation of the ground underneath and all around also takes place. If this is not possible, the body should be buried two metres deep. The rest of the herd should be vaccinated.

The disease in animals

In 1999 two outbreaks of anthrax occurred in the Kruger National Park; 16 species of game were affected and 160 animals are known to have died. Another smaller outbreak occurred in the Northern Cape. In the same year the last two outbreaks of anthrax in sheep and goats were recorded, affecting 166 animals.

In 2000 five antelope died in the Western Cape and one cheetah was infected in the Northern Cape. In 2001 anthrax occurred in two areas infecting 10 cattle close to the Kruger National Park and there was an outbreak near Schmidtsdrift in the Northern Cape.

In October 2005 at least 21 buffalo died at Hwange in northwestern Zimbabwe in a suspected outbreak of anthrax. The year before more than 2 000 animals, including 100 buffalo, had died in the biggest ever outbreak of anthrax in Zimbabwe's private game sanctuaries. The disease could have been spread by vultures from an outbreak in neighbouring Botswana.

A heifer that died of anthrax and was later burned to prevent contamination.

Leptospirosis

This is a bacterial infection caused by a spirochete *Leptospira*. 'Leptos' is a Greek word for slender, and 'speira', also Greek, for coil – a good description of the appearance of the organism.

Animal carriers

Several wild and domestic animal species are infected with leptospirosis, mainly rats and mice, which usually show no symptoms, but also dogs, cattle, sheep, pigs and horses. It causes spontaneous abortion in cattle in KwaZulu-Natal, kidney lesions in pigs in what used to be Transvaal, and possibly chronic kidney disease in dogs in the Witwatersrand region of Gauteng province.

Distribution

Leptospirosis is the most widespread zoonotic disease and it occurs worldwide in temperate and tropical areas. The number of human cases is not well documented, often overlooked or misdiagnosed, and therefore under-reported. The percentage of human cases probably ranges from one per 100 000 a year in temperate climates to 100 or more per 100 000 a year during outbreaks, or in high-risk groups. These include farmers, dairy workers, sewage workers, veterinarians and adventure travellers, as well as people who engage in recreational water activities, such as canoeing.

Dairy workers, especially those at facilities with poor levels of hygiene, are highly susceptible to leptospirosis.

In some tropical areas leptospirosis may account for 15 % of all cases of undiagnosed fever. In South Africa the first cases of leptospirosis in dogs were proven in 1953, and by 1974 the infection rates in different animals throughout South Africa and Namibia were: 25 % dogs, 16 % sheep, 9 % horses, 6.4 % sheep and goats, 5.4 % cattle. In some countries the disease can be a serious threat to cattle and pig farming.

Transmission

Infected animals excrete the leptospires in their urine for up to six months. Transmission occurs either by direct contact with sick animals and their urine or through contact with water or food contaminated by animal urine. More cases occur in the rainy season and after severe flooding because this often causes rats to move into settlements. Leptospires can enter the body through small skin lesions, through intact mucous membranes of the mouth and nose, and through the conjunctiva of the eyes.

Symptoms

Most commonly the disease in humans is mild and does not cause jaundice. Symptoms are high fever, chills, severe headache, muscle pain, abdominal pain and redness of the eyes. Later meningitis may develop and uveitis (infection of the iris and the vascular coat of the eye). The illness is usually self-limited and lasts four to 30 days. It is commonly confused with influenza and another name is 'seven day fever'.

The classic leptospirosis with hepatitis is called Weil's disease, but it is seldom diagnosed in South Africa. It is the most severe form of the disease. In addition to the symptoms already mentioned, it affects the kidney and liver functions, there is jaundice, bleeding in the skin and mucous membranes, and an abnormal mental state. The mortality rate is 5 to 10 %.

 ## Treatment

Penicillin is an effective treatment.

 ## Prevention

Avoid coming into contact with animal urine. Hygiene is paramount in animal husbandry, especially in dairies.

Leptospira, with their spring-like structure, have a rather apt name derived from the Greek 'leptos' and 'speira', meaning slender coil.

Janice Carr/PHIL (CDC)

Histoplasmosis

Histoplasmosis is caused by the fungus *Histoplasma capsulatum,* which grows in warm and moist areas, mainly in caves where there is an accumulation of bird or bat droppings, or in poultry houses. Bats can become infected and excrete the fungus in their droppings. Birds themselves do not get infected, so fresh bird droppings do not pose a risk, although the fungus can establish itself in bird droppings after a while. The fungus is uncommon but not unknown in dry, hot attics of buildings where bats may also often roost. When accumulations of droppings are disturbed, humans inhaling the dust – and the spores – can contract the disease, mainly of the lungs.

PHIL (CDC)/Dr Libero Ajello

A photomicrograph of the fungus Histoplasma capsulatum.

Distribution

There are two types of *Histoplasma*. *H. capsulatum* var. *capsulatum* occurs worldwide, including in South and East Africa. The second type *H. capsulatum* var. *duboisii* only occurs in west and Central Africa and is endemic there. The disease it causes is sometimes also called 'African histoplasmosis'.

Symptoms

African histoplasmosis caused by *H. c.* var. *duboisii* mainly causes large destructive lesions of the skin and subcutaneous tissues, first nodules and then ulcers. In bones, so-called 'cold' abscesses can lead to bone destruction. Usually a canal forms and the abscess drains through the skin.

Approximately 80 % of people living in endemic areas have been infected by *H. c.* var. *capsulatum* without being aware of it or ever being sick. It may cause a mild flu-like illness with fever, cough, headaches and muscle pains, but may also develop into a severe pneumonia or chronic lung disease that resembles tuberculosis and can worsen over months or years. People with a weakened immune system can develop disseminated histoplasmosis, a severe illness that also affects other organs, and can be fatal.

No cases had been recorded in South Africa up to 1986, and no statistics are available since then. Occasional cases are reported in the rest of Africa.

Treatment

Antifungal medication is used to treat severe cases of histoplasmosis and all chronic and disseminated disease. Even with medical treatment, some patients may die.

Prevention

Avoid closed places with accumulations of bat or bird droppings.

Toxoplasmosis

This is a disease caused by a single-celled parasite, the protozoa *Toxoplasma gondii*, which causes disease in animals and humans. The primary host and main reservoir of toxoplasmosis is the domestic cat, but all wild cats can be primary hosts.

Distribution

Toxoplasmosis occurs worldwide and is one of the most common human infections. It is more common in warmer climates and at lower altitudes and the prevalence within a population may vary from 5 % to 80 %, depending on the occurrence of stray cats, or the human habit of eating undercooked or raw meat.

Life cycle

The parasite reproduces in the cat's intestines, producing encased eggs (oocysts) that are excreted in the cat droppings. They are very resistant to environmental conditions and disinfectants. They become infective within one to five days and can remain infective for weeks and even months (up to 18) in moist soil.

Humans and other intermediate hosts (sheep, cattle, rodents, birds) get infected by swallowing these oocysts. In these intermediate hosts the oocysts form sporozoites (larvae) that develop further in the brain, muscles and nerve tissues, finally producing cysts that contain bradyzoites, the resting larval stages, which remain there for years.

Transmission

Transmission to humans takes place mainly through direct contact with soil containing cat faeces. This can occur while gardening or changing your cat's litter box. Infection can also take place through contact with or eating of raw or undercooked meat, so ingesting the cysts containing the bradyzoites.

Signs and symptoms

Acquired infection with *Toxoplasma* in otherwise healthy people with an intact immune system only presents with symptoms in 10 to 20 % of cases. The symptoms may include fever, swelling of the lymph nodes (especially on the neck), flu-like symptoms, rash and enlargement of the spleen. Most patients recover spontaneously without medical treatment. Patients with a weakened immune system (for instance, AIDS or cancer patients) may show severe signs with encephalitis, pneumonia, altered mental state, seizures and neurological defects.

Congenital transmission occurs when a non-immune pregnant woman becomes infected for the first time. She usually shows no signs of disease, but the parasite infects the foetus she is carrying. Only a small percentage of the infections result in miscarriages or stillbirths, but there may also be severe brain or eye damage at birth. More than 85 % of the infected and apparently normal newborns will develop brain or eye problems later in life. In the eye, inflammation can lead to sight defects, blurring, pain and sensitivity to bright light. Rarely glaucoma (increased pressure within the eye) or blindness may result.

 Treatment

Treatment is available with a combination of antiparasitic drugs for several weeks, but is usually not necessary for otherwise healthy, non-pregnant humans.

 Prevention

Prevention includes thorough hand washing after contact with soil or cat litter, and keeping cats away from children's playgrounds and sandpits. Clean utensils used to cut and prepare meat thoroughly with soap and hot water. Meat for human consumption must be well cooked.

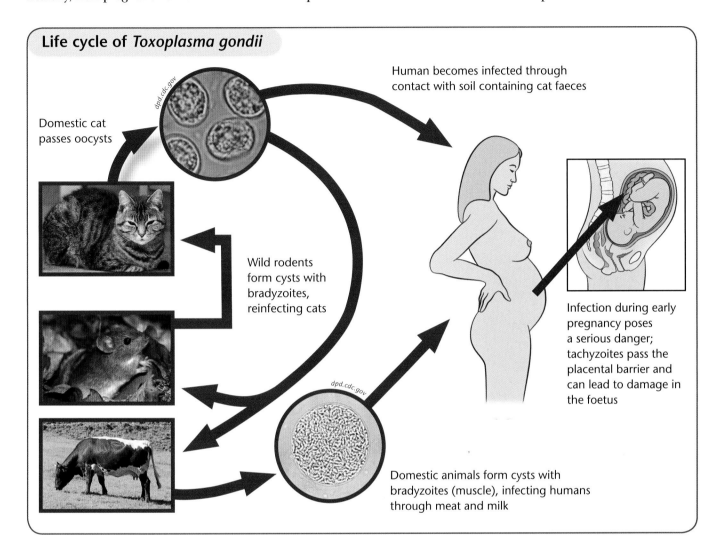

Life cycle of *Toxoplasma gondii*

Domestic cat passes oocysts

Human becomes infected through contact with soil containing cat faeces

Wild rodents form cysts with bradyzoites, reinfecting cats

Infection during early pregnancy poses a serious danger; tachyzoites pass the placental barrier and can lead to damage in the foetus

Domestic animals form cysts with bradyzoites (muscle), infecting humans through meat and milk

Psittacosis

Also known as parrot disease, parrot fever or ornithosis, this is a zoonotic disease caused by *Chlamydia psittaci* (now called *Chlamydophila psittaci* by some specialists). The organism belongs to the same genus of bacteria-like micro-organism as the one that causes trachoma (see page 191).

Not only the parrot family can be infected with *Chlamydia psittaci,* which causes psittacosis, but also pigeons, sparrows, ducks, hens, gulls and probably many other species of bird. In birds the disease is called avian chlamydiosis and infected birds shed the bacteria through droppings and nasal discharges.

The disease occurs worldwide. Infected birds may appear healthy, but more often have enteritis with diarrhoea, are in poor condition and have a nasal discharge. This bacterium can stay infective for several months and if dried bird droppings get stirred up the air becomes infective.

People usually pick up the disease by inhaling infected air, or through direct contact with a pet bird, perhaps 'kissing' a favourite parrot, or feeding it from the owner's mouth. Most at risk are bird owners, pet shop employees and veterinarians. There have been outbreaks in poultry processing plants.

The disease in humans appears about seven to 14 days after infection and can be mild, with headaches, chills, fever and a dry cough, but severe pneumonia may also develop and require intensive care. Less then 1 % of cases are fatal.

Psittacosis is a notifiable disease in South Africa although its incidence is apparently rare.

 Treatment

Tetracycline antibiotics are effective.

 Prevention

Avoid close contact with birds, especially when they do not look healthy.

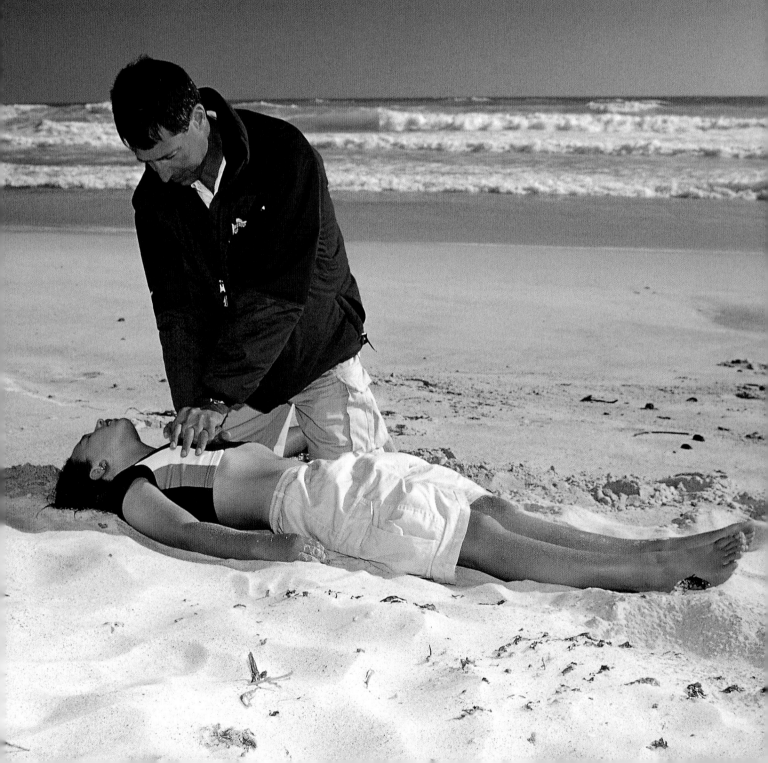

Jacques Marais/Images of Africa

First aid in emergencies

This section is not a comprehensive guide to treatment of injury or illness in the bush; rather, it offers basic, emergency help that can be administered in the event of an encounter with a dangerous or poisonous creature. The guidelines are simple and practical, and should be used in conjunction with the more specific treatment offered within the descriptions of some of the individual creatures.

The first and most important aim in any emergency situation is to get the injured person and the helpers out of harm's way. There is no point in the helpers also getting injured or attacked.

The best protection is prevention – learn about animal behaviour and what to expect when encountering animals, and use common sense when venturing into the bush or a region that presents any sort of health hazard.

Nick Aldridge/Images of Africa

UNCONSCIOUSNESS

It is possible for a person to collapse and lose consciousness as a result of a wound, bite, envenomation or allergic reaction. Irrespective of the cause, a specific and logical routine needs to be followed to assist the unconscious victim:

- Determine if the surroundings are safe. If not, move the person carefully into a safe situation.
- Assess responsiveness. Tap the person on the shoulder or gently shake them and ask, 'Are you all right?'
- Notify emergency services.
- Determine if the person is breathing properly – share duties if you are in a group: one person continues assessing and helping the collapsed/injured person while another phones for help.
- The victim should be lying supine (flat on his back) on a flat, firm surface.
- Place your face near the victim's mouth and nose and look for the chest rising and falling; listen and feel for airflow.
- Use the head tilt/chin lift manoeuvre (see details below) to open the airway.
- Remove any obvious foreign bodies from the mouth and wipe excessive saliva or vomited liquid from the mouth.

Head tilt/chin lift manoeuvre

- Kneel at the victim's side, put one hand on his/her forehead and apply backward pressure with the palm of your hand to tilt the head backwards.
- Place the fingers of the other hand under the chin, lift the jaw upwards until the top and bottom teeth are aligned and touch each other. Do not apply this manoeuvre if the victim has a head and/or neck injury.
- If the person is breathing, check for injuries or blood loss and move him/her into the recovery position (see instructions and photographs on page 220).
- If there are no signs of breathing, or you are not sure, begin ventilation immediately (see mouth-to-mouth ventilation points below).

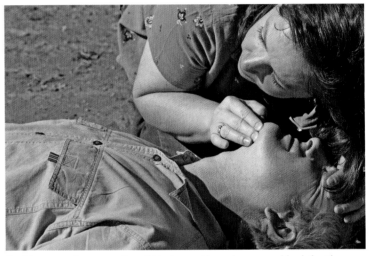

Position your face near the victim's mouth and nose and look for the chest rising and falling; listen and feel for airflow.

Mouth-to-mouth ventilation

- Kneeling at the side of the victim's head, perform the head tilt/chin lift manoeuvre, at the same time as pinching his/her nose closed with the fingers of the hand that lies on the forehead.
- Take a deep breath and put your mouth on the victim's mouth, creating an airtight seal with your lips. Give slow gentle breaths, each lasting one second.
- Make sure that the victim's chest rises with each breath.
- After each breath take your mouth away from the victim's mouth, listen for the spontaneous exhalation of air from his lungs, take another deep breath and deliver another slow breath.
- Keep a regular rhythm (10 to 12 breaths per minute) until he starts breathing spontaneously, or expert help arrives. If more than one person is available, take turns.

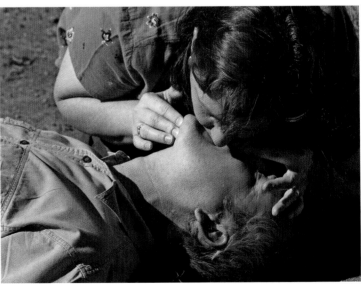

Give slow gentle breaths of one second each, making sure the victim's chest rises with each breath.

Blood circulation check

Lay people are discouraged from checking for a pulse at the carotid artery (the main artery in the neck, on either side of the trachea); this has proven to be unreliable and time consuming, and valuable time can be lost before chest compressions and successful cardiac resuscitation is started.

To check for cardiac activity and circulation in a victim deemed to be 'safe' for intimate contact, do the following:

- Apply two breaths to an unresponsive, non-breathing victim, look, listen and feel for normal breathing or coughing, and scan the whole body for some other signs of movement as reaction to the breaths. This assessment should take no more than 10 seconds.
- If the victim is still not breathing normally, nor coughing, nor moving any part of the body, and if you are unwilling to perform mouth-to-mouth resuscitation, begin chest compressions.

Chest compressions

- Position the victim flat on his back on a firm surface, making sure the head is not elevated.
- Kneel at one side of his chest. Put the heel of one hand on his sternum (breastbone) at the level of an imaginary line connecting the two nipples.
- Place your other hand on top of the first hand, keeping your hands parallel to each other. The fingers may be extended or interlaced, but should be kept off the chest of the victim. Straighten your arms and lock your elbows.
- Thrust down firmly with your hands ('push hard and push fast'). Each thrust should be straight down onto the sternum of the victim.
- The compressions should depress the victim's sternum by about four to five centimetres (in a normal-sized adult).
- Release the pressure on the chest completely after each compression, to allow blood flow into the chest and the heart.
- Perform chest compressions at a rate of about 100 per minute, which equals roughly two compressions per second.
- Time these compressions with rescue breaths: after 30 chest compressions apply two rescue breaths, whether you are resuscitating alone or two people are co-operating.

The combination of chest compressions and rescue breaths is called cardio-pulmonary resuscitation (CPR). Continue this rhythm until expert help arrives. If this is not available break the resuscitation only to move the patient into a vehicle for transport to a health care facility. Resume resuscitation in the vehicle during transport. Interruptions should be as brief as possible.

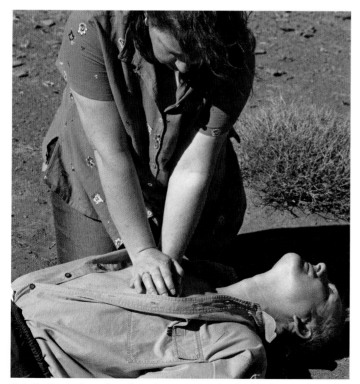

Put the heel of one hand on the sternum, level with the nipples.

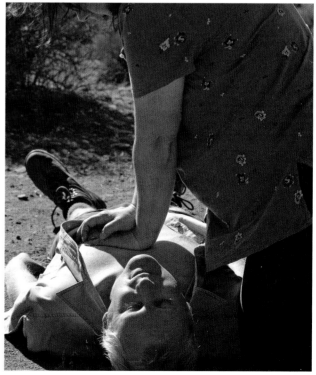

With hands parallel and arms locked, thrust firmly, then release.

Recovery position

1. Kneel at the supine victim's side, extend the arm nearest to you out to the side and bend it at the elbow so the forearm is parallel to the head with the palm facing up.
2. Place the other arm across his chest.
3. Grasp his far-side thigh and pull it upwards to bend the knee.
4. Take the victim's far shoulder and, pulling both on the shoulder and the thigh, roll him towards you onto his side. Take care that his upper hand is not trapped underneath; move this hand under the lower cheek and tilt the head backwards.
5. The victim's upper leg should be bent at 90 degrees both at the hip and at the knee, to keep him stable.

Check breathing regularly.

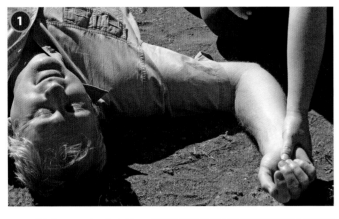

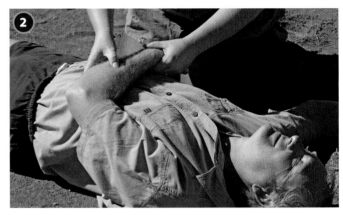

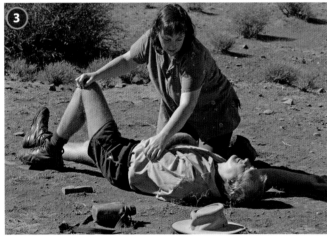

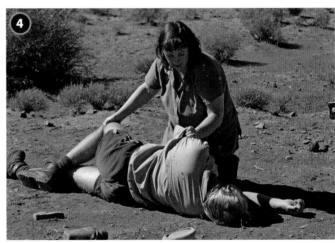

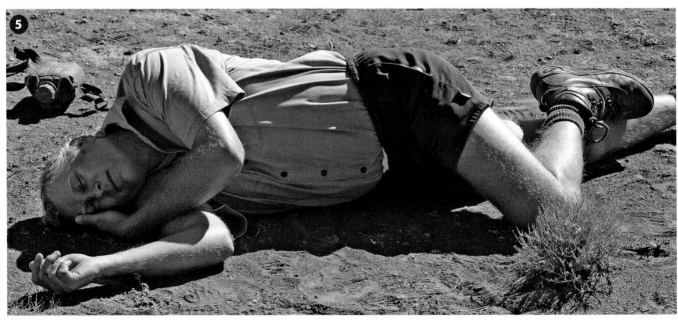

INJURIES

The greatest risks here are of contracting tetanus and rabies. Contracting rabies, in particular, is a possibility whenever someone is attacked and bitten by a carnivore, even more so if the animal shows unusual behaviour, such as a wild animal that has lost its natural shyness of humans. Any wounds contaminated with soil can potentially cause tetanus, which can also be fatal. To prevent contracting tetanus it is best to have your tetanus vaccination up to date at all times, which means a booster every 10 years.

Non-venomous bite wounds

In general, treat bites as follows:
- First aid for any open bite wound is to clean and cover it.
- Use clean water to wash out the wound thoroughly, removing any foreign bodies such as small stones, soil or plant material. If an antiseptic solution is available use it in the last rinse of water.
- Once this manual wash-out is complete, cover the wound with clean dressing material to prevent dirt or insects getting into the wound. In an emergency, a cotton shirt torn into strips or a bandana will do the trick.
- Seek medical attention immediately because bite wounds carry a high risk of infection and antibiotics often need to be administered.
- Seek immediate medical attention for post-exposure prophylaxis (prevention of disease after exposure). To protect against rabies, this will mean five injections in the four weeks following the bite. Once symptoms develop, rabies is fatal – even nowadays.
- For large and dirty wounds, a tetanus toxoid booster is still necessary if the previous booster was administered more than five years previously.

Injuries with severe bleeding

The first goal is to stop the bleeding and this can usually be achieved with pressure:
- Make a bulky pad out of dressing material, pieces of clothing or a small towel. Press this firmly onto the wound and hold it there for a few minutes. The victim can often do this himself. Avoid direct contact with the blood and thus the risk of infection. Once bleeding stops, proceed with cleaning the wound.
- If the bleeding does not stop easily, apply a broad elastic bandage firmly over the pad.
- Elevate the limb above the level of the heart.
- If the victim feels dizzy help him to lie down, keeping the legs elevated.
- Seek medical attention.

Make a bulky pad and press it firmly onto the wound.

Apply a broad elastic bandage over the pad if bleeding continues.

Victims' responses to bites vary from mild to hysterical, depending on the circumstances. Whatever the case, it pays to stay as calm as possible and to reassure the victim. For serious bites, such as snakebites, the priority is to get the victim to a medical facility as soon as possible. If private transport is available at the site, use it immediately; do not wait for an ambulance. Phone or send for help, or phone to warn the medical facility that you are on the way.

Snakebite

Snake venom acts quickly and can be highly poisonous, so it is important that help be immediate and sustained, and that the victim be transported to the nearest hospital in the shortest possible time. These measures can help keep a seriously ill victim alive until they can be treated with anti-venom, or symptomatically, depending on the situation.

The important things are:
- Immediately transport the victim to a medical facility.
- Be prepared to ventilate the patient.

For detailed help see:
➪ First aid for snakebite on page 123

Scorpion stings

In general, follow these guidelines:
- Clean the wound, cover it with a sterile dressing and immobilise the affected part.
- Apply crushed ice to the sting site early – it may be refused later by the patient because hyperaesthesia (extreme sensitivity to touch) develops.
- The patient will need hospitalisation only if stung by the more venomous, thick-tailed scorpions.

For detailed help see:
➪ First aid for scorpion stings on page 128

In the case of envenomation or injury that takes place in water, move the patient away from the water, stay calm and, if necessary, apply cardiac resuscitation until help arrives.

Spider bites

Spider bites can be treated as follows:
- Clean the wound and cover it with a sterile dressing.
- Do *not* apply a bandage. Ice is of little value.
- If anything more than a local reaction occurs, take the victim to a hospital or doctor.

For detailed help see:
➪ First aid for spider bites on page 136

Centipedes, bees and caterpillars

These creatures all have defence mechanisms that can cause pain and, in the case of allergic reaction in the victim, even death.

For detailed help see:
➪ First aid for centipede bites on page 145
➪ First aid for bee stings on page 140
➪ First aid for caterpillar envenomation on page 144
➪ Allergic reactions on page 223

Sea creatures

A number of fish need to be treated with caution because they can deliver poison with their harpoon-like teeth, or carry venom in their fin spines. They can deliver pain ranging from mild to extreme, and some can even kill, particularly if the poison generates an allergic reaction in the victim. Some spine wounds may take a long time to heal. And there is, always, the possibility that the combination of pain and shock could result in a drowning.

For detailed help see:
➪ First aid for cone shellfish envenomation on page 149
➪ First aid for fish envenomation on page 152
➪ First aid for sea urchin envenomation on page 153
➪ First aid for bristle worm envenomation on page 154
➪ First aid for marine stings on page 157

For advice on venomous stings, bites or poisonous substances phone:

Poison Information Centre, Tygerberg Hospital
Emergency number (24 hours): +27 (0) 21 931-6129
Office hours: +27 (0) 21 938-6084/6235

South Africa's countrywide poison information
tel: +27 (0) 800 333 444

Poison Information Centre, Ghana
Emergency number: +233 (0) 21 2433552/238626
Administration: +233 (0) 21 244773

SUBSTANCES THAT IRRITATE

Many substances in nature – for example, plant resins or fluids exuding from a broken branch, hairs from caterpillars – can cause local irritation when they come into contact with human skin. Mucous membranes (in the mouth and nose) are even more sensitive. Blindness may be caused by irritants coming into contact with the eyes. The most dangerous example is venom in the eye from a Mozambique spitting cobra.

General guidelines are:

- In the event of contact with an irritant, rinse the affected body part. Pour copious amounts of water over the site, gently but continuously, and remove sticky substances without rubbing the skin. Any bland liquid can be used – cold tea, cool drink, whatever is available, as long as it does not further harm the skin.
- To rinse an eye, get the person to lie or sit with the head tilted back and to the injured side. Keep the eye open by retracting both lids gently with clean fingers, then slowly pour the water in from the side closest to the nose and let it run off freely towards the outer side of the face. Have the person roll the eye and blink repeatedly. Wash the entire face as well. It is important to use lots of water (fluid), and to continue with the rinsing for 15 to 20 minutes. The desired effect is dilution and removal of the offending chemical. Seek medical attention to establish if there is any damage to the cornea.

ALLERGIC REACTIONS

An allergic reaction is an overreaction of a person's body to a foreign substance, often out of proportion to the actual injury. The classic example is allergy to bee stings. A bee deposits a small quantity of poison under a person's skin but this normally only leads to a small local swelling. In a case of severe allergy, however, one bee sting can kill a person and this can happen rapidly. Allergic reactions can also be triggered by other insect stings, bites, contact with certain plants and even ingested food.

The first signs of allergy are a larger-than-expected swelling at the site of the bite, sting or contact, swelling spreading up the whole limb, swelling of the eyelids, blocked nose and difficulty in breathing. Shock, collapse, cardiac arrest and even death can follow. Here's how to respond:

- In mild allergy, antihistamine tablets taken in accordance with the packet instructions may be all that is needed.
- In severe cases only the injection of adrenalin will save the person. People with allergies must carry adrenaline with them at all times; this is available as pre-filled ready-to-inject syringe-pens. If the person is no longer in a condition to inject himself, someone else must do it. Injections can be given on the outer upper thigh or the outer upper arm, into the fat layer or muscle beneath the skin.
- If the person remains unconscious follow the guidelines for resuscitation on page 218.

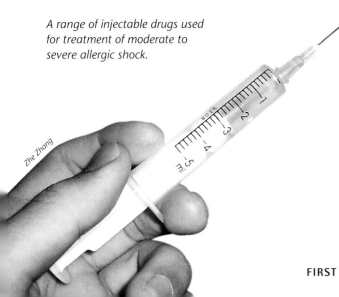

A range of injectable drugs used for treatment of moderate to severe allergic shock.

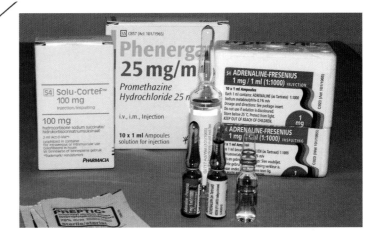

APPENDIX

The tables in this appendix are neither exhaustive nor comprehensive. Their purpose is to provide an overview of the huge array of human zoonotic diseases, and the animals that transmit or cause them.

Important zoonotic virus diseases in humans in Africa

Family	Genus	Disease caused	Transmission via
Togaviridae	Alphavirus	Chikungunya fever	Mosquitoes
		O'nyong'nyong fever	Mosquitoes
		Sindbis	Mosquitoes (culicines)
		Semliki Forest virus	Mosquitoes
Flaviviridae	Flavivirus	Yellow fever	Mosquitoes
		Dengue fever	Mosquitoes
		West Nile fever	Mosquitoes
Bunyaviridae	Phlebovirus	Rift Valley fever	Mosquitoes (and sand flies)
		Sand fly (Pappataci-, three-day-) fever	Sand flies
	Nairovirus	Crimean-Congo haemorrhagic fever	Ticks
	(Ortho) Bunyavirus	Bunyamera virus (fever, encephalitis)	Mosquitoes (culicines)
		Bwamba virus (fever and rash)	Mosquitoes
Filovirus	Marburg virus	Marburg haemorrhagic fever	Man to man close contact, animal reservoir unknown
	Ebola virus	Ebola haemorrhagic fever	Man to man; animal reservoir: possibly primates, possibly bushmeat
Arenaviridae	Arena virus	Lassa fever	Rodent droppings
Rhabdoviridae	*Lyssa* virus	Rabies	Bites, wound contact with saliva
Orthomyxoviridae	Influenza A virus H5N1 strain	Avian influenza ('Bird flu')	Through air, reservoir: wild and domestic birds
	Influenza A virus H1N1 strain	'Novel' influenza ('Swine flu')	Through air

Overview of the most important disease-carrying mosquitoes in Africa

Mosquito group	Mosquito genus	Mosquito species	Disease	Disease-causing organism	Locality restrictions
Culicines	*Aedes* (bush mosquitoes)	*Aedes aegypti* Yellow fever mosquito	Yellow fever	Flavivirus	Urban areas
			Dengue fever	Flavivirus	
			Chikungunya fever	Alphavirus	
			Rift Valley fever	Phlebovirus	
		Aedes albopictus Asian tiger mosquito	'Jungle' yellow fever	Flavivirus	Rural areas, west Africa
			Dengue fever	Flavivirus	West Africa
			Chikungunya fever	Alphavirus	West Africa
		Aedes bromelia	'Jungle' yellow fever	Flavivirus	Rural areas
		Aedes africanus	'Jungle' yellow fever	Flavivirus	Rural areas
	Culex (house mosquitoes)	*Culex pipiens*	Lymphatic filariasis	*Wuchereria bancrofti* (parasite)	Urban areas, southern Africa
			Rift Valley Fever	Phlebovirus	
			West Nile fever	Flavivirus	
		Culex quinquefasciatus	Lymphatic filariasis	*Wuchereria bancrofti* (parasite)	Urban areas, tropical Africa
			West Nile fever	Flavivirus	
Anophelines	*Anopheles* (malaria mosquitoes)	*Anopheles gambiae*	Malaria	*Plasmodium* (parasite)	
			Lymphatic filariasis	*Wuchereria bancrofti*	Rural areas
			O'nyong'nyong fever	Alphavirus	
		Anopheles funestus	Malaria	*Plasmodium* (parasite)	
			Lymphatic filariasis	*Wuchereria bancrofti*	Rural areas
			O'nyong'nyong fever	Alphavirus	
		Anopheles arabiensis	Malaria	*Plasmodium* (parasite)	
			Lymphatic filariasis	*Wuchereria bancrofti*	Rural areas

Classification of helminths (worms) and the most important diseases caused in Africa

Class	Species	Disease	Transmission	Host
Trematodes (flukes)	*Fasciola hepatica* Sheep liver fluke	Fascioliasis	Watercress, aquatic vegetables, water, salads	Herbivores, esp. sheep
	Schistosoma haematobium Blood fluke	Urinary schistosomiasis (bilharzia)	Slow-moving fresh water, *Bulinus* snails are vectors	Humans
	Schistosoma mansoni	Intestinal schistosomiasis	Slow-moving fresh water, *Biomphalaria* snails are vectors	Humans
Cestodes (tapeworms)	*Taenia saginata* Beef tapeworm	Intestinal tapeworm infection	Raw and undercooked beef	Humans
	Taenia solium Pork tapeworm	Intestinal worm infection and cysticercosis	Raw, undercooked pork, cysts in water, food, hand to mouth	Humans
	Echinococcus granulosos	Hydatid disease (echinococcosis)	Direct contact with hosts and intermediate hosts or contaminated food and water	Domestic dog, wild canids (jackal, foxes)
	Diphyllobothrium latum Fish tapeworm	Intestinal worm infection	Raw or undercooked fish	Humans, dogs, other fish-eating animals
	Hymenolepis nana Dwarf tapeworm	Intestinal worm infection	Direct contact, food, water, pure hygiene	Humans
Nematodes (roundworms) 1 – Intestinal infections	*Ascaris lumbricoides* Roundworm	Ascariasis	Contaminated food, water, soil	Humans
	Trichuris trichiura Whipworm	Trichuriasis	Contaminated food, water, soil	Humans
	Enterobius vermicularis Pinworm, Threadworm	Enterobiasis	Orally, hand to mouth, through eggs on household goods	Humans
	Ancylostoma duodenale *Necator americanus* Hookworms	Hookworm disease	Larvae penetrate skin, walking barefoot, working in rice paddies	Humans
	Strongyloides stercoralis	Strongyloidiasis	Larvae in the soil penetrate skin	Humans, also dogs, cats, primates

Class	Species	Disease	Transmission	Host
2 – Infections of tissues and blood vessels	*Wuchereria bancrofti* (filaria)	Lymphatic filariasis (elephantiasis)	Mosquitoes	Humans
	Loa loa (filaria)	Loaiasis	*Chrysops* flies	Humans
	Onchocerca volvulus (filaria)	Onchocerciasis (river blindness)	*Simulium* sp. Black flies	Humans
	Dracunculus medinensis Guinea worm	Dracunculiasis (Guinea worm infection)	Water infested with *Cyclops* water fleas	Humans
	Trichinella spiralis and *T. nelsoni*	Trichinosis (trichinelliosis)	Raw or undercooked pork	Humans, domestic pigs, wild pigs, carnivores
3 – Infections through larvae of nematodes	*Ancylostoma braziliense* Cat hookworm *Ancylostoma caninum* Dog hookworm	Cutaneous larva migrans or creeping eruption	Sandy soils (beaches, playground) contaminated by dog and cat faeces	Cats, dogs
	Toxocara canis Dog roundworm *Toxocara cati* Cat roundworm	Visceral larva migrans (toxocariasis)	Eggs from direct contact with dogs or cats, or in soil	Domestic dogs, wild canids, domestic cats
	Angiostrongylus cantonensis	Eosinophilic meningoencephalitis	Larvae in uncooked snails, shrimps, fish, on vegetables	Rats

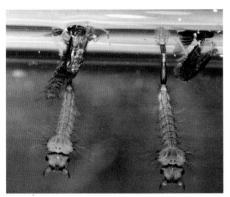
Larvae of house mosquitoes (Culex sp.).

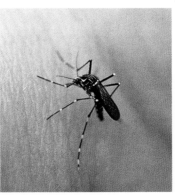
A female bush mosquito (Aedes sp.).

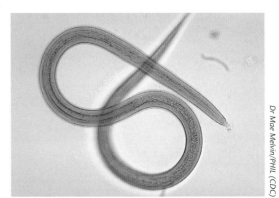
An infective larva of a Strongyloides *roundworm.*

Dr Mae Melvin/PHIL (CDC)

Infectious diseases caused by protozoa in Africa

Protozoa	Disease	Vector – transmission	Locality	Hosts
Trypanosoma	African sleeping sickness	Tsetse flies (Glossina sp.)	South of Sahara to 20° S	Game animals, domestic animals, humans
Leishmania	Leishmaniasis	Sand flies (Phlebotomus)	Subtropical and tropical areas	Wild and domestic animals, humans
Plasmodium	Malaria	Mosquitoes	Subtropical and tropical areas	Humans
Entamoeba complex	Amoebiasis	Faecal – oral route, mechanical transmission through flies, arthropods	Subtropical and tropical areas	Humans
Babesia	Babesiosis	Ixodes ticks	South Africa	Wild and domestic animals, rarely infects humans
Toxoplasma	Toxoplasmosis	Contaminated food, water, earth, cat litter	Worldwide	Animals and humans

Major tick-borne diseases of humans in Africa

Family	Species	Disease	Disease-causing organism	Reservoir
Argasidae (soft ticks or tampans)	Ornithodoros moubata (eyeless tampan)	Endemic relapsing fever	Borrelia duttoni	Rodents, tampan
Ixodidae (hard ticks)	Amblyomma variegatum (tropical bont tick)	Congo fever	Nairovirus	Ticks, wild and domestic animals
		Q-fever	Coxiella burnetti	Rodents, ruminants, direct transmission from dairy cattle
	Amblyomma hebraeum (South African bont tick)	East African tick typhus (tick-bite fever)	Rickettsia sp.	Rodents
	Amblyomma sp. (bont ticks)	Tick typhus (tick-bite fever)	Rickettsia spp.	Rodents
		Ehrlichiosis (rare)	Ehrlichia chaffeensis	Rodents, dogs, horses
	Rhipicephalus appendiculatus (brown ear tick)	South African tick typhus (SA tick-bite fever)	Rickettsia conorii var. pijperi	Rodents

Family	Species	Disease	Disease-causing organism	Reservoir
Ixodidae (hard ticks) (continued)	*Rhipicephalus* sp. (brown ticks)	Tick typhus (tick-bite fever) in several African regions	*Rickettsia* spp.	Rodents, dogs
		Ehrlichiosis (rare)	*Ehrlichia chaffeensis*	Rodents, dogs, horses
		Crimean-Congo haemorrhagic fever	Nairovirus	Wild and domestic animals
	Boophilus decoloratus (African blue tick)	Crimean-Congo haemorrhagic fever	Nairovirus	Wild and domestic animals, ticks
	Haemaphysalis spp. (eyeless ticks)	Tick typhus (tick-bite fever)	*Rickettsia* spp.	Rodents, dogs
		Q-fever	*Coxiella burnetti*	Rodents, ruminants
	Hyalomma sp. (bont-legged ticks)	Tick typhus (tick-bite fever)	*Rickettsia* spp.	Rodents
		Q-fever	*Coxiella burnetti*	Rodents, ruminants
		Congo-Crimean haemorrhagic fever	Nairovirus	Ticks, wild and domestic animals
	Ixodes sp.	Lyme disease	*Borrelia burgdorferi*	Rodents
	Ixodes rubicundus (Karoo paralysis tick)	Tickparalysis (tick toxicosis)	None (toxic substance in saliva of female ticks)	

Major tick-borne diseases in livestock in Africa

Disease	Tick species	Disease-causing organism
Swine fever	*Ornithodorus moubata* (tampan)	Swine fever virus
Heartwater	*Amblyomma hebraeum* (South African bont tick)	*Ehrlichia ruminantium*
Redwater	*Boophilus decoloratus* (African blue tick) *Rhipicephalus evertsi* (red-legged tick)	*Babesia bigemina* *Babesia bovis*
Gallsickness	*Boophilus decoloratus* (African blue tick)	*Anaplasma marginale*
East coast fever and corridor disease	*Rhipicephalus appendiculatus* (brown ear tick)	*Theileria parva* strains
Biliary fever in horses	*Rhipicephalus evertsi* (red-legged tick)	*Babesia caballi*
Biliary fever in dogs	*Rhipicephalus sanguineus* (dog kennel tick) *Haemaphysalis leachi* (yellow dog tick)	*Babesia canis*

Classification of some of the medically important Arthropoda

Arthropoda are characterised by a hard, jointed external skeleton

Superclass	Class	Order	Family
Hexapoda	Insecta	Phthiraptera (lice)	Pthiridae (crab lice, pubic lice) Pediculidae (human lice)
		Hemiptera (bugs)	Cimicidae (bed bugs)
		Diptera (flies)	Chironomidae (midges, gnats, bloodworms) Culicidae (mosquitoes) Ceratopogonidae (biting midges) Simuliidae (blackflies) Tabanidae (horse flies) Muscidae (houseflies, stable flies) lossinidae (tsetse flies)
		Siphonaptera (fleas)	
	Arachnida	Araneae (spiders)	
		Scorpiones (scorpions)	
		Acarina (ticks and mites)	
Myriapoda (centipedes and millipedes)			

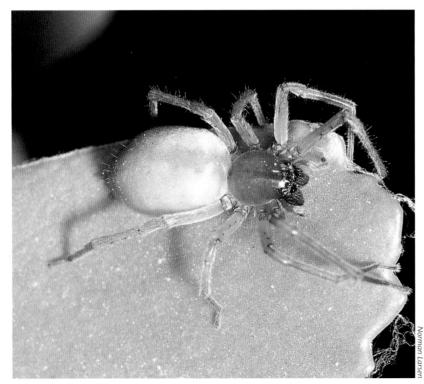

A sac spider.

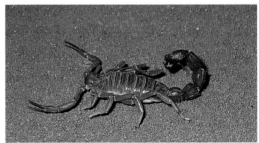

A Parabuthus granulatus *scorpion.*

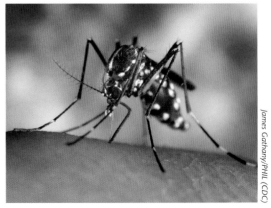

An Aedes albopictus *mosquito.*

GLOSSARY

Anaemia: a condition in which there is a reduction of 1) the number of red blood cells, 2) the level of haemoglobin or 3) the total blood volume, or a combination of these factors

Anthelmintic: medication used in the control of parasitic worms

Anti-venom: (= antivenin, antivenene) a biological product used in the treatment of venomous bites or stings, to counteract the venom's effect; it consists of specific proteins (antibodies) reacting with the venom's active molecules (antigens)

Arachnid: all arachnids (class Arachnida) have eight segmented legs, compared to six in the insects, and most are carnivorous; arachnids include well-known groups such as scorpions, spiders and ticks

Arbovirus: derived from **Ar**thropod-**bo**rne virus

Arthropod: an invertebrate with jointed legs, segmented body and an exoskeleton composed of chitin, such as insects, arachnids and centipedes

Chaetae: bristles, or bristle-like structures, composed of chitin

Chitin: a polysaccharide that is the main component of the exoskeletons of arthropods

Congenital: present at birth

Cutaneous: involving the skin

Cysticercus: larval stage of the tapeworm, between oncosphere and adult

Dorsal: the back, or spinal, part of the body

Duodenum: first section of the small intestine, attached to the stomach

Ectoparasite: a parasite that lives on the outside, on the skin of the host, e.g. mites

Encephalitis: inflammation of the brain, usually caused by a virus

Endemic: (of disease) widespread in a given population; occurring continuously and with predictable regularity in a specific area or population

Endoparasite: a parasite that lives inside the host's body, e.g. intestinal worms

Enteritis: inflammation of the intestines, particularly inflammation of the mucous membranes of the small intestine

Envenomation: injection of venom into the tissues

Enzootic: (of disease) constantly present in the animal community, but only occurring in a small number of cases

Epidemic: the occurrence of cases of an illness in a community or region which is in excess of the number of cases normally expected in that area at that time; a widespread outbreak of an infectious disease where many people are infected at the same time

Epithelial: pertaining to or composed of epithelium

Epithelium: the layer of cells forming the outer layer of the skin and the surface layer of mucous membranes

Epizootic: an outbreak or epidemic of a disease in animal populations

Febrile: feverish

Globuline: a simple protein present in blood serum

Hepatitis: inflammation of the liver of viral or toxic origin; usually jaundice, fever and liver enlargement is present

Infective: (= infectious) capable of being transmitted with or without contact; producing infection

Infestation: harbouring of parasites, presence of parasites in a host

Intestinal: pertaining to the intestines

Intestine: section of the digestive tract extending from the end of the stomach to the anus; divided into small and large intestine

Jaundice: yellowing of skin and eyes due to excess bilirubin (bile colour) in the blood

Meningitis: inflammation of the membranes of the spinal cord and the brain

Monovalent: 'to have single power'; mainly used in connection with anti-venoms – an anti-venom that can counteract only one type of venom

Nematocyst: cyst, or encapsulated cyst, relating to roundworms

Oncosphere: embryonic stage of the tapeworm, following the egg stage

Oocyst: encapsulated egg stage

Pandemic: an epidemic occurring worldwide, or over a very wide area, crossing international boundaries and usually affecting a large number of people

Papule: 'pimple', raised small solid node on the skin; may be red

Parasitism: the co-existence of two unrelated organisms over a prolonged period, in which one organism, usually the smaller one, benefits (the parasite) and the other (the host) gets harmed

Pectoral: refers to chest, breast or thorax, e.g. pectoral fins of fish

Pedipalp: a pair of segmented appendages, e.g. the pincers of scorpions, or the palps of spiders

Poison: a broad term for any substance (natural or synthetic) that interferes with the normal function in the body, mainly in humans, and as such poses a health risk; it can be ingested, inhaled, injected, absorbed through the skin; the effect is dose dependent, and may even be harmless in small doses

Polyvalent: an anti-venom that is effective against the venom of several species

Protozoa: single-celled organisms whose cells do have nuclei, they are *not* animals, but show characteristics associated with animals, e.g. mobility

Reservoir: any person, animal, plant, soil or substance in which an infective agent normally lives and multiplies; the agent primarily depends on the reservoir for its survival

Serum: the liquid part of the blood after all blood cells have been removed

Strain: a stock of micro-organisms (bacteria, virus or parasite) from a specific source and maintained in successive cultures

Sub-caudal: beneath the tail; usually referring to the scales under the tails of snakes and lizards

Toxin: a poisonous substance of animal or plant origin produced by living cells or organisms

Vector: any living creature that transmits an infectious agent to humans; transmission can be purely mechanical, through contamination of feet, mouthparts, saliva or faeces; the vector may also be the host to the infective agent and necessary for its development and reproduction before it is transmitted

Venom: a poisonous substance produced by animals, it is normally injected when the animal is hunting prey or used in defence; venoms are usually not dangerous or poisonous when ingested

Ventral: relating to the belly – in humans relating to the front side of the body, in animals walking on four legs relating to the underparts of the body

Zoonotic: (of disease) transmitted from vertebrate animals to humans

BIBLIOGRAPHY

African Hunting Info. Future Publishing Online. http://africanhuntinginfo.com

Blaylock, RS. 2005. 'The identification and syndromic management of snakebite in South Africa.' *SA Family Practice* 47(9): 48–53.

Branch, B & Haacke, W. 1980. 'A fatal attack on a young boy by an African Rock Python, *Python sebae.*' *Journal of Herpetology* 14 (3): 305–307.

British Broadcasting Corporation, News Services. www.bbc.co.uk

Cahill, KM & O'Brien, W. 1990. *Tropical Medicine – A Clinical Text.* Heinemann Medical Books, Heinemann Professional Publishing, Oxford.

Compagno, L & Kock, A. 2006. 'Cape Town's Great White Hype.' *African Wildlife* 60 (4), pp 19–21.

Centers for Disease Control and Prevention, Atlanta USA. www.cdc.gov

Centers for Disease Control and Prevention, National Center for Infectious Diseases, Special Pathogens Branch. www.cdc.gov/ncidod/dvrd/spb

CME. South African Medical Association Health and Medical Publishing Group.

Current Medical Diagnosis & Treatment. 2002. Lange Medical Books, McGraw-Hill, New York.

Department of Health, South Africa. www.doh.gov.za

Dippenaar-Schoemann, AS. 1997. *African Spiders – An Identification Manual.* Plant Protection Research Institute Handbook no. 9. Pretoria.

Dippenaar-Schoeman, AS. 2002. *The Spider Guide of Southern Africa.* CD-series 2.1. ARC-LNR Plant Protection Research Institute, Pretoria.

Dippenaar-Schoemann, AS & Müller GJ. 2000. *Medically Important Spiders and Scorpions of Southern*

Africa. CD-series 1.1. ARC-LNR Plant Protection Research Institute, Pretoria.

Doctors Without Borders. www.doctorswithoutborders.org

Eddleston, M & Pierini, S. 2000. *Oxford Handbook of Tropical Medicine.* Oxford University Press, Oxford.

Filmer, MR. 1991. *South African Spiders – An Identification Guide.* Struik Publishers, Cape Town.

Foelix, RF. 1982. *Biology of Spiders.* Harvard University Press, Cambridge, Mass.

Henning, MW. 1956. *Animal Diseases in South Africa.* Central News Agency, South Africa.

Hunt Network. www.huntnetwork.net.

International Journal of Clinical Practice. Blackwell Publishing Ltd, United Kingdom.

Iziko Museums of Cape Town, Biodiversity Explorer. www.museums.org.za/bio

Jocque, R & Dippenaar-Schoeman, AS. 2006. *Spider Families of the World.* Koninklijk Museum voor Midden-Afrika, Tervuren.

Leeming, J. 2003. *Scorpions of Southern Africa.* Struik Publishers, Cape Town.

Levitan, AE. *et al.* 1992. *Handbook to Middle East Amphibians and Reptiles.* Contributions to Herpetology No. 8, St. Louis, Missouri.

Marais, J. 2004. *A Complete Guide to the Snakes of Southern Africa.* Struik Publishers, Cape Town.

Medscape. www.medscape.com

Miller, PJ & Loates, MJ. 1997. *Fish of Britain and Europe.* Collins Pocket Guide. HarperCollins Publishers, London.

Modern Medicine of South Africa. Monthly clinical journal. National Publishing, Cape Town.

Mönnig, HO & Veldman, FJ. 1974. *Handboek oor Veesiektes.* Tafelberg-Uitgewers, Cape Town and Johannesburg.

National Geographic. Official Journal of the National Geographic Society. Washington, D.C. www.nationalgeographic.com

National Institute of Communicable Diseases, NICD. Pretoria. www.nicd.ac.za

Norval, RAI & Horak, IG. 2004. Volume 1, Chapter 1: 'Vectors: Ticks' in *Infectious Diseases of Livestock*, edited by Coetzer, JAW & Tustin, RC. Oxford University Press, Oxford.

Peschak, TP & Scholl, MC. 2006. *South Africa's Great White Shark.* Struik Publishers, Cape Town.

Peters, W & Gilles, HM. 1995. *Tropical Medicine and Parasitology.* Mosby-Wolfe, Times Mirror International Publisher, London.

Picker, M, Griffiths, C & Weaving, A. 2002. *Field Guide to Insects of South Africa.* Struik Publishers, Cape Town.

Public Health Image Library. http://phil.cdc.gov

Road Traffic Management Corporation. *Interim Road Traffic and Fatal Crash Report 2006.* www.arrivealive.co.za

Ross, CA & Garnett, S. (Eds). 1989. *Crocodiles and Alligators.* Merehurst Press, London.

Schistosomiasis Control Initiative, Department of Infectious Disease Epidemiology, Imperial College London. www.sci-ntds.org

Selous, FC. 1881. *A Hunter's Wanderings in Africa.* Richard Bentley & Son, London.

Skelton, P. 1993. *A Complete Guide to the Freshwater Fishes of Southern Africa.* Struik Publishers, Cape Town.

Smith, JLB. 1965. *The Sea Fishes of Southern Africa.* Central News Agency, South Africa.

South African Broadcasting Corporation. www.sabcnews.co.za

South African Medical Journal. Health and Medical Publishing Group, Pretoria.

Spawls, S & Branch, B. 1995. *The Dangerous Snakes of Africa.* Southern Book Publishers, Halfway House.

Statistics South Africa. *Mortality and Causes of Death in South Africa, 2003 and 2004. Findings from Death Notification.* Statistical Release P0309.3. *South African Statistics 2006 + 2007.* www.statssa.gov.za

Stuart, C & Stuart, T. 2006. *Field Guide to Larger Mammals of Africa.* Struik Publishers, Cape Town.

Stuart, C & Stuart, T. 2007. *Field Guide to the Mammals of Southern Africa.* Struik Publishers, Cape Town.

Taber's Cyclopedic Medical Dictionary. 1979. F.A. Davis Company, Philadelphia.

The Biology of Scorpions. 1990. Edited by Palis, G.A. Stanford University Press, Stanford, California.

United Nations Roll Back Malaria. www.rbm.who.int

Wagstaff, SC. *et al.* 2006. 'Bioinformatics and Multiepitope DNA Immunization to Design Rational Snake Antivenom.' *Public Library of Science. 3 (6);* 832–844. http://medicine.plosjournals.org

Wiesmann, E. 1982. *Medizinische Mikrobiologie.* Georg Thieme Verlag, Stuttgart.

Wikipedia, the online encyclopedia. http://en.wikipedia.org

World Health Organisation. www.who.int

World Health Organisation Weekly Epidemiological Report. www.who.int/wer/en

Zahradnik, J. 1991. *Bees, Wasps and Ants – A Field Guide to the World's Hymenoptera.* The Hamlyn Publishing Group, London.

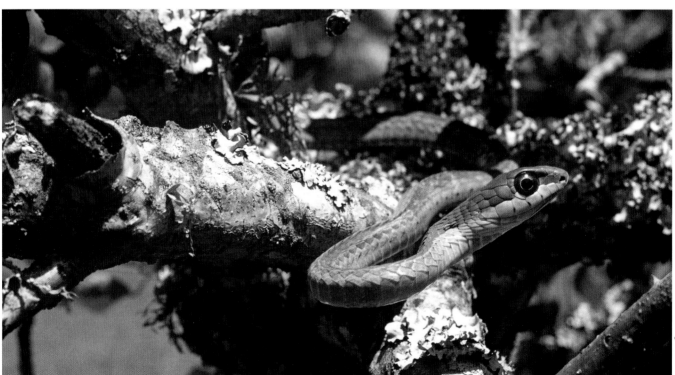

A boomslang (Dispholidus typus).

Leonard Hoffmann/Images of Africa

INDEX

sun spider 137, *137*
suricate 127
Surra 190
swallows 52
swimming crab 94, 95
swine fever *229*
swine flu *224*
swordfish 87
Synanceia verrucosa 147, 149–150, *149,*
 150, 152
Synodontis sp. 151, *152*

T

Tachypompilus ignitus 141, *142*
Taenia saginata 204, *204,* 205
Taenia solium 204, 205, 206
tailor ant 96, *96*
tampans *see* ticks
tapeworms
 see also flukes; roundworms
 beef tapeworm 204, *204,* 205
 dog tapeworm 207, *207*
 dwarf tapeworm 206
 fish tapeworm 206
 pork tapeworm *204, 205,* 206
tarantula *see* baboon spider
tawny owl 51
Tegenaria domestica 136
Telescopus semiannulatus 115, *115*
termites 96, *96*
terns 52
tetanus 60, 134, 136, 221
Tetraodon mbu 162
textile cone 148, *148*
Thelotornis capensis 116, *116*
Thelotornis kirtlandi 116
threadworm 208
three-day fever *224*
three-spotted swimming crab 94
Thyrsites atun 92
tick-bite fever 196, *196, 228, 229*
tick-borne relapsing fever 198, *198*
tickparalysis 195, *229*
ticks
 Congo fever 197, *197*
 description 137, 194, *194, 228–229, 230*
 Lyme disease 198
 Q-fever 198
 tick-bite fever 196, *196, 228, 229*
 tick-bites 195, *195*
 tick-borne relapsing fever 198, *198*
tick toxicosis *229*
tick typhus *see* tick-bite fever
tigerfish 93, *93*
tiger shark 74, 76, 80, 83, *83,* 163
tilapia *152*
toadfish 151, 162
toads *102,* 124–125, *124, 125*
Torpedo marmorata 90
Toxocara cani 201
Toxocara cati 201
toxocariasis 201, *227*
Toxoplasma gondii 214–215, *215*
toxoplasmosis 214–215, *215, 228*

Toxopneustes pileolus 152
trachoma 191
Transvaal black button spider *132*
trematodes *see* flukes
Trichinella nelsoni 208, *208*
Trichinella spiralis 208, *208*
trichinelliosis *227*
trichinosis 208, *208, 227*
trichuriasis 201, *226*
Trichuris trichiura 201
Trinervitermes spp. *96*
tropical nest fly 191
Trypanosoma brucei 190
Trypanosoma brucei gambiense 185, *185*
Trypanosoma brucei rhodesiense 185, *185*
Trypanosoma evansi 190
trypanosomiasis 184, 185–186, *185, 228*
tsetse flies 184–186, *184, 185, 186,*
 228, 230
tumbu fly 191, *192*
twig (vine) snake 103, *104,* 116, *116*
typhoid fever 196

U

urban yellow fever 180
Uroplectes sp. 127

V

Varanus albigularis 60
Varanus niloticus 60
variable burrowing asp 117
velvet ant 141
vervet monkey 42–43, *44*
Vespula germanica 142
vine snake *see* twig snake
violin spider 134, *134*
vipers
 bush vipers 120
 carpet vipers 121
 description 100, 102, 117
 desert vipers 121, *121, 122*
 exotic vipers 120, *120*
 rhinoceros viper 119, 120
viral diseases *224*
visceral larva migrans 201, *227*
visceral leishmaniasis 187, 188, *188*
vlei rat 118

W

Wagstaff, Simon 104
Wahlberg's epauletted fruit bat 209
warthog 28, 29, *29*
wasps 141–142, *141, 142*
water mongoose 124
water scorpion 97, *97*
Weil's disease 213
West African brown spitting cobra 110
West African carpet viper 104, 121
West African green mamba 107
western barred spitting cobra 111
West Nile fever 182, *182, 224, 225*
whale shark 71, 86, *86*
whip spider 137, *137*
whipworm 201

white-bellied carpet viper 121
white rhinoceros 18, *18,* 19, *19,* 20
white-throated monitor 60
wild dog 27, 40, *40*
wildebeest, black 26
Wilson, Viv 29
wolf, Ethiopian 41
wolf spider 136, *136*
Wolhuter, Harry 31–32
wood-owl, African 51
worms *see* flukes; roundworms;
 tapeworms
worms, bristle 153–154
Wuchereria bancrofti 178, *179*

X

Xiphius gladius 87

Y

yellow-bellied sea snake 147, *147*
yellow fever *9,* 170, 172, 180, *180,*
 224, 225
'yellow jacket' wasp 142
yellow mongoose 40, 146, *209,* 210
yellow-spotted rock hyrax 42

Z

Zambezi shark *see* bull shark
zebra snake 111
Zimbabwean brown button spider
 132, 133

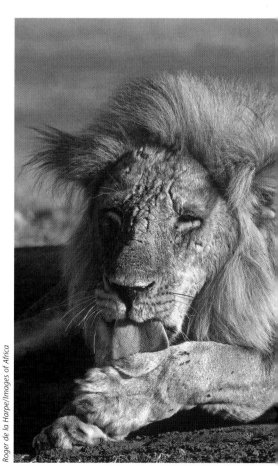

Roger de la Harpe/Images of Africa

Lion, Matusadona National Park, Zimbabwe.

ACKNOWLEDGEMENTS

Of necessity, a book of this nature – *Dangerous Creatures of Africa* – cannot be a solitary process by the authors alone. Many people have been involved with information gathering, providing facts and details in their specific field(s) of interest and knowledge. A great number of people have been willing to verify facts and incidents. All the people listed here are sincerely thanked for their input, great or small. We apologise if anybody has been overlooked in the process. We hope not, but we thank you all the same. Any errors or shortcomings are ours and ours alone.

Daryl Balfour for pictures and permission to quote from his book on big tuskers in Kruger National Park; Roger Bills provided pictures and information on freshwater fish; Richard Boycott for snake photos and information; Lynne Broderick for her anecdote on the cone shell incident (and the delicious tiger prawns she served us); John Carlyon for the owl attack incidents; Ansie Dippenaar-Schoeman, Plant Research Institute (ARC) for spider and scorpion information and pictures; Wulf Haacke and Pieter Bos provided python bite pictures and information; John and Jane Hoepfl shared some of their 'not so nice' tales from their Natal Parks Board days; Norman Larsen for reading through and checking the spider section and providing photos; David Lloyd for information on man-eaters of Serenje District, Zambia and access to colonial correspondence; Gus Mills provided information on spotted hyaena attacks; Steve Moseley and Brent Moseley-Naudé for shark viewing pictures, good discussion and for 'lending' their bodies to be photographed for the first aid section; Prof. G Müller and his staff at the Tygerberg Poison Information Centre, Department of Pharmacology, Faculty of Health Sciences, University of Stellenbosch for information, discussion and photos; André Naylor provided bee information and gave access to his swarms for photography; Guy Palmer for snake skulls and information; Public Health Image Library (PHIL) of the Centers for Disease Control and Prevention (CDC), Atlanta, Georgia, USA; Peter Schneekluth shared his ostrich encounter and offered great photo opportunities; Enid Stuart related baboon incidents in Glencairn, Cape Town; John Visser provided information and photos, especially on sharks and snakes, and Alan Weaving for photos and information on insects.

A special word of thanks is due to Pippa Parker for embracing the project. Roxanne Reid did the original editing, followed by Helen de Villiers and Colette Alves, who has also done a fine job of 'herding' the book through its various stages. We also thank Janice Evans and Martin Endemann for making the book very pleasing to the eye.

Chris and Mathilde Stuart, Loxton 2009

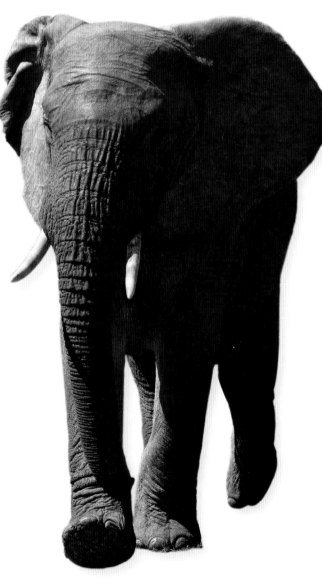